RUTH HARRIET LOUISE AND HOLLYWOOD GLAMOUR PHOTOGRAPHY

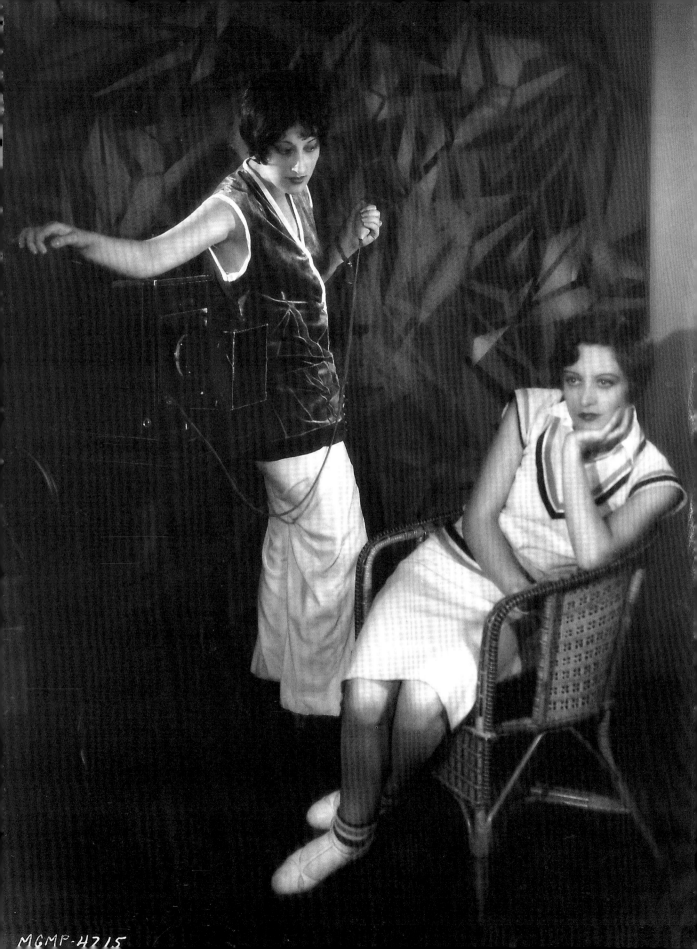

MGMP-4715

RUTH HARRIET LOUISE AND HOLLYWOOD GLAMOUR PHOTOGRAPHY

ROBERT DANCE *and* BRUCE ROBERTSON

UNIVERSITY OF CALIFORNIA PRESS Berkeley Los Angeles London
PUBLISHED IN ASSOCIATION WITH THE SANTA BARBARA MUSEUM OF ART

THE PUBLISHER GRATEFULLY
ACKNOWLEDGES THE GENEROUS
CONTRIBUTION PROVIDED BY
THE GENERAL ENDOWMENT OF
THE UNIVERSITY OF CALIFORNIA
PRESS ASSOCIATES.

EXHIBITION TOUR

Terra Museum of American Art, Chicago, Illinois
APRIL 26–JULY 7, 2002

Santa Barbara Museum of Art, Santa Barbara, California
JULY 27–OCTOBER 6, 2002

Edwin A. Ulrich Museum of Art, Wichita State University,
Wichita, Kansas
NOVEMBER 9, 2002–JANUARY 12, 2003

FRONTISPIECE

Ruth Harriet Louise and Joan Crawford, 1928, by Clarence
Sinclair Bull (1896–1980), courtesy The John Kobal Foun-
dation. Bull, who headed the stills department at MGM,
made this study of Louise photographing actress Joan
Crawford in her portrait studio on May 14, 1928. The caption
provided by publicity: "Ruth Harriet Louise, only woman
photographer in the motion picture business, asks Joan
Crawford, M-G-M player, to watch the birdie."

University of California Press
Berkeley and Los Angeles, California

University of California Press, Ltd.
London, England

Santa Barbara Museum of Art
Santa Barbara, California

© 2002 by the Regents of the University of California

Library of Congress Cataloging-in-Publication Data

Dance, Robert
 Ruth Harriet Louise and Hollywood glamour
photography / Robert Dance and Bruce Robertson.
 p. cm.
 Includes bibliographical references and index.
 ISBN 0-520-23347-6—ISBN 0-520-23348-4
 1. Glamour photography. 2. Motion picture actors
and actresses—United States—Portraits. 3. Louise, Ruth
Harriet, 1903–1940. I. Robertson, Bruce. II. Santa
Barbara Museum of Art. III. Title.
 TR678 .D36 2002
 779' .2'092—dc21

 2001007365

Manufactured in Canada

11 10 09 08 07 06 05 04 03 02
10 9 8 7 6 5 4 3 2 1

The paper used in this publication meets the minimum
requirements of ANSI/NISO Z39.48-1992 (R 1997)
(Permanence of Paper). ∞

To Frederica Sagor Maas,
Anita Page, Maurice Rapf,
Freda Sandrich, and the late
Douglas Fairbanks Jr., who
sat before Louise's camera
and shared their memories.

CONTENTS

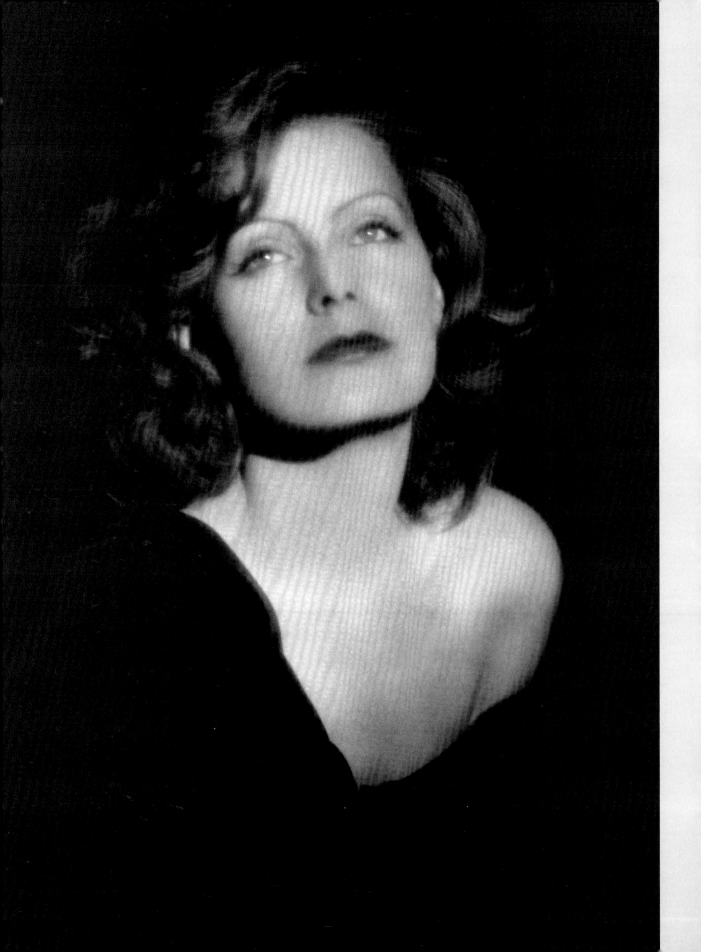

INTRODUCTION

THIS PHOTOGRAPH, TAKEN IN 1927, SHOWS GRETA GARBO when she was just twenty-two and already the greatest romantic star of the day. Out of the darkness only her head and one shoulder appear but that is enough to convey the substance of her presence. She tilts her head back, blonde hair gathering like silk around her face, in a gesture that emphasizes her weariness and her allure. Gazing past us, Garbo shimmers in the light. Even after seventy-five years the portrait radiates glamour.

Ruth Harriet Louise, the head of Metro-Goldwyn-Mayer's portrait studio, was Garbo's photographer. Twenty-four years old and a two-year veteran of Hollywood when this image was created, Louise had joined MGM, the studio with "more stars than there are in heaven," just a few months before Garbo. She photographed all the stars, contract players, and many of the hopefuls who passed through the studio's front gates. Her original photographs, most often portraits, were then reproduced and circulated to millions of moviegoers, magazine and newspaper readers, and fans every year. The movies and publicity machine that these photographs sup-

**GRETA GARBO
FOR *THE DIVINE WOMAN,*
NOVEMBER 1927**
Private collection

Greta Garbo's fifth American film, *The Divine Woman,* was in production when Ruth Harriet Louise made this portrait.

ported shaped the basic concepts of stardom, glamour, and fashion in the 1920s and continue to influence our notions today. Photographs of Garbo by Louise were as important as the movies themselves in defining and sustaining the image we have of the star. As Louise Brooks, an actress and contemporary of Garbo, said: "When you think of it, what people remember of those stars is not from films, but one essential photograph. . . . When I think of Garbo, I do not see her moving in any particular film. I see her staring mysteriously into the camera. No matter how many times I've seen her in films, that is how I always see her. She is a still picture—unchangeable."[1]

During her short career at MGM, from the summer of 1925 until the end of 1929, Louise shot some 100,000 negatives. This vast body of images was not merely a byproduct of the movies; it was critical to their success. Just as many Hollywood films can be considered works of art and vital cultural documents, so too can many of the photographs used to promote players and films.[2] The process of star making, after all, began with a portrait photograph, which was then transformed into images that adorned theater lobbies, filled magazine pages, and were printed in the tens of thousands and distributed to fans, who cut them up and pasted them into albums or pinned them on bedroom walls throughout the world. They formed, then and now, the bedrock of Hollywood imagery.

Most people have encountered Louise's work, if at all, only from reproductions, through the faces gazing out of 1920s fan magazines or the iconic images featured in Hollywood histories and biographies. But central to Louise's accomplishment are her original large-format prints—11 by 14 inches (made from 8- by 10-inch negatives)—the source of all later reproductions. From the moment a performer sat in front of her camera, Louise exerted control, painstakingly framing the composition and then carefully modulating the image in the darkroom with different tones and papers. An examination of Louise's original prints and negatives as well as surviving ephemeral material provided the foundation of our research.

To understand how Louise worked, it is necessary to understand the system within which she operated. She was hired by the publicity department specifically to develop MGM's studio image. Publicity was a key aspect of Louis B. Mayer's tightly run ship, its aim being to connect the movie to the audience and sell MGM's product to the largest number of ticket buyers. Photography played a critical role in this effort, and it was carefully systematized, both as to the types of photographs taken and the ways in which they were used.

Louise's photographs condensed each film production into its essential element: the stars. For in the end, what MGM produced, and fans consumed, was not so much movies as stars. Audiences flocked to the "latest Crawford" or the "new Billy Haines." The way MGM created and used stars was highly self-conscious, and quite different from how stars are treated today. Many

studios in the 1920s—and MGM in particular, under Mayer's regime—focused on female stars and aimed their movies at a female audience with elaborately glamorous productions. Irving Thalberg, the producer behind much of MGM's success, once claimed: "When you've got a picture women want to see, the men will have to go along. A woman can always keep a man away from a picture that attracts only him."[3] Accordingly, MGM emphasized fashion, from flamboyant Erté creations to the latest in smart sportswear. A fundamental job of women stars was to display themselves in beautiful clothes, both on the set and off. The constant demand for new and different fashions had a profound effect on Louise's photographs, which blend exoticism and references to the avant-garde with elegant couture. Most Americans first glimpsed the visual styles of modernity through Hollywood and Louise's photographs.

Stars were created and thrived only within limited categories. As a romantic lead, a male star might be the Latin lover, the college boy, or the hero; a female might represent the vamp, the innocent, or the good girl saved on the brink of turning bad. Stars were formed in these preexisting molds, but then—if the process was successful—the stereotype could be adapted to the overpowering personality of the star. Here Louise's keen interest in personality, the foundation of her love of photography, served her well. Her best photographs synthesize the star's persona, the role being played, and the demands of glamour.

Most MGM films were, at heart, romances. But during the 1920s, the nature of romance seemed to change—thanks to women. A young Ohio State student, writing in 1922, put it this way:

> We are "playing the game" and flattering ourselves that we are "doing it well" in all these things—smoking, dancing like Voodoo devotees, dressing décolleté, "petting" and drinking. . . . The college girl . . . is secure in the most critical situations—she knows the limits. . . . She kisses the boys, she smokes with them, drinks with them, and why? Because the feeling of comradeship is running rampant. . . . The girl does not stand aloof—she and the man meet on common ground.[4]

Romance movies began to be built around this new woman, a contradictory figure who explored for the women in the audience the social changes they were themselves living through. Many of Louise's subjects exemplified aspects of this modern woman, especially the quartet of MGM queens, Norma Shearer, Marion Davies, Joan Crawford, and above all, Greta Garbo.

As one journalist wrote in September 1925 (the same month as the publication of Louise's first photographs), "Hollywood is sex under the spotlight."[5] No modern viewer would disagree. But

3

how are we to understand this use of sex? From a feminist perspective, many critics have insisted that Hollywood movies persist in sexualizing and objectifying women, and that the ideal of the glamorous female star is a strong element in that trap.[6] Some recent historians and theorists, however, have suggested that women spectators find ways to counteract the male-dominated narratives of movies, deriving both pleasure and power from strong female characters and the vision of alternative possibilities for constructing their lives, and even from the fascination with fashion.[7] Historians of early cinema have insisted that the situation of women both in the industry and in movie audiences was very different in those days. Although many women were seduced by the romantic images offered by the movies, for others the moviegoing experience was emancipatory. Whether the action onscreen was as trivial as choosing a purse or as dramatic as chasing after a man, women could imaginatively focus on the vitality of the female characters rather than the moral of the story.[8]

In the 1920s commentators acknowledged that something new was happening in the way women imagined themselves and in the way they behaved. "New women" or "modern women"—or, a bit derisively, "flappers"—provoked both horror and fascination among onlookers. In 1929 the influential social critic Walter Lippmann resigned himself to a "revolution in the field of sexual morals" because "external control of the chastity of women is becoming impossible."[9] Women were making their own decisions about romance and sex and asserting their independence through such outward signs of modernity as bobbed hair, short dresses, and smoking. The producer Jesse Lasky was clear about the connection between the latest fashions and liberation. Urging his director Cecil B. DeMille to stop making historical dramas, he argued: "Joan [of Arc] will get over big—a modern story would have gotten over bigger. . . . What the public demands to-day is modern stuff with plenty of clothes, rich sets and action. . . . Write something typically American . . . that would portray a girl in the sort of role that the feminists in the country are now interested in . . . the kind of girl that dominates . . . who jumps in [and] does a man's work."[10]

Hollywood knew that such changes would be challenged and that it was safest to contain them within stylishly produced narratives that emphasized conservative values. If women were wild in 1920s movies, by the final frames they had (almost always) calmed down, order had been restored, and men had reassumed their traditional roles. Yet the experience of movies was never purely one of the stories they told. In the silent era, there was no spoken dialogue to stress the story line and tie the visual image to the spoken word. As a result, silent movies were conceptually more open than modern movies. Audiences knew that these narratives, despite their moral endings, were ripe to be dismantled and enjoyed in their juiciest parts. Garbo might die at the end of *Flesh and the Devil*—a bad woman receiving her just rewards—but the image people re-

membered was of John Gilbert and Garbo swooning in mutual desire after a kiss that packed coital power. This image was seared into audiences' minds by a still photograph.

Movies, before the days of video recorders, were generally seen only once or twice. They lingered in memory thanks to still shots and portraits. These were the enduring images of Hollywood, not the flickering pictures seen on the screen. And in the uncharted cultural space that the movies were creating for modern women, Louise was a crucial figure. In her collaborations with her subjects, especially such stars as Garbo, Shearer, and Crawford, movie audiences worldwide were treated to new and powerfully affecting images of strong female characters. For an understanding of how Hollywood has affected the way in which modern women perceive themselves, there is perhaps no better starting point than the work of Ruth Harriet Louise.

Louise was neither the first nor the only professional woman photographer to take portraits of actresses and actors. Charlotte Fairchild preceded her in New York City as a photographer of theater and film figures in the late teens and early twenties; Janet Jevons and Dorothy Wilding were Louise's contemporaries in London (Jevons enjoying a long career). In Hollywood, however, Louise reigned supreme. (Only one woman, June Estep at First National, is listed among the members of the American Society of Cinematographers; she later photographed Marlene Dietrich at Paramount.) Indeed, given the importance of the stars Louise photographed, and the power and pervasiveness of the studio she worked for, it is not going too far to say that Ruth Harriet Louise was one of the most influential women photographers of the century; more people have seen her images than those of any other woman photographer. In fact, there is no need to qualify her status by gender: during her tenure at MGM, Louise was *the* dominant practitioner of her profession. Her photographs have been seen by countless people, inspiring them in their lives and in their dreams. This book makes visible, for the first time, the person behind the shutter and her art.

~

A Portfolio of

Original Photographs by

Ruth Harriet Louise

~

The following group of reproductions
have all been made from original vintage prints.
This portfolio documents the first
comprehensive public exhibition of Louise's
work since the early 1930s.

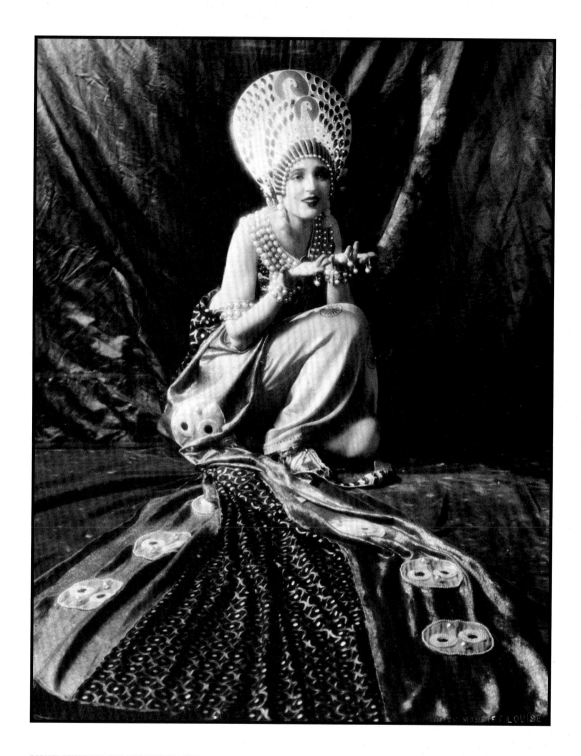

CARMEL MYERS FOR *BEN-HUR*, OCTOBER 1925

Robert Loper Collection, New York

Louise's first cousin, actress Carmel Myers, models a costume created by French designer Erté. Playing the evil priestess Iras, she appears only briefly on screen in the outfit, in the stands of the famous chariot race scene from *Ben-Hur*.

RAMON NOVARRO FOR *BEN-HUR*, 1925

The John Kobal Foundation

Novarro's character Ben-Hur goes through a full cycle of fortune in the movie: from prince to slave to hero. Here he is seen at his most romantic, as a leader of the rebellion against the Romans.

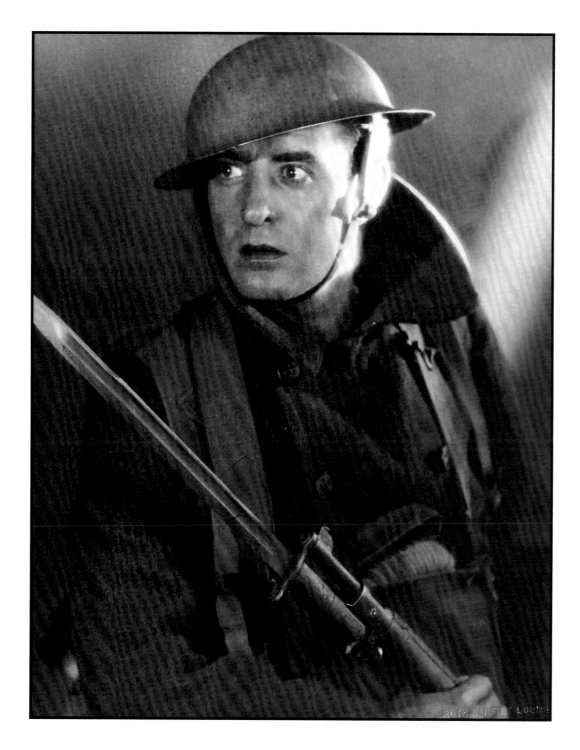

JOHN GILBERT FOR *THE BIG PARADE*, SUMMER 1925

Courtesy Maurice Rapf, Hanover, New Hampshire

Gilbert was MGM's leading male star when he made *The Big Parade*, directed
by King Vidor. Usually cast in glamorous roles, in this movie he plays an ordinary
doughboy, who progresses from enthusiastic volunteer to war-weary veteran.

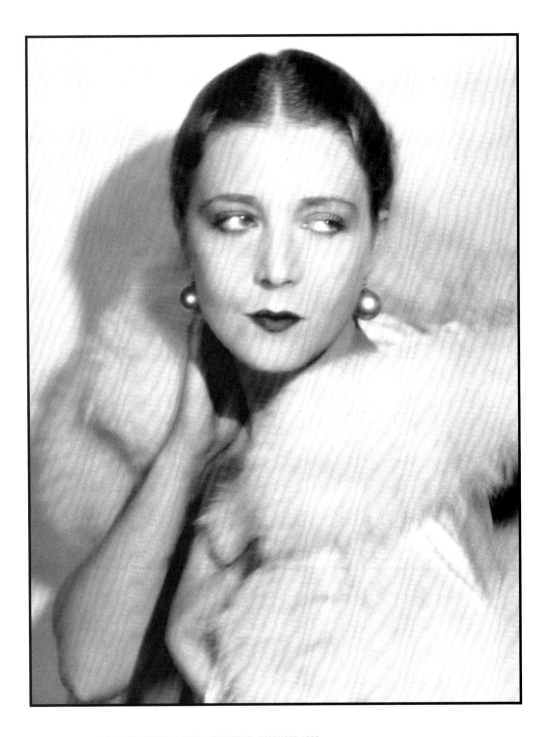

VILMA BANKY FOR *A LADY TO LOVE* (ALSO TITLED *SUNKISSED*), DECEMBER 1929

The John Kobal Foundation

Before joining MGM, Louise photographed Vilma Banky for her American debut, *Dark Angel*. Four years later, during one of her last MGM portrait sessions, Louise again photographed Banky. Banky's brand of exoticism was by then on the wane, her career, after ten American films, largely finished.

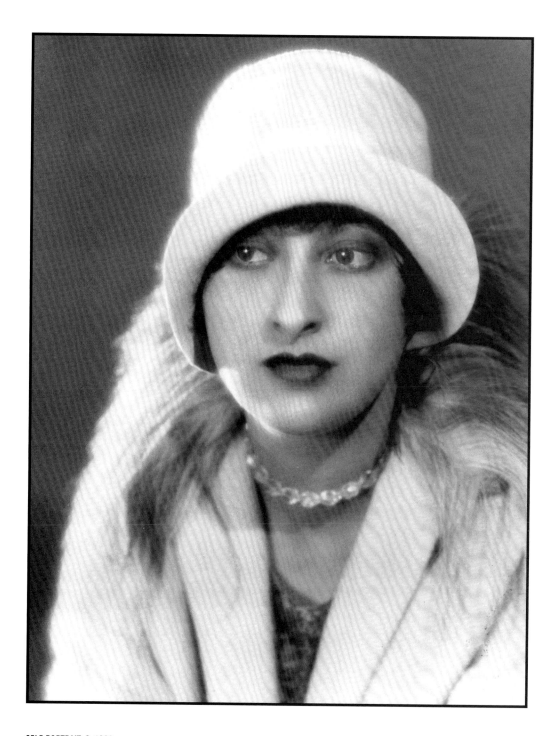

13

SELF-PORTRAIT, C. 1928

Hulton Archive/Getty Images

Throughout her career Louise made many self-portraits. Here she has
depicted herself chicly dressed, in the guise of a studio leading lady. Louise
gave this photograph, presumably never published, to Margaret Chute, a
London journalist and publicist who featured Louise in several articles.

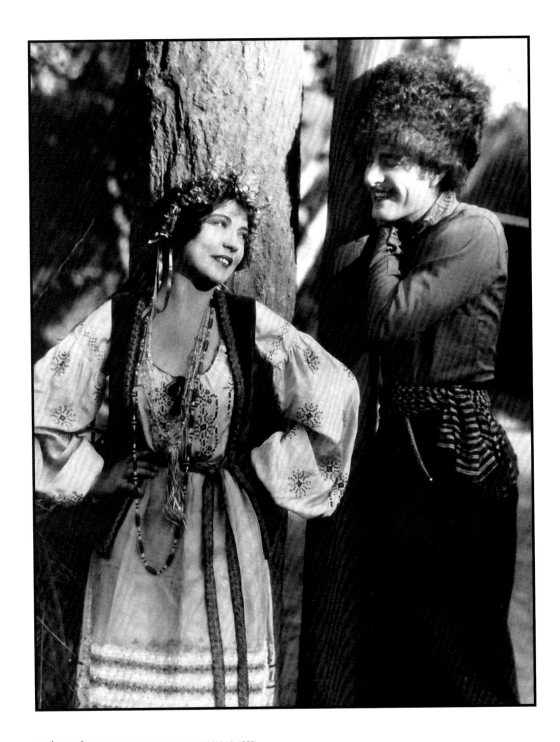

RENÉE ADORÉE AND JOHN GILBERT FOR *THE COSSACKS*, 1927
Santa Barbara Museum of Art, gift of Sid and Diana Avery Trust
Gilbert and Renée Adorée co-starred in one of 1925–26's biggest hits, *The Big Parade,* and studio producers, hoping lightning might strike, teamed them again in the 1928 costume drama *The Cossacks.* Louise seldom took photographs on the set, and even fewer are so casually posed.

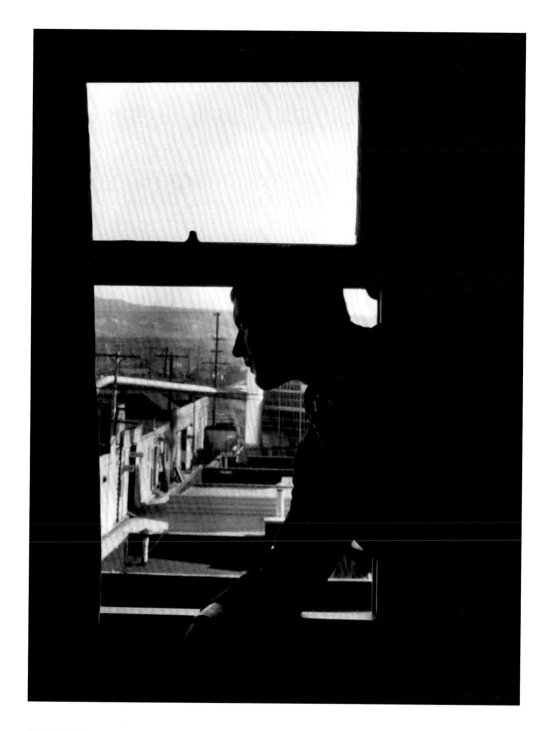

RALPH FORBES LOOKING OUT LOUISE'S STUDIO WINDOW
Hulton Archive/Getty Images
Louise's studio was on the third floor, accessible by an exterior
staircase. This unusual photograph of English-born actor
Ralph Forbes looking out the window gives a rare glimpse of
the world outside Louise's tightly controlled environment.

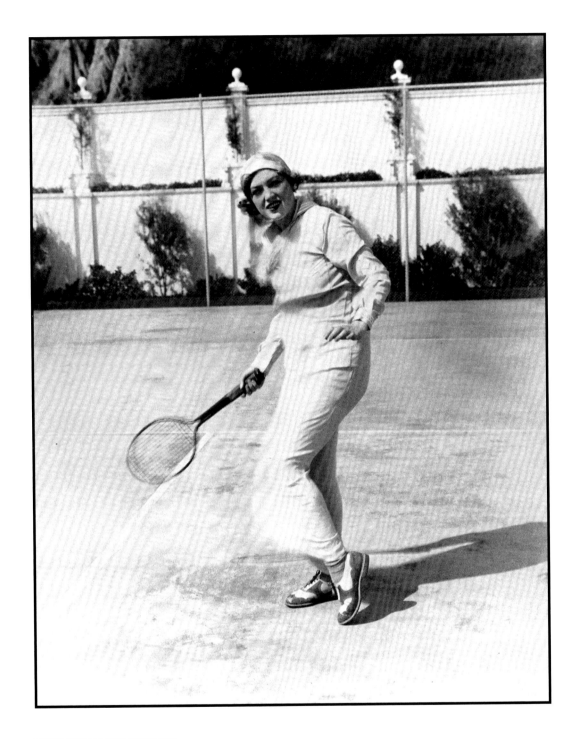

MARION DAVIES PLAYING TENNIS, 1927

Santa Barbara Museum of Art, anonymous gift

Hollywood's most popular and ebullient hostess, Marion Davies built
an ocean-front compound with tennis courts and a fabled swimming
pool in the summer of 1927 on the beach in Santa Monica. Louise pro-
duced six photographs of Davies at play there.

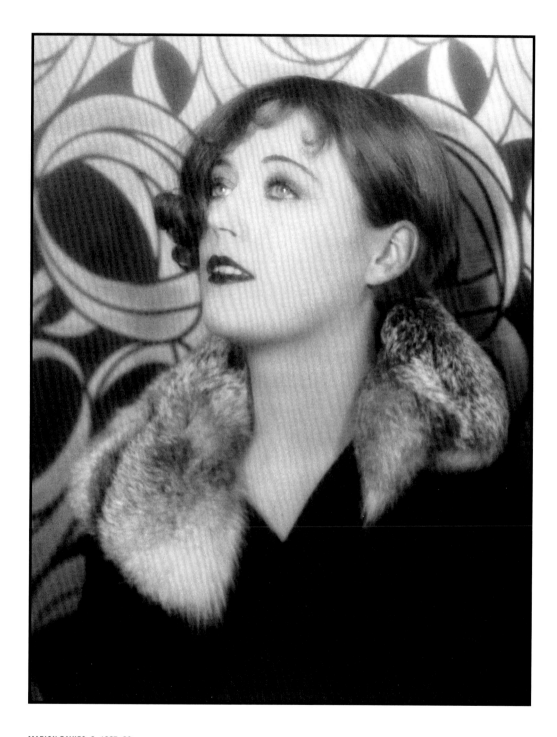

MARION DAVIES, C. 1927–28

Santa Barbara Museum of Art, anonymous gift

Louise's interest in pattern and texture is well revealed in this
study of Marion Davies. The portrait is one of several in which
Davies is photographed with and without a hat, and facing left
or right. It does not seem to be connected with any production.

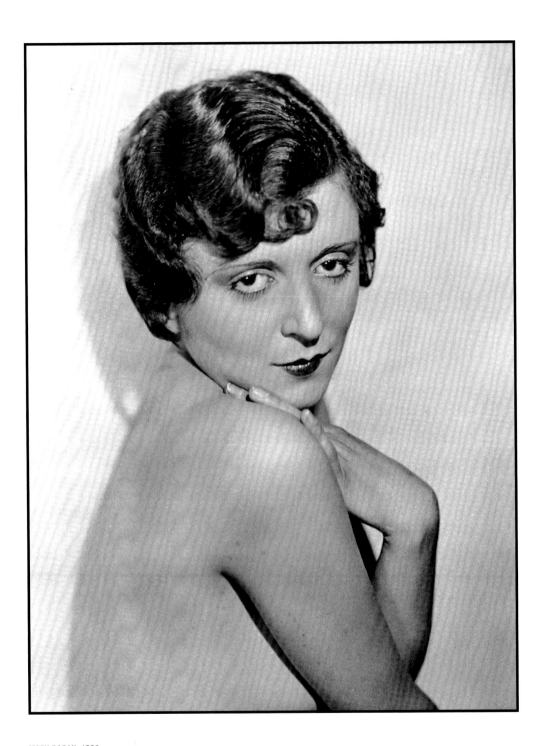

MARY DORAN, 1928

Private collection

Mary Doran came to MGM in 1928 and played small roles for
three years. In portraits such as this Louise, under the watchful
eye of the publicity department, attempted to find the next
romantic siren among the many hopefuls.

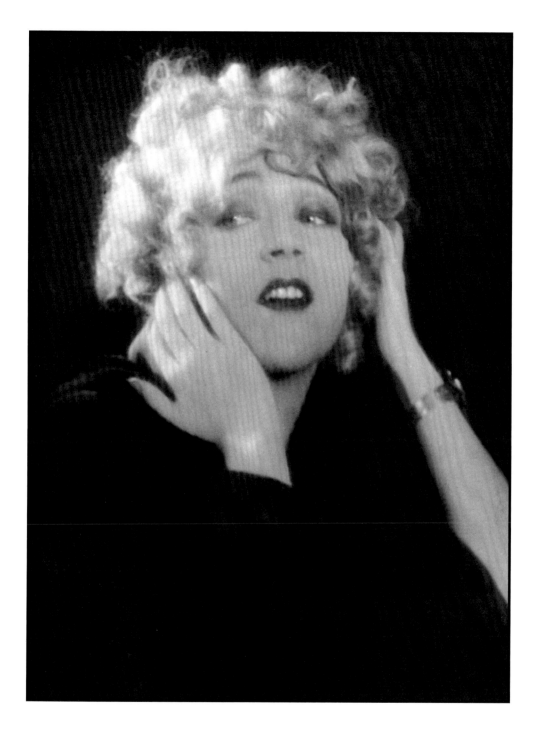

MAE MURRAY FOR *THE MASKED BRIDE*, 1925

The John Kobal Foundation

Mae Murray was MGM's top female star in 1925 thanks to her
great success in *The Merry Widow,* in which she starred with
John Gilbert. The next year she made three films for the studio,
including *Altars of Desire.*

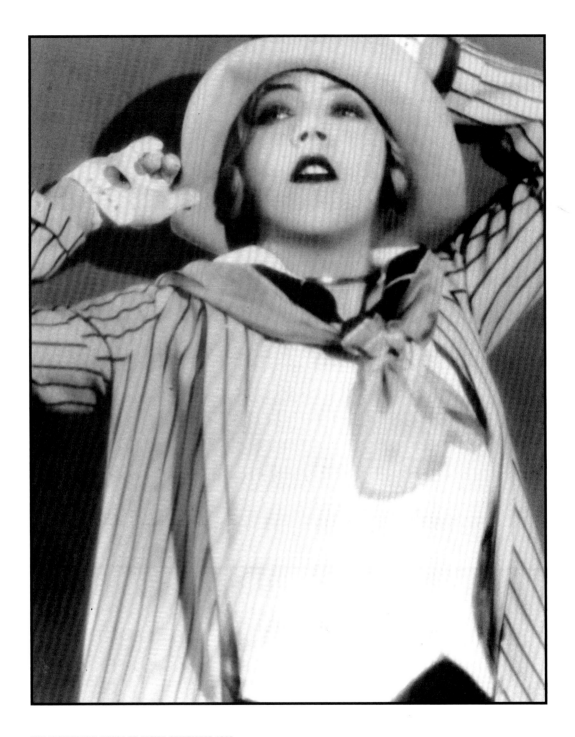

MAE MURRAY FOR *ALTARS OF DESIRE*, SEPTEMBER 1926

The John Kobal Foundation

Murray transforms what is essentially a fashion shot into high
drama, underscoring her histrionic persona.

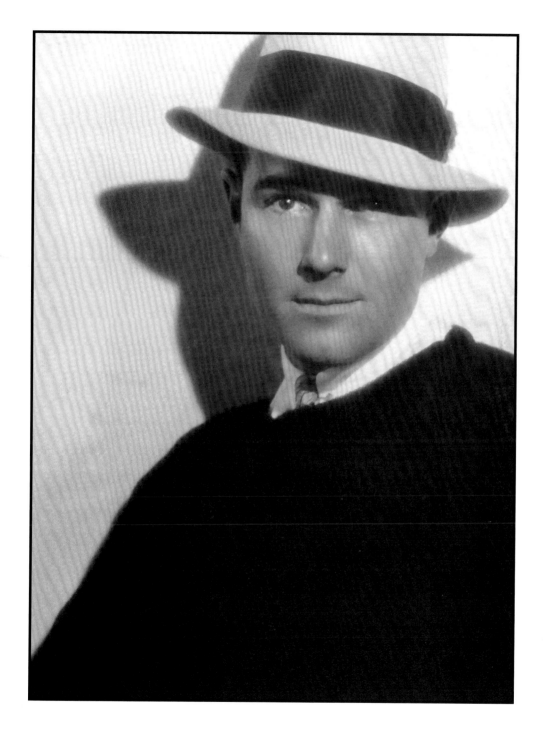

WILLIAM HAINES

The John Kobal Foundation

Haines was MGM's top box office juvenile lead through the
1920s but failed to make a transition into more adult roles and
left the studio in 1932.

William Haines TM likeness, courtesy Henry Haines.

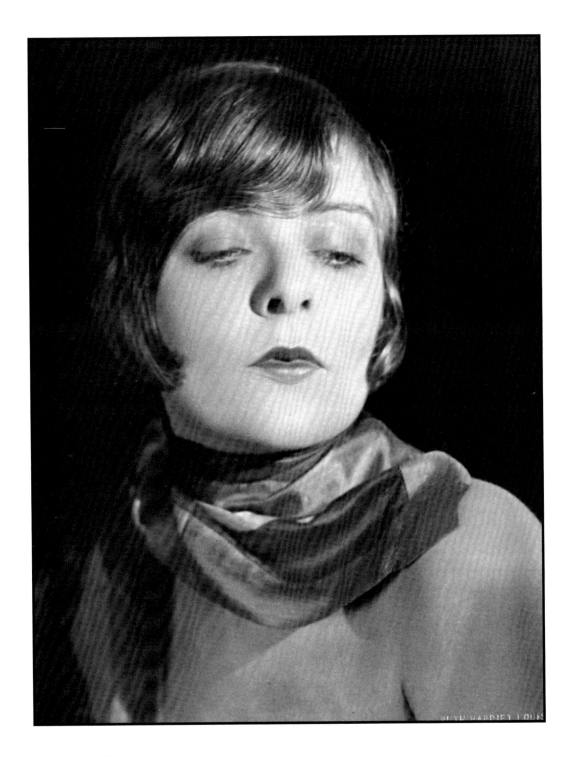

BLANCHE SWEET, 1925
Private collection
Goldwyn star Blanche Sweet and her director-husband Marshall Neilan came
to MGM in the 1924 merger but left after two films: *Tess of the d'Urbervilles*
(a hit) and *The Sporting Venus* (during which this portrait was made).

NINA MAE MCKINNEY FOR *HALLELUJAH,* WINTER 1929

Courtesy Louis F. D'Elia, Santa Monica

Seventeen-year-old Nina Mae McKinney scored a big hit in her
first film, King Vidor's 1929 all-black musical *Hallelujah.* For the
balance of her career she played supporting roles.

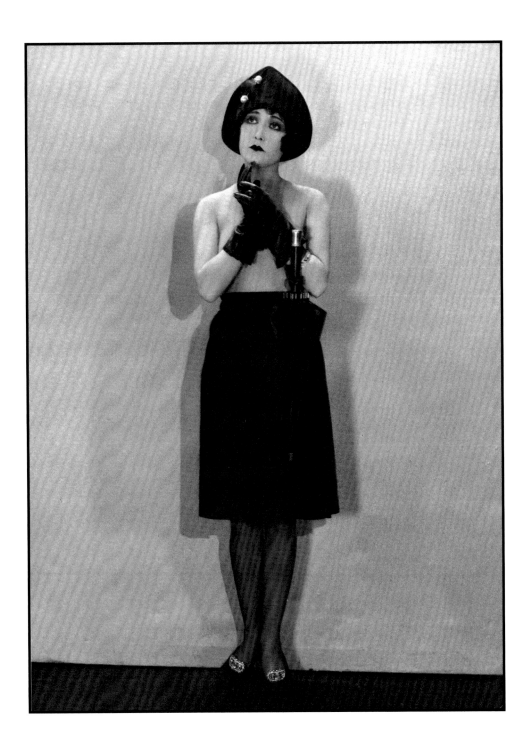

DOROTHY SEBASTIAN FOR *THE DEMI-BRIDE*, OCTOBER 1927

Private collection

With second leads such as Dorothy Sebastian, Louise could try "art" photographs. This image is from a long sequence of shots of Sebastian dressed as a French maid, in connection with *The Demi-Bride* (see also page 115).

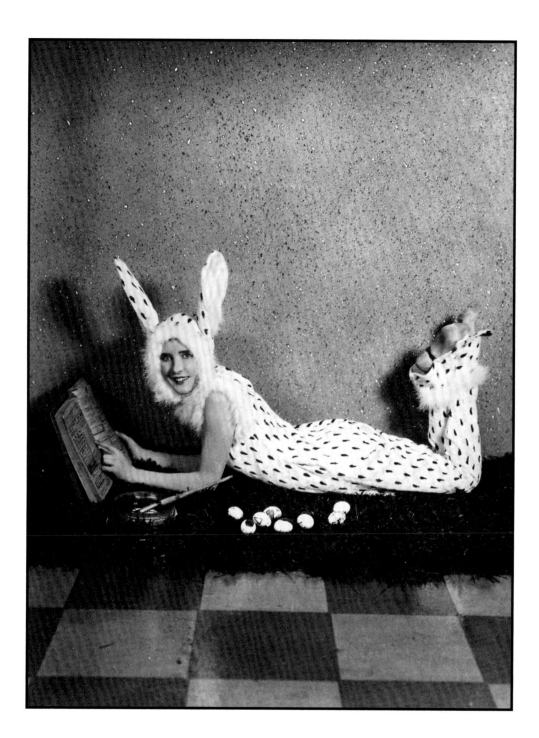

PATRICIA AVERY AS THE EASTER BUNNY, 1926

Private collection

Patricia Avery, like other young hopefuls, posed for Louise in many different costumes and attitudes, from elegant sophisticate to a nun (see page 130). Photographs of Raquel Torres wearing this same suit appeared in *Motion Picture* in April 1929.

ANITA PAGE, 1928

Private collection

Page was on the verge of a major career when this photograph
was taken and rivaled Crawford in the number of images of her
published.

JOSEPHINE DUNN, 1929

The J. Paul Getty Museum, Los Angeles

Josephine Dunn made ten films at MGM during 1929, including *Red Hot Rhythm*. Dunn never quite made it out of the second tier of MGM actresses, despite a big push in 1929, when she made the cover of *Motion Picture* in August and shared the cover of *True Romances* with Billy Haines in April.

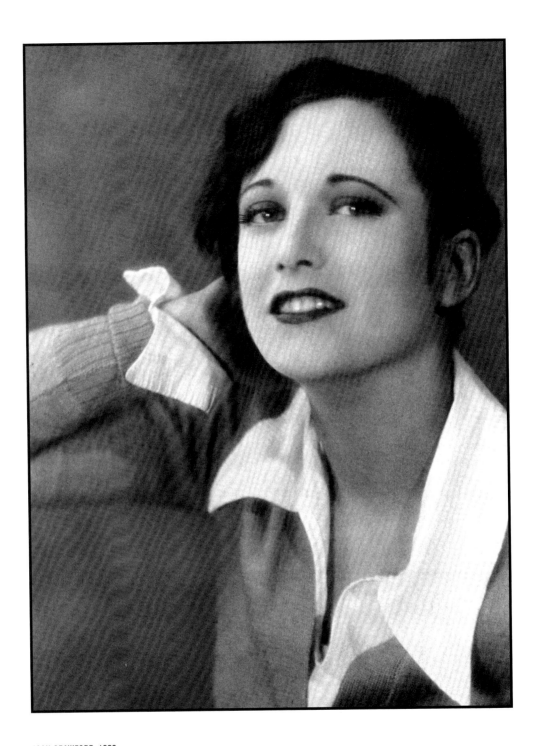

JOAN CRAWFORD, 1926

Private collection

Taken a year after Crawford joined MGM, this photo demonstrates her
transformation from New York night club dancer to MGM contract player.
To promote Crawford, publicity sent out many photographs from this
session, and one was reproduced full-page in *Motion Picture* (June 1926).

FREDERICA SAGOR, 1925

Courtesy Frederica Sagor Maas, La Jolla

Louise photographed writers such as Freddie Sagor, and others who worked
behind the scenes at MGM, as soon as they had a valid screen credit. Sagor was
among the first to welcome Joan Crawford to Hollywood, taking the young
actress shopping for her first California wardrobe.

JOAN CRAWFORD MODELING FUR-TRIMMED COAT, C. 1929

Private collection

Although the coat seems the subject of this photograph, the image in fact
appeared in *Photoplay* (Oct. 1929, p. 82) advertising Velvetta suede calf shoes.
The shoes that appear on Crawford's feet were carefully cut out of another
photograph and pasted over those she actually was wearing.

JOAN CRAWFORD MODELING FUR COAT, 1929

Santa Barbara Museum of Art, anonymous gift

Fashion photography became increasingly important at MGM in
the late 1920s, and actresses modeled clothing for local merchants
and national manufacturers.

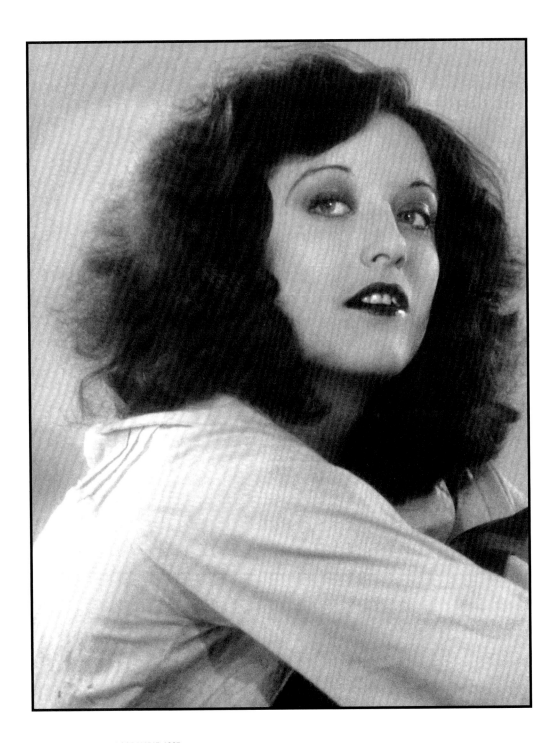

JOAN CRAWFORD FOR *ROSE MARIE*, 1927

Private collection

By the time of *Rose Marie* in 1927, Crawford, one of the studio's most popular
young leading ladies, was being groomed for stardom. In this extended session
Crawford also posed with a black terrier and against a flat with an abstract
"bubble" design that Louise used frequently that year.

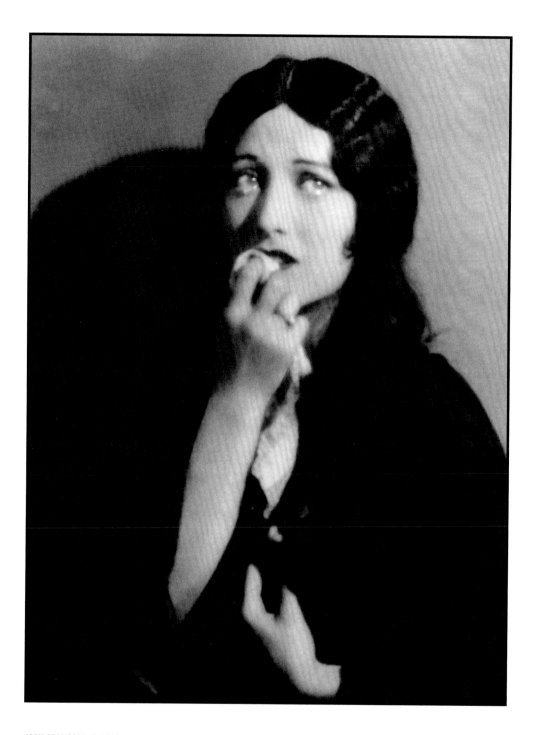

JOAN CRAWFORD, C. 1926

Private collection

Crawford used her portrait sessions to try out different character types.
Here she tries a tearfully dramatic role, perhaps thinking of Lillian Gish's
soulful performances.

NORMA SHEARER, 1928

Private collection

Louise made Shearer look patrician and elegant, but the actress also wanted
to be portrayed as sexy—a circumstance that finally cost Louise her position
at MGM. Not until Shearer was photographed by George Hurrell (see page
220) would her image change.

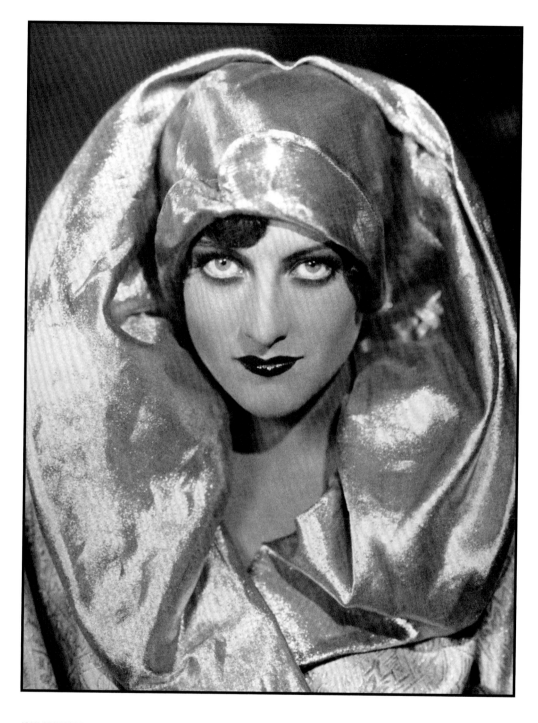

JOAN CRAWFORD, 1928

The John Kobal Foundation

Crawford was at her best when she had a strong role or dramatic costume
to model, such as this outrageous metallic hood. The image of Crawford
that Hurrell would definitively shape in the 1930s begins to appear first in
photographs like this.

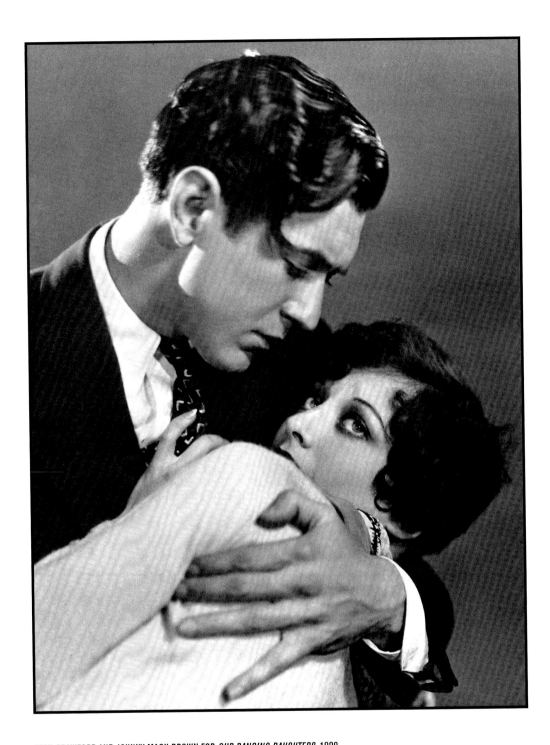

JOAN CRAWFORD AND JOHNNY MACK BROWN FOR *OUR DANCING DAUGHTERS*, 1928

Culver Pictures

Johnny Mack Brown came to MGM in 1927 and was immediately cast
in small parts in several of the studio's most important productions. By
the next year he had graduated to leading roles, including co-starring
with Crawford in *Our Dancing Daughters*.

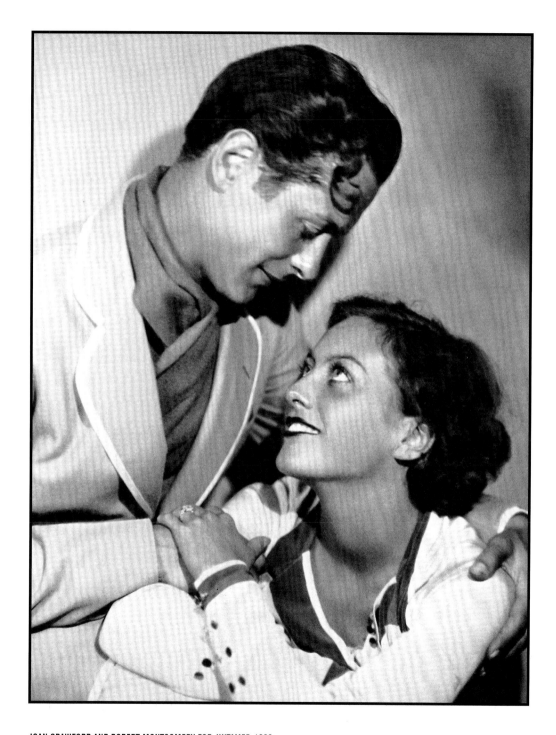

JOAN CRAWFORD AND ROBERT MONTGOMERY FOR *UNTAMED*, 1929
Private collection

As a newcomer to MGM, Montgomery was paired with Crawford in
Untamed. His next outing was with Norma Shearer in her first talkie, *Their
Own Desire.* Back-to-back hits established Montgomery as a star. This image
was used for the cover of *True Romances* in 1932 (color plate 6).

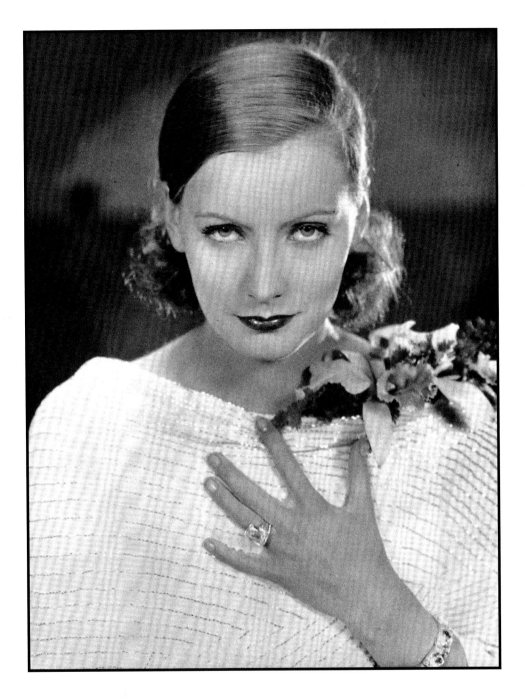

GRETA GARBO FOR *WILD ORCHIDS*, NOVEMBER 1928

Private collection

The few portraits of Garbo made by Louise during production of *Wild Orchids* were used over and over. This image appeared as a postcard, on the cover of the sheet music for the film's theme song (see page 101), and on the cover of the August 1929 *Photoplay*.

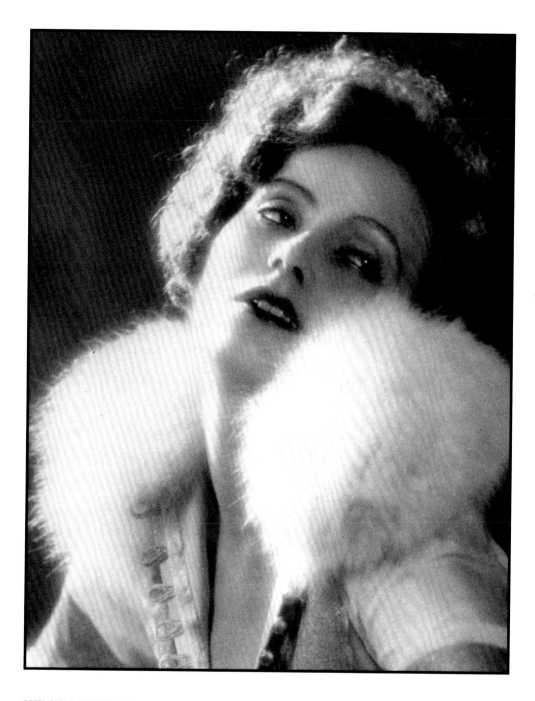

GRETA GARBO, SEPTEMBER 1925

Private collection

Garbo as she was photographed by Louise in her first MGM portrait session in September 1925. This image appeared in *Picture Play* (Aug. 1926), on the cover of the French magazine *Mon Ciné* (Feb. 26, 1926), and on a postcard sent out to fans.

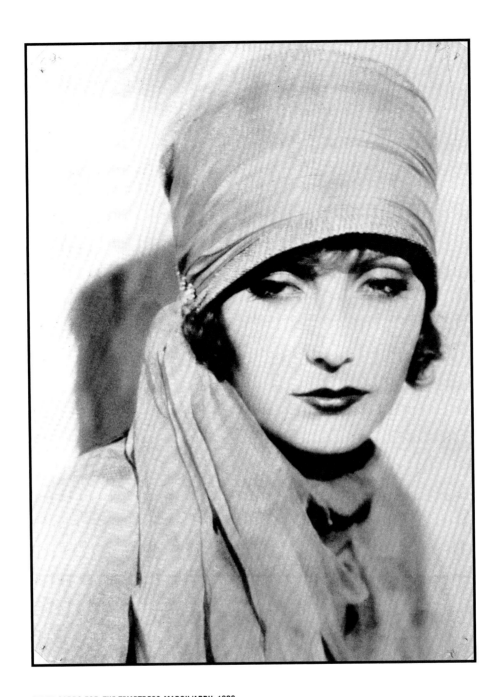

GRETA GARBO FOR *THE TEMPTRESS*, MARCH/APRIL 1926

Private collection

Garbo was photographed relentlessly during the production of her second film, *The Temptress;* both this photograph and the next come from the same session. This poignant study anticipates the tragic heroines Garbo would portray in the 1930s. Few photos of Garbo in this costume were released by publicity.

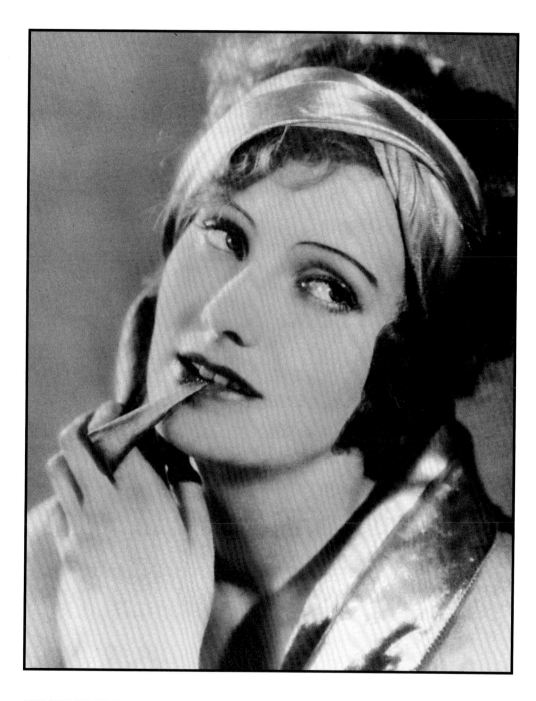

GRETA GARBO FOR *THE TEMPTRESS,* **MARCH/APRIL 1926**

Santa Barbara Museum of Art, anonymous gift

MGM wished to promote a glamorous image of the new Swedish star, as its
publicity blurb for this session—"Garbo is endowed with almost unsurpassable
beauty"—makes clear. This photograph was "exclusive" to *Motion Picture*
(Oct. 1926) and filled an entire page.

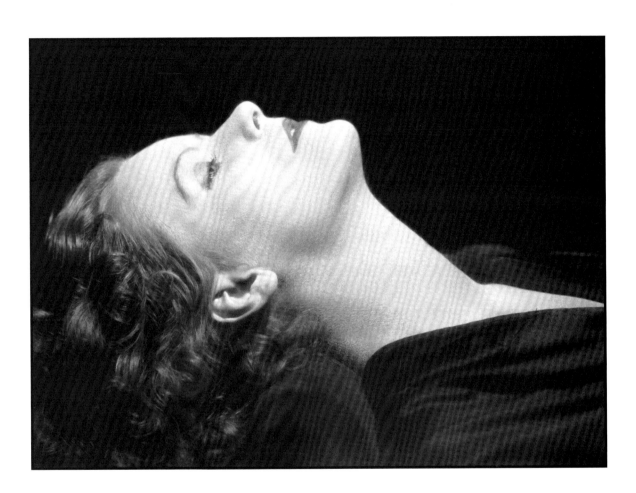

GRETA GARBO FOR *LOVE*, 1927

Private collection

Louise photographed Garbo lying on her back, but in *Photoplay* (Feb. 1928, p. 18) the orientation was confusingly altered to upright and captioned: "Not America's Sweetheart, but America's Suppressed Desire—Greta Garbo. What every woman wants to look like. The Eternal Feminine to every man."

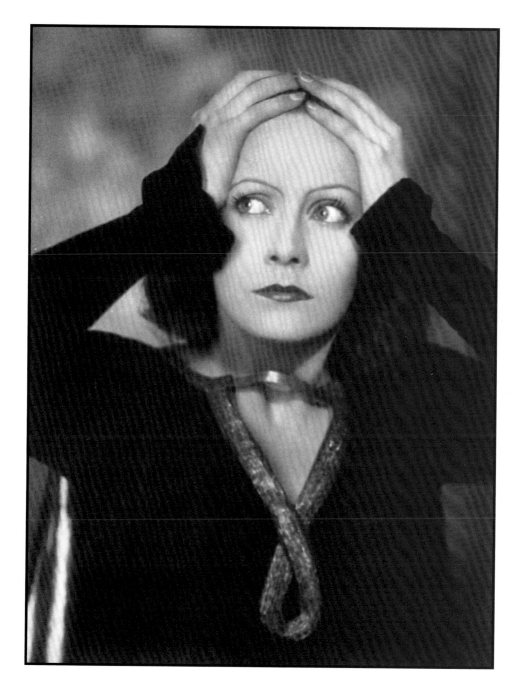

GRETA GARBO FOR
THE DIVINE WOMAN, 1927
Private collection

Taken in early October 1927 soon after *The Divine Woman* started shooting, this photograph anticipates by almost a year the gesture recorded in Edward Steichen's famous portrait (see page 178).

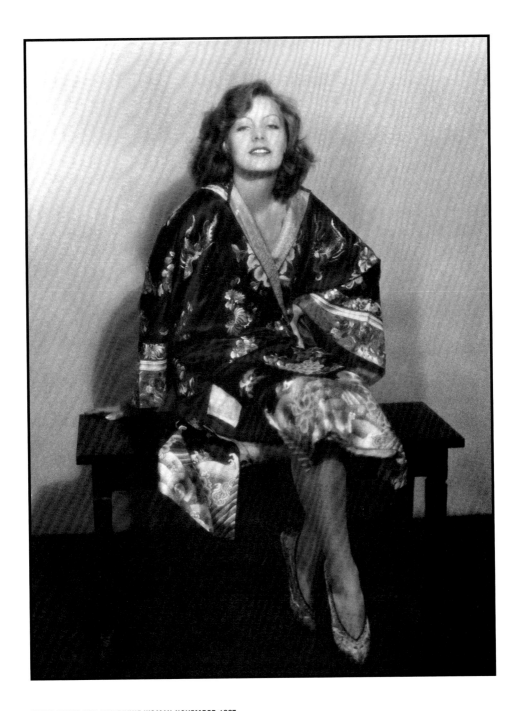

GRETA GARBO FOR *THE DIVINE WOMAN*, NOVEMBER 1927

Private collection

Louise often used Asian-themed props, costumes, and accessories to lend a touch of exotic glamour to her portraits. This photograph was published in *Motion Picture* (Feb. 1929, p. 34).

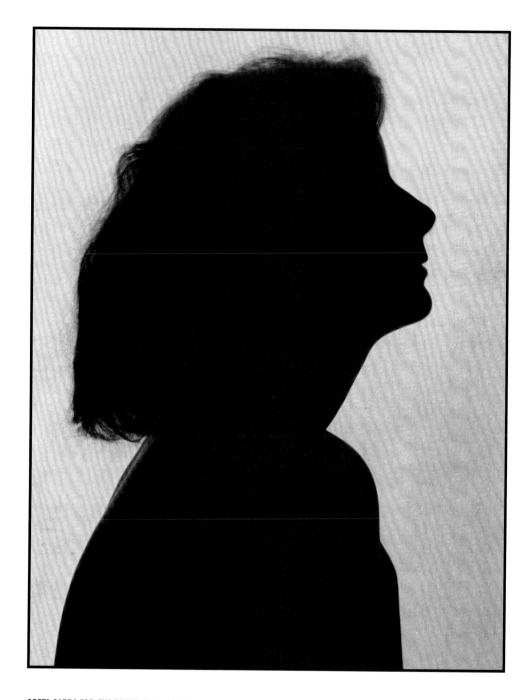

GRETA GARBO FOR *THE DIVINE WOMAN,* NOVEMBER 1927

Private collection

Images like this stark silhouette generally were made for the European
market, considered by publicity to be more sophisticated than the
American. It was reproduced in the 1929 Spanish biography of Garbo
by Cesar Arconada. ·

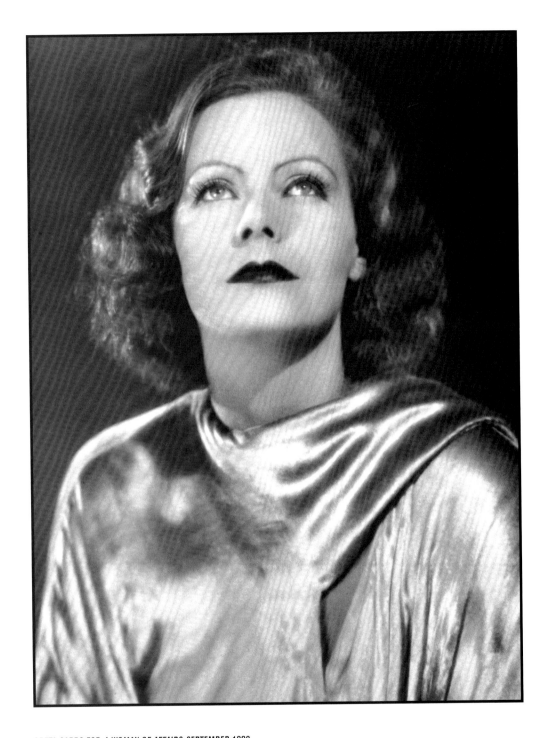

GRETA GARBO FOR *A WOMAN OF AFFAIRS*, SEPTEMBER 1928

Private collection

Garbo appears in this costume in a scene deleted from the movie. Publicity
images of Garbo wearing this dress were sent out to fans, and the cover of the
1930 special-edition magazine *New Movie Album* derives from this photograph.

JOHN GILBERT FOR *THE COSSACKS*, 1928
Culver Pictures

Louise captures Gilbert as the most dashing and vibrant star
at MGM, just before his fall from grace. This image, in contrast
to the informal shot on page 14, illustrates the way formal
portraits condense the essence of a performer and role.

LILLIAN GISH ON THE BEACH AT SANTA MONICA, 1927

Hulton Archive/Getty Images

Photographs by Louise taken outdoors are rare. Gish accompanied
Louise to the beach during the production of *The Wind* in the winter
of 1927, where this study was taken.

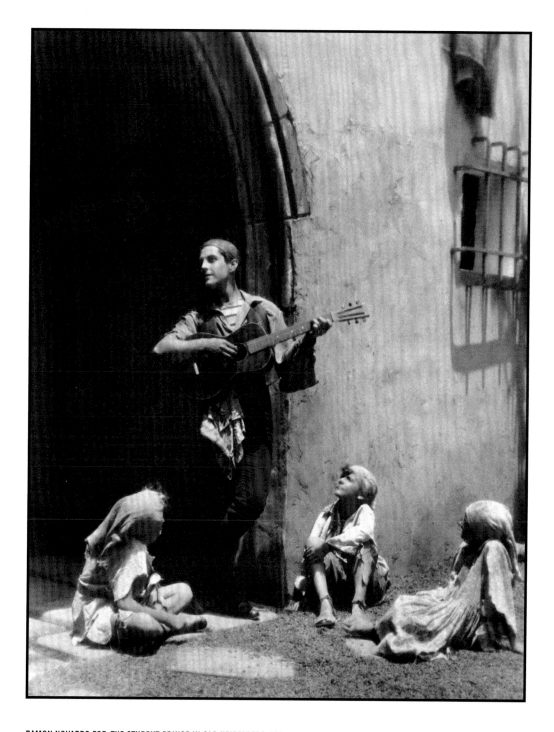

RAMON NOVARRO FOR *THE STUDENT PRINCE IN OLD HEIDELBERG*, 1927

Private collection

Music was important to Novarro, and this silent film gave him a chance to sing on screen, though audiences could not hear him. This portrait was published in *Photoplay* (Oct. 1927, p. 81) under the title "Novarro to Quit Screen for Music."

RAMON NOVARRO ONSTAGE AT HIS TEATRO INTIMO, 1928

Hulton Archive/Getty Images

Novarro's aspirations to be a professional singer motivated him to build
a real theater at his home. He gave many performances to select friends at
the aptly named Teatro Intimo, which seated about sixty-five.

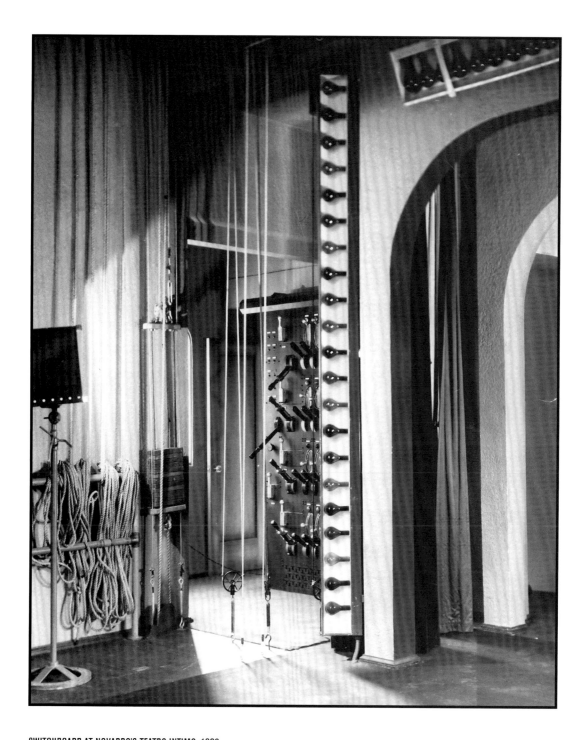

SWITCHBOARD AT NOVARRO'S TEATRO INTIMO, 1928

Hulton Archive/Getty Images

Louise sometimes had the opportunity to transfer the modernist sensibility out of the world of fashion into other subjects. Her love of surface pattern dominates this image of the controls for the lights of Novarro's Teatro Intimo. The photograph was published in *Photoplay* (July 1928, p. 84).

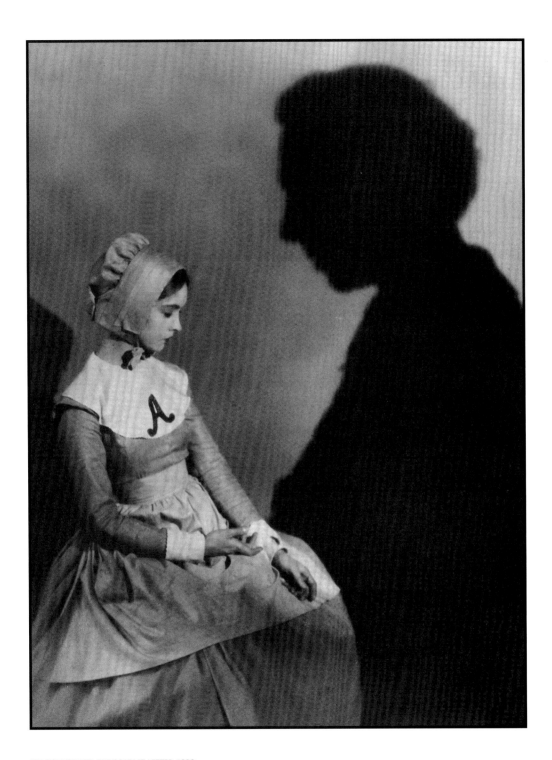

LILLIAN GISH FOR *THE SCARLET LETTER*, 1926
Culver Pictures

Gish famously preferred subtlety to obvious displays of violence. Louise
indicates the looming presence of Lars Hanson merely by a shadow.

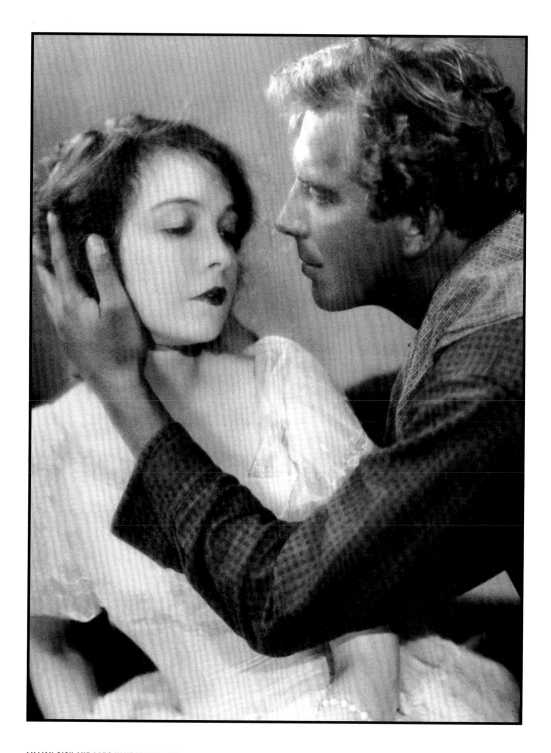

LILLIAN GISH AND LARS HANSON FOR *THE WIND*, 1927
Culver Pictures

Lars Hanson worked with Gish again in *The Wind* (her last picture
at MGM). Like *The Scarlet Letter*, it was a production dominated by
Europeans. Louise's images reflect this cosmopolitan sophistication.

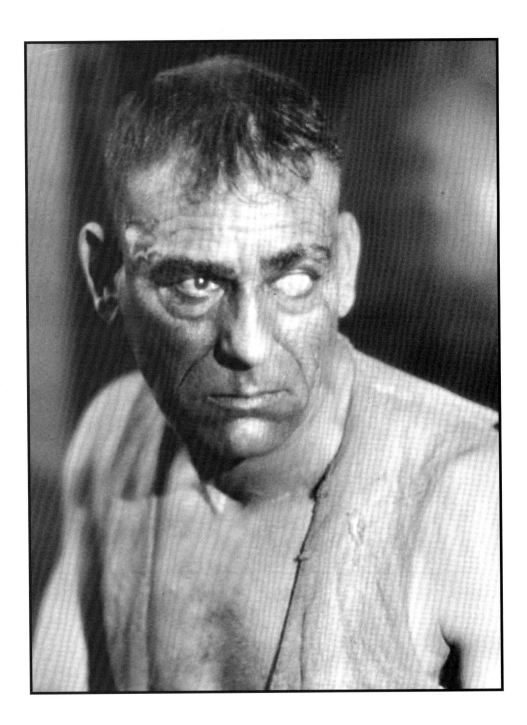

LON CHANEY FOR *THE ROAD TO MANDALAY,* 1926

Culver Pictures

The reputation of Lon Chaney, the "Man of a Thousand Faces," was well
earned as he tortured his body in film after film. Here Louise photographed
the actor wearing a glass lens in his eye for *The Road to Mandalay.*

Lon Chaney TM likeness, courtesy of Chaney Entertainment.

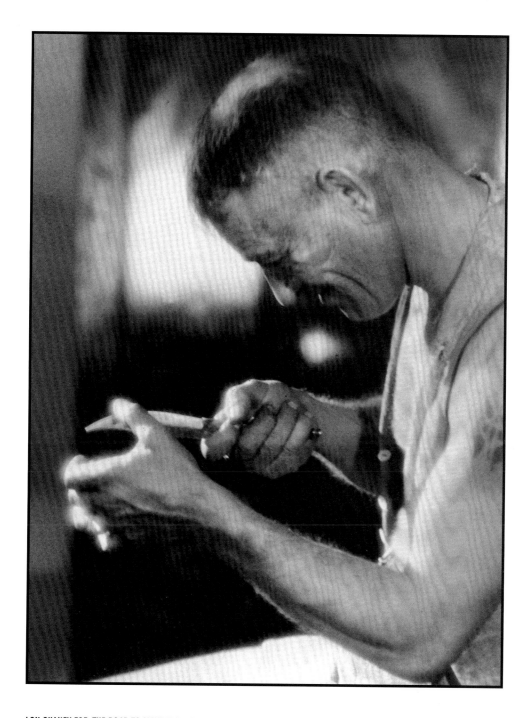

LON CHANEY FOR *THE ROAD TO MANDALAY*, 1926

Culver Pictures

Chaney was perhaps Louise's greatest male subject, and she had the chance to photograph him in nearly all of his MGM portrayals. In this portrait from *The Road to Mandalay,* Louise records Chaney as a hardened criminal, focusing her lens on the knife that will eventually be his undoing.

Lon Chaney TM likeness, courtesy of Chaney Entertainment.

LON CHANEY FOR *LAUGH, CLOWN, LAUGH*, FEBRUARY 1928

Culver Pictures

For Louise, character was always the most important aspect of her compositions. Her studies of Lon Chaney in costume for *Laugh, Clown, Laugh* all capture the pathetic character of his role (see also page 211).

Lon Chaney TM likeness, courtesy of Chaney Entertainment.

MARIE DRESSLER FOR *CAUGHT SHORT*, 1929

Private collection

Louis B. Mayer signed former vaudeville great Marie Dressler to the studio
in 1927, and she soon became a popular comedian, often teaming up with
Polly Moran. This 1929 portrait was made the same year she starred with
Garbo in *Anna Christie,* the film that revealed her dramatic talents.

ANNA STEN, 1932

Private collection

Louise's only documented portrait session with a Hollywood actress after
she left MGM was in the fall of 1932 when she photographed Anna Sten for
Samuel Goldwyn. At the time this portrait was taken Sten had yet to make
a film in the United States.

RUTH GOLDSTEIN BECOMES
RUTH HARRIET LOUISE

chapter 1

RUTH GOLDSTEIN WAS HIRED BY METRO-GOLDWYN-MAYER as chief portrait photographer in the summer of 1925. Her transformation into Ruth Harriet Louise involved hard work, a certain amount of luck, and the indispensable element of talent. Contemporary sources discussing Louise's career always begin with a mention of her gender, youth, and attractiveness, as though what was interesting about her was how much she looked like her subjects. As one journalist put it, "If you saw her walking across the lot you'd think that she was a star going from one set to the other. She is as pretty as a star but instead of being one of them she bosses them!"[1] Her work and the extraordinary fact that she was the most reproduced photographer in America during her tenure at MGM seemed less important to outside observers. Louise, however, had a different view of herself: "With actors, of course, . . . having their pictures taken is part of their business and they are more or less in my hands. I don't mind bossing them around one bit—I realize some of their success depends on me."[2] She was absolutely correct.

One Girl and Six Men ·· and She "Bossed" Them All

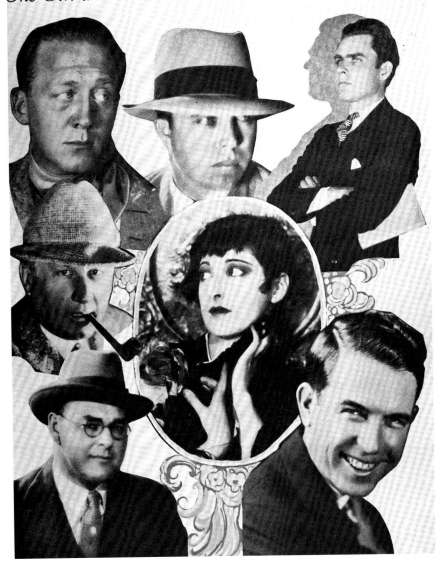

"ONE GIRL . . . AND SHE BOSSED," *HOLLYWOOD LIFE* (AUGUST 1926)

Courtesy of the Academy of Motion Picture Arts and Sciences

Louise had been at MGM barely a year when she was featured in
Hollywood Life. Seen here in a self-portrait, she is surrounded by six
of her subjects, the leading (male) directors of the day.

Ruth Goldstein was born in New York City on January 13, 1903, the daughter of Rabbi Jacob Goldstein and Klara Jacobsen Goldstein. She was the second child; her brother, Mark Rex Goldstein (1900–1945), was three years older. Her parents had immigrated to the United States not too long before the turn of the century; Jacob (1859–after 1925) had been born in London and Klara (1872–1956) in Vienna, but they journeyed to the United States, it seems, through Australia.[3] Once in the New York area, the Goldstein family moved every few years, changing both homes and congregations, until eventually they settled in Trenton, New Jersey, around 1915.[4] In 1921 Rabbi Goldstein left Trenton and accepted a position with Temple Anshe Emeth in New Brunswick, New Jersey, a dynamic and rapidly expanding congregation closely allied to the American Jewish Congress, a progressive Zionist organization. It is fair to assume that the rabbi and his family were equally progressive; the children were certainly cultured and musical, as old friends and contemporary documents record.[5] The Goldsteins lived in a modest two-family home in the suburb of Highland Park, just across the Raritan River from the temple—an easy walk or quick trolley ride away. After New York or even Trenton, New Brunswick must have felt quite provincial. After all, it had only one first-run movie theater, the Opera House, while Trenton had seven.

Louise's brother, Mark, attended Columbia College the fall semester of 1918, taking classes in economics and science. He left the family in 1922, shortly after the move to New Brunswick, to find his fortune in Hollywood. He was drawn there by the success of their cousin Carmel Myers (the daughter of Klara's sister, Anna, and her husband, Isodore, a rabbi in San Francisco), who had a flourishing career as a motion picture actress. While visiting Myers, Mark discovered that he had his own skills to offer Hollywood. Although show business was not new to the young man— he was, as the *Banner,* the newspaper of the Young Men's Hebrew Association in New Brunswick, described him, "director of the recent Flapper Revue and lyric composer par excellence"[6]—he obtained his first job because of his scientific aptitude. A story often repeated has him visiting a set on which his cousin was working at Century Studio. The comedy director Al Herman was trying to shoot a gag involving a "mechanical contrivance" that kept failing to go off. Mark, calling on his knowledge of physics, helped set up the gag correctly, and immediately found himself with a job as "prop boy" for Mr. Herman. By 1924 he was working as a writer at Educational Pictures (page 65), and later he became a director. By the time he returned to New Jersey in 1925 to marry, he had changed his name to Mark Sandrich, adopting an anglicized version of the original family name, Sandreich, which his father had changed to Goldstein before coming to the United States.[7] Within a few years he would become famous by directing the classic Fred Astaire and Ginger Rogers movies *Top Hat* and *Carefree.*

New Brunswick was the home of the New Jersey College for Women (later Douglass Col-

lege, a part of Rutgers University), but Louise did not pursue further education. Sharing her brother's interests in the theater and music, Louise appeared in local musical comedies put on by the youth of the temple. In one such production, "Captain Applejack," she portrayed Anna Valeska, a supposed Russian spy. "No one would think," wrote one reviewer, "that our sweet, gentle Ruth could transform herself into such a double-crossing vamp."[8] This sweetness was remarked on by everyone who encountered her. She was, in the words of her sister-in-law, "natural," with a no-nonsense attitude. What also stood out were her large, attractive eyes and youthful intensity, so much so that later she was sometimes mistaken for Joan Crawford on the lot of MGM.

Like her brother, Louise soon sought work at a juncture between science and art when, in 1922, she set herself up as a commercial portrait photographer. As she explained to a reporter in 1926, she had wanted to be an artist, a painter, "but somehow her fingers failed to create the images of her active mind." Sitting for a portrait by famed New York portrait photographer Nickolas Muray, however, "she realized what he could do with lights and shadows and a camera and saw that he was not merely 'taking a picture' but creating a personality." Encouraged by this revelation, she enrolled in a photographic school, but then dropped out to apprentice herself "in the studio of a well-known photographer in New York" (probably Muray).[9] Once she had gained the skills she needed, she set up her own studio in New Brunswick, in Montalvo's Temple of Music, a music store down the block from Temple Anshe Emeth.

She began advertising her services as early as the fall of 1922, listing her qualifications as "D.G.P."—Darn Good Photographer, we can assume. "Won't you visit my studio, and let me perpetuate your personality," she coaxes in the *Banner*.[10] It was a one-room studio, and she was the only staff member. According to a 1927 account in *Royal Magazine,* "She did it all, from the taking of pictures to retouching, developing, printing, even down to scrubbing the floors."[11] The following year she listed herself in the city business directory, a clear expression of her professional ambitions. She also assumed what would become her professional name: the first published appearance of "Ruth Harriet Louise" appears in a listing in the *Banner*'s holiday greetings issue of September 1923.

Although few photographs from this period survive, we can learn something of her early thoughts as a photographer from a short essay, "The Better Photography," she published in November 1922 in the *Banner*.[12] "Good photographs," she writes, "like good books, or a resonant mellow old violin, possess a soul. . . . A violin sings to you, a book holds a mental seance with you and makes you think. Even so a photograph can talk to you. If it is the better type of photograph, it not only talks to you, but it strikes you between the eyes and makes you gasp for breath." Balancing this romantic emphasis on soul and the emotional response to photographic art, however,

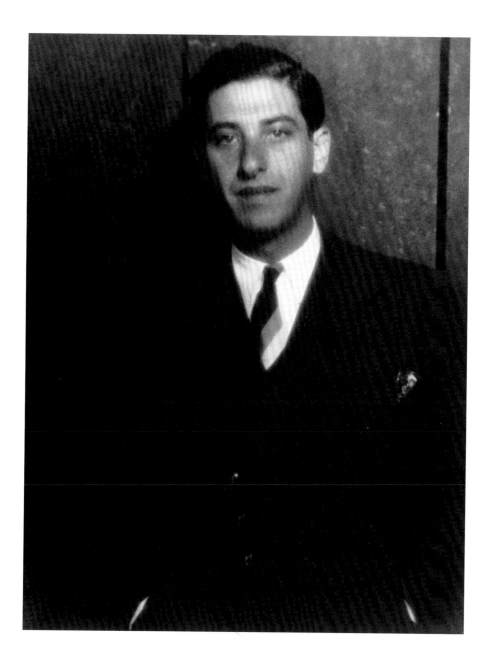

MARK SANDRICH, 1928

Private collection

Louise made this portrait of her brother in late winter 1928, when he was working as a writer at Educational Pictures. Soon he would move to RKO and direct Fred Astaire and Ginger Rogers.

is a confident assertion of her knowledge of the "science" of photography, in the handling of lighting, film, and chemicals and the making of fine prints.

Certain aspects of her character as a Hollywood photographer can be discerned even at this preliminary stage. First, there is an interest in fashion. In a striking simile, she compares a good photograph to a glamorous evening dress: "The difference between a photographic study, and an ordinary picture is just like a gown of Poiret of Paris compared to a dress displayed in the shop window of some small town shop. One is a creation expressing individuality, and grace, the other is—well, the other, let us say, is a necessary evil!" Evident in this comparison is also her ambition, since by most reckonings a teenager (even a precocious one) in the town of New Brunswick would be more like the small-town shopkeeper than the Parisian couturier.

In addition, she carefully enunciates her criteria for a good photographic portrait. First and foremost, "the photograph must express personality." Flaws in appearance should be minimized through posing and lighting, and in the print itself the subject's features should be softly and evenly modeled (Louise decries "needle point sharpness"), not "over-touched and lighted till a soft round face looks like a paste" but revealing real skin texture. Finally, the print should be finished and presented pleasingly. Only with regard to retouching would Louise's Hollywood technique differ from the program she set herself during her first months as a professional photographer.

How commercially successful she was is uncertain.[13] The only photographs we know of from this period are family portraits and portraits of her father's congregants. Certainly Louise worked hard at her career within the limited realm of New Brunswick, keeping abreast of photographic trends in New York. She also took advantage of the first opportunity to move on to a larger arena. Soon after her brother's marriage and his return to Hollywood in March 1925, Louise moved to Los Angeles.[14] With a safe, chaperoned environment provided by Mark and Freda Sandrich to welcome her, Louise immediately set up shop in "a tiny studio on Vine and Hollywood, close to Famous Players-Lasky Studio" and began to forge an independent career.[15] Two sessions can be dated with great certainty to the months before her MGM contract. One was with the Fox director Emmett Flynn, who continued to use Louise's photograph for publicity for many years.[16] And Samuel Goldwyn, working as an independent producer, hired Louise to photograph his latest discovery, Vilma Banky, in costume for *Dark Angel* (which was in production in June 1925). A portrait from this session appeared in *Photoplay* magazine in September 1925, Louise's first published Hollywood image. In Louise's account, within three weeks of arriving in Los Angeles she was brought to the attention of "a man who was a big power in the moving picture world."[17] This might have been Goldwyn, but more likely it was MGM studio boss Louis B. Mayer.

To make this jump, especially so quickly, Louise needed talent, luck, and connections. We

know she was talented, and her meteoric rise suggests considerable luck. Her Hollywood connections, however, played an especially important role in her quick success. With a brother established at Educational, she might have found some work at that small studio, but hardly at MGM. Rather, the key to Louise's success was certainly her cousin Carmel Myers.[18] Myers, who was just completing the filming of *Ben-Hur* on MGM's Culver City lot (page 9), not only was on good terms with Goldwyn, but was also very friendly with Louis B. Mayer and his family: she was often Mayer's choice to chaperone his daughters. Nepotism ruled the MGM lot, as it did nearly all the Hollywood studios.[19]

Myers, in fact, was the first Hollywood actress Louise photographed (though the session took place not in Hollywood but in Manhattan), and it was through Myers's intervention that Louise came to the attention of MGM.[20] Early in the spring of 1925, Myers had returned from Italy to Hollywood along with the rest of the cast and crew of *Ben-Hur*. She stopped in New York on the way, and it was there that Louise photographed her cousin. As reported in 1928: "Carmel could not arrange to get to Ruth's home, which was out of the city, so the girl took her camera and all of her heavy lights to Carmel's hotel. It was this very sitting ultimately that changed the tide of her career, for Carmel returned to the MGM studios with the portraits and showed them to Mayer."[21] Mayer, however, wanted proof that Louise could handle the responsibilities of such an important job, so MGM actress Paulette Duval, a close friend of Myers, was sent for a sitting. Although Duval was not impressed by Louise's youth and required some cajoling, the results were excellent and brought Louise an interview. The studio bosses were prepared to accept a young woman as an actress or even scriptwriter, but were dubious of one in a male-dominated technical field and asked if she were receiving help. "Send some other star—a man, if you like—and he can watch the whole proceeding from beginning to end," Louise suggested.[22] Yet that proved to be unnecessary, and before the middle of the summer she had a contract with MGM.

When Louise arrived in Los Angeles in 1925, Hollywood was already a marvel for the entire country. As early as 1920, the reaction was ecstatic:

> No one can breathe [Hollywood's] atmosphere long and not be profoundly conscious that some tremendous force is stirring here. It is for our generation an almost incredible experience to watch the beginnings and development of a wholly new art. It is no use for gentlemen with a Broadway past to assert, with a pungent oath, that it is not an art, but just the "show business." It is, or is going to be, an art and a great one, and in Hollywood they realize the fact with a kind of vague terror. It is a little as if they had somehow unloosed a great and beautiful beast and

were wondering whether, with their inexperiences, their ineptitudes, and their vulgarities, they could long hold and control him.[23]

By 1925 the beast was even larger: investment in the industry was reckoned at $1.5 billion, with seven hundred or so feature films made every year. The United States alone had some twenty thousand movie theaters, which sold 130 million tickets a year on average, if we are to believe industry figures—equaling approximately one visit to the movies for each man, woman, and child in the country.[24] As Harry Reichenbach, one of the great publicists of the day, observed: "Pictures were the new Klondike and people swarmed to it like grifters to a mardi gras."[25]

The biggest change between 1920 and 1925, though, arose from the decision by a small group of Hollywood's biggest producers to consolidate the industry. As a result of this move, the array of small film companies that characterized early Hollywood soon gave way to a core group of stable enterprises that were to dominate the industry for the next three decades. Whereas in 1924 there were some nineteen studios still in Hollywood, by 1935 only eight major ones ruled the scene. The most important single development leading to consolidation was the creation of Metro-Goldwyn-Mayer Studios in 1924, under the supervision of Louis B. Mayer (1885–1957) and controlled by Marcus Loew in New York.[26] Loew, who owned a large chain of theaters, had purchased Metro Pictures several years earlier as a means of enlarging his empire and securing a steady supply of movie offerings. Louis B. Mayer had been a small-time theater owner who made a fortune by acquiring exclusive rights to exhibit D. W. Griffith's *The Birth of a Nation* in New England. A founding partner of Metro in 1914 in New York City, by 1918 he was in Los Angeles with his own production company, part of the larger movement of studios to the West Coast. The third piece in this complicated puzzle was Goldwyn Studios, shares of which Loew had been purchasing throughout the winter of 1923–24. In late April Loew reached a merger agreement with Samuel Goldwyn, who no longer controlled the studio (he had been forced out in 1922) but who remained a large shareholder. So too was William Randolph Hearst. Newspaper and magazine publisher as well as sometime politician, Hearst also owned Cosmopolitan Pictures, which existed primarily (though not exclusively) to make films starring Hearst's mistress, Marion Davies. Cosmopolitan's films were distributed by Goldwyn Pictures. In the various negotiations leading up to an agreement, satisfying the egos and filling the pocketbooks of Mayer, Goldwyn, Hearst, Loew, and their many partners must have been a monumental challenge. Nonetheless, on Saturday, April 26, 1924, the completed merger was celebrated by a large party on the front lawn of the former Goldwyn Pictures, now rechristened Metro-Goldwyn Pictures (the name would become Metro-Goldwyn-Mayer by the end of 1924).

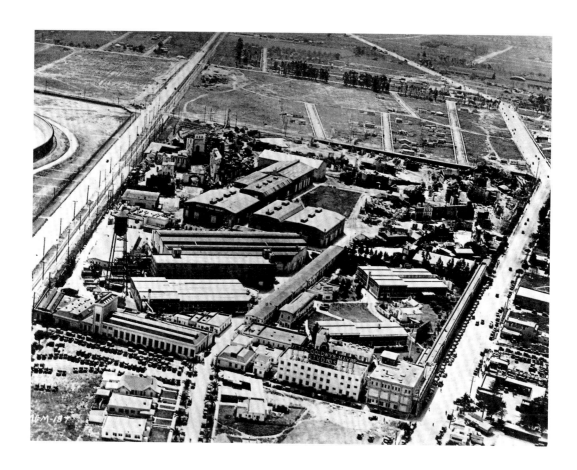

MGM FROM THE AIR, 1925–26
Culver Pictures
MGM from the air about the time Louise
joined the studio.

Given the complexity of the merger, and the often tense and acrimonious prior relationships of all the partners, it was far from a foregone conclusion that MGM would prove any more long-lived than its predecessors. Yet owing largely to the authority and vision of Mayer and his chief production assistant, Irving Thalberg, the constituent parts did quickly meld into an empire. Goldwyn's Culver City lot, which was perhaps the best filmmaking facility in Hollywood, took over films already in production. Metro Pictures and Louis Mayer Productions, both smaller operations, contributed primarily stars and directors under contract; in addition, Mayer provided the management team necessary to integrate the disparate pieces. Within the year, Cosmopolitan would come into the MGM fold as well, giving up independent production facilities in New York and Los Angeles to make its films exclusively in Culver City. Moreover, Hearst's newspaper chain could be counted on for positive reviews and for feature articles spotlighting the new studio, its films, and its stars. Finally, theater owner and now studio emperor Marcus Loew was in a position to regulate the product he needed to fill his many seats, in movie palaces in and around Times Square as well as numerous small theaters situated primarily in the Northeast.

Once the merger was completed, Mayer seems to have turned his attention toward developing talent, for he knew that the studio's success would depend on a reliable stable of performers and an equally strong crew behind the scenes. Money seemed to be no object in Mayer's quest for talent; in the single year of 1925, for example, MGM placed under contract the established actresses Lillian Gish and Marion Davies and future stars Greta Garbo and Joan Crawford. The studio's population grew quickly as every department added new employees to meet the ambitious production schedule of one new feature a week and numerous short subjects.

Louise came into this swarming enterprise in midsummer 1925. Six-month contracts were typical, and undoubtedly Louise signed on for half a year with renewal options at the discretion of management. Just twenty-two when she first set foot on the lot, Louise entered a world where youth was not a novelty, much less a hardship.[27] As one awestruck commentator exclaimed: "Movie-land is, above everything, the land of youth, where success may come overwhelmingly before you are twenty-one."[28] Early female stars such as Mary Pickford and Gloria Swanson were household names as teenagers. Garbo, already a star in Europe, arrived at MGM just a few days before her twentieth birthday, and producer Harry Rapf signed Lucille LeSueur (later Joan Crawford) to the studio when she was only eighteen years old.

Within the context of the enormous MGM enterprise, Louise's responsibilities might seem somewhat trivial. She was hired as a portrait photographer, high in the pecking order of still photographers but still small fry in the ego-driven world of producers, directors, stars, and designers. As it turned out, her job was in fact much more important than she might at first have imagined.

GRETA GARBO FOR *THE TORRENT*, 1925

The John Kobal Foundation

Two weeks after the shooting was completed on her first American film, *The Torrent,* Garbo was back in Louise's studio on December 31, 1925, for one final session.

Mayer's careful and thorough rationalization of all parts of the movie business included publicity; indeed, from the beginning of his career Mayer had taken an intense interest in how film studios created and promoted stars through photography.[29] Because it was a concern of Mayer, this difficult task would become a principal concern of Louise and her portrait studio as well.

Louise's timing could not have been better. Competition in her field was intense; when she arrived in Los Angeles there were about thirty-five portrait studios, making it potentially very difficult to get noticed. (The fact that all the prominent photographers in Hollywood in 1925—notably Walter F. Seely, Melbourne Spurr, and Witzel—were men was a problem, but Hollywood was still generally hospitable to women professionals.) Most of Hollywood's portrait photographers specialized in promoting movie actors; about the same number of photographers worked in New York shooting theater and film performers.[30] Opportunities were expanding in Los Angeles, however, and declining in New York as more motion picture studios shifted operations to Hollywood. Although the number of photographic studios and portrait photographers who advertised would not change much in the next few years, the way of doing business would, and quite radically. So too would the kinds of photographs taken.

The year 1925 was an auspicious one for MGM. *Ben-Hur* and *The Big Parade,* both of which premiered at the end of 1925, were among the silent era's biggest commercial and critical successes (see color plate 1). As these films opened, Garbo, who had sent a shock wave through Hollywood the moment she stepped before a camera, was wrapping up her first MGM production, *The Torrent* (page 71). At the beginning of the year, however, the outlook was not so rosy; in fact, Mayer had skirted real disaster. His single greatest headache, and one that might have cost a lesser mogul control of his studio, was the production of *Ben-Hur,* a project inherited from Goldwyn Studios. In development since 1920, when Sam Goldwyn acquired the rights to Lew Wallace's popular 1880 novel, *Ben-Hur* began filming in the summer of 1924. While Mayer, in California, steered the new merger, production on *Ben-Hur* progressed badly in Italy, eating up scandalous amounts of money. Finally, Mayer decided to go to Rome to oversee what was quickly becoming a fiasco. In January 1925 he decided to bring the production home, scrapping most of the Italian footage. For the next many months Mayer's team endeavored to squeeze something golden out of this incredibly expensive goose, a process that included the enactment of the famous chariot race in Culver City in October and did not let up until the film opened on December 30, 1925. Throughout much of this period, especially the spring of 1925, MGM faced real financial problems. Stories circulated throughout Hollywood, such as the one of the bit player who was fired because his costume didn't fit; it was cheaper to hire another player than to alter the costume.[31]

Nevertheless, Mayer fearlessly carried on, and even continued to expand during this tumultuous period, realizing that his greatest assets and most worthwhile expenses were his players. In September 1925, for example, MGM advertised the addition of six new female and six male stars to its heavens. Louise, of course, was not listed, but it was her photographs that would end up promoting these stars and preserving their memory.

LOUISE'S STUDIO PRACTICE

THE MOVIE STUDIO THAT LOUISE JOINED IN THE SUMMER of 1925 is long gone. MGM's fabled main gate is still there on Washington Boulevard, but the studio no longer thrives beyond it. Still, we can gain a sense of what greeted Louise when she first walked through that gate from a short film made to celebrate the studio's first anniversary in the spring of 1925.[1] In this thirty-minute documentary, *MGM Studio Tour,* actors and producers make brief appearances and every department is featured. As the tour proceeds, the viewer gains an impression of the complexity and lavishness of the MGM operation. The lot has the appearance of a campus, with buildings scattered amid lawns and luxuriant vegetation. At the center is a large green expanse surrounded by offices, dressing rooms, and stages. The overwhelming feeling is one of capaciousness and comfort, as epitomized, perhaps, by the fabled staff cafeteria, serving chicken soup daily to all Mayer's "family" of employees.

Louise's portrait studio was three third-floor rooms at the top of an exterior iron staircase above an editing building near the front of the lot.[2] She looked out over a landscape increasingly crowded

with buildings, as seen in a photograph of the actor Ralph Forbes gazing out her studio window (page 15). It was just as crowded inside her rooms, described as "tiny" by more than one reporter and packed with "artistic backgrounds, swing mirror, and up-to-date gramophone."[3] Although Louise worked with a minimum of help, her studio must have seemed even more crowded as stars arrived accompanied by assistants from the costume and makeup departments; sometimes, as actress Anita Page remembers, portrait sessions were "just the two of us."[4]

Within this workspace, the largest room served as the portrait studio, while the smallest was reserved for developing and retouching negatives. The third room was a rather narrow lounge: "It is here," wrote one reporter, "that Ruth Harriet spends a lot of her leisure time, and where she entertains the great and famous of the 'Celluloid City.' In this cool room she has many treasures—books, pictures, curios—all given her by film folk in appreciation of her work."[5] Page recalled her studio as full of "lots of pretties!"[6]

Louise's subjects—Garbo, Gilbert, Crawford, and the rest—climbed the two flights of steps, sometimes hauling their own costumes; props were maneuvered up the same narrow route. The passage had unexpected dangers. Near the building was an old Moreton fig tree that shed its fruit on the paths. Budd Schulberg, son of Paramount's chief of production, B. P. Schulberg, remembers hiding in the tree as a youth along with his pal Maury Rapf, son of senior MGM producer Harry Rapf, and lobbing unsuspecting passersby with the fruit. The height of their success was splattering Garbo on her way to a portrait shoot.[7]

Stars who survived the trip unscathed and unwinded entered a cozy, colorful space. One side was kept free of clutter; there, on a hardwood floor against a simple light-colored backdrop, Louise posed many of her subjects. The remainder of her studio, however, was crowded with elaborate backdrops and props: all the materials she required to create glamour and fantasy. An original negative of Norma Shearer exposes some of the illusion involved (opposite). Wearing an elaborate gown from *Upstage* (1926), Shearer stands in front of a neutral-colored screen on a box, the train of her dress carefully arranged over it. Behind the actress may be seen layers of curtains, flats, and the patterned hangings that Louise favored, while to her right is a comfortable sofa and a cigarette burning in an ashtray. Shearer has stepped for a moment out of ordinary life into the mirage of perfect beauty, the space of Louise's photographs.

The idea of an in-house photography studio was relatively new to the Hollywood of 1925. Goldwyn Studios was probably the first to have a permanent photography department, employing Clarence Sinclair Bull starting in 1920. Bull retained his job after the merger and became head of the stills department at MGM, where he remained until 1956. Following Goldwyn's lead was Paramount, which hired Eugene Robert Richee in 1923. By the end of the 1920s most large studios

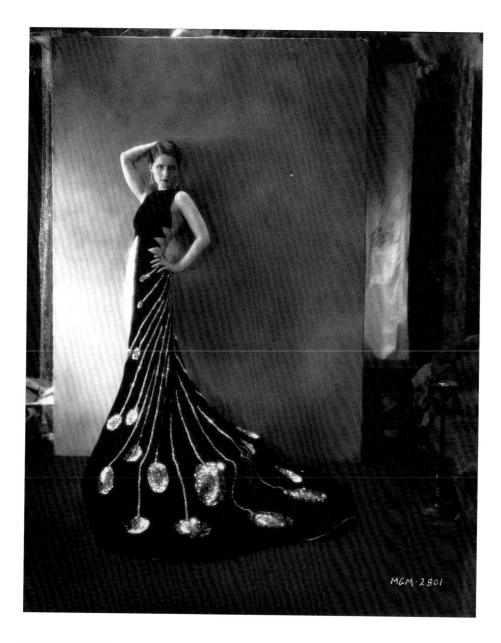

MGM-2801

NORMA SHEARER, 1926
The John Kobal Foundation

When Louise pulled the camera back from Norma Shearer, in a costume
designed by Kathleen Kay for *Upstage* (1926), she revealed her cramped
working quarters. The published photograph was cropped to hide such
distractions as the flats in back.

created virtually all publicity material in-house, relying on portrait and stills photographers under exclusive contract, though smaller studios continued to work mainly with outside vendors.

Spread among three buildings, the MGM stills department housed as many as a dozen photographers who, working under Bull's supervision, created scene stills and general publicity photographs.[8] There were spaces for developing, retouching, and printing the photographs, a reception area and offices, as well as two portrait studios, one for Louise and one for Bull on the ground floor with the other stills photographers.[9] Louise, who enjoyed a large degree of autonomy, had her studio on the top floor of a separate film editing building. Unlike the stills photographers, who generally worked for specific film productions, Louise worked on the full range of images produced for publicity (see chapter 4). As a result, she reported not to Bull but to the head of publicity, Howard Strickling.[10] Al St. Hilaire, who assisted Louise during her last year at MGM and became an important MGM portrait photographer in the 1930s, recalled that this structure bothered Bull. St. Hilaire also claimed that Louise was "a much better photographer than Bull," a general perception that may well have added to the tension between the two. Louise worked with an assistant, who helped with the lights; developed, washed, and dried the prints; and delivered finished prints to publicity. St. Hilaire was one such assistant (paid $17 a month). She also employed a retoucher, Andrew Korf, who prepared the negatives for printing.[11]

Although Bull maintained a portrait studio, increasing administrative responsibilities restricted his work. After Louise was hired, Bull's photographs were largely limited to costume studies, general studio publicity, portraits of stars at home, and the occasional trick or action shot. He also took portraits of many of the men at MGM: performers, directors, and executives. He seems generally to have seen himself as a troubleshooter, at least for the first few years that Louise was there. In the instances when both Bull and Louise photographed the same subject for a single film, usually Bull worked with the subject on the set while Louise worked in her studio. A portrait of John Gilbert and Renée Adorée on the set of *The Cossacks* (page 14) is a rare foray outside for Louise, as a well as a rare example of unposed, candid work.

A portrait session involved real effort for a star. Working under hot lights in the southern California climate must have been excruciating. Moreover, the cumbersome 8 × 10 camera required that each negative be loaded individually and that the focus be adjusted prior to each exposure. On the set, Douglas Fairbanks Jr. remembered that the production of stills simply required posing a trifle longer once the director had shouted "Cut"—just long enough for the photographer to catch the scene.[12] But a session in the portrait studio meant long hours of posing, costume changes, and more posing. Page remembers two-plus-hour sessions, with just her and Louise. Unless a specific dress needed to be photographed, Louise chose the costumes and props.[13] Marion

Davies liked to begin her sessions as the day wound down, around five, and continue until seven or eight.[14] But for others it was an escape from the pressures of the set. Generally, portrait sessions connected with a film were scheduled the day after principal shooting wrapped up, when costumes and makeup were still readily accessible. At that point, everyone could relax, and Louise strove to make the atmosphere convivial, playing records and moving about constantly.[15] Margaret Chute, an English reporter working in Hollywood, described her at work: "Ruth Harriet, I must explain, takes all her photographs to music. She poses her sitter, then darts to the gramophone and slips on a record that is gay, sad, pert, pensive, passionate, loving—according to the mood she wants to catch with her wonderful camera."[16]

A pair of photographs by Clarence Bull taken in 1928, while clearly posed, capture this effect as Louise prepares to photograph Joan Crawford, who is dressed in tennis whites and seated on a rattan chair. Louise, in a long sleeveless vest and loose white pants, is, like Crawford, comfortably and stylishly dressed for the active life.[17] In the first photograph, Louise moves close to Crawford, obviously giving her instructions; then, in another (see frontispiece), she steps back to release the camera shutter. Crawford is alternately coquettish and reflective, and Louise matches her animated changes. Against the back wall may be seen one of Louise's "moderne" flats—perhaps more futurist than cubist, all fractured diagonal elements. The impression in these photos is one of lively and personal interaction between two modern women.

The entire process was highly complex, requiring multiple steps and advanced equipment to achieve the "effortless" image. In her studio, Louise used a large-format, relatively immobile 8 × 10 camera; George Hurrell, her successor at the studio, recalled inheriting a new Eastman Century Studio camera, along with the latest lighting equipment.[18] The self-conscious use of light was essential to her style, as was increasingly true for all Hollywood portrait photographers. Although Hurrell, with his inventive use of bold shadows and harsh highlights, is generally credited with making lighting effects the dominant aspect of the star photograph, the work that immediately preceded his, especially Louise's, certainly established a strong precedent. Nickolas Muray laid out the basics of portrait lighting in an article in *Photoplay*:

> When I take a still photograph I place one light directly facing my subject. This is usually a powerful hanging light, just out of range of my still camera's lens. Then another light goes at the side of my subject, and slightly back of him. This is to soften the first light and to give outline and contour to the face. . . . This light should be exactly on the level of the lens. . . . Never take a picture closer than three feet, regardless of the capabilities of your lens, unless you are trying for a special effect.[19]

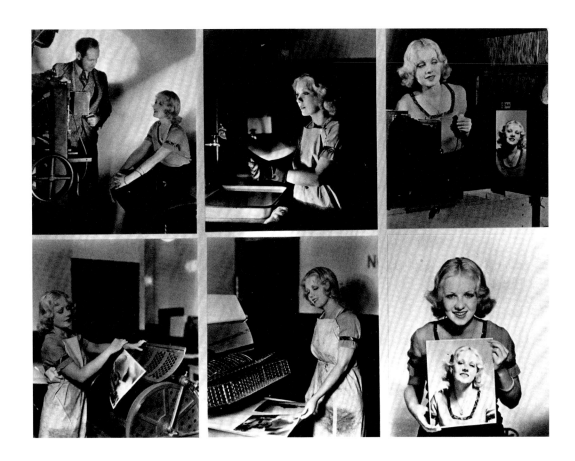

"ANITA PAGE DEMONSTRATES HOW TO MAKE A PHOTO," 1930

Photos by Clarence Sinclair Bull. Hulton Archive.

Anita Page is photographed by Clarence Bull with an 8 × 10 camera,
then "supervises" the developing and printing of her portrait.

Davies liked to begin her sessions as the day wound down, around five, and continue until seven or eight.[14] But for others it was an escape from the pressures of the set. Generally, portrait sessions connected with a film were scheduled the day after principal shooting wrapped up, when costumes and makeup were still readily accessible. At that point, everyone could relax, and Louise strove to make the atmosphere convivial, playing records and moving about constantly.[15] Margaret Chute, an English reporter working in Hollywood, described her at work: "Ruth Harriet, I must explain, takes all her photographs to music. She poses her sitter, then darts to the gramophone and slips on a record that is gay, sad, pert, pensive, passionate, loving—according to the mood she wants to catch with her wonderful camera."[16]

A pair of photographs by Clarence Bull taken in 1928, while clearly posed, capture this effect as Louise prepares to photograph Joan Crawford, who is dressed in tennis whites and seated on a rattan chair. Louise, in a long sleeveless vest and loose white pants, is, like Crawford, comfortably and stylishly dressed for the active life.[17] In the first photograph, Louise moves close to Crawford, obviously giving her instructions; then, in another (see frontispiece), she steps back to release the camera shutter. Crawford is alternately coquettish and reflective, and Louise matches her animated changes. Against the back wall may be seen one of Louise's "moderne" flats—perhaps more futurist than cubist, all fractured diagonal elements. The impression in these photos is one of lively and personal interaction between two modern women.

The entire process was highly complex, requiring multiple steps and advanced equipment to achieve the "effortless" image. In her studio, Louise used a large-format, relatively immobile 8 × 10 camera; George Hurrell, her successor at the studio, recalled inheriting a new Eastman Century Studio camera, along with the latest lighting equipment.[18] The self-conscious use of light was essential to her style, as was increasingly true for all Hollywood portrait photographers. Although Hurrell, with his inventive use of bold shadows and harsh highlights, is generally credited with making lighting effects the dominant aspect of the star photograph, the work that immediately preceded his, especially Louise's, certainly established a strong precedent. Nickolas Muray laid out the basics of portrait lighting in an article in *Photoplay:*

> When I take a still photograph I place one light directly facing my subject. This is usually a powerful hanging light, just out of range of my still camera's lens. Then another light goes at the side of my subject, and slightly back of him. This is to soften the first light and to give outline and contour to the face. . . . This light should be exactly on the level of the lens. . . . Never take a picture closer than three feet, regardless of the capabilities of your lens, unless you are trying for a special effect.[19]

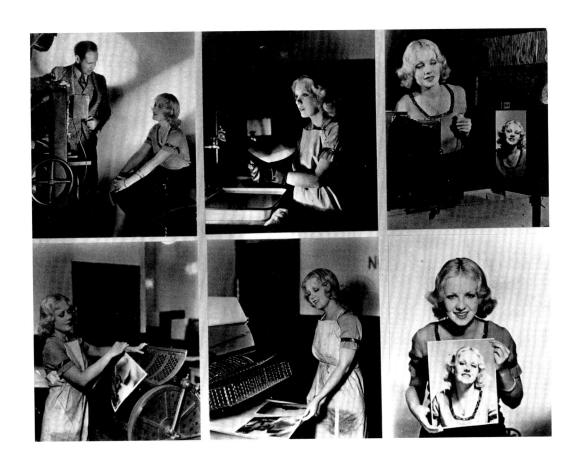

"ANITA PAGE DEMONSTRATES HOW TO MAKE A PHOTO," 1930

Photos by Clarence Sinclair Bull. Hulton Archive.

Anita Page is photographed by Clarence Bull with an 8 × 10 camera,

then "supervises" the developing and printing of her portrait.

In some respects, his suggestions became the rule in the studios: "If the face is a long one, the light will be arranged so as to throw a shadow under the chin, which will have the effect of cutting off some of the length. A broad face is lighted so that the dividing line between the chin and the neck is not too clearly defined. A light from above may accentuate a wrinkle, while a lower light would completely obliterate it."[20] Muray offered various other tips: "If you add a blue gelatin filter to your lights, you will find that a whole lot of the sharpness is eliminated." And: "Never use white backgrounds. Remember that it is always best to photograph your subject against a background at least a shade darker than the skin. White backgrounds make faces and arms appear dark or negroid." Russell Ball, a photographer who occasionally worked for MGM, had even more specific suggestions, such as that people with light eyes should not look directly into the light, for that would wash all the color out. Subjects with eyes too wide apart or too close set should always turn their head fractionally from the camera, while those with retroussé noses should avoid being shot in profile. "Ninety-nine out of a hundred women," he further noted, "photograph better with their mouths very slightly open. . . . This gives a soft feminine look."[21]

Louise, who learned from Muray, shared much of this common practice. When she went to Palo Alto to photograph president-elect Herbert Hoover, for example, she brought along just two broad lights and one spotlight for the face.[22] Nonetheless, she did not entirely avoid striking lighting or special effects. In several instances she experimented with strong lights against dark backgrounds, highlighting just the face to produce what she called mask photographs (see page 132), or highlighting the whole figure.[23] On other occasions she reversed the effect, silhouetting her sitters in front of strong lights or posing them against an open window to cast their features in near darkness (pages 15 and 45). In a number of instances she abandoned altogether the rather diffuse lighting recommended by Muray and employed sharp focus and strong shadows, the very thing Hurrell claimed to have invented and certainly popularized at MGM (pages 11 and 22). Strong shadows could also be employed in the background, as with a recoiling Dorothy Sebastian or a reluctant Lillian Gish (see pages 115 and 52). Given her top-floor location, she occasionally used natural light in combination with artificial. Strong lights were generally needed, however, both to compensate for the relatively slow film used at the time and to replicate as closely as possible conditions on the sets.

The process was not over when Louise snapped the shutter. The negative and print received nearly as much attention as the sitter and the lighting. According to Louise's assistant St. Hilaire, "A lot of the work on those photographs was usually done in the dark room, in the enlarger. Of course, once the neg went to the publicity department one had no more control over how they would print them. What we tried to do was to send a complete 11 × 14 print to the studio the way

we wanted it, and they would have to make a copy neg of that, so it would look something like we wanted." St. Hilaire also noted: "She had her own lab and could control things so that gave her an edge. She must have been the first to have that sort of authority. She was the only one, the only photographer in Hollywood who had control over the development of her negs."[24]

As Louise's surviving negatives demonstrate, and the prints confirm, the work of her retoucher, Andrew Korf, was critical. Once developed, the negatives were carefully examined and any tiny flaws her subjects possessed miraculously disappeared under his skillful touch. "It was fabulous what he did for her," recalled St. Hilaire. Many of the negatives are covered with tiny touches of lead white over large areas of the image. According to St. Hilaire, moreover, Louise did not compose her images in the camera but relied on cropping. It is true that the bulky camera limited Louise's movement, and she often took full-length shots that later had to be cropped during printing. Contrary to legend, however, she did not exclusively photograph her subjects in full length; countless original negatives show performers from mid-body up or even in close-up.[25] Nevertheless, by using full-length shots—and in this she was a master—Louise gained the freedom to compose the final images as she needed. In fact, she often released two prints to publicity, one full or half length, the other a close-up, both derived from the same negative.

The original negative was not sacrosanct. Often a second negative was made from a print, enlarged again, and reprinted. One reason for this was to allow additional retouching, particularly in the case of close-ups. A print might also be duplicated so that negatives could be sent to different publicity offices (in the Midwest or on the East Coast) and additional prints made for local distribution. Just as often, a new negative would be made in order to record different codes, since many images served more than one purpose. (For more on MGM photo codes, see appendix B.) It is often difficult, if not impossible, to determine whether a print was made from an original negative or a negative made from a print. Given the exigencies and haste of studio schedules, and the many purposes for which the images were used, such confusion is not surprising.

Laszlo Willinger, a Viennese-born portrait photographer who joined MGM in the mid-thirties, reflected on how he negotiated the many demands of his job. He had no problem with the fact that the operation was basically a commercial one, even if he considered himself, as an artist, capable of much more. As publicity head Howard Strickling told him, "That kind of picture with shadows and things we can't use. We need pictures that can be reproduced in newspapers. Those you did sold you, so shoot two or three like that if you feel like it, to satisfy the star, but for me you shoot flat light with white backing." The stars, however, often had specific ideas of what they wanted—and most of them didn't want to strike a boring pose against a white wall. Willinger, in turn, had ideas he wanted to try out. Still, he noted, "For every magazine picture

that was published, they had a hundred newspapers." So "I always shot enough of flat light to make Strickling happy. [Then] I . . . shot something to satisfy me, and some to satisfy the star."[26]

Unlike the negative, the status of the print was paramount. Most important were the fine, large-format (11 × 14-inch) prints made under Louise's supervision in her studio, most of which exist in very small numbers (perhaps only one or two) and represent but a portion of all the negatives she made. Virtually all of these prints have a blindstamp (her full name, embossed) on the front or a red stamp reading "Ruth Harriet Louise / Metro-Goldwyn-Mayer" on the back. Images approved for distribution (primarily to the fan magazines and newspapers) would also be printed in quite limited numbers—often no more than five or ten, also in 11 × 14-inch format. Only after a set number of these special prints were made would 8 × 10s be produced.[27] A few of these smaller prints would be turned out under the photographer's supervision and stamped by her, but for the most part they were produced in large quantities to meet expected circulation. These might also be blindstamped or stamped on the reverse. The large prints were both the control, acting as a guideline from which copy prints might be made and the 8 × 10s manufactured, and works of art in their own right. The enormous care Louise took in producing these images indicates that she thought of her work in the latter sense.

Often when printing an image, Louise would experiment with papers differing in color, texture, and contrast, rejecting unsatisfactory prints.[28] In this she was in the vanguard, for none of her contemporaries at MGM or other studios worked with such a wide range of papers and tonal ranges. Reproductions, unfortunately, inadequately convey the richness of Louise's prints. Whether working in black and white or sepia, Louise varied the intensity considerably, experimenting throughout the value scale, from light to dark. A portrait of Marion Davies seated on her diving board at home, for example, is rendered in delicate light tones on yellow or buff-colored paper, while Joan Crawford as Santa's helper is printed in a rich sepia (see color plates 2 and 3). Prints were sometimes hand-tinted as well, though it is not clear whether tinting was done in Louise's studio or sent out to another department. A portrait of supporting actress Patricia Avery, for example, has been delicately hand-tinted in soft pastels over a very pale black-and-white image (color plate 4). A photograph of Greta Garbo, shown in a beautifully painted image taken in 1926 for *The Temptress,* is more densely printed, and the colors are correspondingly richer (color plate 5).

In her compositions, Louise was equally careful. One distinctive feature of her prints, often lost in arbitrarily trimmed reproductions, is the close attention she gave to the edges of the image. Rather than centering her sitter and allowing a great deal of surrounding space, she often framed quite tightly, so that the figure touches the very edges of the composition. When she does

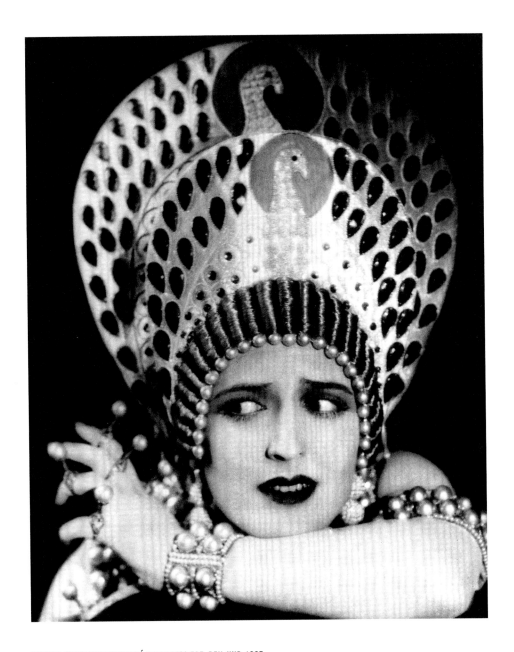

CARMEL MYERS WEARING ERTÉ HEADDRESS FOR *BEN-HUR*, 1925

Turner Entertainment Co./MGM Collection; courtesy of the
Academy of Motion Picture Arts and Sciences

Of all the fantastic costumes Erté created at MGM, perhaps none rival his
gown and headdress for Carmel Myers as Iras in *Ben-Hur,* photographed in
late October 1925 and published in *Picture Play* (Feb. 1926, p. 76).

allow space around the sitter, it is subtly and dynamically balanced. In the tight close-up of Carmel Myers in her Erté headdress for *Ben-Hur* (opposite), her head is just off-center enough that her fingers, laden with ferocious rings, can curl up beside her chin. In the photograph of Lillian Gish and Lars Hanson from *The Wind* (page 53), their two heads define the left and right edges, while Hanson's elbow and the top of his head extend from lower to upper extremes of the image. These compositional touches are not purely formal, but serve dramatic purposes: Hanson, as the dominant male, frames the composition; but Gish is the dramatic center of the story, and so her face is set off by the blank background. The work of other still photographers can generally be distinguished from Louise's because the subjects are consistently centered, with considerable space left around them to accommodate the vagaries of reproduction. Louise, who had considerably more control over her images, could aim for more precise compositional effects.

Although dozens of negatives might be exposed, the outcome of a portrait session resided in a small number of fine prints. The special quality of these photographs has been obscured by the vast cloud of copies, duplicates, and reprints that surround them. Nonetheless, what Louise produced—and what the stars and management reviewed and approved—were remarkable portraits, works of art in their own right. Indeed, toward the end of her tenure at MGM (and in the 1930s as well), Louise took the time to print and exhibit the best of them.[29]

THE PORTRAIT PHOTOGRAPH

chapter 3

THE PHYSICAL DETACHMENT OF LOUISE'S STUDIO FROM the sets did not mean she was isolated from the bustle of making movies. The rhythm of her workdays, the schedule of her projects, the kind of photographs she took and the look of them, all were defined by the demands of particular productions, of which she was always keenly aware. But within the rapidly evolving star system, the portrait photograph had begun to be an object in its own right, recording the stars as distinct phenomena and helping to define the image of the new studio.

When Louise started at MGM, it was not uncommon for outside photographers to photograph studio personnel, usually stars who specifically requested their services.[1] Traditionally, studios had asked leading players to provide their own publicity materials (or at least pay for it), and this practice remained in force to a degree. At the beginning of 1925, for example, stars such as Mae Murray and Lillian Gish controlled much of their own publicity and could request any non-MGM photographer they wished. This would change at MGM as, beginning in the mid-1920s, the studio con-

solidated both photography and publicity, bringing nearly all of this work under direct studio control. Only fashionable, wide-circulation, general-interest magazines such as *Vanity Fair* were permitted to send their own photographers to the studio, and occasionally a star might, while traveling, sit for a major New York or European photographer. These exceptions aside, beginning in the mid-1920s MGM developed a consistent, highly controlled house style—a style that, in the realm of portraiture, was largely the creation of Ruth Harriet Louise.

To understand how portraits functioned within the studio, it is necessary to grasp the full range of photographs required by publicity and the full range produced by stills photographers. Portraits, Louise's specialty, were only one of three basic types of still images produced by the studio. The first, and most common, type comprised the scene stills taken on the set documenting the production. Scene stills served two basic functions. First, they recorded each camera setup and the players' positioning. This ensured continuity during the course of a film's production, which, in the case of features, typically lasted four weeks, but very occasionally ran on to several months or more (*Ben-Hur,* for example). Scene stills also provided the publicity department with images of stars in costume that could be used for lobby cards, poster art, and fan magazines. The second type of still photograph was the publicity shot: images taken off the set yet outside the portrait studio; these often featured fashion or product endorsements, or revealed the stars at their leisure. Portraits were the most formal of the three categories, and the most important for creating or refining a performer's image. In addition, portraits were the lifeblood of the fan magazines, which by the early 1920s were the single most important vehicle for the promotion of films and establishment of cinema personalities. Louise was responsible for the majority of the portraits taken at MGM during the late silent period; she was also involved with the increasingly important fashion work that the studio initially saw as a way of promoting stars and films, and later embraced as an additional source of income.

Star photographs were still rather primitive in the early 1920s, relying largely on late Victorian portraiture conventions that reinforced the subject's social position and role rather than expressing emotion and personality. For example, of the hundred photographs in the 1916 edition of *Stars of the Photoplay,* only two—those of Lillian Gish and Helen Holmes—show a pair of gesturing hands (a standard expressive device); the rest were basically head shots. In the years following the First World War, however, the limited number of formats slowly increased and a greater variety of poses, costumes, and situations appeared.

New York photographers such as Baron de Meyer, Edward Steichen, and Nickolas Muray, coming from the rich tradition of photographing for the theater, were in the vanguard in the years after the war, their images well known from frequent reproduction in major magazines. They had

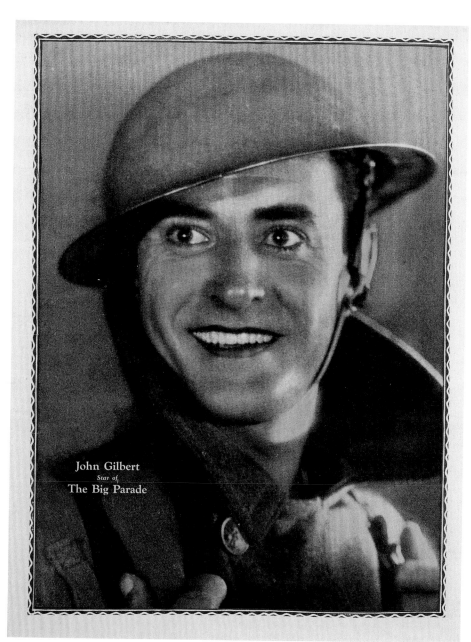

John Gilbert
Star of
The Big Parade

1

JOHN GILBERT, *THE BIG PARADE*
SOUVENIR BOOK, 1925

Private collection

For the most prestigious
productions, including
Ben-Hur and *The Big
Parade,* MGM, like other
studios, produced lavish
souvenir books with color
illustrations. Reproductions
of hand-tinted photographs
of the stars—such as John
Gilbert, here wearing the
uniform of a World War I
infantry man—frequently
occupied full pages.

2

MARION DAVIES SEATED ON DIVING BOARD, C. 1927

Private collection

Perhaps commissioned by Marion Davies herself, the photographs from this session are printed on buff paper. In the prints that she controlled, Louise frequently experimented with different textured or toned papers.

JOAN CRAWFORD AS SANTA'S ELF, C. 1928

Private collection

While most of Louise's photographs are printed in black ink, she sometimes used sepia, ranging tonally from warm to cool. This image of Crawford, taken for Christmas publicity, is particularly rich and warm in tone.

3

4

5

PATRICIA AVERY AS A SHEPHERDESS, 1927

Santa Barbara Museum of Art, anonymous gift

Patricia Avery made only one film at MGM, *Annie Laurie* (1927) with Lillian Gish, and her option was dropped after filming was completed. During her short term at the studio she was photographed many times by Louise, and publicity even took the trouble to hand-tint prints from this session depicting the actress as a shepherdess.

GRETA GARBO FOR *THE TEMPTRESS*, MARCH/APRIL 1926

Private collection

Color photography was still experimental in 1926, so hand tinting was sometimes used to make images appear natural. Although presumably the hand coloring was authorized by MGM publicity, the intended use of the print is unknown. A variant was used for the cover of *Motion Picture Classic* (Feb. 1927).

**JOAN CRAWFORD
AND ROBERT MONTGOMERY,
TRUE ROMANCES COVER**

Private collection

Fan magazines always placed Hollywood stars on the cover, hiring illustrators to paint copies of recent portraits. Specialized, non-Hollywood-oriented publications directed toward women also made use of these recognizable faces. Here a 1929 Louise portrait of Crawford and Montgomery (see page 37) taken for the film *Untamed* graces the cover of a 1932 *True Romances*. *Screenland* was the only magazine in the 1920s to use tinted photographs for covers rather than the more typical "paintings from life."

transformed star portrait photographs from staid studies of a player's visage and figure (emphasizing as much the propriety or worldly success of the actor) to lively representations of character and personality. Muray, Louise's teacher, accomplished through innovative techniques an animation of the sitter rarely seen in earlier commercial photography. His lighting became more imaginative, with strong contrasts of light and dark, as he created drama by raking light across a face or adding a halo of light around a head. He introduced varied settings and the use of rich fabrics along with assorted props (sometimes bizarre) into his compositions. The hands of his subjects now came into play, gesturing, theatrically clutching at the torso or face, or posed independently of the body as a sort of prop to add drama and create interest in the subject. Under his eye, the photograph ceased to be merely a record of a face, but rather registered a personality.[2] Louise was deeply sympathetic to Muray's portrait goals, which she would have known well both from experience as his subject and assistant and from his many published images. When she arrived in Hollywood, bringing her big-city sophistication and photographic style, she was truly the latest thing from New York.

The 1925 edition of *Stars of the Photoplay*, published just before Louise alighted in Los Angeles, reveals that some of the East Coast stylistic innovations were already being tested on Hollywood subjects, however tentatively. Because of her training, Louise, more than most of her West Coast contemporaries, succeeded in consolidating and extending these developments. Louise thrived at MGM and saw her contract repeatedly renewed because she was able to adapt the new styles of portraiture to the requirements of MGM's publicity, animating and humanizing her subjects, making them appear approachable yet still celestial. Working with what she had learned from Muray, over her five-year tenure Louise experimented with a wide range of styles even as she magnified the success of MGM's feature films and its galaxy of stars.

Even more than contemporary New York theatrical portraits, the Hollywood portrait relied on visual impact to make its point: whereas audiences went to the theater to hear people talk or sing, they went to the movies during the silent era to look at stars and watch a story. The Hollywood portrait thus attempted to condense the movie's narrative into a single image, while simultaneously presenting the essence of the star player (page 91). There was a direct relationship among the different kinds of cameras employed in a production: the motion picture camera, the flexible stills photographer's camera that was used on the set, and the portrait photographer's relatively stationary 8 × 10 camera. Because the central business of this image-making was to make performers look their best,[3] portrait photographers and cinematographers often traded ideas. An accomplished portrait photographer, it was generally agreed, had a lot to teach about lighting and lens.

The director King Vidor remembered filming Laurette Taylor in early 1924 in *Peg o' My Heart* for Metro. His aim was to make her look younger than her forty-two years—and on film, every line showed. "I recalled that during one of my recent pictures, no matter how dreadful the leading woman looked in any one day's rushes, the still photographs of the same day would be beautiful. Yet these photos were made with the same lighting as the motion-pictures scenes. I surmised that it must be some peculiarity of the still-camera lens, a distortion that photographed the face with more flattering results." Vidor asked his cinematographer, George Barnes, to imitate the work of the stills photographer. He also trained a small spotlight on her face: "This served to burn out some of the lines around the eyes and created a false but perfectly formed, jaw and chin shadow."[4]

A number of important cinematographers got their start as photographers. Best known is Karl Struss (1886–1993), who had a career as a pictorialist photographer before he came to Hollywood, where he made famous studies on the sets of *Ben-Hur* and *Sunrise* as well as beginning his career behind the movie camera. James Wong Howe, who had a very distinguished career as a cinematographer, recalled how he got his start:

> I thought, if I really wanted to be a photographer, I should buy a still camera and start by learning how to take regular pictures. . . . I practiced by taking pictures of all the extras and bit players. They didn't have agents in those days. Every actor and actress would have to leave pictures with the casting office to get work. I got so I could make pretty good portraits, which I would enlarge to eight by ten prints and sell for fifty cents each. I made more money that way than I did as an assistant! I almost quit being an assistant to become a portrait photographer, but Mr. Wycoff [DeMille's chief photographer] advised me to keep doing both. He said, "A portrait is like a close-up in movies. It's a very important thing to learn. All the stars, especially the women, want good close-ups. If you can make them look beautiful, they will ask for you."

Howe got his break by managing to make Mary Miles Minter's blue eyes photograph light instead of dark, by shooting her against a dark background; this was just before the widespread use of panchromatic film, in 1922. "I was on [Minter's] set one day, and I asked if I could take a few pictures. She answered yes, that she would be pleased. I took three or four portraits, which I enlarged to eleven-by-fourteen prints, and presented them to her. She said, 'Oh, Jimmy, these are very nice. Could you make me look like this in a movie?' I said, 'Why, yes.'"[5]

As her work with MGM's greatest stars attests, Louise was able to make her sitters shine, through carefully composed and printed photographs. But the fine-art aspect of the photographer's work was quickly engulfed in the huge publicity system for which the prints were produced.

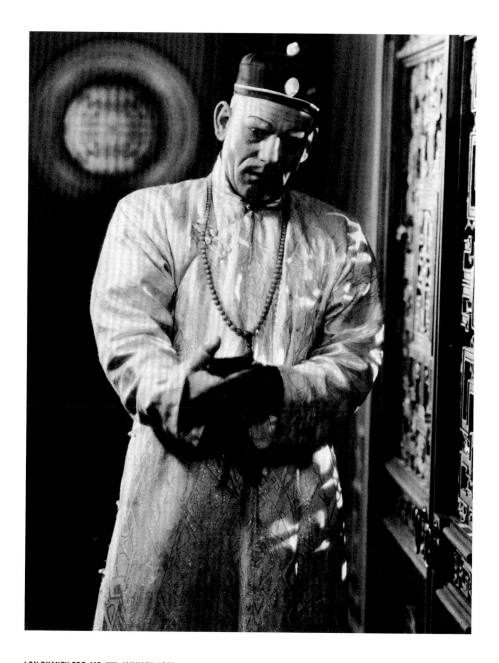

LON CHANEY FOR *MR. WU*, JANUARY 1927
Private collection

Louise made a rare foray onto the set to photograph Lon Chaney
in costume for *Mr. Wu.*

Lon Chaney TM likeness, courtesy of Chaney Entertainment.

The number, size, and kind of photographs needed for a star's publicity varied from performer to performer. Women were the most frequently photographed, and these images were the most often requested by fans. The number alone could be staggering. A 1910s photo of Mary Miles Minter humorously shows her standing beside a day's worth of photographs being mailed out to fans; she is nearly overwhelmed by the stacks of envelopes, which tower over her.[6] This volume is exaggerated—but not by much. By 1927 stars like Colleen Moore were sending out twelve thousand photographs a month, most of them admittedly small 3 × 5s.[7]

The avalanche of photographs began each morning with the arrival in Louise's studio of that day's first sitter, who might be a star or a newcomer to the lot, sent first thing to be photographed. As Hurrell explained, "It started with stills—the buildup, the exploitation, feeling out the public. . . . No matter who it was, they would have a stills session when they arrived, and from that they would make up their minds. Then they would go to the producer, whether it was Jack Warner or L. B. Mayer—you know the top man, not just the intermediary. Then, if they felt there was something there, they'd do the screen test. Most of the time the gallery would take place before the screen test."[8]

In a 1930 essay entitled "The Still Picture's Part in Motion Pictures," Fred Archer, a leading independent photographer in Hollywood and member of the American Society of Cinematographers, outlined the still photograph's role in the production and distribution of movies. His observations provide a handy template for understanding the range of images required by publicity. Everyone, he notes, understands that still photography is used to advertise a picture: "In order to have a Motion Picture in a theatre for the public to view, it is necessary to sell that production to the theatre. There has long been a saying that 'The Stills Sell the Movies.'" But, he continues, "there are equally important minor roles to be played by the still pictures before they are used for advertising purposes. . . . The main objectives of the still picture may be classified as follows: *Advertising the Production; Marketing the Production; Production Reference Work[;] and Trick Photography.*" Advertising and marketing were most important, but reference stills were also critical, with "photographs of all kinds circulat[ing] to costumes, buildings, properties and characters." During retakes, and for pictures involving special makeup, "cinematographers often have stills shot and rushed through the laboratory in order to get a confirmation of lighting, color values and other details before shooting a scene."[9] And of course, stills were used in trick photography for clouds, scenery, and art titles. Louise seldom was called on for this sort of work.

Archer then discusses the studio portrait department—just a few years old at that point—declaring that portraits have more uses than just for publicity, especially in preproduction. Before filming, when the players get their costumes, for example, "they are photographed against a plain

or otherwise suitable background in scenes from the play" (page 57); these portraits were then used for preproduction advertising, posters, and billboard layouts. Furthermore, "the artist in charge of the Portrait room creates ideas for magazine art and layouts to keep the magazines supplied with pictures which in turn keep the players and the title of the productions before the public." Of particular value were the fashion photos for "the feminine readers." Another special subcategory was seasonal art (page 25 and color plate 3): "winter and Christmas art must be made about August, Fourth of July art in March and so on." The last subcategory was "candids": carefully staged photographs of the stars at home and at play. Since Louise's day this last category has subsumed the rest.[10]

Detailed as Archer's analysis is, it leaves out one crucial function: the use of still photographs in the casting of movies and the development of an actor's career. To be sure, this activity to some extent fits into all Archer's categories, especially advertising. As a result, he omits from discussion the most ubiquitous type of portrait: the head shot, the image used by casting directors. Head shots, which formed the bulk of any portrait photographer's work and of any star's portfolio, have a special place in Hollywood mythology. They circulated everywhere, including right back into the movies. In *Woman of Affairs,* at a key moment when Garbo realizes she cannot ask John Gilbert to return to her, she gazes at a framed photograph of her rival, Dorothy Sebastian, sitting on the piano. It is a portrait photograph by Louise. And a general publicity still of John Gilbert, taken during the filming of *Flesh and the Devil,* shows him relaxing and looking at a photo album compiled by a fan, most prominent among the images being Louise's iconic portrait of him from *The Big Parade* the year before.[11] They were essential currency in the economy of stardom. As a gossip columnist in a fan magazine commented in 1919,

> Albums and autographed photos are at once the bane and the hobby of Hollywood. A bane when the tourists want 'em. A hobby when the celebs themselves are collecting. Some of the most rabid addicts of actors' signatures are other actors. No two players ever got together for a picture who didn't exchange likenesses of one another. It's an old Hollywood custom. "Just one for my dressing room, dearie." You know? Now what one star says to another is a lot different from the sentiments they ship out to you and me at a quarter a shot.[12]

Such was the self-consciousness of star photographs that they quickly became an object of parody. Madge Bellamy in 1929, for example, was photographed in the poses of an earlier generation (by a decade!), as Theda Bara and other vamps, very specifically in the style of independent portrait photographer Edwin Bower Hesser.[13] Louise even parodied herself, photographing

Marion Davies for *The Patsy* (1928), a movie in which Davies mimics other MGM stars, in the poses and costumes she used for Garbo, Mae Murray, and others.[14] Or going to the opposite extreme, a bizarre anecdote concerns the silent star Ramon Novarro. A reporter had gone to pick up some prints of the actor at Mandeville's, a photography studio on Hollywood Boulevard, when one "Peter the Hermit" came in the door crying: "Soul. God bless ye, my man, ye have shown the lad's soul. . . . The whole world will be the better for a-gazin' on it."[15] For Peter, apparently, the star's photograph had the ability to save mankind.

The photographic portrait, critical as it was to forming a star's image, quickly became the key element in many stories—both fact-based and mythic—of an actor's rise to fame. We know the legend of Veronica Lake's curl falling accidentally to the center of her forehead during a portrait session and catapulting her to stardom, and there is always Lana Turner's tight sweater. In both instances it was the interaction of the photograph with a canny publicist that set the star machinery turning.[16] But plenty of actors pointed to hard work and lucky breaks in getting anyone to pay attention to their portraits. William Bakewell, a silent-era actor, recalled: "In those days, if you wanted to break into the picture business you went to a photographer and had a lot of pictures made. You took the pictures and on the back wrote your aptitudes, and then dropped them off at the studios. Then they'd call you with a part."[17] This was the work that Louise did in her first, independent Hollywood studio, before she was hired by MGM.

Such photographs could spark the very idea of a career in movies. Eddie Quillan, a young member of his family's vaudeville team, had some photographs made of him and his brother for their act. "My mother, looking at the pictures, particularly the individual one of me, said, 'Eddie, you ought to be in pictures.' It was only then that the idea of being a movie actor came to me."[18] Mildred Harris, an actress and the wife of comedian Harold Lloyd, told a *Photoplay* reporter in 1925 that "the biggest thrill of her life had been when Viola [Dana] sent her an autographed photograph" when Harris was in high school—inspiring her to follow a similar career.[19] Even directors could be swayed by the power of a good portrait. W. S. Van Dyke recalled how thrilled he was to be invited to direct for MGM, and then horrified to realize it was to direct westerns with a new cowboy star, Tim McCoy. Howard Strickling convinced him that McCoy was worth working with by showing him the actor's file photographs.[20]

Samuel Goldwyn was a particular focus of stories about the power of the right head shot. Walter Byron, a British actor, remembers his "lucky break" with Goldwyn in 1929: told to sit for a series of still photographs in London, New York, and Hollywood, he finally met the producer for an interview in London, where "he and Mrs. Goldwyn compared me with my portraits."[21] Lois Moran, having made films in Europe, wanted to get into a Goldwyn movie: "I wrote to him

and enclosed some pictures of myself."[22] She succeeded. The story of Vilma Banky's discovery by Goldwyn, in contrast, was itself the stuff of Hollywood legend. Goldwyn, prospecting for talent in Europe, had arrived in Budapest. There he was told repeatedly about a beautiful girl, but he was too busy to respond. "He went his way, until he happened to see a girl's photograph in a shop window. 'Who is that?' he wanted to know. 'Vilma Banky,' came the answer. And then it was a different story for the American producer."[23] A fellow Hungarian was less fortunate. A human interest story written for *Motion Picture* magazine in 1929, recording the toll of sound on the fortunes of most European actors, described a handsome young man dressed neatly in a threadbare suit, looking as though he were about out of hope. He was seen at a Los Angeles post office telling the clerk in a thick Hungarian accent that the package he was mailing home to Budapest contained a portfolio of his portraits. Both the young man and the clerk knew that these photographs were as close as he would come to Hollywood success.[24]

Louise's aerie of a studio, though set well above the tumult of filming proper, was not separate from that scene. With her photographs, she made possible the first step toward movie success for many young hopefuls. Portraits were as important as screen tests in determining who would be assigned even a bit part in a movie. For the lucky few who made it, portraits would continue to be an essential career tool.

THE PUBLICITY DEPARTMENT AND THE FAN

chapter 4

LOUISE'S PHOTOGRAPHS PROVIDED A DIRECT LINK BE-
tween the fans who bought tickets to MGM's films and the fea-
tured stars. These images were disseminated through the publicity
department, to as wide and diverse an audience as the studio could
imagine. In the end, the fans were the most loyal moviegoers, and
the publicity department took great pains to serve them well. A
Louise photograph in the hands of a devoted fan might become a
fantasy object, to be studied and manipulated lavishly and copi-
ously. Of course, the photographs most fans received in the mail
were humble versions of Louise's originals, but that made little
difference. The mere shadow of the star within the image was po-
tent enough.

The studios unceasingly advertised and marketed new films.
In the 1920s, such advertisements were largely in print, and they
permeated every possible publication. Nor was marketing limited
to specific movies. The studios placed stories about directors, cam-
eramen, editors, writers, and every other conceivable aspect of
moviemaking and life in Hollywood. In mid-1928, in fact, Holly-

wood ran second only to New York as the most written about place in America: a town of 250,000 rivaling a city of some seven million![1] The majority of this print output concerned the stars.

The alliance between publicity and the movies was fundamental. One of the first and most famous promoters at the beginning of the century, Harry Reichenbach, reflected on a lifetime of "ballyhoo" in the movie industry:

> The magic of advertising and publicity transformed [the industry] overnight from little store shows with hand-cranked cameras and tumble-down camp stools into the richest temples of pleasure in the world. From hand-painted oil-cloth signs and cheap circulars, its network of publicity spread to newspapers, magazines, sky-writing, posters, electric displays, stunts and freak methods never before used by any other industry. And while the picture business primarily owes its phenomenal growth and progress to publicity, publicity developed into a powerful business instrument largely through this industry.[2]

Both the mechanism of stardom and the use of photography to enhance it can be traced back to the theater and vaudeville, which provided a familiar and useful template to follow. Yet even though little was actually invented by the movie industry, it did create, virtually overnight, a publicity machine of unprecedented scale.[3] Reichenbach gives as one example of the power of publicity to create a public image his campaign on behalf of Gail Kane: "I had Miss Kane pose for every photographer who could focus a lens and ordered hundreds of dollars' worth of highly colored gelatin enlargements and cheap oil paintings. I distributed thousands of souvenir powder puffs with Miss Kane's picture on them."[4]

MGM had the most efficient and (eventually) the largest publicity department of any studio. At the beginning, during the 1924 merger, Mayer was faced with three publicity chiefs, but that situation soon changed. Howard Strickling, head of publicity at Metro, quickly left to join the director Rex Ingram (who had been with Metro but was now working independently). Charles Condon, who had run publicity for Mayer's own outfit, was evidently well enough known to Mayer not to be considered for the bigger job. Joe Jackson at Goldwyn, the studio that was then working on *Ben-Hur,* was the obvious choice, but he, too, left in relatively short order. The job was then offered to Pete Smith, an independent publicist. After some negotiation Smith took the job, and a few months later Howard Strickling rejoined the team as his chief assistant.[5]

With these two at the helm, MGM methodically began to build its publicity apparatus (always, it should be pointed out, in harness with MGM's East Coast offices and the parent corporation, Loew's). The scale and complexity of the operation were immense, as can be determined

by statistics recorded in the 1929 *Film Daily Yearbook*, which included fourteen separate modes for publicity campaigns, pertaining variably to different genres. For movies described as "Sex Dramas and Romance," for example, nine publicity vehicles are identified: newspapers, lobbies, theater fronts, ballyhoos, tie-ups, window displays, printed matter, special stunts, and special showings. Of these, seven involved reproduced images. In one subcategory of "printed matter," the department presents its salesmen with "a fine novelty herald for any picture featuring kissing scenes." On the cover appears the caption "The Kiss Technique," followed by catch-lines such as "Do you know how to kiss?" "Do you enjoy a good kiss?" and "This folder contains some pointers on the Art of Kissing." Inside are those "pointers," consisting of stills of three or four kissing scenes from the picture being promoted. Alternatively, the salesman might distribute cards with a kiss imprinted on them in red, with the phrase "A kiss from [name of star]."[6] This list did not, however, include all the fashion photographs, seasonal art, trick and stunt photographs, and candid shots that were also distributed, unconnected to particular productions but requested by magazines or flogged to them. Louise's portraits might appear in any of these venues, and often did; they were ubiquitous, showing up on everything from postcards to billboards.

Coming to the theaters almost religiously, week after week, to see their favorites, the fans were the keystone of the movie audience. They were also the primary audience for the countless magazine stories about stars and photographs that filled the empty times between new productions. Mayer's brilliance lay in his fundamental understanding of the fans and his creation of an efficient and powerful publicity machine to seduce and service them. (This was one reason why having Hearst on his team was so critical.) MGM calculated, like no other studio before, the precise amount of publicity required to keep fans satisfied. Photographs of its stars circulated to every conceivable life-style magazine, the prize being a prominent place on the cover. Even large-circulation magazines such as *True Story* and *True Romances* that rarely carried features about Hollywood could still be counted on to adorn their covers with current favorites, most often women (see color plate 6).

The most important tools for the promotion of movies and stars by the mid-1920s were the fan magazines, which had some of the largest circulations of the period. Fan magazines targeted female audiences, following the conventional wisdom that women were the primary moviegoers.[7] As film author L'Estrange Fawcett noted in 1927, "The average film is made for women to enjoy."[8] In truth, they more than enjoyed them: they consumed them entirely. A young woman wrote to *Photoplay* in 1929: "The movies taught me how to dress, how to act and how to be popular. I always wondered why I couldn't be popular and why I wasn't pretty. Then it came into my head to watch the stars."[9] Although such comments worried some observers, they thrilled the in-

dustry. The nature of fan response was analyzed frequently, both in the fan magazines themselves and in scientific studies that attempted to gauge the depth and nature of what some perceived to be debilitating the morality of America's youth. Using these sources, published letters, and surviving fan albums, we can gauge the depth and variety of the interactions between fan and star—at the center of which, of course, lay the photograph.

The studios received some 32,250,000 fan letters annually, and most of these asked for photographs. The biggest, most popular stars sent out some ten thousand photographs a month to their fans. At about six cents a letter, these responses ended up costing some $2 million a year.[10] In addition, many fans connected to form fan clubs. *Screen Secrets,* one of the major fan magazines, had a fan club department for this very purpose. Marie Leslie, head of the Norma Talmadge Correspondence Club (with annual dues of 50 cents), declared frankly: "The club's main attraction is its photo exchange—anyone who sends in photos of Norma will be sent in exchange photos of any other player. They exchange magazines and newspaper pictures, besides post-card size, five by seven and eight by ten regular photographs—or, in fact, all kinds of photos and pictures."[11]

Fan magazines were the major venue for star photographs. They ranged in format and scale of distribution from magazines produced for local or regional theater chains; to newssheets like *Loew's Weekly,* which consisted of several illustrated pages and was distributed nationally in theaters; to the major fan magazines, thick, large-circulation publications brimming with features and hundreds of photographs. During the 1920s they were also a reasonably accurate source of news about both Hollywood business and the activities of its personalities. The most prominent fan magazine was *Photoplay,* which was first published in 1912. Its format was enlarged in October 1917 specifically to accommodate reproduced 8 × 10 photographs of the stars. At first most of the photos were uncredited, but by the early 1920s photographers' names started to appear. As the portrait photograph moved to center stage in the fan magazine, photographers demanded recognition.

Photographs were used by the fan magazines in various ways. Virtually every magazine had a special section toward the front with full-page portraits, often printed in sepia or blue to make them more distinctive. Sometimes these images were printed on heavier paper, to enhance their quality. Photographs were also used to illustrate articles and, especially by the mid-1920s, to endorse products. Requesting photos from the studio and collecting fan magazines were but two of the many ways fans could acquire images of favorites. Ephemera produced by the movie studios in the form of programs, lobby cards, and posters circulated everywhere. Moreover, fans could find images on "tie-ins" like sheet music, as well as on promotions such as cigarette cards and spoons. Sometimes the interchange between products—star and commodity—became indivisible. In

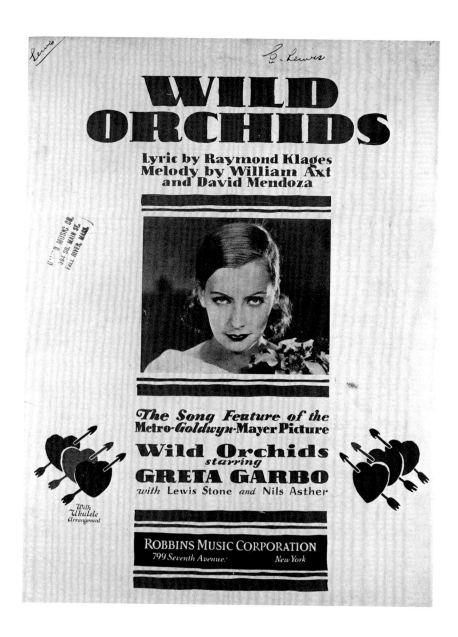

GRETA GARBO ON COVER OF "WILD ORCHIDS" SHEET MUSIC

Private collection

Starting in the silent era, Hollywood commissioned theme songs like "Wild Orchids" for films. The song may have been played before the film began, and the sheet music featured a Louise portrait of Garbo (see page 38).

the early teens, for example, a minor star, Muriel Ostriche, was named "the Moxie girl" after a soft drink, and her image became firmly associated with the product, ultimately appearing on handheld fans, baseball cards, and china dinnerware.[12]

All fan magazines offered fans the chance to collect the small photocards that became the common currency of collecting and trading. *Picturegoer,* a British fan magazine, invited its readers to "Join the Picturegoer Postcard Club," and as a premium one would receive a "large 1 [shilling] portrait free." The offer in February 1929 was a portrait of Garbo by Louise, a 9½-by-7-inch black-and-white glossy on heavy card. Thrown in free was a 5-shilling postcard album capable of holding three hundred cards. Also offered were sepia cards for 3 pence each, 2 shillings 6 pence a dozen.[13] By way of comparison, on this side of the Atlantic *Motion Picture* magazine in October 1929 offered a set of twenty-four "sepia-finish pictures of popular players (set no. 6), size 5½ by 8 inches, suitable for framing or for your album" for $1.[14]

The photographs themselves were collected and prominently displayed, or placed in albums. In 1916, the archetypal movie fan was described in *Motion Picture,* somewhat hyperbolically, as having on "the walls of her room . . . in the vicinity of 450 or 500" pictures of movie stars.[15] The May 1927 *Motion Picture Art Portfolio* advertised "gorgeous enlargements in two sizes—11 × 14 inches and 16 × 20 inches," which could be had in three styles: black and white, sepia toned, or hand colored. "These mammoth enlargements are real photographs and their size makes them elaborate and beautiful art works especially suited for framing."[16] Fans could hang them on the wall or put them on a dresser or mantelpiece along with family photographs. A subscription to *Screenland* or *Motion Picture* brought the star of one's choice in a nice metal or leatherette frame for display on the dresser.

Fans were not invited merely to collect and display the photographs. Additionally, they were encouraged to imaginatively reinterpret and manipulate the images published in the magazines. The process of looking at stars' photographs, for the most devoted followers, was highly interactive and creative. Sometimes, for example, the magazines published distorted photographs or collages that combined different elements of multiple faces, and the reader had to guess who was who. More frequently, fans were invited to cut up the pictures in the magazines and recombine them in artistic ways. All the major fan magazines featured "Cut Picture Puzzles," accompanied by prizes. In January 1926 *Photoplay* published the winning results of one exercise in decoupage; these included chests covered in photographs, elaborate wall decorations, and fanciful scrapbooks.

The development of this vivid material culture reflects the intensity with which fans responded to the movies. The young woman who declared that the "movies taught me how to dress, how to act," described the process in some detail:

One night I saw Bebe Daniels wearing a dress I liked, so I made one just like it. It improved my looks, because it was just my type. Then I began to act like I felt. I always felt full of pep, but I was afraid that if I acted that way people would laugh. I went to see Lupe Velez in a picture, and tried to act like her. I succeeded. Now I dress well, am seemingly well-liked and seem to be very popular with both sexes. Now that the talkies are here I intend to study the way the stars talk, and if there are any improvements to make on my voice you can believe they will be made.[17]

Fans even imagined that the relationship was reciprocal: that their adulation made a difference, that they in a sense "owned" the stars. Harrison Rhodes, a reporter writing about the state of America, declared in his essay "High Kingdom of the Movies" that "a good day will bring in the morning post to a really beloved movie actress as many as eighteen hundred and sixty-seven letters from unknown remote worshippers." He then added (somewhat unbelievably, since the box office seems a more reliable guide) that the letters were then analyzed so that "the 'appeal' of each star is reduced to figures, and the results guide the future choice of plays."[18] The fan magazines promoted this idea assiduously. A 1928 article in *Photoplay*, "What Happens to Fan Mail?" explained: "The stars find constructive criticism and real encouragement in their mail order applause."[19] Mary Brian at Paramount, the article reported, was plucked from Beery-Hatton comedies and promoted to feature player when it was realized that she was getting almost as much mail as Bebe Daniels, an established star. In April 1928, the top recipients of fan mail were Clara Bow, with 33,727 letters, and Billie Dove, with 31,128, followed by Buddy Rogers with 19,618. At MGM, Anita Page, without a picture to her name but an extensive advance campaign, even received fan mail. John Gilbert headed the list of fan mail recipients, with about 6,000 letters a month, closely followed by Marion Davies, Norma Shearer, and Ramon Novarro.[20] (However, at 8,000 letters a month, Warner Brothers star Rin-Tin-Tin had more devoted fans than any human star at MGM.) Women accounted for three-quarters of the fan letters, while 90 percent of the correspondents were writing to request photographs or to acknowledge photographs received. Each magazine had its own fan letter department as well, to handle queries about stars. *Photoplay*'s was entitled "Brickbats and Bouquets, letters from Photoplay readers." One fan certainly believed in the reality of the fan's relationship to the stars: "I have written to a great many of the stars and have found most of them very kind in replying and sending photographs. I think they appreciate sincere criticism or praise from their fans."[21]

The activity of fandom has been interpreted by some historians as a way for women to escape traditional roles and explore new identities.[22] Certainly, women were the busiest writers, judg-

ing by the correspondence published in fan magazines. They also participated more enthusiastically in the magazines' "Cut Picture Puzzle" and similar contests. Of the fifty-five contest winners listed in the January 1924 *Photoplay,* for example, thirty-three were women and thirteen were men (the gender of the remaining nine cannot be determined from their names). Two years later, a more selective winners' circle was made up of four women and one man.[23]

The studios did address male fans occasionally. Accordingly, the "Gifts from the Star to *Screenland* Readers" in 1925, which asked, "Would you like to have something your favorite star has worn?" was aimed at young men—college boys, or "in some village of the North country a movie fan in a storm-assailed cabin."[24] But the stars' appeal might cross gender lines. One fan named Albert wrote to *Screenland* in 1929: "I am an enthusiastic collector of stars' photographs and would like to tell all SCREENLAND readers about the splendid pictures I have received from my favorites. Did you notice David Rollins, the handsome youth in 'The Air Circus'? He sent me a nice, large photograph on which he wrote, 'To Albert—I hope I can be all you expect of me. —Always, David Rollins.' I predict a wonderful and bright future for him. Mary Pickford sent me the most beautiful picture of herself in a white fur coat."[25] Albert's infatuation with Rollins's looks and Pickford's clothes pales beside the act of homage MGM recorded of a female impersonator transforming himself into Garbo, circa 1927 (the costume he wears is from *The Temptress*).[26] The young man is first depicted in profile holding a portrait of Garbo. In a sequence of photographs we then see the metamorphosis until, finally, he assumes the Garbo pose, with all its drama and languor. These images are amazing on two counts: first, because they were adopted by MGM publicity at all, but also because their adoption came so quickly: *The Temptress* was only Garbo's second American movie. But by then, she was already a star.

Among Norma Shearer's papers is a scrapbook that reveals the reaches of fan devotion even more completely.[27] Sent to the actress by an adoring fan in the early 1930s, the scrapbook is dedicated "to my friend Norma Shearer with sincere regards." It begins with a poetic paean entitled "Things to Remember": "The sea's sault [*sic*] spray on your lashes, / The sea's salt spray on your lips, / These are things to remember—when you / Are far from the sea and ships!" Then follow fashion shots, photographs, and poems. The fan describes the horror felt upon witnessing, in a movie, Norma falling off a horse; there follows a vivid account of the anticipation felt with every forthcoming movie. Then, at the very end, is a horoscope, cast for Shearer's birthday. Although at first glance the album appears to be anonymous, on lifting up the horoscope the fan's identity is revealed—"Born April 21, 1904, Live Oak, Fla., your greatest admirer, Jacqueline Prescott"— along with two photographs. While claiming, because they share the same birthday (though she is a couple of years younger), to feel like a little sister to Shearer, this fan clearly identifies com-

pletely with the star—so completely that she is compelled to hide her identity even as she reveals it, in an attempt to breach the wall between her and the star.

For such a fan, the movies were not an end in themselves. Rather, a whole environment of adoration was created, sustained by a huge output of photographic images. Indeed, given the quantity of advertising, we may understand the movies almost as a vehicle for the real product: stardom first, then the packaging (cosmetics, clothes, furniture) into which a star's image could be inserted. By the mid-1920s, making movies was about marketing stars' life-styles. And, sometimes, enabling fans to live them.

SELLING FASHION AND GLAMOUR

chapter 5

LOUISE HAD A PERSONAL INTEREST IN FASHION, WEARING distinctive clothes that she sometimes designed herself.[1] In her photographs as well, Louise was strongly drawn to texture and design, especially in fabric; this was a feature not just of the costumes her subjects wore, but also of the backgrounds and props she used. Louise was also photographing for an industry that was deeply invested in selling a dream, the most tangible manifestation of which for many was clothing. The glamorous persona of some stars was defined by fashion, and in fact fashion was the lubricant for many a movie plot. Louise understood the critical importance of fashion and its display, and worked with designers and subjects to the best advantage of both. Louise's contribution to fashion photography— like Hollywood's contribution to fashion itself— cannot be ignored.

In marketing the star, the studios understood that the real connection between performer and audience occurred when the fan took on, in the dream space of the movie theater, the star's intangible qualities of personality and style. But the movie industry— the studios, the fan magazines, and the many other businesses that

surrounded the production of movies—also understood there was profit in selling real products that could be linked to the star. By engulfing fans with images of the star, the industry sought to encourage active consumption of all products associated with that star. Indeed, not only the lifestyle of the star but also the spaces in which that life was led could be seen as objects for imitation or possession. The art of product placement, while nowadays a high art, is not a recent invention; rather, it was foundational to the very notion of stardom.[2]

Because the studios sold primarily to women, the products that came to be associated with the female star were largely domestic—ranging from intimate cosmetics or lingerie, for example, to functional household objects, to more subtle aspects of style and taste. As one fan from Pennsylvania, Kathryn Beam, wrote to *Photoplay* in 1928: "We read so many bouquets about screen personalities and some of us try to observe our type and imitate it. I should like to give a bouquet to those who plan the settings of the pictures, because these trained decorators are helping us to develop our own personalities and are influencing us in giving our homes personality and charm."[3] The first films generally credited with awakening such imitative desires were DeMille's in the early 1920s: "For a long time Cecil DeMille's ideas of furnishings and settings used in his pictures, dominated the salons and boudoirs of every well-to-do home."[4] By 1923, *Photoplay* was running articles on interior decorating based on ideas from the movies,[5] with topics ranging from individual items of furniture to ambitious remodeling projects.[6] *Photoplay* also offered a shopping service that included an "Interior Decorating Department": "Let the screen make your home a better place to live in."[7] But this phenomenon proved to be short-lived. Instead, the most enduring product the movies promoted was the obvious one: fashion.

The modern woman, the flapper, was identified with her clothes.[8] Just as DeMille was usually credited with inventing the taste for luxurious interiors, he was also credited with inventing the first star whose glory was her fashionable dress, Gloria Swanson.[9] Although other stars before her were noted for their clothes, Swanson was strictly modern. Swanson remembered the moment she became a fashion plate, when Jesse Lasky, her producer, explained why her recent movie, *Under the Lash,* had failed: "'Because women didn't go to it,' [Lasky] said. 'And women didn't go because you wore dull, gray, buttoned-up, housedresses through most of it. Women refuse to accept you in homely clothes. . . . Never look drab again, because the public won't stand for it.'"[10] The screenwriter Frances Marion explained the change like this: "Whether it was the aftermath of the war, the fact that women could now vote, the effect of bathtub gin, or the insidious propaganda of the Gloria Swanson movies, when the Fabulous Twenties burst upon us, fashion held the reins in the feminine world. With the vote came hair-clipping."[11] Another writer, discussing glamour in Hollywood movies, declared that the best way to emulate your favorite star was to dress like

her: "the imitative fan is almost always feminine."[12] From the earliest days of film, fashion was essential, sometimes so much so that it became the movie's subject, disrupting the story and garnering all the attention.[13]

One of the triumphs of Mayer's 1924 trip to Europe in search of fresh talent was his success in luring the designer Erté to MGM. Erté's genius was revealed to the Hollywood community on April 13, 1925, when his fashions were paraded at a charity show organized by the Council of Jewish Women. Among the models were Norma Shearer, Aileen Pringle, and Carmel Myers.[14] Erté designed special costumes for a number of prestigious films, including the troubled *Ben-Hur*. The chariot race scene, filmed that October, features one of his most extravagant costumes, created for Carmel Myers (page 9). Caparisoned in the most extraordinary gown and headdress, she capers and mimes with true delight for Louise's camera—making it clear why she was Erté's favorite model in Hollywood. The dress is a triumph: her cloak is lined in leopard skin and covered with sequined carnival masks, while a peacock of silver nubbins displays itself against her sequined breastplate; the headdress is virtually indescribable. In these photographs Myers's own personality emerges: her enjoyment of the situation and her slight incredulity at the surreal costume. This harmony of the person, the pose, and the accessories constitutes the hallmark of Louise's work. Although they have little to do with the real world of fashion, they certainly proclaim MGM as the leader in style.

Erté's importance to the studio can be seen in the way the films he designed were advertised. Order forms sent to theater operators by regional MGM salesmen give the title of the picture along with a listing of star, director, and, sometimes, author. For the 1925–26 season, however, the films *Paris* and *Monte Carlo* accord top billing to Erté. Something significant had changed in the marketing of the movies: now the sets and costumes could be the main draw. Mayer wanted Erté to recreate Paris on screen—or rather, the Paris that was the center of glamour and fashion. This relationship between "Rue de la Paix and Hollywood Boulevard" underlay a profound revolution in American manners and culture.[15] Although at the start of the 1920s Paris was the undisputed fashion capital, by the end of the decade, for most Americans, that was no longer the case.[16] As a 1929 article in *Photoplay* asserted in its title: "Your clothes come from Hollywood: How the creations you see on the screen influence you more directly than Paris fashions." Even more: "Hollywood is the broadcasting agency for fashion! Hollywood creates the modes of the world! You are wearing photographic clothes!" The author identified the creation of "fads" and fashion with the "defects in the stars' figures," as though fashions were generated out of the star's own body: "Because Greta Garbo has a long neck, Max Ree put a ruff on her collar in *The Torrent*. The wide Garbo collar was evolved from this and it is a world-wide fashion." Hollywood fashion became

ineluctably tied to the physical qualities of the star. The development of the modern, elegantly dressed star, the article also asserts, was a conscious decision by Hollywood designers to erase the image of the vamp; they wanted clothes to have some relevance to the larger world of fashion. At the same time, the article gives several examples of clothes that fit a character's "suppressed desire," noting the designers' consciousness of Freudian symbols. In the end, modern sexuality was the keynote of Hollywood design, lodged in the clothes Hollywood stars wore both on screen and off.[17]

A number of Hollywood designers now began to be recognized by name: Max Ree, Peggy Hamilton (who dressed Swanson), Howard Greer, Sophie Wachner, and, most successfully, Adrian. By 1929 Adrian was not only chief designer for MGM but also the fashion editor for *Screenland* magazine. While it is unlikely that he wrote his articles himself, they do offer practical advice for the consumer (the fan) in her attempt to emulate Hollywood fashion. In an article on Bessie Love's style, for example, he warns the reader: "Women in Hollywood are continually thinking photographically and not from the standpoint of smartness, even off the screen. What is too beautiful with a battery of backlights is too silly at a smart night club. Keep your picture frame personality for your picture frame and never drag it into the tea dance."[18]

The studios and fan magazines worked hard to connect the fan to Hollywood fashion. Beginning in April 1925 *Photoplay*'s shopping service introduced a fashion department, associated with its monthly fashion feature: "Hitch your wardrobe to a star—Let *Photoplay* help you shop." During the summer it offered: "Cool things for summer suggested by the Santa Monica Beach Club." And in November: "The screen suggests your fall wardrobe."[19] An advertisement for Printz-Biederman coats, a Cleveland company, put it plainly: "Almost every woman thinks to herself, 'If only I could have clothes like that,' when her favorite star strolls across the screen. For motion picture actresses are among the smart women of today."[20] Joan Crawford's oft-repeated emphasis on the vigilance required to maintain her glamorous appearance in public (in contrast to the laconic chic of someone like Katharine Hepburn) marks her completely as a star formed in the 1920s, not the 1930s.[21] If, later, "authenticity" became one of the signs of stardom, in the 1920s stardom had entirely to do with surface, a surface created through fashion.

Some stars seemed almost entirely identified with their wardrobes. When Carmel Myers was in Italy filming *Ben-Hur,* so far as the newspapers and fan magazines were concerned, she spent most of her time looking at the latest European fashions. The blonde wig Myers wears in her first scenes in the movie, for example, was said to be the result of a shopping expedition to Vienna. Upon her return to the United States, press photographers captured her in Paris gowns designed by leading couturiers such as Callot.[22] As late as January 1929, Marion Davies was the subject

of a two-page spread in *Photoplay,* "Clothes That Speak French": "Some Paris costumes show the excellent taste of Marion Davies' personal wardrobe." The Paris designers Jenny, Lelong, Callot, and others were featured with a range of outfits ranging from lounging pajamas to evening gowns; virtually all were photographed against backgrounds of bold abstract designs, signifying modernity and European chic. The next month, however, *Photoplay*'s monthly fashion feature was entitled "Costumes with the Dramatic Instinct—Hollywood challenges Paris to create a more interesting collection of gowns." Spotlighted were gowns by Adrian and Howard Greer, photographed against neutral backgrounds but modeled by Joan Crawford, who runs through her dramatic paces for the camera, scowling, vamping, laughing. From now on, clothes advertised will be positioned on the personalities of American actresses, in contrast to the "character" of Paris.

This shift occurred thanks to the use of photography. When *Photoplay* first introduced its "Fashion Review of the Month" in January 1924 with the article "Screen Inspired Readymades" by Grace Corson, the illustrations were not photos but drawings.[23] The first photograph to appear in this series, in July 1925, featured Lillian Gish—a heavyweight star.[24] By September the monthly fashion feature relied exclusively on photographs. Not coincidentally, this change occurred just as Louise's first photographs became available to the magazines.

This is not to suggest that Hollywood was the first to use this sort of photography. *Vanity Fair,* at precisely the same moment, was running occasional fashion photographs, such as a full page devoted to stage actress Katherine Alexander, then starring in the play *It All Depends,* wearing a coat from Bergdorf-Goodman and photographed by Alfred Cheney Johnston.[25] Alexander stands gracefully in front of a white flat, caught full length and turned toward the camera—an image virtually identical in composition and use to fashion photographs becoming current in Hollywood. The appearance of a star actress in an advertisement photographed by a prominent portrait artist underscores the interconnectedness of celebrity, fashion, and commerce. If *Vanity Fair,* with its sophisticated readership, could merge these worlds, plebeian Hollywood could do so even more aggressively. Hollywood, after all, had an efficient promotional apparatus in place and a ready supply of actresses who could sell products. Moreover, Hollywood had a huge national audience. What was a trickle in New York became a flood in Los Angeles.

The use of the actresses (stars, whenever possible) was fundamental. Even Lillian Gish was not immune from having to engage in fashion work—which makes Garbo's ability to avoid it a year after her MGM debut especially remarkable.[26] When Garbo refused to model, scene stills from her movies were used instead. In 1929, for example, stills from *The Single Standard* were inserted in a fashion commentary on pants for women.[27] Norma Shearer, one of Hollywood's leading dramatic actresses, periodically was obliged to model fashions as well. Shearer may have

enjoyed features showing her shopping for beautiful clothes; however, she was probably less enthusiastic modeling hats knitted for her by fans.[28]

The movie magazines and local newspapers were full of advertisements featuring actresses wearing the latest fashions. For local businesses, particularly department stores, this close connection to the studios was enormously beneficial.[29] Occasionally, fashion shots found multiple uses, as a sequence by Louise of Joan Crawford modeling a fur-collared coat suggests. In one she is photographed standing and turning; in the other she is seated (pages 30 and 31). In both, the main interest in the image is the coat: that is what she is selling. But the seated pose emphasizes her legs—and her feet. So it is amusing to find one print in which shoes from another model have been carefully pasted onto the original photograph: the coat advertisement has become a shoe advertisement!

At MGM, the burden for producing images to feed the fashion industry fell on Louise. In part, this was likely due to generic expectations that as a woman she would be more sensitive to fashion issues. In fact, Louise was interested in fashion. In her first statement of artistic philosophy, as we have seen, she compared the fashions carried by her local stores to those of the premier French designer Poiret. Louise may have inherited her fashion consciousness from her mother, who apparently sewed beautifully without needing a pattern. Once she made a suit for her daughter out of a lavender and green horse blanket, which Louise wore proudly to the studio.[30]

Portraits made of Louise underscore her interest in design and fabric. In the photograph by Bull (see frontispiece), the outfit she wears to photograph Crawford is as fashionable as the star's. In other photographs she wears boldly patterned fabrics. In one self-portrait (page 13), both the textures and the tonal values of her costume are carefully calculated. The white felt hat radiates light in contrast to the wool coat, while the braid of metal around her throat sparkles; the hint of her black dress marks the bottom of an inverted wedge of darkness leading up to her lips, eyes, and hair. Texturally, the relative hardness of the hat contrasts to the feathers that curve around the back of her neck; these in turn merge into the coat, which contrasts with the lace dress. This use of differing texture, shape, and value is a constant theme in Louise's work.

Throughout her oeuvre we see a shifting balance between an interest in fashion and a desire to record the personality of the sitter. Louise's use of clothing, both the style and the way it is photographed, was sometimes determined by the disposition of the actress. One of Louise's last MGM portrait sessions, in December 1929, was with Vilma Banky, among the screen's most beautiful and exotic blondes (page 12). Here she uses similar effects as in her self-portrait, though more subtly rendered. Swathed in white fur, with large glittering baubles at her ears, Banky is a study in melodious white. Against this sensation of softness, however, Louise has created tension

by posing the actress's hands touching her neck, thus reinforcing the turn of her body. The strong diagonal of her left arm in particular creates a strong geometry that enlivens the composition.

Louise's interest in design and texture led her to explore contemporary art and to incorporate "modernism" into her images, as revealed by two photographs, one of Norma Shearer (see page 141), the second of her with Joan Crawford (see frontispiece). Abstract art—cubism, Orphism, futurism, and so on—had been introduced into American culture by and large through the Armory Show of 1913 (held in New York, Chicago, and Boston); there, the works of artists such as Picasso, Delaunay, and Kandinsky opened a new world to cultured Americans. Reproductions of these artists' works in art periodicals (and the occasional newspaper) soon reached an even broader audience. But abstract modernism did not truly enter the mainstream of American life until it was assimilated into fashion photography.[31] This occurred around 1925, in large measure owing to the International Exhibition of "Arts Decoratifs" held in Paris that year. This display of fashion and interiors consolidated the interest in modernist motifs that are the hallmark of art deco style. By 1928, such motifs had become commonplace in photography. As Frank Crowninshield, editor of *Vanity Fair,* remarked that year: "More and more the American photographs are being touched by so-called Modernism . . . more and more they are yielding to the beauty of cubes; to sharply oppressed effects of shadow and light; to the Picasso-like quality which everywhere we see reflected in the life about us."[32]

Most of the modernist design elements employed by fashion photographers, in both fabrics and settings, were "cubistic," but it was common to mix and match—futurism against cubist, Orphist against kitsch.[33] A generalized sense of the modern was fair play for the fashion world. Modernism and fashion were, moreover, intimately connected, as can be seen in a *Vanity Fair* cartoon parody of Brancusi, "Styles in Spring Sculpture"—with pieces rendered as though they were a line of spring fashions.[34] Just how quickly the modernist idiom was accepted may be judged by this offhand remark of photographer Russell Ball: "Often women who might be called plain, or even ugly, can stand a sort of violent, modernistic background. They cannot achieve a beautiful effect, but they may achieve a fascinating and distinctive one."[35] His comment also underscores the fundamental relationship between modernism and ideas of female beauty.

According to historian Elizabeth Wilson, "Fashion . . . is essential to the world of modernity, the world of spectacle and mass communication. . . . Fashion is modernist irony."[36] The photographer Cecil Beaton, reflecting in 1954 on the fashions of the first half of the century, comments that the first really modern figure in fashion was the dancer Irene Castle: "Mrs. Castle was as important an embodiment of the 'modern,' in the social and fashion sense, as these artists [Picasso and Stravinsky] were in the world of art." Her modernity lay in her simple, light clothing

and cropped hair, and in the very way she moved. She combined a sense of "exquisite grace with an extraordinarily boyish youthfulness," marked by not only the bluntness of her gestures and their straight lines, but also her long, striding walk, "with the pelvis thrust forward and the body leaning backwards" and her shoulders rising with her stride.[37] Beaton saw the same physical characteristics in Chanel and her models, and finally in Garbo, the culmination of the new modern woman. To female spectators of the 1920s, Garbo was a model to emulate, a fusion of film and fashion who moved and inhabited her body in an utterly new way.

The influence of this modernist idiom can clearly be seen in Edward Steichen and Baron de Meyer's fashion photographs by 1928.[38] In Louise's work it is even more pervasive, and enjoys the benefit of her personal interests in fashion and her access to resources beyond anything available to the editors of *Vanity Fair* or other East Coast fashion magazines. Indeed, Louise made such high fashion available to the masses.

Louise utilized both senses of modernism—its visual vocabulary and its signal of female physical freedom—in her sessions with MGM starlets. We can see her version of modernism at play in the sets as well as the poses of her sitters. When she had the chance for a lengthy sitting (thirty to forty images), Louise would take the opportunity to develop mini-narratives: as in a session recording Dorothy Sebastian as a naughty Parisienne (opposite). Here Louise poses the actress in front of a simple background (to allow reproduction in newspapers), then encourages her to act out the character. In one of the first shots (page 24), she is photographed in full length wearing a stylish outfit. Her pose, with arms crossed against her chest, is a trifle odd—until one realizes that she is nude from the waist up. A profile pose is less daring—she is fully dressed—but every gesture is pushed just a little more than is normal. The hands are tighter, as are the shoulders; every element is tense. In the third shot from the sequence, Sebastian is seated and a jagged shadow falls behind her. She exaggerates surprise or alarm, to render the situation harmless. In this photograph, Louise is relying on a classic element of German expressionist design, the angular shadows of *The Cabinet of Dr. Caligari*, well enough known by now to be appropriated. The point, however, is to provide a contrast to the spotlit face and torso of Sebastian and the black corset. The stockings and lace slip further emphasize the corset's centrality, as do the white dots that embroider the edges. Compositional devices that signify the modernity of Paris or Berlin make Sebastian seem all the more exotic and alluring.

In one of many publicity photographs taken of Anita Page in 1928, the year she was being promoted as an upcoming a star, she too is depicted as a young modern (page 26). Active and athletic, she preens in her short skirt in front of a net. Her dress is decorated with an accelerating pattern of dots that zoom up to her head; the fabric provides a startling contrast to the geometries

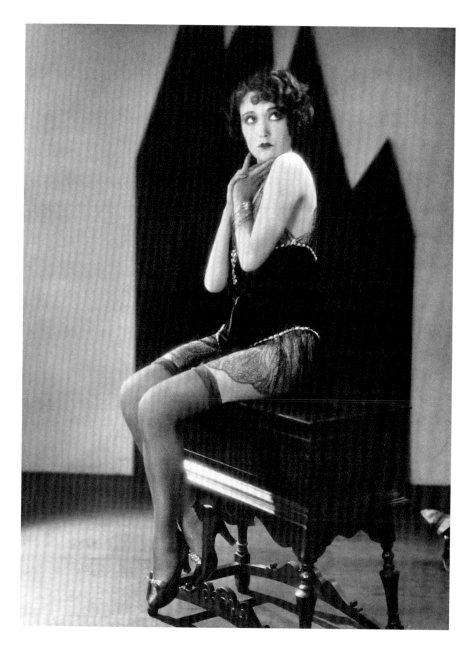

DOROTHY SEBASTIAN
FOR *THE DEMI-BRIDE*, OCTOBER 1927
Santa Barbara Museum of Art, gift of Sid and Diana Avery Trust
Here Louise exploits dramatic shadows in a seriocomic homage
to German expressionist cinema.

of the rosettes on her shoes and the patterns of the net, and to the bolster lying on the ground. The overall effect is almost surreal, a group of disparate patterns organized "tongue-in-cheek" to suit the vivacious personalities of both actress and photographer. The many photographs of starlets wearing clown and harlequin outfits lead to similarly surreal moments, as in the study of Bessie Love opposite.

Exoticism is another element fundamental to the development of modernism, with Picasso's interest in African art the most prominent example. Hollywood's interest in exoticism is perhaps best recorded in the photographs of Anna May Wong, Louise's most consistently fantastic subject.[39] Many portraits present Wong as a delicately erotic subject, bashfully exposed in a manner common in "orientalist" depictions of women. But the image Louise selected for exhibition (page 118) shows a forceful Wong in silver and black, with a bold necklace around her neck and long-nailed fingers brushing against her breast.[40]

All the more striking, in an opposite manner, are Louise's photographs of Nina Mae McKinney for *Hallelujah*, the only all-black film made by a major Hollywood studio in the 1920s. In the fan magazines, discussion of McKinney was patronizingly racist. One journalist called her a "jungle Lorelei," while the color of her skin ("tawny," "not black, she's coppery") allowed writers to imagine a rampant sexuality not permitted a white woman: "Shake that thing! Do it, do it! Come on an' show your sex attraction!"[41] But when McKinney poses for Louise, she is seated on a stool, looking happily at the camera (page 23). There is nothing provocative about either the actress or her pose. In another image from the session, a close-up, her face glistens with tears. For McKinney, Louise concentrates not on her exoticism and sexuality but rather on her humanity and vulnerability.

This range of her photographs reveals some of the processes by which Louise made her own decisions about fashion. While a great deal of her work was controlled by explicit advertising needs (as when the gowns of a specific production had to be photographed), much of what she did was pure fantasy. Louise was required to generate much more material than was called for by particular productions or commercial contracts with stores, and for that material she could call on the costume department of MGM, invent juxtapositions, and produce her own vision of the fashionable woman.

Ultimately, Hollywood's idea of fashion was constructed on notions of glamour. As of 1920, argues historian Maureen Turim, "Seduction and elegance are . . . on the verge of yielding to a new concept, 'glamour,' in which Hollywood will play a determining role in setting fashion for the world. . . . What emerges in cinema . . . is a new form of elegant and sensual female representation that realigns the discourse of what constitutes womanhood."[42] The glamour of Hollywood

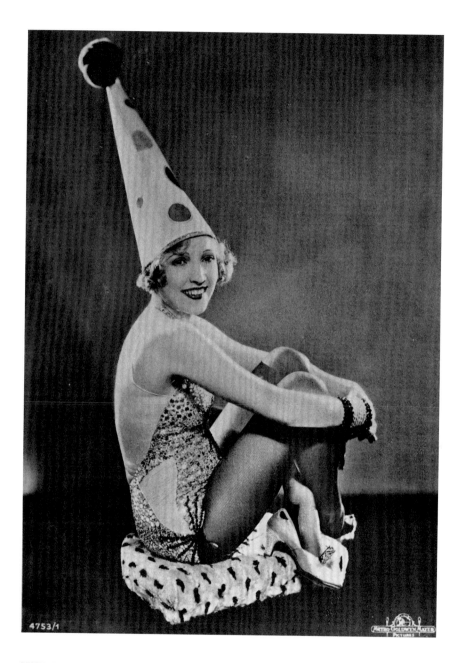

BESSIE LOVE IN CLOWN HAT (POSTCARD)

Private collection

Hundreds of thousands of postcards, cigarette cards, and other
promotional ephemera were printed in the 1920s, including this
curious Louise photograph of Bessie Love.

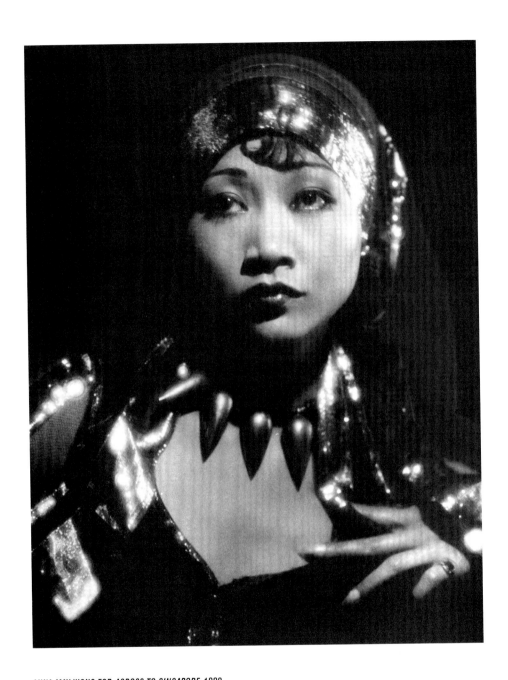

ANNA MAY WONG FOR *ACROSS TO SINGAPORE*, 1928

Courtesy of the Academy of Motion Picture Arts and Sciences

Wong never held a long-term contract with MGM but did appear
in several productions. Louise felt so positive about this portrait of
Anna May Wong that she exhibited it after she left MGM.

was different from the glamour of either the Paris or New York fashion worlds, however.[43] The difference lay in the fact that it was embodied in stars or potential stars. It was constructed around personalities that were known to the public (however artificially); moreover, it was specifically constructed around the stars' sexuality.

Contemporaries were well aware what was happening. Margaret Farrand Thorp, writing in 1939 on Americans' relationship with the movies, focused right in on the subject of glamour: "The natural American spelling of glamour would be g-l-á-m-o-r, with the accent on the first syllable. Hollywood spells it with a 'u,' accenting the last syllable and drawing it out as long as possible, whether in derision or enthusiasm—glamóur. Glamour might be defined, first and most important, as sex appeal (though that phrase is banned by the Hays office, you have to say 'it' or 'oomph'), plus luxury, plus elegance, plus romance."[44] She adds: "The place to study glamour today is in the fan magazines. . . . A study of current fan magazines will make it immediately apparent that the most important thing for a glamorous star to have today is personality. The insistence on this in the midst of a standardized society is touching."[45]

Louise negotiated the twin needs for images that merged personality with glamour, in a matrix that became increasingly sexualized. Her great achievement was the creation of MGM actor and actress portraits that successfully reflected the demands of publicity while incorporating her own tastes as a photographer.

WHAT IS A STAR?

chapter 6

LOUISE'S PHOTOGRAPHS PLAYED AN INTEGRAL ROLE IN the creation and promotion of stars. But the process was dynamic, and during this period the nature of stardom, and the ways studios (particularly MGM) deployed it, changed radically. With few exceptions, those who were stars in 1925 were not in the same position in 1930, the demise of the silent movie being the chief, but not only, cause. In September 1925, just as Louise's first photos were published, *Motion Picture*'s editor-in-chief, Eugene V. Brewster, pondered the question "What is a star?" He suggested that although producers felt that they created stars, ultimately that power lay in the hands of the audience. "It is a great problem to say who are stars and who are not. . . . The public is the court of last resort and no producer can keep a star in stardom any longer than the public wishes. . . . This leads to the conclusion that possibly the star system is coming to an end."[1] Brewster asked this question just when the industry, in the process of consolidation, realized that it could not afford to let the system work the way it always had—with astronomical amounts being paid to the major players, whose

lives and careers consumed the studios' attention—and still enjoy its benefits. As the historian Alexander Walker remarks, "Stars were never again to be so well rewarded . . . as in the early years of the 1920s. The star system which had created them was in the ascendant, while the studio system which was to curb their power had not yet been fully formed."[2] Stars did not emerge spontaneously, whether through the magical connection between audience and performer or through sheer will or talent. Rather, they were the result of a calculated collaboration between studio and audience. By 1925, most studios had a clear sense of how to produce stars—and generate profits from them. Over seventy-five years later, stars remain at the heart of the Hollywood system.[3]

Brewster, providing specific examples of how the star system might be reimagined, advocated two remedies. For aging stars whose appeal was fading, he suggested pairings with rising stars. Even a figure as seemingly eternal as Mary Pickford was now waning, he recognized, but that process could be slowed by partnering her with younger leading men, like John Gilbert. Or, he suggested, producers might avoid big stars altogether and rely instead on the appeal of lavish sets and spectacle. The producers of the about-to-be-released *Ben-Hur,* he pointed out, were clearly not relying on the box office bankability of Ramon Novarro, a virtually untested property in Brewster's opinion, to recoup their expenses.[4] Brewster understood well both the cost of the star to a movie production and the need to balance that expense against revenues. Because most movies contained a star—but only one, so that costs and resources could be spread as broadly as possible—his recommendations reflect a considerable adjustment in the normal allocation. Embedded in his specific examples, moreover, are fundamental truths of Hollywood: movies are basically about the sexual relationships between men and women, presented through a visual imagery of abundance, luxury, and glamour. Hollywood, in the end, is a romantic mirage inhabited by stars.

No studio believed more passionately than MGM in the theory, economy, and practice of stardom. As the journalist Leo Rosten wrote in 1941, "Mayer has made the entire MGM organization revolve around the hub of Personalities. The stories and production of MGM's pictures are geared to the studio's stars and, more than in any other studio in Hollywood, are subordinated to the final goal of star-appeal."[5] As MGM studio manager J. J. Cohn put it, Mayer, unlike other studio bosses, "believed completely in building, not buying. He'd rather develop people."[6] The career of Joan Crawford is emblematic of Mayer's approach: within the space of a few years, an uneducated hoofer from Texas was so thoroughly groomed and polished that she managed to marry a Hollywood royal. Performers were taught to dress, to talk, to eat, to walk, to ride horses; and correspondingly, their lives were strictly monitored so that no untoward publicity would befall

RAMON NOVARRO, SEPTEMBER 1929

The John Kobal Foundation

Novarro's triumphant success in *Ben-Hur* would be
repeated in nearly all of his roles for the studio during
the twenties, including his portrayal of Armand in
Devil May Care.

them. Paradoxically, these working-class women were trained to behave like debutantes even though they in fact worked harder than shop girls.

How did MGM create stars? And what role did publicity—photography in particular—play in this process? Among the thousands of hopeful aspirants who made their way to Hollywood, few got farther than the studio gates. But for the small number who were given a chance in front of a camera, the selection process quickly became standardized.

The studio did not need many stars. What it did want was enough actresses to play the many necessary supporting roles—both on screen and off. The vast majority of these were contract players who appeared in but a few minor roles. Their primary function, however, was to fill the needs of the publicity department, posing for a steady stream of calendar art, novelties, and fashion shots. An attractive young woman entering MGM's gates progressed through at least three stages, if she was successful. The first step was to work as a model, as background material, or as a walk-on. Next, she might become a featured player. The top echelon—one that very, very few reached—was that of star. Fewer still—like Garbo and Davies—arrived at the top level and never left. Movies from the twenties that we still watch today tend to feature stars. Only a few films made without established stars, like King Vidor's *The Crowd* (produced on the strength of the director's reputation), are screened anymore. From the vantage point of three-quarters of a century, we can say that the casting choices for MGM films, made by Mayer and his able team of producers, were excellent—although we might ask a version of the chicken-and-egg question: Do these movies continue to succeed because of their artistry or the star?

Lot hierarchy was well established. Stars, who occupied the top acting position, were few in number but received the lion's share of the publicity. Featured players, one step down, formed the permanent troupe of actors who took most of the speaking roles. Contract players—as the term suggests—were hired for six months to determine how they would fare before the cameras. There were also free-lancers, hired for a specific role and often well-established performers who did not quite fit into the permanent troupe. They might be exotics, character actors, or former stars and leading players who preferred not to have a regular connection with any single studio. At the bottom was a subclass of performers who gave atmosphere to a film: to cite Mary Eunice McCarthy's 1929 book *Hands of Hollywood,* these consisted of children, extras, doubles, freaks, professional dancers, horseback riders, prizefighters, and duelists—a list that suggests the methodical way in which Hollywood thought about these players.[7] Productions at MGM divided roughly into two categories: larger-budget productions under Irving Thalberg's control, and "program" pictures supervised by Harry Rapf (known nowadays as "B" movies). Within the quality productions there were further distinctions: Cosmopolitan Pictures (Hearst's production company at MGM), for

example, nearly always turned out lavish productions. One sure sign that a production had been accorded first-class status was when 11 × 14 stills were commissioned by publicity, to be placed in first-rank magazines. The surest sign, of course, was the actors: stars were never wasted on lesser productions, unless they were being punished or were on the way out.

Newcomers were always cast as standard fixed types. Ultimately, there were only a few kinds of roles, within a limited number of genres (drama, romance, comedy, western, and so on). When the personality of a new performer stood out and seemed marketable, a role might be reconfigured or even written especially for that person. In this process of building talent, photographic portraits played a crucial part. The first portraits made of a newcomer might have a narrow range of expressions and attitudes. Later, as the personality became better understood, they would become more varied and individual.

Russell Ball, whose career making portraits for both motion pictures and the New York stage began in 1916, described the process of sitting for a portrait in general terms in 1930. "Photographs play a large part in everyone's life," he observes. "They are jewels of memory, consolation in separation, reminder of love and friendship. In the motion picture industry and the theater, they represent business." If a woman is going to have her photograph taken, there are four questions she needs to answer. First, "What is my type? . . . Every girl and woman belongs under some type heading. . . . A study of the wonderful pictures of motion picture stars . . . should help you." Determination of type will also decide the clothing she should wear. The final three questions are "What is your best background?" "What are you going to be thinking about?" and "What are your best and worst features?" Ultimately, these factors, too, will be determined by one's type. Out of the type comes the costume and the setting, and finally the "motivation" and the pose.[8]

Although Ball suggested that individuality and distinctiveness be downplayed, the result was inevitably boring pictures—whether portraits or movies. It also created confusion in audiences. One day Carmel Myers, who at the start of her career was billed as "the new siren extraordinaire," was approached by an avid fan for a photograph. Myers was gratified by the attention—until she realized she was being confused with Nita Naldi, the "old" siren extraordinaire.[9] How to create difference while keeping it in check was the responsibility of all parties involved in the production of stars.

The producer Jesse Lasky was blunt about the process: "The best way and the simplest is to pick a face that attracts you . . . not always a face that is beautiful, mind, but one that you can't forget. And as to what makes it unforgettable, you know that as well as I. Personality." But always, the body was key: "Bodily perfection is important, for an aesthetic point of view. Women should be graceful. Men should be stalwart. It fits into the scheme of our imaginations better. . . .

We demand that a heroine be as graceful as a field of wheat in a gentle breeze and that her lover be as firm and upstanding as an oak-tree." Lasky aims for the high ground when he stresses good breeding: "What I want to emphasize is that there is a crying need for well-bred women in pictures. . . . we found the girls with the most cultured manners in society and in college." But his explanation of why the public gets tired of stars has an authentic ring: "They put on weight."[10]

The magazines endlessly analyzed and enumerated the characteristics of beauty.[11] Just as Louise arrived at MGM, Jameson Sewell, a journalist writing in *Photoplay*, published a list of exact specifications for "Camera Beauty," encompassing eyes, hair, height, weight, nose, mouth, and complexion. For women, he says, eyes should be dark—brown or black—and deep-set; hair black or auburn; height 5 feet 4 inches and weight 120 pounds; nose straight or slightly aquiline; mouths sensitive, fairly large and full; and complexion medium or fair. Men should be darker than women in coloring: only black hair and dark complexions are allowed. Their faces should be like women's in their general configuration. Only in build do the specifications differ (thank goodness): height should be 5 feet 10 inches and weight 165 pounds. Sewell concludes—somewhat hypocritically, given this extensive analysis—that it is "intelligence and personality that makes an actor."[12]

A few years later, MGM used two of its stars as models against which all others might be compared. Anita Page and Joan Crawford were at comparable points in their careers, competing for the same roles (as Page remembers bitterly still). Crawford was presented in terms of the ideal past, Early Greek versus Modern Hollywood.[13] In a gag photograph by Louise, she is posed to resemble the *Venus de Milo* (page 128). Anita Page, in contrast, was measured against her contemporaries, becoming "The Ideal Screen Type" (page 129).[14] What one learns from these comparisons, other than the anatomical details, is the degree to which the actresses' bodies were objectified. But this objectification is one that focuses on shopping and marketing: it is a mode of comparison rather than fetishization. Did anyone take these standards seriously? The answer was probably a mixed yes and no.

Within this elaborate classification system, how might an actress work her way up from chorus girl to contract player and finally to star? How would she make herself distinctive? Often the answer was found in the portrait studio. As Hurrell says, referring to Crawford's eagerness to be photographed and her willingness to experiment: "In a sense, she used this opportunity to try to present a new image that might possibly work for her whole screen personality."[15] Crawford herself was equally clear: "I probably had more pictures taken than any girl who'd ever been signed at the studio. . . . I have made a careful study of every single still picture that was ever shot of me. I wanted these stills to teach me what not to do on the screen. I scrutinized the grin on my face, my hair-do, my posture, my make-up, the size of my feet."[16]

What Crawford did for herself, Louise tried to provide for all her young sitters. In the sittings devised by Louise for general publicity, she was able to experiment with imaginative photographic styles, compositions, and settings. Under her tutelage these actresses became remarkably malleable. Photographs of Patricia Avery, a minor player who appeared in one MGM film *(Annie Laurie)* in 1926 in a supporting role, provide interesting examples of the range of moods she developed for her subjects.[17] In three sittings done over the course of her contract, we see Avery posing as a nun (page 130), as Little Bo-Peep (color plate 4), and as the Easter Bunny (page 25). The photo of her as a nun is virtually identical to Louise's later parody, featuring Marion Davies, of Gish's portrait studies made for *The White Sister*. Many aspiring actresses were photographed as nuns, even Crawford, and here Avery takes the opportunity to concentrate prayerfully for the camera. The Little Bo-Peep impersonation was also common. Here, seen in profile with one finger delicately propped against her throat, Avery is pensive and sweet. In contrast, the bunny suit photograph has a surreal quality.

The photographs of young actresses also tended to be the most sexually adventurous images Louise produced (these were often seen only in European markets), as well as the most exotic, in part because these women had the least defined personalities. Louise was careful in how she took the so-called drape shots, which were meant to artfully suggest the hidden parts of the body and were a standard element in most young actresses' portfolios. Mary Doran, holding herself closely and leaning forward, manages both to expose her body and withhold the revelation at the same time (page 18). Louise generally avoided overly provocative poses.

More artistic allusions were possible as well, even with established players. Two photographs of Renée Adorée, a featured player who never quite made it to the rank of stardom, suggest two directions these allusions could take. For the British periodical *Eve,* Louise developed a new way to dramatically record her female subjects, the "mask" photograph, in which her subjects' faces emerge from a stark black background. In a mask photograph of Adorée (one of a series that included stars Page, Crawford, and Sebastian), she is photographed wearing a black, tight-fitting cap that forms a widow's peak over her forehead, giving her face the shape of a heart and emphasizing her eyes and mouth (page 132).[18] Louise derived the idea from classical studies of expression taught to both art and drama students. In these photos, the actresses' disembodied faces are intended to represent fear, hope, despair, and other emotions. A more conventional artistic reference is found in a pair of photographs in which Louise recreates an actual work of art. Here Adorée is posed as Salome, mimicking the French painter Regnault's 1918 work hung in the Metropolitan Museum of Art (page 133). Although Louise copies the tableau precisely (apparently working from a reproduction, though she likely knew the work from her youth in New York),

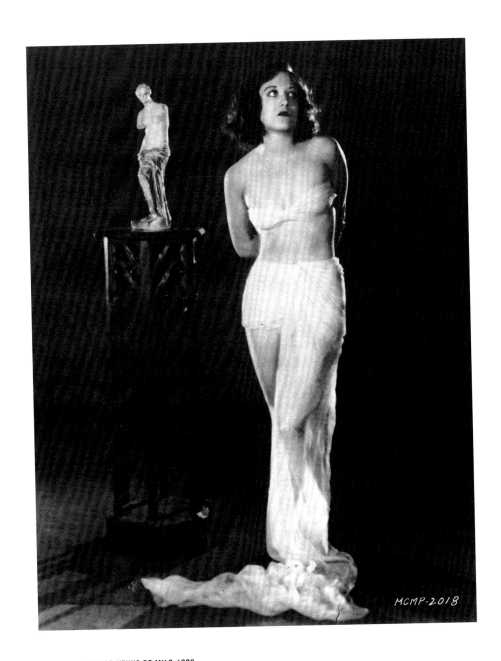

MCMP-2018

JOAN CRAWFORD AS *VENUS DE MILO*, 1928

The John Kobal Foundation

In this gag photograph Crawford imitates the *Venus de Milo.*
The photograph was published with a comparison of Crawford's
measurements to those of the ancient sculpture (paired with
Richard Arlen as Apollo) in *Photoplay* (May 1928, p. 35).

ANITA PAGE AND THE "IDEAL SCREEN TYPE," 1928

The John Kobal Foundation

Hollywood constantly measured the perfection of its
starlets' beauty against ideal types, whether ancient or
self-fashioned.

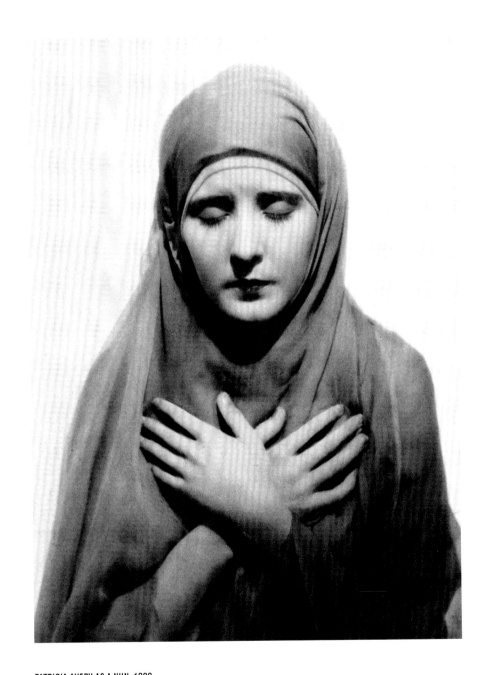

PATRICIA AVERY AS A NUN, 1926

Private collection

Patricia Avery poses as a nun, emulating Lillian Gish's famous role in *The White Sister*. Potential starlets like Avery had images of themselves in possible roles circulating in the press for months before appearing in a movie.

she changes the spirit of the composition, such that the role Adorée plays seems less Salome and more an earthy peasant woman or gypsy—appropriately enough, given Adorée's leading roles in *The Cossacks* and *The Big Parade*. Louise, in other words, is drawing on conventional high-art imagery to amplify the assigned role of her subject.

Among these uses of the actress for "artistic" or "commercial" ends, we also find character studies. In one photograph, Louise uses her knowledge of contemporary European photography, particularly German, with its hard-edged character, to produce an image of featured player Blanche Sweet as a Weimar woman (page 22). The photograph plays against Sweet's name and confirms the character of her roles. Josephine Dunn, in her first role as a dancer in *Excess Baggage,* is, in contrast, a hot potato (page 27). Louise uses the angle and the background to make the actress virtually pop out at us. The message: Dunn stands out from the crowd.

For all the help a starlet might gain from Louise's photographs, the studio ultimately controlled the business of stardom. At about the time Louise arrived at MGM, the studio's attitude toward its stars underwent a shift. In 1925, it was still advertising a heaven full of some twenty-one stars, beginning with Lillian Gish and ending with Bert Roach.[19] Within a year there would be less than ten, a winnowing that was in part an outgrowth of the consolidation process but that also reflected the new emphasis on the "product worthiness" of the studio's stable of stars. One didn't go to the movies to see Joan Crawford because she was the next Sarah Bernhardt, after all. The decline of Lillian Gish's career may be marked against just this understanding: the studios were marketing stars, not actors, and the public came to see personalities, not performances. Nonetheless, no matter how much the studios desired to control the process, they had no choice but to listen to public opinion.

From his first venture in moviemaking, Mayer clung to the idea that female stars were the key to his success. In 1917, he made his first significant move toward creating his own production company when he hired a star around whom he could build his movies. The star was Anita Stewart, and he precipitated a lawsuit when he stole her from Vitagraph. Seven years later, starting afresh in the conglomerate that was Metro-Goldwyn, and in which as an employee of Loew's Inc. he needed to prove himself if he were to keep his job, Mayer stuck by his instincts. Within the first year of the merger he was to sign filmdom's most prestigious female star, Lillian Gish (who arrived on April 14, 1925);[20] on his 1924 European trip, meanwhile, his most important acquisition was the nineteen-year-old Greta Garbo.

The year 1925 was critical for launching a new stable of stars, as most old-timers were let go and fresh faces were hired. During the first year and a half of MGM's existence, Mayer used actresses he had inherited from Metro. Viola Dana, Alice Terry, and Barbara La Marr, and to a lesser

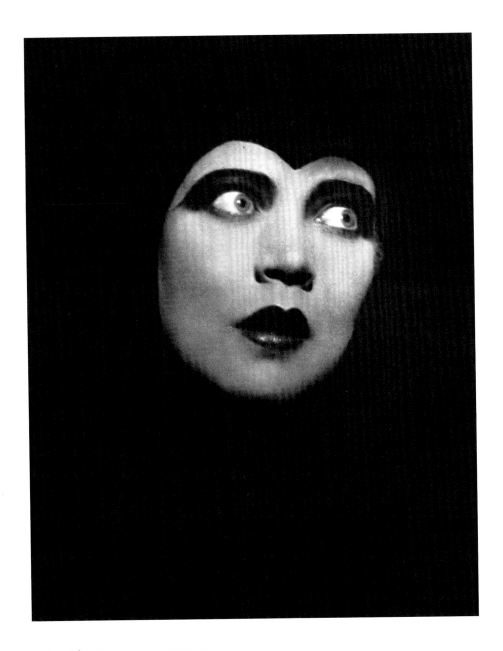

RENÉE ADORÉE IN A "MASK PHOTOGRAPH," 1928

Turner Entertainment Co./MGM Collection;
courtesy of the Academy of Motion Picture Arts and Sciences

To create "mask photographs" illustrating basic emotions. Louise
covered an actress's hair and body and photographed her against
a black background so that only her expressive face emerged.

RENÉE ADORÉE AS SALOME, 1928

Private collection

Louise looked to the world of fine art for
inspiration when she asked Renée Adorée to pose as
Salome, reproducing a painting by the nineteenth-
century French painter Regnault from the Metro-
politan Museum of Art in New York.

SALOMÉ (OIL ON CANVAS), 1870,
BY HENRI-ALEXANDRE-GEORGES REGNAULT

The Metropolitan Museum of Art, New York,
Gift of George F. Baker, 1916

Although Louise would have seen the original,
a reproduction in Renée Adorée's MGM files is
probably her direct source.

extent Laurette Taylor and Pauline Frederick, were heavily employed by the studio, appearing in several features each. None of them lasted much past the end of 1925, however. The reasons had as much to do with power as with talent: power, in that these actresses were not Mayer's creations and never adapted to the new efficiencies of the lot; talent, in that Mayer and Thalberg were both looking for a new type—younger, but also more modern and less vampish.[21] Mae Murray was the one exception. Hired by the studio when already a star, she had an early success for MGM and seemed positioned for even greater triumphs. But this was not to happen.[22]

Mae Murray was MGM's one star in the style of the great early cinema legends such as Gloria Swanson. She had an oversized personality, lived a lavish life-style, drove expensive automobiles, and even married a prince. Audiences loved her. She came to MGM in 1924 after a string of successful films made with her first husband, director Robert Z. Leonard, and released by Metro Pictures. Her initial MGM film was *The Merry Widow,* an Erich von Stroheim production that almost matched *Ben-Hur* in problems for the studio. But *The Merry Widow* proved to be a hit, and the studio was anxious to keep her. Murray, though, was a bit older and more seasoned than most of the other MGM leading ladies, and her production experience led her to believe that she could control her career at the studio. As soon as filming on *The Merry Widow* was finished, she left for a European vacation and, while abroad, divorced Leonard. It is not clear whether, at the time of her departure, she had an agreement with MGM to make another film. During this sojourn, in any case, she was approached by the giant German film company UFA and offered an extraordinary contract, which she accepted. MGM, however, had no intention of letting Murray get away with it. They couldn't prevent her from signing with UFA, but, through Hearst, they informed her that they could prevent her films from being released in the United States. Murray returned to MGM in the fall of 1925 and made *The Masked Bride.* She enjoyed the full benefit of MGM publicity and was featured in the fan magazines, arriving home with all the latest Paris fashions, the embodiment of glamour and chic as she attempted with little subtlety to upstage Swanson. Louise now had the opportunity to study Murray's personality. For *The Masked Bride,* she posed Murray wearing a dark top, with her blond hair intensely lit (page 19). Her face flares like a beacon. With great self-dramatization, Murray raises her hands to her head, one poised on her neck, the other gently grasping her hair. She turns as though to cry out. The results are theatrical, especially when compared with Garbo's similar repertory of gestures.

Murray returned to Europe for the winter and spring of 1926, and while there signed with MGM to make four more films. Upon her return she was soon involved in production of *Altars of Desire,* the first of her contractual obligations. That summer—a professionally fateful moment for Murray—Murray's close friend Rudolph Valentino introduced her to (alleged) Prince David

Mdivani, who set himself to claiming the actress as his bride. The couple was married at Valentino's Hollywood estate shortly after they met. Then, almost as soon as *Altars of Desire* was finished, Murray went to work on the second film under her new contract, *Valencia*. This demanding schedule was to be typical of Mayer's management: although MGM was willing to pay what it took to have stars, these actors were going to work for their rewards. Given her glamorous life as an old-style star, Murray found the transition difficult.

In a portrait made of Murray during filming of *Altars of Desire*, once again we see her posing like a star (page 20). Dressed in a chic sporting outfit worn in the film—striped jacket and tight-fitting white bodice, with a silk scarf at her throat and a jaunty white-brimmed hat—Murray draws attention away from the clothing and toward her personality through a dramatic gesture: arms raised above her head, she emotes shock or surprise. There is no integration of costume and attitude. How differently Crawford would model clothing for Louise! Again, it is Murray's face on which the camera focuses. It is not a beautiful face, such as in the portraits Louise would make of Garbo at exactly the same time; yet with eyes raised heavenward and lips parted, it is truly the face of a star.

Three events at the end of the summer provoked a crisis: Murray found that she was pregnant; Valentino suddenly died; and Murray's new husband insisted that she accompany him to Europe and, now that she was pregnant, stop working. Murray capitulated and left before filming was completed on *Valencia*. Mayer and the MGM legal department implored her to return. She did not respond. *Valencia* was finished with a double and released in January 1927. Mayer never forgave this breach and promised Murray that she would never work in Hollywood again. In any case, the nature of Murray's persona—outsized and histrionic—was not his style. With her departure, the stage was set for Mayer and Thalberg's own creations, and Louise's role in shaping them.

QUEENS OF THE LOT

Norma Shearer
Marion Davies
Joan Crawford

THE HEART OF THE GIANT FILMMAKING EMPIRE AT MGM
in the late 1920s was its female stars. Many women were given a
chance at stardom, but in the end only four from this period still
command our attention: Davies, Crawford, Shearer, and Garbo.
Each could be regarded as queen of the MGM lot. As the histo-
rian Leo Rosten said some twenty years later, "MGM prefers epics
to tales, drawing room comedies to dramas, elegant backgrounds
to simple ('dreary') locales."[1] Davies and Garbo never worked for
the title, for various reasons; Shearer and Crawford, however, pur-
sued their thrones aggressively. The differences in how each woman
reached stardom is evident in the strategies Louise used to create
their portraits. Shearer, Davies, and Crawford will be considered
in this chapter. Garbo, MGM's most important creation and
Louise's most enduring subject, will be the subject of chapter 8.

Of the three, Norma Shearer was first on the MGM lot.[2] A
movie veteran at the time of the MGM merger, she had appeared
in twenty films since arriving in Hollywood from New York in
1920. Shearer had a phenomenal appetite for the hard labor of

movie acting, paying her dues by working through a grinding routine of small roles, then bigger roles, becoming not quite a starlet and ultimately a featured player. She had worked for Mayer once before (*Pleasure Mad,* 1923), had played opposite Gilbert at Fox (*The Wolf Man,* 1924), and had worked with Harry Rapf at Warner's, where he was a producer in 1923 and 1924. Shearer was twenty-four when she signed on at MGM, and during her first two years at the studio she appeared in twelve productions, including the enormously successful *He Who Gets Slapped* with Lon Chaney and John Gilbert. Her first Metro-Goldwyn production was *Broken Banners,* filmed in the summer of 1924.

After half a decade in Hollywood, Shearer had a secure place at MGM well before her rivals appeared. Crawford arrived only six months later, and it would be much longer before she played even small parts. Davies signed on in the spring of 1925, but didn't actually start filming at MGM until 1926. Garbo also came in 1925; her first film, *The Torrent,* was not released until the following spring. Yet even though Shearer was well situated and had calculated every step of her career, real stardom still eluded her. Ultimately, time seemed not to be working to her advantage.

Shearer was a strategic thinker and among her peers was perhaps the most deliberate at achieving success. She consciously considered her career in an era when even stars did not have agents and virtually no performer had control over the roles they were offered unless they ran their own production companies, like Pickford and Swanson. (Garbo, for example, was able to have a say over the roles she was offered only by going on strike—and even then, she had trouble being cast as anything other than a vamp.) Shearer did plan, but ultimately her most strategic decision was, in mid-1925, to start dating Irving Thalberg, Hollywood's boy wonder and bachelor crown prince of MGM. He immediately took an active interest in her career. But it wasn't until they married in September 1927 that we can trace Shearer's final ascent to stardom, thanks to carefully placed stories and a lavish publicity campaign.[3]

Marriage allowed Shearer to claim the studio's best roles. It also placed her squarely at the center of Hollywood's limelight. But it would be unfair to dismiss Shearer's stardom solely as a reflection of her husband's power. Here, instead, is an instance of wife and husband truly working together as partners. Under Thalberg's watchful eye, Shearer's talent was allowed to blossom. She thrived as a star, working hard to be a better actress and seeking an ever wider range of roles. In the fall of 1929, as we will see in chapter 11, she even decided to modify her image, requesting the help of George Hurrell to do so. This unusual example of an actress making an independent decision about the way she would be presented to the public was firmly in keeping with Shearer's character.

Images played an integral part in Shearer's strategy. Her use of still photography was every

bit as omnivorous as Crawford's, and just as astute. Shearer was an intense actress, and this intensity was revealed in front of the portrait camera as well as the moving camera. But unlike Garbo and Crawford, she never allowed herself to give in completely to the camera. Perhaps this was because, although attractive, Shearer was not beautiful, and she found it safer to hide behind soft elegance or cool glamour. In addition, her right eye wandered slightly, a defect she could control through concentrated effort. Shearer could never fully afford to relax, especially in front of the still camera.

During her relatively long career before she established herself firmly at MGM, Shearer garnered tremendous experience working with portrait photographers and learned how to use them to her best advantage. She had sat for most of New York's and Hollywood's leading portraitists, including Nickolas Muray, Kenneth Alexander, Alfred Cheney Johnston, Edward Thayer Monroe, and Henry Waxman.[4] Nonetheless, regardless of the role she was playing, Shearer's portrait image was much more confined than her screen image. Her elegance and glamour remained more or less fixed whether she was playing an ex-convict, a "spoiled daughter of jazz," or a circus bareback rider. Louise could not alter this fundamental aspect of Shearer's image. Photographing the actress extensively in the summer and fall of 1925, Louise hardly penetrated Shearer's veneer, ultimately revealing a narrower range of emotions than she does in the other stars. Shearer may well have insisted that her portraits remain pretty much cast in the mold established early on by Muray's softly elegant studies, with an emphasis on hair.

Thalberg was satisfied with Shearer's persona and thought that the now married actress ought to appear dignified, on screen and off. (Marion Davies suffered a similar fate. Hearst preferred Davies in costume dramas and resisted allowing her to play the contemporary roles to which she was better suited.) Thalberg did cast his wife as the modern woman, but seldom as a bad or "hot" one, even though Shearer herself desired interesting (and risqué) roles. She may have been aware that, regardless of the roles she played, audiences tended to regard her narrowly. "Somehow," wrote one fan magazine after her first talkie debut, *The Trial of Mary Dugan,* "Norma has always been so securely established as the well-bred young star of nice, normal, safe and sane program pictures that we expected her to stay put. [Taking the role of alleged murderer Dugan] was a daring thing for this popular girl to do. She was always the ingenue. . . . What will Shearer fans who delight in sweetness and light think?"[5] This comment comes after roles, in the previous four years, in which she had played a lawyer, a vaudeville dancer, a barmaid, and a blackmailer.

Louise addressed some of these issues when she described her reactions to Shearer in 1928, noting both the actress's desire for stronger roles and the constrictions of her established look:

One of the most interesting things about this work is watching a personality develop. There's the case of Norma Shearer. I've photographed her for three years and I have watched her change from a sweet, charming girl into something much much more than that. She has developed a vivid personality with a great flair for strong dramatic work. She puts definite thought into her portraits. She is always helpful to me and is one of the easiest subjects I have. Her face is fine and patrician and there is a beautiful spiritual quality about it which definitely registers on the negative.[6]

Louise's portraits of Shearer confirm these observations. The actress seldom looks directly at the camera, and Louise rarely uses an inventive or unusual angle; instead she frames Shearer squarely. One example (opposite) finds Shearer posing against a large diamond pattern for a fashion shot. The backdrop secures her place precisely; her stance, with arms akimbo, mimics the diagonals of the design and further locks her in. Even the hem of her dress is carefully arranged to hide her thick ankles. Such painstaking calculation on Louise's part always serves to brace her subjects visually within the composition.

Two other images of a more glamorous kind function similarly. Shearer is portrayed in half length wearing a sequined gown, the lines of her extended arm, her back, and the lower edge of the image forming a triangle (page 34); to avoid any twist or opening in the actress's torso, Louise moved her near arm forward. On this stable pyramid, Shearer's head turns toward us, a nearly perfect ovoid. The image suggests a certain inertness, as Louise enhances the strong lines of Shearer's jaw and forehead. A more voluptuous image (page 142) shows Shearer in a simple, sheer satin gown. Facing the camera, Shearer holds her spine erect and her hands steady. The impression is one of unapproachable glamour, glacial in its regal quality. Only occasionally did Norma vamp for Louise's camera. In one such example (page 143), she plays with a thick string of beads, caressing her neck and shoulders as her head falls slightly backward. With eyes half open, she gazes at us longingly, perhaps imaging herself as Garbo.

Shearer, like all the women on the lot, posed for fashion and advertising shots. But unlike, say, Crawford, who loved this sort of work, Shearer appeared detached from the process. She never displayed her body the way Crawford did, but always remained modestly clothed. Where Crawford relied on the movement of her body, Shearer was as still as a mannequin. Comparing the two in sporting clothes, one senses that Shearer didn't sweat in hers (although, in truth, she was a good and frequent tennis player). Fashions worn by Shearer, moreover, were less exotic than those worn by Crawford.[7] And when it was her turn to dress up, playing Faust's Marguerite in a photograph commissioned by a fan magazine, for example, she looked all too solid in a heavy blonde wig with braids.[8]

NORMA SHEARER, 1928

Santa Barbara Museum of Art, anonymous gift

Although Shearer posed for her share of
fashion photographs, she was not completely
at ease modeling.

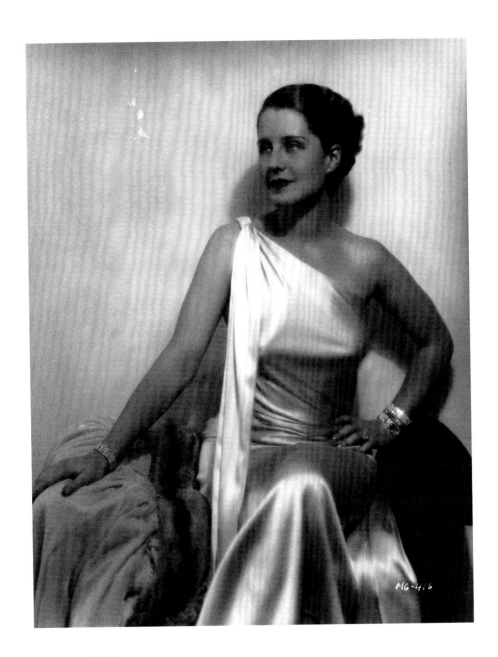

NORMA SHEARER, 1929

The John Kobal Foundation

Shearer strove to achieve a look of supreme elegance
and assurance in many of her portraits.

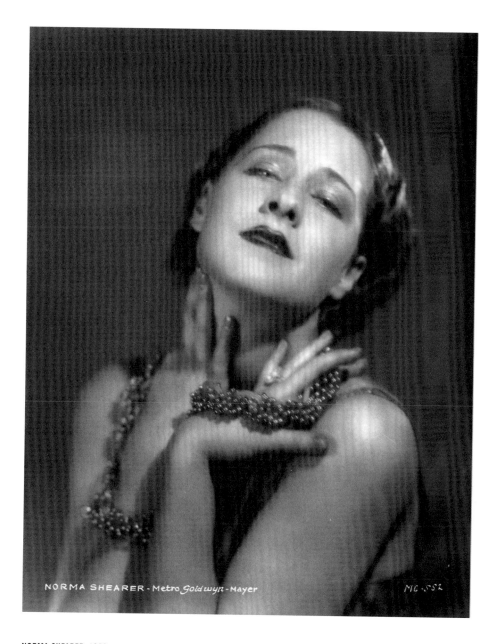

NORMA SHEARER - Metro Goldwyn - Mayer MG-552

NORMA SHEARER, 1929

The John Kobal Foundation

Louise liked to focus on her subject's hands whenever possible,
favoring complicated arrangements such as Shearer playing with a
long string of beads. Compare Louise's soft focus with George
Hurrell's almost harsh contrasts (see p. 220).

Although Shearer recognized the usefulness of portraits and exploited them, she thought of them as both distinct from and secondary to acting. Here too she differed from Crawford or Garbo, who tried actively to develop characters in front of the portrait camera. Perhaps it was her physical flaws—heavy legs and ankles, and her wandering eye—that kept Shearer from feeling totally at ease in the portrait studio (at least until she met George Hurrell).[9] She definitely preferred the movie camera. Countless stories exist of Shearer demanding retakes, striving always for perfection. To prepare, she practiced, sometimes for months beforehand, the particular demands of the role, including the quirks of period costume.[10] Shearer thought the basis of her stardom lay in her abilities as an actress, not in her image, and in her series of costume roles from the thirties—*Marie Antoinette, The Barretts of Wimpole Street,* and *Romeo and Juliet*—her assessment was correct.

Marion Davies arrived on the lot in the spring of 1925, already a star, veteran of nearly twenty films and with considerable stage experience in New York.[11] As the mistress of William Randolph Hearst she occupied in a real sense the position of queen consort of Hollywood. Davies had her own bungalow—the only person on the lot so privileged (not even Mayer had such palatial quarters). Known for being an extravagant host, she was also extraordinarily generous. Anita Page remembered, "She was always giving someone a break in the business." Davies was seldom photographed for advertising purposes or calendar art, in part, probably, because Hearst disapproved, but also because their travel schedule and active social life kept her away from the studio except when she was filming. While others worked six days a week, Davies was often to be found at her beach house in Santa Monica or entertaining at San Simeon. As with Garbo, most of her photographic sessions were closely tied to productions.

Among the female stars Louise worked with, Davies was her most relaxed and easily molded subject, despite the difficult position in which she found herself. Hearst, namely, wanted her to be a great actress—which for him meant performing in historical dramas. Davies's great gift, however, was comedy. Her heart seems never really to have been with the movies; still, in the MGM archive, Davies's file is one of the largest, for Hearst spared no expense in publicizing her productions. She may not have appeared in front of the camera as often as Shearer or especially Crawford, but when a portrait was needed she sat patiently as frame after frame was exposed. Louise recalled that Davies liked to begin her sessions as the day's production began winding down, around 5:00 (a subtle reminder that no one asked Marion to work overtime on films). But once there she would work steadily: "Marion is one of the hardest workers," said Louise, "and she loves to see a job well done. She always turns out an amazing amount of work."[12]

Yet for such a malleable subject, her portraits display surprisingly limited range. Davies is nei-

ther hot nor cold, and she is seldom glamorous, no matter how beautiful the costume (page 17). Her somewhat characterless façade does come alive, however, with portraits made in conjunction with the comedies *Show People* and *The Patsy*. For *Show People,* Davies hilariously parodies Pola Negri, Lillian Gish (in *The White Sister*), Mae Murray, Gloria Swanson, and others. Louise pushes the game a bit further when she asks Davies not merely to mimic but actually to recreate a few of Louise's earlier photographs, including one of Garbo in *Flesh and the Devil.*

Although Davies did become a memorable subject—and, indeed, one of the greatest performers of her generation when her comic talents were allowed to shine—this did not happen often. In the end, Marion Davies was indifferent toward her image and toward stardom. Always a willing enough subject, she never—unlike Shearer and Crawford, who used photography relentlessly to perfect their images—felt the necessity of performing before the still camera. Instead, she saved her energy for her job, which was moviemaking.

Given all this, it is perhaps not surprising that a series of photographs taken at Davies's beach house, when the actress was fully relaxed, constitute the most interesting "at home" photographs in Louise's career. These photographs seem to have been commissioned by Davies herself, since few (if any) appeared in fan magazines. The focus of the session is the house's garden and pool. In one photo, Davies seated under a tree is as soft and delicate as gauze. But posing on the diving board, she is "today's woman" (see color plate 2), as Louise takes advantage of the angles of the pool and diving board to create a modernist composition. Standing by the gates of her cottage, she is the lovely hostess. Playing tennis, she is vital and dynamic (page 16); Louise underscores the energy by slightly blurring the racket and skirt. In all of these images, Davies seems to enjoy being photographed: at home, she did not have to pose as an actress or star, but instead could relish the role of enthusiastic hostess.

In contrast to Shearer and Davies, Joan Crawford came to MGM in January 1925 untested as an actress, vulgar but full of verve.[13] She was hired, she later realized, to be part of the decorative background, and certainly not as an actress.[14] Lucille LeSueur, as she was born in 1906, had been noticed dancing in the back row (or the end of the row, accounts differ) of a revue in Manhattan by Harry Rapf, who offered her a contract. She stood out in the line of chorus girls, Rapf said, not so much because of her beauty, but because of her limitless energy and expressive large eyes. Crawford was determined to secure her place at MGM and from the outset focused on becoming a leading lady like the ones she admired, especially Shearer (whose double she was in her first screen appearance) and Garbo. In this age of the flapper, there were many screen possibilities for Crawford, whose image was initially not about sex so much as about vitality. After a num-

ber of false starts, she finally achieved fame in *Our Dancing Daughters* and its sequel, *Our Modern Maidens.* It is no wonder that her best friend at the studio was Billy Haines, her male counterpart in the youth roles that MGM writers crafted for her.

The story of Crawford with Louise is not so transcendent as that of Garbo, but it is perhaps more quintessentially Hollywood, for it is the product of pure will. Watch Crawford, in front of the camera, try anything on for size. If Garbo created attention by turning down the gush of publicity to the merest trickle, Crawford opened the faucet as far as it would go. The two had a fundamentally different approach to achieving stardom, but both worked. And for both, stardom came through Louise's photographs as well as their screen work.

Screenwriter Frederica Sagor (Maas), who arrived at MGM at about the same time as Crawford, describes meeting Crawford early on and finding her dressed in a manner more suited to a New York chorus girl than a new actress at MGM. Sagor was kind to the poor teenager, and the writer's elegant New York good taste (which can be seen in Louise's photograph of Sagor, page 29) must have appealed to Crawford, for one day the actress knocked on her office door and asked if Sagor would take her shopping, saying: "I like the way you dress. You dress like a lady. I need that. I want to be dressed right. Smart. I figured you could help."[15] Poignant, considering this background, are two early photographs in which Crawford wears a plain white-collared blouse and a wool sweater: she is now simple and discreet. In the first, she pulls her hair behind one ear, revealing the full left side of her face (page 28). She raises her chin and presents an infectious half grin—the effect is mildly flirtatious, unlike the photographs of her later on. Here Crawford seems natural and a bit naive, a young woman still somewhat uncertain about her place. Another photograph from the same session shows a variation on this theme: Crawford's hair is pulled back completely, but now she is looking down and seems sober and reserved, even somewhat depressed. Crawford gave a copy of this photograph to Sagor; a view of herself proudly co-opted from Sagor, bearing an inscription to her teacher, it serves as a testament to how much she had learned.

As Crawford began her MGM career, this was the image both actress and studio wanted to present to the public: that of a refined lady, the sort producers like Lasky were interested in. How different, thanks in part to Louise, that image would be by the end of the decade.

To get where she ultimately did, Crawford posed for every photograph possible. She remembered how athletic the early publicity sessions were—and it would seem that as Lucille LeSueur she did spend much of her time jumping around in shorts skirts or bathing suits. Being renamed Joan Crawford six months after coming to MGM was the first big step in changing that image,

though it still did not occur overnight. Misremembering the chronology slightly (Garbo's first publicity was based on Crawford's, not the other way around), she recalled:

> Within a week, I was spending most of my time before the camera. Not the movie camera, but the still camera in publicity. I was strictly the "action queen" of cheesecake, as Great Garbo had been. Pete Smith . . . had just bought an action Graflex for photographer Don Gilum [*sic*] and Don's action shots were favorites with newspaper editors. . . . I probably had more pictures taken than any girl who'd ever been signed at the studio, because, as a dancer, I could leap the highest and jump the farthest. I threw myself into action shots with youthful abandon.[16]

Even Louise, in a 1928 portrait session putatively devoted to Thanksgiving, featured her lunging, strenuously demonstrating her physicality (page 148).

Crawford quickly became an indispensable part of the fashion parade promoted by MGM. She recalled being photographed "in all sorts of chiffon scarves and beads I'd dig up in wardrobe, some of the most artistic of these for European publications."[17] The 1925 *MGM Studio Tour* devoted a substantial portion of film to displaying the actresses as fashion models, each with a distinct personality.[18] Claire Windsor is tailored and elegant as, walking toward the camera, she fends off a dog. Carmel Myers plays the flirt as she walks into camera range, her face hidden under the brim of her oversized white hat, and then turns slowly and lifts her head to reveal her face, ending with a big wink. Crawford is given the most glamorous—and least personality-filled—moment: she simply stands still, her arms stretched out to either side, as she models an Erté gown being created around her.

Crawford's portraits will take a long time to catch up to this short moment of glamour. Still Lucille LeSueur for her first few months at MGM, she modeled sporty fashions and the short-skirted costumes dreamed up by the costume department to show off long legs. Not until she became a fledgling actress and began to model gowns and other expensive accessories did she serve as more than a decorative piece of fluff in the background. Only after Crawford became a personality in her own right, one that audiences wished to emulate, was she asked to model fashions being offered commercially. By the end of 1928 she was modeling shoes, bags, coats, dresses, and hats, all of them modern and most of them elegant (pages 30 and 31). The pleasure Crawford took in modeling clothes was very different from Garbo's habit of hiding behind her wardrobe.

In between came a huge amount of novelty posing. Some of this was seasonal: the picture of

JOAN CRAWFORD, 1928

The John Kobal Foundation

Other photographs from this session illustrate a feature
published in *Motion Picture* (Dec. 1928, p. 54), "A Bacchante-
dote for the Blues": "[Crawford's] performance in this exultant
harvest dance manifests a grace that is truly autumn-atic."

Joan as Santa's little helper (color plate 3) was marketed by MGM for Christmas in 1927. Earlier that year she sat for Clarence Bull on an oversized firecracker, to celebrate July 4; another year, scantily clad, she hefted a silver cornucopia for Thanksgiving. She twisted, pirouetted, jumped, and danced in front of the camera. In addition to becoming Louise's most photographed subject, by 1928 Crawford was pictured in the press more than any other star.[19] By now a constant presence in fan magazines, she appeared everywhere: on covers, in advertisements, in portraits, in gossip sections, in features, even in the back-cover advertisements. She understood that she was promoting herself as much as any product she might be advertising.

As Crawford's persona was refined and developed, the content of her portraits, whether associated with a specific movie or taken for general publicity, reflected that progression toward stardom. Indeed, it now became virtually impossible to separate image from subject. Crawford stands as the figure who traverses, over the five years examined here, the full range of studio images, tropes, and activities, from raw fodder for the publicity department to blazing star. Although her final apotheosis was achieved in the hands of George Hurrell, it is in Louise's portraits that we can see, better than with any other player, a star in the making. This process is worth examining in some detail.

Crawford was constructed as a star by measuring her against established types and emerging competition. Her first substantial movie, for example, *Sally, Irene, and Mary* (1928), was advertised as "a little test in temperament. Here are three girls—each a distinctive type and each with a mind of her own—cast in equally important parts. . . . The race is on between Constance Bennett, Joan Crawford and Sally O'Neil." The captions spell out the young showgirls' differences: Bennett (Sally) is the classy, glamorous one; O'Neil (Mary) is the histrionic one, "another Mabel Normand"; while Crawford (Irene) is "comparatively unknown," with no identifiable cinematic personality: her photograph alone distinguishes her, though she does manage to stand out because her clothes are more elegant than O'Neil's and her pose more dramatic than Bennett's.[20] After the success of *Sally, Irene, and Mary*, articles featuring Crawford began to appear in fan magazines, with images carefully chosen to support the copy. "Joan does the Charleston," an account of Joan dancing at a nightclub in Hollywood, declares that she is a little bit like her role in the movie: she has brought, it seems, "that New York suppertime restlessness to Hollywood." But she is still a nice girl, "her manner modest and unsmarty."[21] The photograph shows her at just that balance, caught moderately in midstep.

By the end of the decade Crawford had risen to fame as a quintessential modern: such an authority as F. Scott Fitzgerald dubbed her a flapper, while *Hollywood Vagabond* columnist Fred Fox called her "the symbol of the American girl": "There seems to be a rather vague and experimen-

tal regard for Joan Crawford on the part of Metro-Goldwyn-Mayer. It may be that they are allowing her to run the gamut from semi-farcical drama to dyed-in-the-wool melodrama to determine her fitness for certain vehicles." But "the girl is apart from the coteries that can only be classed as either ingenues, vamps or lovely heroines."[22] The clothes she modeled for Louise and other photographers are generally inseparable from the clothes she wore in *Our Dancing Daughters* and *Our Modern Maidens.* In these movies her dancing, her boundless energy—the very reason she was noticed in the chorus line in the first place, and qualities seen in the first portraits Louise made of her—become part of a genre and a star type.[23]

Along the way, Louise experimented with different visions of Crawford's face. There were "types" inhabited by other stars, which Crawford tried out to see if they fit. There were the characters she played on film, sometimes successfully, sometimes not. Finally, there were the hundreds of general publicity photographs, which constitute something of a role in themselves. An example of Crawford aping others is seen when she imitates Swanson, with short bobbed hair, vivid small mouth, an elegant hand, and a corsage of gardenias raised to her face; or Crawford as Gish, in long hair under a spotlight, her face a glowing pool of sympathy: a tear wells to one eye as she clutches a handkerchief to her lips (page 33). Portraits from the sitting for *Rose Marie,* the first filming of Victor Herbert's musical, are an example of the second mode. They show her in a white blouse and with thick puffy hair—utterly unlike her usual bob. In one photograph she sits hugging her knees to her chest, her head turned up to the camera, a study in poise and calm (page 32). One genre of publicity photographs featured actresses "playing" literary roles (ones they would be unlikely to play on screen), usually in conjunction with publicity arranged for or by specific fan magazines. Crawford portrayed Hamlet as part of one such series appearing in *Motion Picture* in 1929 (page 152). The series also included the photograph of Shearer portraying Faust's Marguerite.[24] The difference between Crawford's fiery and histrionic Hamlet, dressed in a costume that emphasizes her body, and Shearer's modestly dressed proper maiden is emblematic.

By 1929 Crawford was a star. On the personal level, she copied her role model Norma Shearer and consolidated her position in Hollywood by marrying film royalty. She chose Douglas Fairbanks Jr., son of reigning king Doug Sr. and stepson of queen Mary Pickford, who held court at their famous Pickfair estate. Crawford couldn't have married anyone more important at MGM: Thalberg was taken, and Mayer had only daughters. With her marriage she became both a star and a princess (her queendom would have to wait a few years). Rising on both the success of her movies and the hype of her marriage to Fairbanks, she now appeared even more frequently in the

press, in both featured stories and advertisements. In April 1929 alone, for example, we see her advertising Frederic's Vita-Tonic Permanent Wave in *Photoplay,* Max Factor's "new kind of make-up" in *Screenland* and *Motion Picture,* and Lux Toilet Soap in *Motion Picture.*

Crawford's ascent to stardom was officially announced in June with full-page ads from MGM "welcoming a new star to the film firmament."[25] Stills from earlier films and one from *Our Modern Maidens,* about to be released, frame her portrait, in which she stands, clad in a sleeveless metallic dress, with arms raised and bent back behind her neck: she is limber, dynamic, physical. The photograph confirms the essential qualities that make Crawford a star, "vibrant with the spirit of youth." Two months later she was featured as a "star at home" in *Photoplay.*[26] Publicity wasted no time in promoting the elevated few.

Perhaps most telling were the photographs of Crawford and Douglas Fairbanks Jr., whom the studio exploited mercilessly as a couple. Crawford's Hamlet feature had contained the most telling reference: "To wed or not to wed, that is the question." The convergence was even more complete in the publicity surrounding *Our Modern Maidens,* the movie in which she and her new husband co-starred. Private and public merged in an uncanny fashion: photographs of the couple "acting" engaged, which had appeared in the spring, were soon replaced by similar (or sometimes identical) photographs of the two of them actually engaged. A similar blurring can be seen in photographs of Joan at home before the wedding, where her "engagement" photograph in the silver frame is actually a movie still. The final coup for Crawford was to be photographed off the lot by a prestigious non-Hollywood photographer. Edward Steichen snapped Crawford and Fairbanks at the beach in August; the photo was published in *Vanity Fair* that November. Sitting for a New York photographer established once and for all the legitimacy of Crawford's hard-won crown. Still, it was Louise's images that got the most circulation.

There is perhaps no greater distinction between Crawford and either Shearer or Davies than the manner in which each was photographed with a leading man. Davies was rarely seen in a double portrait, and most of those that survive (which are often comic) feature pal and frequent co-star William Haines. Although Shearer posed with many of her co-stars beginning in the late 1920s, the photographs are remarkably similar. In a typical double portrait for Shearer, with Robert Montgomery for *Their Own Desire,* the composition has been carefully posed so that her face remains central and unobscured (page 153). The couple are loving but not demonstrative. Contrast Crawford with Robert Montgomery photographed for *Untamed* the same year (page 37): the radiance with which she looks up at him is unmistakable and powerful. More remarkable is Crawford posing with Johnny Mack Brown, for *Our Dancing Daughters* (page 36). Here the face of

JOAN CRAWFORD AS HAMLET, 1929

The John Kobal Foundation

Crawford dressed up as Hamlet in an homage to the actor John
Barrymore. Six photographs from the session were reproduced with
the caption "To wed, or not to wed," in *Motion Picture* (June 1929,
p. 46), just before her marriage to Douglas Fairbanks Jr.

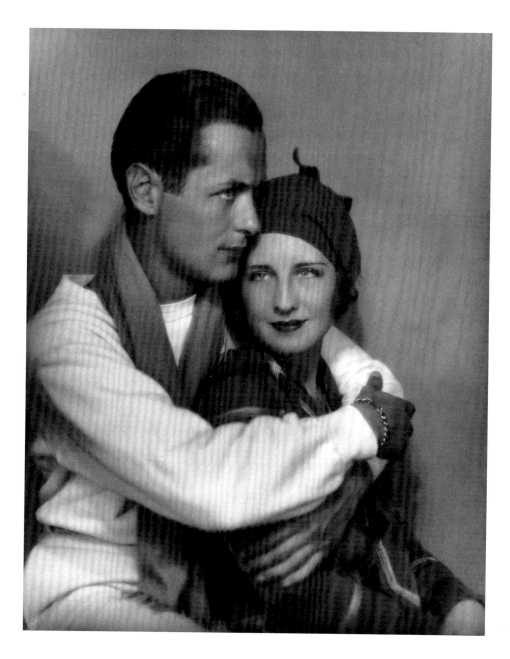

NORMA SHEARER AND ROBERT MONTGOMERY
FOR *THEIR OWN DESIRE*, SEPTEMBER 1929

The John Kobal Foundation

Montgomery had the chance to play opposite
Norma Shearer during his first year at MGM.

the manhandled Crawford is obscured so that only her large haunting eyes are seen. Shearer would never allow herself to be photographed by a still camera in such an aggressive manner.

The secret of Crawford's success lay in the degree to which she opened herself to the camera. Director George Cukor once remarked: "The nearer the camera, the more tender and yielding she became—her eyes glistening, her lips avid in ecstatic acceptance. The camera saw, I suspect, a side of her that no flesh-and-blood lover ever saw."[27] In the early photograph of her pulling back her hair, a cardigan over her simple white blouse (page 28), Crawford seems completely unguarded. Virtually every other actress who is photographed with hand at head does so for dramatic effect (Murray, Garbo) or as a sensual invitation (Shearer). Crawford can play those roles as well, but no other can match her modesty (not a term one normally attaches to Crawford). This openness pervades even her most staged portrait sessions. Crawford's pose in a portrait for *Rose Marie* is composed like the photograph of Shearer in the sequined gown, with the figure filling the frame and the head balanced on a pyramid of arms and torso. But the inquiring tilt to Crawford's head renders the situation vulnerable, in decided contrast to Shearer's assured impenetrability. Eyes—which in succeeding decades became first balanced with and then overwhelmed by her alarming cheekbones and shoulders—are the key to Crawford's look. From the first, Crawford seems to have had the largest eyes in Hollywood.

Crawford learned her profession in front of the camera, one still, one film frame, at a time, and there she slowly assumed the mantle of glamour that Hurrell so completely revealed. In one of her earliest portraits, Crawford adopts all the outward signs of glamour: she wears white camellias, displays a fur cuff and rings on her long fingers; her eyes widen, and her head leans forward slightly, but without hauteur. A later photograph of her costumed entirely in gold lamé, a giant hood encircling her head like a mandorla, is more aggressive: she stares directly out at us (page 35). This photograph is a good example of Louise's constant concern with composition. The edges of the giant hood bump up against the frame of the image with precision. The lighting has been calculated to leave one side of the hood bright and flat, the other shadowed and concave. A single black curl of hair has been carefully arranged on the bright side of the picture, with the crumple of the fabric at the base of her throat counterbalancing it. The brightest point of the composition is across the cheekbones and eyes. The result, for all the golden textures and shimmering surfaces, is that Crawford's eyes dominate the image. In an image that seems to focus on the costume, the actress herself becomes paramount, with Louise's careful help. Crawford holds her own within all that gold. In the end, the difference between the glamour of Crawford and Shearer is one of temperature. Shearer at her best exudes a cool elegance; Crawford radiates heat.

Crawford's presence gives substance to even her silliest images. The photograph of her as Santa's elf (color plate 3) suggests the delight she took in front of the camera. Part of this pleasure must have come from a real rapport she felt with her photographer, Ruth Harriet Louise. Not only did the two women work well together, but Louise was sometimes mistaken for Crawford. Once or twice, driving in through the gates at MGM, Louise would be approached by fans with photographs or autograph albums in hand, pleading: "Miss Crawford, sign for me." She asked Crawford what she should do—and the actress just laughed and told her to sign and enjoy the confusion.[28]

PHOTOGRAPHING GARBO

chapter 8

GRETA GARBO WAS LOUISE'S MOST REWARDING AND MOST difficult subject. They worked together from the moment Garbo arrived on the MGM lot in September 1925 through her rise to stardom, until just before her first talkie. This collaboration between actress and photographer brought us the definitive image of Hollywood beauty and glamour. It came, however, neither easily nor inevitably. Garbo's image was carefully crafted, despite her resistance to publicity and her legendary reserve. In 1928 Louise reflected on the process for a reporter: "Miss Garbo has such a many-sided nature, and is so full of moods, that I have to photograph her in a dozen ways, and in a dozen poses, without attempting to reproduce the real Greta in one picture, as one can do with most people." She added: "All the tragedy of the world seems hidden in her brooding, heavy-lidded eyes. I only wish I could capture it through my camera."[1]

Louise was not the only photographer who wished to snare the "real Greta" with her lens, but she may have come the closest. Because Garbo's official MGM publicity was so tightly controlled, and

finally rested on many fewer photographs than were released of her contemporaries, it is possible to examine the work of all her photographers and the creation of Garbo's image quite closely. The countless stories of Garbo hiding from the camera, and the intense interest provoked by this avoidance, coalesce in the official photographs—the ones we must return to in any effort to uncover the real "Garbo."[2]

It is important to understand how closely Garbo's face was guarded. From the beginning of her career in America to the end sixteen years later (in December 1941) only seven photographers were ever authorized to make portraits of her: Russell Ball, Arnold Genthe, Ruth Harriet Louise, Nickolas Muray, Edward Steichen, George Hurrell, and Clarence Sinclair Bull. Stills photographers recorded her at work on the set, and at the beginning of her career a small number of publicity photographs were taken; news photographers, of course, pursued her throughout her entire life. It would be Garbo's portrait, however, that ultimately would be the central device for molding the mythic image. And the photographer with the greatest access to and the first sustained relation with Garbo was Louise.

In the heyday of the studio system, studios and stars collaborated in scrupulously controlling all aspects of the star's life, blurring as completely as possible home life and screen persona. The publicity for each new film was inextricably linked with images of stars going about their daily routines. In this, a process by which virtually all great stars were sustained, Garbo assumes a critical position because her approach to the half of the equation that lay outside the screen—her life—was like no other. Garbo, indeed, is unique in the way she withheld herself from both the camera and her public. By her third film, less than a year after arriving at MGM, she had unilaterally drawn strict limits around the ordinary publicity used to promote players and films. One effect of her fiat was to heighten the role of the portrait in building and maintaining her public image. No other star created such mystery or imposed such restrictions, yet neither did any other star succeed in retaining the public's rapt attention so long after her screen performances had come to an end. She perfected the art of projecting an image that was powerfully attractive even as she rejected the resulting attention. For all these years, Garbo's mysterious, glamorous image has sustained her myth, since the real woman never made herself available to her audiences.

The focus of this attention lay in her face (page 38), the mythology of which is highly elaborated. Rudolph Arnheim, the German critic and art historian, described his reaction in 1928, upon seeing *Flesh and the Devil* (slightly misremembered): in the midst "of an indifferent American society film . . . a young woman descends the stairs." The establishing shots of her actions entrance him, and he catalogues them: she descends the stairs, opens her car door, drops a bouquet of flowers, retrieves them, and gets in. He is "enslaved." The long shot is followed by a close-

up. Arnheim, as directed by the filmmakers, moves inevitably from watching Garbo's whole body in action to staring at her face in repose. He next intently describes her kissing, detailing every aspect of her face—her chin, her eyelids, her nose and upper lip, her eyebrows—and then her reactions to the kiss: her smile; her trembling; her sinking, starting, and lifting. He concludes: "Greta Garbo passes censorship. And every evening three hundred men are unfaithful to their wives."[3]

While her walk might draw the viewer first, the key to Garbo's magic spell lies ultimately in the memory her face leaves behind, one that seems to break through any veils of censorship and present itself directly to the soul of the viewer. Some twenty years later, Roland Barthes would render Garbo even more essentially, in his essay "The Face of Garbo."[4] In this reduction of Garbo to her close-ups, we see both the action of memory—since few films of hers were circulating in the 1950s—and the way in which photographic portraits focus that memory on the face. Because Garbo projected mystery and reticence, her face became an ever more potent screen onto which one could project desire. Perhaps the most discussed moment in all of Garbo's performances is the closing shot of *Queen Christina,* when the camera moves in closely on her utterly still face as she stares silently into ineffable distance. Asked how he achieved the performance, the director Rouben Mamoulian said that he told Garbo to think of nothing. Nobody asked Garbo how she created the moment, and if they had she would not have answered.

For that was the key to the unrelenting attention: Garbo refused to participate in the publicity machine. One of her first recorded comments on publicity, in *Photoplay* in May 1926 (published less than six months after she completed her first American film), was to the point: "I vill be glad when I am a beeg star like Lillian Gish. Then I will not need publicity and to have peectures taken shaking hands with a prize fighter."[5] Almost immediately, Garbo's attitude toward publicity fostered developments that were important to the industry. With the star's refusal to speak, and the severe limits that she put on the production of her image, those images that did circulate were critical. Her absence from the usual round of fashion spreads, at-home features, playing-around-Hollywood shots—and the lack of stories that could be pegged to these images—focused attention on the only remaining evidence of her presence: photographs of her face.

The development of Garbo's image came in three stages, as the studio came to grips with the phenomenon they had landed. Her first encounter with the image-making machine occurred the moment she arrived in New York. The second stage was launched when she reported to work on the lot in Culver City, and continued until her star power was definitively established in *Flesh and the Devil,* her third MGM movie, made in 1926. The third stage lasted three years, from the premiere of *Flesh and the Devil* until she embarked on her first talkie, *Anna Christie,* in 1929, some eight films later. From the moment she first sat for Louise through her sessions for *The Divine*

Woman two years later in 1927, Garbo's image undergoes a continuous and observable development. After 1927, however, that image, though it would be further refined, remained fundamentally fixed for the balance of her career at MGM.

Mayer had noticed Garbo in her first feature, the important Swedish production *Gösta Berling's Saga* (1924), directed by her mentor, Mauritz Stiller. While traveling in Europe that fall, Mayer, always on the lookout for new talent, had screened the film and made a point of meeting Stiller and Garbo when he visited Berlin that November. Accounts differ as to whom Mayer was most interested in courting—Stiller or Garbo—but it is evident that he took both seriously, and offered them contracts.[6] Between this film and her arrival in America she appeared in one more production, G. W. Pabst's *Joyless Street*. If there were any concerns about Garbo's talents, they would have been put to rest in May when the film opened in Berlin and Paris.

Stiller and Garbo arrived in New York on July 6, 1925, and immediately the MGM publicity machine swung into action. In traditional accounts of Garbo's career, much is made of the fact that she languished in Manhattan for nearly two months, ostensibly because the studio did not know what to do with the Swede and because Stiller was still renegotiating his—and Garbo's—contracts. Then, after arriving in Hollywood, Garbo sat around even longer as Stiller haggled once again with MGM over contract details. In fact, their arrival was typical from the point of view of MGM publicity, and if they were somewhat delayed in New York it was by Stiller's intransigence and not the studio's disinterest. MGM, which had paid Garbo's way across the Atlantic, immediately put her to use, not as an actress but as a publicity subject. Even before the ship docked, Hubert Voight, one of MGM's Manhattan publicists, had arranged for a photographer to meet her onboard. Soon after they were settled, writers from magazines such as *Movie Weekly* and *Motion Picture* interviewed Garbo and feature stories were developed. Moreover, contrary to legend, Garbo was assigned her first role before she left New York (although during her first weeks in California that schedule would change slightly): an adaptation of the Spanish novelist Vicente Blasco Ibáñez's *The Temptress,* to be directed by Stiller.[7] This first encounter with the MGM publicity department also produced three sets of photographs, all very different. These photographic sessions immediately established an index to the studio's efforts to classify her, and to Garbo's ambivalent efforts to participate while at the same time reserving herself as a serious actress. Making matters even more difficult, the studio proceeded on two contradictory tracks: trying to match an unknown actress with established types, on the one hand, while trying to uncover what made her unique, on the other.

The first of the three photographers Garbo posed for in New York was James Sileo. Sent by Apeda, a photo service that MGM often used in New York, Sileo photographed Garbo and Stiller

even before they disembarked from the ship. Four photographs (three of her alone, one of her with Stiller) survive, documenting a gauche and almost unrecognizable Garbo. Undoubtedly tired from the journey but excited by the new country, Garbo playfully mugs for his camera. In one picture, she stretches an arm above her head and thrusts her chest forward provocatively. The gesture is awkward, and her drab checked suit undercuts the playfulness. Nonetheless, they became the first published images of Garbo after her arrival in America and would be used continually by MGM in later years, possibly because they made it clear how far, thanks to the studio, the star had come from her dowdy origins.

Such candid publicity photographs, however, were of secondary importance for image building. Since Garbo was unknown in the United States, these first pictures had little impact in determining the direction of her American career. It was, in the end, formal portrait sessions that mattered. Also while she was in New York, Voight arranged Garbo's first session with Russell Ball, who frequently freelanced for MGM; these pictures were intended for immediate circulation to fan magazines and newspapers.[8] A few weeks later, in early August, Garbo sat for the independent photographer Arnold Genthe, in a session that could only have taken place with Voight's knowledge and blessing.[9] These two portrait sessions were radically different. Ball, a rather conventional photographer, treated Garbo (who did not speak English) as just another Metro ingenue. Genthe, on the other hand, not only shared Garbo's European sensibilities, but he was also someone with whom she could talk (in German) and to whom she could impart her own dramatic ideas. Moreover, he apparently saw—and paid attention to—the portfolio of photographs taken of her earlier in the year in Berlin by Atelier Binder, with their expression of what it meant to be a dramatic European actress.[10] If Ball saw these photos, he ignored them.

The contrast between Ball and Genthe emerges vividly in the range of poses and effects depicted in their portraits. Ball photographs Garbo pressed against the wall, her turned face seductively close (page 162). The constriction of her pose underscores the suggestion of sensuality: Garbo has no place to move, and her body forces itself toward us. A shoulder is bared; she runs her fingers through her hair; her quiet smiles beckon suggestively. Through the course of this session, Garbo steps out of her street clothes and into the dreamland of Hollywood women: she ends up draped in fur. This striptease is one that Hollywood has perfected and promulgated for nearly a century. Ball tries to force Garbo into the role of seductress as she lies down and the camera nuzzles up to her. The result is utterly indifferent: she is one starlet among thousands.[11] Genthe, in contrast, virtually eliminates Garbo's body, concentrating instead on her face and hair (page 163). She may not be wearing clothes—she has some kind of robe wrapped around her—but neither is she unclothed. What Genthe does with Garbo is technically little different from the romantic drape shots

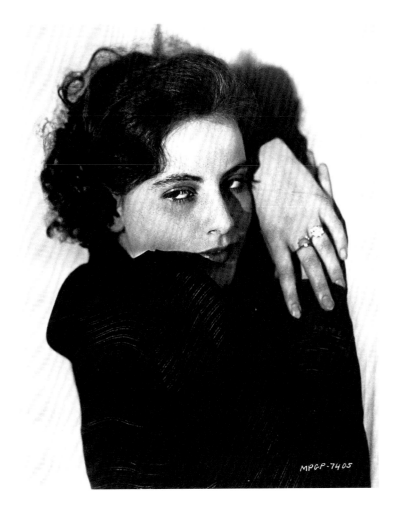

GRETA GARBO IN NEW YORK, JULY 1925, BY RUSSELL BALL (1896–1942)

The John Kobal Foundation

Garbo's first portrait session in New York after she arrived from Sweden in the summer of 1925 was with freelance photographer Russell Ball. Her transformation into a star began when she arrived in Hollywood in September.

he has made of other young players, like Norma Shearer: there's the same soft focus, the same attention to the flowing hair, even similar poses.[12] But the effect of the photographs is very different, and the difference resides in Garbo. Garbo, in Genthe's photographs, is intense and dramatic. Her hair is thick, even fierce; there is nothing softly languorous about her appearance whatsoever. Garbo's partial nudity here projects not vulnerability, but an abstract idealism. She radiates tragedy, not sexuality; she moves through a tremendous range of moods and emotions, from penetrating intelligence to glowing beauty. This is Garbo as La Duse or Bernhardt—two great European actresses—not Garbo as a vamp. Garbo sees herself (and Genthe is forced to agree) as an actress, not as a star.

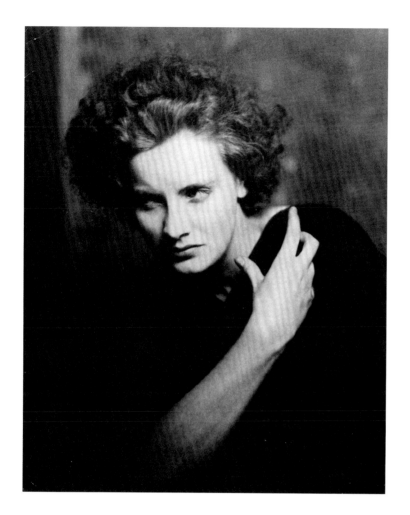

163

Ultimately, the ways in which the two photographers related to MGM and its publicity machine were very different. Ball was a contractor with the studio, and his portrait session with Garbo formed the first entries in her official MGM portrait file. His photographs continued to be part of Garbo's official image bank, part of her publicity apparatus, for many years. Genthe, however, seeing the extraordinary results of his session with the young Swedish actress, sent prints directly to *Vanity Fair,* which continued to publish them for three years. Although the studio knew about this portrait session, it made virtually no use of Genthe's photographs.[13]

Ball's photographs aimed to depict a screen image that MGM could go on to develop; Genthe's aimed to fit Garbo to an ideal crafted by a high-society cultural magazine. One photogra-

pher was working to produce a star, and in this effort Garbo was his subject; the other was portraying an actress, and in so doing he became an active collaborator. The work of the two photographers covers the extremes of imagery suitable to Hollywood's female romantic leads. Into which mold would Garbo be fit? Would MGM's usual approach to typecasting and Garbo's view of herself as an actress reach some accommodation? At the start, MGM's habitual impulses dominated: in her first film, one critic noted, Garbo appeared as an actress "with a surprising propensity for looking like Carol Dempster, Norma Talmadge, Zasu Pitts, and Gloria Swanson."[14] It would take some time for the unique Garbo to appear.

Arriving finally in Los Angeles on September 10, Garbo was greeted at the train station by a group representing Hollywood's Swedish colony, as well as by a publicity photographer and a newsreel cameraman. On Mayer's territory at last, and with a signed contract, she rated the reception due a European leading lady. The photographs of Garbo as she leans down to kiss little Miss Sweden, who presents her with a large bouquet of flowers, place her at the center of attention; Stiller now recedes into the background. Expecting to start work on *The Temptress,* Garbo was forced into a short idleness by another round of contract negotiations between Stiller and Mayer. Again, much has been made of this waiting: one neighbor recalled the two of them sitting for hours on the porch of Garbo's bungalow on the grounds of the Hotel Miramar in Santa Monica, Stiller smoking his pipe and Garbo peeling potatoes.[15] While Stiller held up *The Temptress,* Garbo was cast, within a month of her arrival, in the first-class Cosmopolitan production of *The Torrent,* sharing top billing with one of MGM's leading Latin lovers, Ricardo Cortez—and displacing Aileen Pringle, an established star who had already been advertised in the role. By November 14 makeup and wardrobe tests were being conducted, and filming began on November 27.

Genthe later claimed that it was his photographs that finally made MGM and Mayer take Garbo seriously and cast her in a movie.[16] Garbo is said to have sent copies of his prints to MGM, enlisting a fellow Swede, the director Victor Seastrom, to give a set to Mayer personally. Genthe also claimed that the studio realized Garbo's potential only when his photograph of her was published in *Vanity Fair* in November. In fact, though, not only was Garbo's career set into motion well before Genthe's photograph appeared, but her first role witnessed none of the heroic intelligence clearly projected by his photographs. Indeed, the first action in building Garbo's image after she arrived in Hollywood took place in Louise's portrait studio, not on the set under Stiller's direction, and certainly not under the influence of Arnold Genthe. Here begins the second stage in the creation of Garbo at MGM.

Louise photographed Garbo almost immediately after her arrival on the lot. Portraits, followed by one or more screen tests, always welcomed newcomers and determined their fate. Sit-

ting the first time for Louise, Garbo wears white fur and satin (page 39), and adopts similar poses as in Ball's photographs. The obvious difference is a trivial one: Garbo had had her naturally straight hair curled before the journey from New York to California, so her cascade of short curls becomes an important visual element in these first photographs. The effect of these portraits is more sensitive than Ball's. Louise uses more diffused light and a softer focus; she reads Garbo as innocent and unaware of the camera's gaze, even when she looks into the camera. There is no seductiveness here, and Louise seems to recognize Garbo's essential clarity and lack of vulgarity. Three photographs from this session entered MGM's permanent Garbo portrait file. Like Ball's work from the previous summer, however, they did little to modify MGM's first casting of Garbo.

In Garbo's first two films, she was cast as Latin. The value of the casting was manifold: as a glamorous, hot-blooded foreigner, she could be more sexualized. In the eyes of the studio, they were creating a classic vamp: a dangerous, exotic seductress—and an image Garbo would have to fight against for years to come. This exoticism came with lavish wardrobes and hairstyles. *The Torrent* gives us Garbo as Leonora, who is sometimes hard to recognize from one scene to the next, as she moves from good farm girl (complete with apron and daisies in her hat) to Spanish flamenco dancer (with mantilla) to femme fatale opera diva costumed in an outrageous striped fur wrap. *The Temptress*, Garbo's second role, suffers through a similar range, but this time with the added spice of a whip. She was used carelessly in these films, and neither resulted in a stable, star image. Nevertheless, a coherent and marketable image *was* being developed in the portrait studio.

MGM saw Garbo as a vamp, but this character type was aging badly—and it showed in her first two films. Garbo's sexual allure was not lost on Louise, and it was finally up to the photographer to make sense of the studio's muddled decisions. Louise's first portrait session connected with *The Torrent* was probably a series in which Garbo and Cortez, dressed in peasant costumes, were photographed separately and then together in a series of double portraits. The studio was apparently anxious to capitalize on the pairing, and in addition to Louise's portraits and scene stills (which were plentiful) Garbo and Cortez posed for many publicity photos on and around the set.

It was, however, the romantic photographs that were the most important. In the MGM Garbo files is a set of oversize prints, close-ups of the two together, that at first glance look all of a piece: Garbo and Cortez in a moonlit embrace; Garbo and Cortez with heads together, as though in deep, companionable conversation; Garbo and Cortez in seductive clinches, from vertical to horizontal. In fact, these photos derive from three different sources: scene stills, publicity shots, and the portrait session with Louise. It is in the portrait studio that the fire generated by Garbo and

Cortez burns brightest, and that the Garbo who entranced Mayer and Thalberg watching the first rushes of *The Torrent* first appears. For Louise, Cortez and Garbo acted out a little drama, a refinement and condensation of their film narrative—from the nibble at the ear to the abandonment before the final embrace on the floor. This is the heart of the movie, and Louise was anxious to reproduce it in her studio. Garbo is, in these photos, that peculiar mixture of desire and reticence, erotic energy and ennui, that enabled her to "seduce husbands by the hundreds." But it is precisely at this moment that Garbo's ambivalent relationship with publicity kicked in. Henceforth, although she permitted portraits to be taken, sometimes with her co-stars, her acting was reserved for the screen (and for the stills taken on the set).

This very restriction, however, led Louise to a deeper analysis of Garbo's allure. The photographs Louise took at the end of the filming of *The Torrent* are more dynamic and dramatic than the earlier set. After three months, Louise was getting to know her subject. Selecting a small variety of poses and costumes, Louise records Garbo not as a Spanish peasant girl but as an attractive actress with the makings of a star. She shoots Garbo in full-length profile, as an art deco statuette. She again photographs Garbo with a Spanish fan, but leaves out the mantilla to feature the face. Garbo was brought back into the portrait studio for a final *Torrent* session on December 31, 1925. Publicity clearly felt that the photographs so far generated were insufficiently glamorous, so Garbo poses modeling the luxurious three-quarter-length striped fur coat she wore in the film (see page 71).

A favorite gimmick of MGM publicity was to introduce new players in casual attitudes at home, with family (mothers were a particular favorite), around the studio, or in attractive locations. For Garbo these started off benignly, just before *The Torrent* started filming. Under the direction of Dick Gillum, a freelance photographer the studio used to make "candid" and "action" photos, Garbo was subjected to at least two days posing in various locales. Gillum, who got his start photographing athletes at USC, was more comfortable shooting Joan Crawford doing high splits than trying to draw out a reluctant (and non-English-speaking) newcomer. He first pictures her on the grounds of MGM wearing the same leather coat with fur trim she had worn for her session with Russell Ball the previous July. Garbo is obviously uncomfortable with this sort of impromptu modeling, and Gillum shoots her squinting a little into the sun. Later Garbo is photographed modeling a fur coat on the steps of her "home"; the photo's caption underscores the inanity of the scene: "With that traditional Norse love of the sea, this MGM star has built her home on the very edge of the sea near Coronado Beach." Since she was at the time living at the Miramar Hotel, both the home and the coat are equally borrowed props. Rounding out the day, someone suggested taking Garbo to the zoo. So we have Garbo holding a monkey, in a photo

facetiously labeled: "'Ibsen' is the name Greta Garbo has given this odd pet. . . . 'He taught evolution on the stage,' she explains." Then there's a tiger cub, with the caption: "'I thought it was a new kind of domestic American cat,' she explained in her charming broken English."[17] Finally we see her cowering before a full-size lion, her distress visible on her face. One can imagine Garbo at the end of that day, which may have begun uneventfully enough in the studio but ended in a sort of comic pantomime at the zoo, coming home to Stiller and peeling potatoes to relax herself.

A little more than a month after finishing *The Torrent,* Garbo was back on the set for *The Temptress,* with Stiller directing. Few things in Hollywood go exactly as planned, however, and well into the shooting more than a month later, Stiller was fired. Once again, Garbo was forced to work without her mentor, and in material she thought unsuitable. The production, which had begun March 4, did not end until August 7 owing to the change in director.

As filming of her second movie began, *The Torrent* opened and Garbo was an immediate hit. The European actress now had the makings of an American star. The studio exploited the lengthy production schedule of *The Temptress* and ordered her photographed over and over again in Louise's portrait studio. Garbo would never again be subjected to so many portrait sessions.

The Temptress was a difficult experience for everyone involved—including, no doubt, Louise. The image of Garbo that Louise had worked to manufacture during shooting of *The Torrent* was muddied as the studio debated how she should be presented to the public now that she was a success. Many different costumes were used, offering radically different interpretations. The range is epitomized by Louise's images of Garbo in gold lamé and Garbo swathed in silk scarves. In the first, Louise uses the luxurious and sensuous gold cloth to frame Garbo's head and hair. The actress looks radiantly innocent, but also a bit lost and sad. Louise's sensibility in this session was not perfect, however: in one shot used by the studio fairly frequently, Garbo has wrapped the gold scarf around her head and playfully nips at the end of it with her teeth (page 41). The sequence of photographs of Garbo in silk is a romantic fantasy: Garbo in profile reaches up awkwardly to grapple with an overhanging leafy branch; Garbo, the scarf wrapped tightly around her face, gazes with timid passion over the silk (page 40). Finally, though, Louise lets her do nothing at all, and simply focuses on her face. Garbo is at her most beautiful without props, when she is still, when nothing comes between the actress and the camera's lens. Genthe understood this intuitively; Louise needed to strip away the Hollywood devices before she found her subject's essence.

Gillum was at it again with Garbo early the following spring, for *The Temptress.* Again, the day likely started off innocently enough, with Gillum shooting Garbo practicing for the film's riding sequences. According to Gillum, Garbo was not a natural equestrian, but there was something attractive about the way she rode sidesaddle. Later, he photographed her lying on the grass

in Santa Monica's Palisades Park next to a rustic bridge, and then standing on the bridge. Next—and whether this was Gillum's idea or the studio's is not clear—she was recorded with the USC track team (opposite).[18] From here, the spiral continued downward. In one shot, she appears with Coach Johannes Anderson, a fellow Swede and someone she could presumably feel at home with; but in the next photos she is shown having her biceps squeezed, surrounded by a gaggle of beefy young men, and finally standing under the high bar as Henry Coggeshail, the team's star high jumper, leaps over it and threatens to land on her head. The messages that these photographs send—other than that Garbo looks pretty—are decidedly mixed. Garbo is the homebody, the fashion plate, the animal lover, the athlete, but none of these designations seem to stick.[19]

In the end, it didn't matter. Garbo was through with this sort of general publicity posing; henceforth, she would sit only for photographs that related specifically to her movies.[20] She was able to set limits on her publicity for two reasons: her increasing popularity made her a property the studio did not want to lose (as her famous strike the next year proved); and the publicity department had by now realized that mystery suited Garbo and could be marketed to great advantage.

Up to this point Garbo had been subjected to the predations of a publicity department uninterested in her individuality. Still, Garbo was treated better than most new arrivals in Hollywood, especially since she was accorded star status from the start. Additionally, she found two strong allies, both photographers. Louise cared for her in front of the portrait camera, but equally important was the sensitive attention of cinematographer William Daniels, who guided her through her first and third films. Less actively sympathetic were Garbo's early costume designers and hairdressers.

Normally, romance pictures that featured attractive young stars generated costume studies that formed a fundamental aspect of the movie's publicity. During 1926, therefore, Garbo modeled clothes for photographer Clarence Bull, who occasionally shot costume stills, and general stills photographer Bert Longworth, as well as for Louise. Although the costume stills were widely circulated as fashion photographs, they projected neither Garbo's presence nor a strong fashion sense. A set of composite stills in the MGM archives, dating from mid-1926, provide an indication of how desperate the studio was to fit Garbo into the usual fashion work: her head has been taken from stills for *The Torrent* and *Temptress* and attached to the body of an anonymous model![21] Bert Longworth also made a few "trick" photographs of Garbo. For *The Temptress,* long sequences were shot on the set itself that were not part of the principal photography but enact (somewhat tongue in cheek) the highlights of the narrative. In one series Louise, in a rare foray outside the portrait studio, photographed Garbo playing at choosing among her three leading men. In one

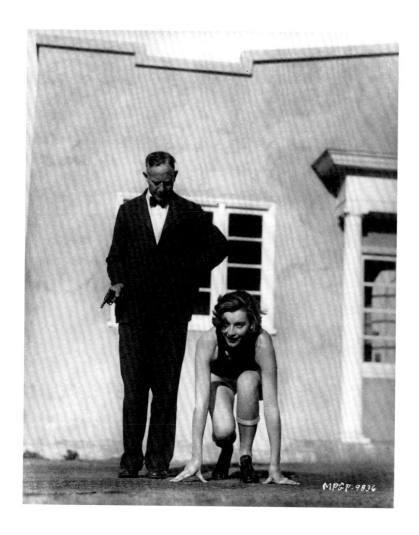

169

shot (page 170), Garbo smiles challengingly at her co-star Antonio Moreno, daring him to strike her with a whip. In another, she enjoys a drink and a cigarette alone in a café, "seducing" only the camera. Charming because of what they tell us about MGM's early attempts to categorize Garbo, such photographs have little to do with the image of Garbo we have today.

In part because she was paired with top leading man John Gilbert, *Flesh and the Devil,* Garbo's third film, was her first unalloyed triumph. The chemistry between the two—let alone the pub- licity surrounding their ensuing affair—would have been enough to assure success by itself.[22] Cast- ing her against an equally strong male star proved to be the right match for Garbo's particular

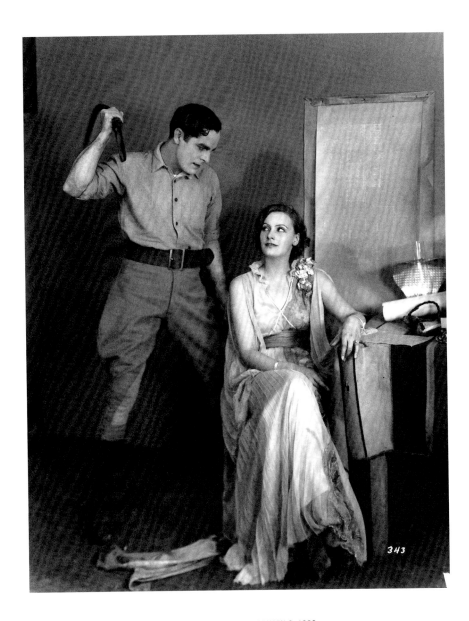

343

GRETA GARBO AND ANTONIO MORENO FOR *THE TEMPTRESS*, FEBRUARY 6, 1926

The John Kobal Foundation

In an unusual session, Louise posed Garbo and *Temptress* co-star Antonio
Moreno in tableaus from the film. At least sixty negatives were exposed, and the
two leads had plenty of opportunity to ham it up for the photographer. By the
end of the year Garbo had enough clout to refuse any similar requests.

erotic energy, which was mysterious, never obvious. But the nature of the pair's relationship was unconventional: Garbo was not just the object of Gilbert's love (and that of audiences); she was its subject. She had power. And the power resided in her magical face. As Louise Brooks says (benefiting a good deal from hindsight): "Looking at Greta Garbo in the Swedish picture *Gösta Berling* in Berlin, [Mayer] knew as sure as he was alive that he had found a sexual symbol beyond his or anyone else's imagining. Here was a face as purely beautiful as Michelangelo's Mary of the Pietà, yet glowing with passion." She adds, trying to convey the effect of Garbo: "From the moment *The Torrent* went into production, no contemporary actress was ever again to be quite happy in herself."[23] Moreover, the appeal of Garbo was androgynous and enormous: she was reputed to receive ninety thousand letters a month, 80 percent of them from women.[24]

Central to the publicity campaign for *Flesh and the Devil* was "the kiss." The shock and fascination of Garbo's first kiss with John Gilbert in that film can still be felt. Not only was it open mouthed, but Garbo—bending over Gilbert—was seen as the aggressor. This was not the first in which she took a superior position: she had done that in her first American film, co-starring with Cortez.[25] Studio executives must have been getting feedback convincing them that a dominant Garbo in love scenes spelled box office success. The kiss was, of course, the central moment in every romance (or "sex drama," as it was innocently described at the time). All the films that Garbo and the other romantic actresses appeared in led up to and away from the kiss. What could not be said or shown about sex was implicit in that one moment of direct physical contact. Surveys of young viewers indicate that their petting behavior, particularly kissing, was learned in large part from the movies, aided by publicity stunts.[26] The kiss was the linchpin on which these movies turned, and as such it was exploited, but it was also dangerous and had to be contained. Gloria Swanson, the epitome of glamour in the early 1920s, remembered that one of the first commandments of the censorship office run by Will Hays, formed in 1922, was that no kiss should run longer than ten feet of film, or two seconds. Two versions of each kiss were therefore filmed: one for American distribution and the other, longer one for European audiences.[27]

The kiss between Garbo and Gilbert from *Flesh and the Devil* (page 173)—one of the most famous images of the silent film era—though often erroneously credited to Louise, was in fact taken by the production's stills photographer, Bert Longworth, on the set just after the scene had been completed. Louise did not even have a chance to recreate the tableau in her studio. Longworth shot four frames in quick succession, capturing the couple in her boudoir after their first night together. These four photographs form two pairs: in both of them, Garbo is reclining. But in the first two, Garbo is sitting up a little, leaning forward, and kissing Gilbert, who sits at her side on the ground. The camera is low, and we are on a level with their heads. In the second pair, the cam-

era is high and captures Garbo lying fully on the couch, with Gilbert crouched above her, not actually kissing her but placing his head next to hers: the angle suggests that they are lying together on the ground. It is these latter photographs that were most reproduced, recording not the moment of the kiss, but the aftermath, with Gilbert and Garbo both in a half-exhausted reverie. It is as close to postcoital bliss as Hollywood could come at the time. As always, Garbo's face dominates: although she may be lower in the picture frame than Gilbert, her face receives the light and our attention.

This moment was not restaged by Louise. Gilbert and Garbo posed together in Louise's studio, on October 2, 1926, but the purpose of these portraits was poster art and not a recreation of the steam generated on screen. In fact, it was probably not until after the film was released that the studio realized how successful Garbo and Gilbert were together. As audiences lined up to see the new romantic pair, publicity scrambled to gather the best photos at hand—which were Longworth's scene stills. Even today, Longworth's photos linger as the central images we conjure up when remembering *Flesh and the Devil.*

Garbo did not begin her next MGM production, *Love,* based on Tolstoy's *Anna Karenina,* until April 7, 1927—though she immediately fell ill, and production did not start in earnest until June 22, some eight and a half months after *Flesh and the Devil'*s completion. This is the period of Garbo's well-documented "strike," which saw Louis B. Mayer capitulate to her financial demands.[28] She threatened—and apparently really was ready—to go back to Sweden if her demands were not met. But what caused Mayer to give in was the enormous box office success of *Flesh and the Devil,* and the support of her fans, who made it clear that they wanted to see more of Garbo and Gilbert. The studio did not want to lose her, so in the end they paid what was necessary to keep her. Mayer also wanted to pair Garbo and Gilbert again as soon as possible, hoping that lightning would strike twice.

The third period of her career at MGM, which witnessed the creation of the Garbo we now recognize, was not an easy one for her or for the studio. Although she did return to the lot in April to begin work on *Love,* with Cortez as her male lead, her illness caused production to stop on May 21. Filming did not resume for a full month, with all the previous footage scrapped because she was now teamed up with Gilbert; principal photography was completed on July 25. Her next movie, *The Divine Woman* with Lars Hanson, followed only a month later, but Garbo seems to have matured through her act of rebellion. Henceforth, she displays none of the uncertainty evident in her first two movies and their publicity. As articulated in portrait sessions with Louise—ranging from one on July 29, 1927, for *Love,* to a mid-November session for *The Divine Woman*—Garbo's image becomes simpler, more elegant, and more sensuous.[29]

GRETA GARBO AND JOHN GILBERT FOR *FLESH AND THE DEVIL*, SEPTEMBER 1926, BY BERTRAM "BUDDY" LONGWORTH

Culver Pictures

This justly famous image from *Flesh and the Devil*, often erroneously credited to Louise, was taken on the set during filming by stills photographer Bertram Longworth.

The July session, which took place a few days after *Love* had finished shooting, saw Garbo back in Louise's studio after a hiatus of nearly ten months. Perhaps the most discernible change in these 1927 portraits was the stylish contemporary dress in which Garbo was costumed. Although she may have declined to promote fashions per se, there was nothing stopping the studio from ordering portraits that featured smart attire as a means of enhancing her image. Garbo, like Dietrich several years later, now became associated (positively) with an androgynous fashion identity—fully exploited by Louise in these portrait sessions. She photographed Garbo, for example, seated on a cloth-draped box in front of a hard-edged geometric cubist stage flat, wearing luxurious white silk men's pajamas. In another pose, Garbo appears in a man's monogrammed black dressing gown against a bold design of stylized leaf-forms. In a third, she wears an oversized black hat and a white camellia pinned to the lapel of her tuxedo jacket. None of these costumes were used in the film.

The poses that Louise invents achieve an unforgettable assuredness. In a rarely reproduced portrait for *Love,* one of her most sensitive renderings of the actress and one of her most influential, Louise depicts Garbo lying on her back, her head hanging over the side of a sofa (page 42). Hair falls away from Garbo's face by the simplest means possible: gravity. The pose emphasizes the length of her neck and her perfect profile, simultaneously suggesting extreme languor and tension, as the weight of her head strains her neck even as it stretches it out. This long neck was, indeed, one of Garbo's quintessential acting props, used most strategically during love scenes, where the hero towers over her and she throws her head back with abandon, clutching and collapsing at the same time. This pose, of course, predates Garbo considerably; it is found, for example, in the French artist Ingres's *Jupiter and Thetis* (1811), with Thetis adopting this exposed position to indicate her closeness and submission. It is also a pose that Garbo assumed for photographers on countless occasions. What is unusual here is Louise's revision of the pose, changing vertical to horizontal, an orientation that Cecil Beaton would find useful a generation later—by which time Garbo had made the gesture her own.

Two sessions with photographers other than Louise were arranged to provide publicity with additional materials. Bull's session, taken on the set of *Love,* was aimed primarily at getting portraits of Gilbert and Garbo together (a lesson learned from the omissions that had occurred with *Flesh and the Devil*). Russell Ball's session was more important. Anxious to promote Garbo as fully as possible, and with magazines clamoring for copy, the studio needed cover art, and apparently none of Louise's photographs were deemed appropriate. Ball was therefore asked to make studies that would translate easily into the painted covers favored by the fan magazines of the 1920s.[30] He photographed Garbo wearing white silk pajamas like those she had worn for Louise, but posed her against a diffused background, her head coquettishly lowered against her shoulder or thrown

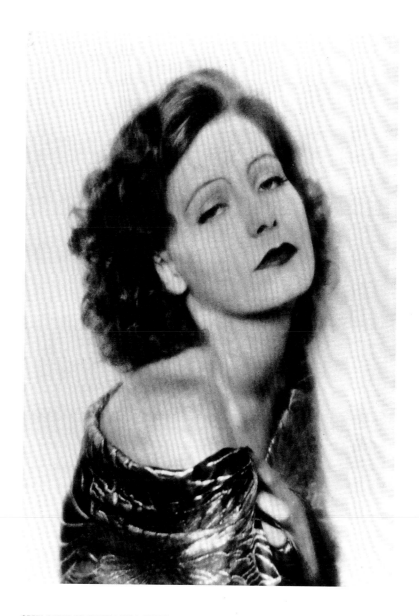

GRETA GARBO BY RUSSELL BALL, AUGUST 1927 (POSTCARD)
Private collection

Russell Ball photographed Garbo in August 1927 to provide cover
art for the magazines clamoring for new images of the Swedish star.
Portraits from this session appeared on countless magazine covers
for years to come and were frequently used as postcards.

back in profile to emphasize the elegant line of her neck. In one photo (page 175), which might have started out as a conventional drape shot, Garbo is photographed in a richly brocaded satin cloth, one shoulder bared, her head tilted slightly back as she clutches the cloth to her chest. In all of Ball's 1927 portraits, Garbo either turns her gaze sultrily aside or directs her eyes boldly at us. Returning to the sensual images he had taken two years before, Ball, though not typically a sensitive photographer, here captures Garbo at her most sexual—his approach now refined through Louise's vision of the actress. In turn, Louise, in her November session with Garbo, would borrow an important element from Ball's repertoire.

It took Louise two years of close scrutiny to find ways to portray consistently the combination of passion and reserve that Garbo revealed before the camera lens. In retrospect, Louise's early portraits of Garbo are attractive but somewhat mannered. When the actress vamped for the camera, she was certainly beautiful, but only when she was in repose did something distinctive emerge. Between fall 1925 and fall 1927, Louise slowly stripped away extraneous props and poses, trusting more and more to Garbo's instincts. In Louise's first session with Garbo in connection with *The Divine Woman,* Garbo rather melodramatically raises her hands to her head, rolls her eyes, and dramatically pulls back on her hair (page 43). The actress does more than reveal her face; now her hands shield her hair and frame her face. The gesture is no doubt one learned at the Swedish Royal Dramatic Theater Academy, used to indicate extreme distress. Together Garbo and Louise make it the very subject of the portrait. Next year she would repeat the gesture for Edward Steichen in his famous photograph for *Vanity Fair* (page 178), and on screen it would become a central motif in *Wild Orchids.* Finally, with the second sitting for *The Divine Woman,* sometime soon after November 9, 1927, everything coalesced. The ground was set in Garbo's session with Ball, but again Louise refines every aspect of his images. In this miraculous session, which began ordinarily enough with Garbo posing in various hats and berets and coats, Garbo slowly unveils herself completely for the camera. The face is uniformly sad, or quiet; Garbo's gestures become slow and heavy.

Louise begins by experimenting with the simplest contrasts: Garbo in a silver velvet dress standing against a black background or wearing a brocaded dressing gown against a neutral flat surface, as she stares provocatively into the camera (page 44). Garbo then agrees to a drape shot. Propped up on the edge of the sofa, a swathe of black velvet around her, Garbo settles into the pose. Louise reverses the contrast found in Ball's soft-focus images: a spotlight leaves everything but her head and one shoulder in utter darkness. Two definitive photographs emerged from this sequence. In one she looks gravely off to her left, her head cocked and her eyes registering her wariness. In the other, head tilted back, she appears to be looking into the camera (page viii),

but on closer inspection we see that her focus is slightly above the camera: she seems lost in that dreamworld unique to Hollywood and the movies. This is the pose seen so often in her movies, as she rests against her leading man, her head tilted upward and the line of her long neck revealed. But now she presents that pose not in profile but head-on; we see the gaze reserved for her leading men, even if it is not quite directed at us. With lips full, eyes wide, hair falling back onto her shoulders, Garbo seems simultaneously to advance and recede. She offers but she does not give. She appears out of nothing and threatens to vanish before our eyes. In this photograph, which embodies the story of all her films—that of love found and lost—Garbo is radiantly beautiful forever, her face shining like the moon set against the black night sky.

And then, in images that circulated rarely, if ever, in the United States but only in Europe, Garbo undrapes completely.[31] In one shot, she assumes a pose Louise has used before, as in her photograph of Mary Doran (page 18). Garbo sits with her body in side view, her right shoulder slightly forward, hiding her breasts, and her face turned toward us. But in contrast to Louise's other women sitters, there is nothing sultry about Garbo's expression, nothing coquettish. Instead she looks soberly and steadily forward, clothed, as the poet Byron would have it, "in beauty like the night." In a final shot, just before the spotlights are switched off, Garbo turns in full profile, and Louise reverses the contrast, shining the lights from behind the scrim directly into the camera (page 45). Garbo is seen in pure silhouette, every feature utterly clear: the straight forehead and nose; the small lips and perfect chin; the long, elegant neck. This is her essence, completely unrevealing and unmistakably Garbo. The results of this session live up unforgettably to the title of the movie they were taken for: *The Divine Woman.*

Garbo had two more sessions with outside photographers in the following years, the last she would grant during her tenure at MGM but out of which came one of the iconic images of the actress. Edward Steichen's encounter with Garbo (page 178), during the second week of August 1928, provides an illuminating contrast with Louise's approach to her work. In his memoirs, Steichen records the sitting as something squeezed into the frantic production schedule of the film, with only a few minutes granted to him and no preparatory time. In fact, he had been given a considerable privilege, since Garbo habitually worked on a closed set and refused entry even to her colleagues, like Marion Davies. Upon her arrival, Garbo, in costume, walked onto the bare stage and straddled a kitchen chair. "I made five or six exposures, all more or less like her typical movie stills. She moved her head this way and that way, chin up and down, but what bothered me most was her hair. It was curled and fluffy and hung down over her forehead. I said, 'It's too bad we're doing this with that movie hairdo.'"[32]

In this recollection, Steichen positions himself as the antidote to the movies: he works on an

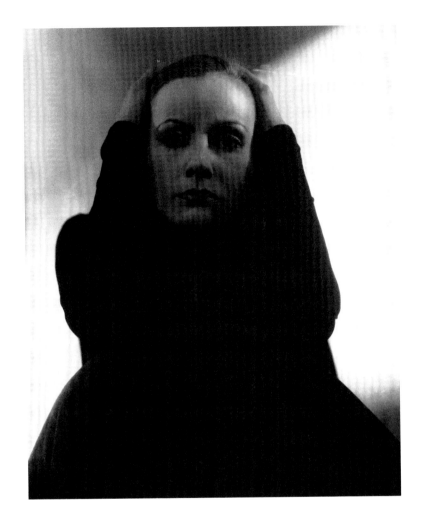

GRETA GARBO, AUGUST 1928, BY EDWARD STEICHEN (1876–1973)

Reprinted with permission of Joanna T. Steichen. Courtesy George Eastman House/Carousel. MGM publicity allowed Steichen to set up his camera on the set of *A Woman of Affairs,* where he shot a handful of negatives of Garbo alone and at least two of her with co-star John Gilbert. This image was published in *Vanity Fair* in October 1929, probably as a substitute for Muray's more risqué image (see p. 181).

empty set and, irritated at his initial inability to get beyond the look of movie stills, is annoyed with the "movie hairdo." His reaction is surprising, since Garbo's hair was simply set and straight, with only a bit of bounce at the end. Indeed, the hairstyle was so simple that *Photoplay* made a special point of picturing it.[33] "At that," Steichen continues, "she put her hands up to her forehead and pushed every strand of hair back away from her face, saying, 'Oh, this terrible hair.' At that moment, the *woman* came out, like the sun coming out from behind dark clouds. The full beauty of her magnificent face was revealed. . . . I don't think Greta Garbo ever had a chance to make the kind of picture she was really capable of doing." Obviously, Steichen regards himself,

as a photographer and artist, the only one capable of rescuing Garbo from the meretriciousness of the movies and revealing her as a *woman.*

The production that Steichen interrupted was *A Woman of Affairs,* starring Gilbert and Garbo and based on the novel *The Green Hat* by Michael Arlen. The photographer's memory is flawed in several crucial ways. First, Steichen remembers that Garbo had been working on a scene in which she leans out the window to see her husband dead. In fact, the costume she wears when she arrives at the shoot is from a subsequent scene. Steichen's memory has been shaped by his subsequent viewing of the movie, and he has chosen his own entry to coincide with the more dramatic scene. Second, Steichen shot several portraits of Gilbert and Garbo together, on the set and certainly under extended and controlled circumstances.[34] Since Gilbert was not in the scenes Garbo was filming, he had to be recalled to the set for the photographs to be taken. The publicity department obviously arranged this portrait session with the cooperation of all participants. In other words, instead of ten minutes alone with Garbo off the set, as he recorded in his memoirs, he had an hour or so with both stars, both on the movie set itself and off. Lastly, Steichen's suggestion that when Garbo pulled her hair back it was a unique gesture, made just for him and at his prompting, ignores the fact that it was by then a common Garbo motif, recorded the year before, most dramatically, by Louise. Steichen may have felt he had revealed the woman beneath the actress, but in fact Garbo was simply acting for him. Steichen's vision of Garbo, which he treats as romantically fresh, is in reality a product of both Garbo's experience and the skill of her previous photographers.

A quintessential image from *A Woman of Affairs* taken by Louise provides an interesting contrast. The composition is simple, a basic head and shoulders shot (page 46). Clad in a plain satin dress, Garbo faces the camera, eyes raised and focusing on some distant point above the spectator. Looking like the figurehead of a ship, Garbo is freed of her usual repertoire of gestures. Here Louise creates one of the first images of Garbo as a heroic dramatic actress. She is monumentally grave; she endures in silence. This is the image of Garbo we find later, at the end of *Queen Christina,* where her enigmatic and unrevealing face seems to sum up every aspect of Christina's character.

In 1928 Garbo made three movies, *The Mysterious Lady, A Woman of Affairs,* and *Wild Orchids,* and was shooting almost continuously from the beginning of May until the end of November. By the third production, Garbo's tolerance for publicity photographs seems to have reached its limit. Mauritz Stiller, who had returned to Sweden, died during the production of *Wild Orchids;* his death was traumatic for Garbo, and, obviously distraught, she curtailed even more severely the time she would give the studio away from the set. For *Wild Orchids,* Louise seems to have

photographed Garbo in only one costume, taking little more than a handful of shots (page 38). Garbo was now treating Louise the way she had Muray and Steichen, giving no more than a few minutes of her time. Nonetheless, these images—perhaps because of their scarcity—were used over and over again, appearing on everything from magazine covers to sheet music and even as advance publicity for Garbo's next film. Leaving for Sweden the minute filming ended, Garbo was again suspended (from December 3, 1928, until the beginning of April 1929). Unavailable for any additional photography, for the second time in her career stills made up the most important part of her publicity, with James Manatt, the film's stills photographer, being duly credited in the fan magazines.

On her return, MGM seems to have decided to get as much out of the actress as it could and shot four movies in grueling succession, the most Garbo ever made in one year. For the first, *The Single Standard,* Garbo and Louise worked together in a typical portrait session (soon after shooting concluded June 4), with a variety of costume changes and a wide variety of poses. But Louise did not take the portraits for the remaining three films. Garbo's single day in the portrait studio for *The Kiss,* on August 27, 1929, was under the direction of Clarence Bull. His vision of Garbo is radically different from Louise's, harder and more abstract. *Anna Christie,* which Garbo filmed twice in quick succession, first in English and then in German with a different director and cast, used one portrait for both productions. Filming of the English version wrapped on November 18, and Garbo sat for Bull the next day. Portraits for *The Kiss* and *Anna Christie* record very different Garbos, an indication that the studio had decided to refashion her image for the sound era. Now that Garbo was turning in a new direction, apparently, Louise no longer seemed so necessary. Exactly why she did not photograph Garbo for *The Kiss* remains the greatest single mystery of Louise's career.

The final session with an outside photographer occurred just as Clarence Bull took over the task of manufacturing Garbo's image, with his first formal portrait session for *The Kiss* on August 27, 1929. Nickolas Muray, Louise's teacher, was sent on assignment by *Vanity Fair* to Hollywood just as Steichen had been the year before. His photographs of Shearer, Crawford with Doug Fairbanks Jr., and other stars would appear beginning that October. The highlight of the trip, however, was his chance to photograph Garbo (opposite). Muray recorded his reaction simply: "Greta Garbo is one of the most beautiful women it has ever been my privilege to photograph," adding, "It is difficult to describe her," but saying that he found her interested in photography and animated in discussing her roles—she was serious, kind, and friendly.[35] She might well have found him approachable because he was a German-speaking Hungarian, and Garbo liked to surround herself with German-speaking foreigners in Hollywood.

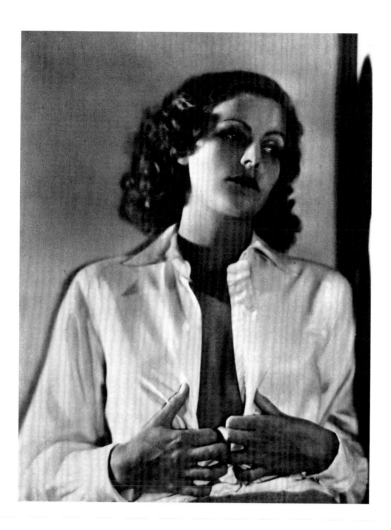

Muray set up his cameras in an empty studio, for a sitting that was to begin after lunch at one o'clock. He requested that Garbo wear a décolleté evening gown "because what I had in mind for the full page was a close-up, with just head and shoulders." Obviously, he wanted her to be both elegant and sensual. She showed up an hour late in a man's shirt, jacket, and tie and a beret, apologizing that she had been unable to find an evening gown that fit her in the wardrobe department. Muray assured her that she looked fine and took "about a dozen shots, with and without the beret, with and without the jacket, with and without the tie. Then I asked her if she would slip the shirt down a bit so that we could get a close-up of just head and shoulders. With complete cooperation she took off the shirt altogether. The noisy set next to our stage became ut-

terly silent." Howard Strickling, the head of publicity who had been supervising the shoot, panicked, ordered the photographer to stop, and ran to get some drapery after covering her with the shirt. Muray took a few more photographs, and then, upon Strickling's return, "we finished the sitting."[36]

As with so many of Garbo's actions, it is hard to interpret her motives: innocent simplicity or calculated deviousness? By posing half nude for Muray, did she merely want to see what Strickling's reaction would be, or was she hoping to get rid of him for a few minutes? Perhaps both— but certainly she was delighted in having Strickling unnerved and found the unsupervised encounter with Muray interesting. Whatever the reasons for her action, the results are unusual. In the most frequently reproduced image from the sitting, Muray captures Garbo leaning against a wall, looking remote and somewhat somber as always, but with her shirt unbuttoned to her waist. She clasps the panels of the shirt with both hands, just below her breasts. If Muray had wanted sex, Garbo was situating herself as a willing subject. And once again, she controlled both the situation and the pose: asked to present herself as a classically glamorous woman, she shows up dressed as a man; an instant later, she reveals her female sexuality. Conscious of her ambiguous sexual appeal (and aware of her own reputation), Garbo enjoyed manipulating it.

As we have seen, Garbo played self-consciously with androgyny for Louise before she posed for Muray in an open man's shirt. For *Love,* Garbo posed in men's pajamas, a man's dressing gown, and a tuxedo jacket. In *The Divine Woman,* she wore a simple Peter Pan collar and beret. And in perhaps the most widely used still for *A Woman of Affairs* the next year, Garbo posed in John Gilbert's tweed coat, as well as her own suede one. A portrait made for *The Single Standard* (1929) features her in slacks and a sweater sitting cross-legged under a Gauguin painting of nude South Seas women. The photograph suggests that Garbo, though clothed in male costume and striking an entirely male pose, retains a close affinity with these sexualized, exotic Tahitians. This was Garbo's great secret, one sensed by Mayer and Thalberg as they watched the first rushes of *The Torrent,* in which she played a Spanish vamp, and by Arnheim and "three hundred men" every night: that within this perfectly beautiful, androgynous, reserved woman glowed deep fires.

By the time she appeared in front of Muray's camera she had been posing since she was a teenager; she was now twenty-three. Through her collaboration with Louise, she knew what she was capable of in front of a portrait camera, what worked and what didn't. It is now Garbo shaping the gestures and their effect. She commands her image. For example, in an image by Muray that is seldom reproduced, taken just before she unbuttoned her shirt, Garbo, her hands resting on the back of her head, pulls her slightly unkempt hair tightly against her skull and back from her face. Again, she repeats the famous pose recorded by Louise and Steichen.

The differences among the three photographers are just as illuminating. Muray's image might be said to be more natural, but it equally conveys a statement about Garbo's public image, and the balance she sought to project between her genuineness, irrespective of gender, and her sexuality. In Steichen's photograph, her protective gesture, in which she clasps her head between hands and forearms, refers as much to her need for privacy, her desire to avoid publicity and self-disclosure, as to her essence as a woman. While Steichen's claim to have revealed the woman behind the star may be debated, that is certainly what he was after. Louise, on the other hand, had a different task: to summarize the essence of the star, as well as the movie—a long narrative with a number of plot turns—in a single image. In one respect, however, Steichen is correct: Hollywood did not serve Garbo well, since all her movies have much the same plot, with her playing virtually the same role in each. That is all the more reason to wonder at Louise's inventiveness in creating an enduring image of a deep and complex woman.

The public remained fascinated by Garbo, who continued to project the allure fashioned first by Louise. The *Vanity Fair Book* of 1931 records the fictional adventures of "The girl who looked like Garbo," one Freda Olson, a simple Swedish-American girl who, because of her resemblance to Garbo, is assumed to have Garbo's devastating effect on men.[37] The pernicious glamour of Garbo is charted against the films her friends see—first *Love,* and then *A Woman of Affairs.* Olson, attempting to escape this reputation, repudiates the resemblance, but then gets jealous when Marlene Dietrich in *Morocco* displaces Garbo, and one of her friends says: "She sure makes Greta Garbo look just like a home girl." *Vanity Fair* underscored the attempt to market Dietrich as another Garbo by printing a Louise photograph of Garbo next to a shot of Dietrich.[38] Louise's images of Garbo continued to reveal the star to the public, even in the face of new stars and a new attitude toward women in 1930s Hollywood (see chapter 11).

During the months that Garbo was filming her first talkie, Louise's last portraits of her began appearing in the press. The caption under one (exclusive to *Photoplay* in November 1929), advertising *The Single Standard,* seems to say it all: "The sole survivor of a the royal line of stars— the queen who, in the eyes of her devoted fans, can do no wrong, Greta Garbo now occupies a peculiar and solitary place in the hearts of picture lovers. . . . 'Our Greta, may she always be right,' says her public. 'But right or wrong, our Greta!'"[39]

LOOKING AT MEN

Ramon Novarro
John Gilbert
William Haines
Johnny Mack Brown

chapter 9

PHOTOGRAPHING LEADING MEN PRESENTED A CHALLENGE for Louise. The "roaring twenties," a period when women were rapidly becoming "modern," had made the photographic depiction of men a problem. Whereas women could be portrayed in a wide variety of attitudes, the depiction of men had barely altered. Indeed, the visual language of femininity began to encroach on that of masculinity: women now wore pants, crossed their knees, stood with arms akimbo! The great danger for men was to be rendered with gestures or props that were rapidly being taken over by women. The distinction between men and women needed to be heightened if men were to avoid being femininized. Not until the 1930s did Hollywood respond with male stars who were decidedly unpolished and tough, such he-man types as Clark Gable, Edward G. Robinson, and Johnny Weissmuller. In the meantime, in the 1920s, the range of pictorial conventions safely masculine was curiously limited. In portraits, the appropriate clothing was restricted (there would be no tee-shirts until Gable revealed his in *It Hap-*

pened One Night, 1934); skin, even an open collar, was practically never seen; ruggedness in pose or costume was seldom exploited.

Clarence Bull solved the problem by photographing all men in much the same manner, removing virtually any sense of individual personality. Louise scrutinized her male subjects more sensitively and attempted to understand the roles her sitters were playing, though she certainly took her share of repetitive head shots as well. Very subtly, Louise began to play more freely with conventional male portraiture, stretching it dangerously close to the imagery of her female ingenues, but at the same time developing "masculine" portrayals that resisted femininization.

Rudolph Valentino, the masculine polestar of the mid-1920s, exemplifies the complexity of male representation more clearly than any other star. The nature of his power was hotly disputed even as his fans' adoration became overwhelming. The two issues that dominated the discussion were his ethnicity and the problematic character of his masculinity: he was not Anglo, and he was overtly sensual. His masculinity did not reside in such commonly "masculine" virtues as strength, forbearance, decisiveness, or rationality. In the dichotomy between masculine virtues—those of the mind—and feminine virtues—those of the body—Valentino's appeal, while obviously centered on his maleness, lay just as obviously in his sexually magnetic body. This paradox was compounded by his ethnicity, which marked him as an emotional and physical Latin.[1] In both instances he stood outside the American norm—and the fierceness with which his female fans venerated him, according to many male commentators, constituted a troubling rejection of this very norm. The movies offered various visions of men, and the American woman had chosen Valentino. He was, in 1925, the only romantic leading man who could command opening nights the way female stars could.

One can gauge the degree to which Valentino shaped the casting of romantic leads by the publicity surrounding the annual crop of male ingenues. In a 1925 piece entitled "Meet the New Sheiks Who Are Storming the Screen," the "advance Fall Style in Heroes" is surveyed: "All they have to do is make passionate screen love to the most beautiful stars of the pictures!"[2] A primary concern of the article is to situate these men's ethnicity, with comments on Paramount's new leading man Richard Arlen being typical: "In spite of an all-American ancestry he looks subtly foreign with his dark hair and eyes. . . . He looks so much like [Ronald] Colman." The trials of a young actor, Don Alverado, who closely resembles Valentino, are also related: instead of having a real career, he is used primarily as a stand-in for the star. It was good to look like Valentino a little, but dangerous to look too much like him. The great screen lover's sudden death the next year left studios scrambling to fill the void. MGM was unusually well prepared, for Mayer had spent nearly as much energy securing male talent as female. Although the range of leading men

was decidedly narrower than that of women, the studio soon created a trio of romantic male stars (and an assortment of pretenders) capable of supporting the women who ultimately came to define MGM. In turn, the questions of masculinity and ethnicity—both associated with Valentino— were the primary factors informing a male star's image at MGM.

The summer Louise arrived at MGM there were several would-be Valentinos on the lot, notably Ricardo Cortez, Antonio Moreno, and Ramon Novarro. The dilemma facing these actors, as it was for women hired as "the next" Mae Murray or (later) Greta Garbo, was that they were not and never could be Valentino. When the dust settled, only Novarro survived because, in an imaginative way, he reinvented the Valentino type. He was the virginal Latin lover, who projected sincerity and purity, as well as a certain boyishness, while possessing the necessary masculine good looks and vitality; he was a cool version of the hot Valentino.

Novarro's first claim to status as a Latin lover lay in his ethnicity: just as Valentino had been clearly Italian, the Mexican Novarro was identifiably of Spanish heritage. This could be construed as both a virtue and a problem, although the question of ethnicity and nationality was at the time in fact much more fluid than one might expect. Small-town audiences were, not surprisingly, somewhat less accepting. John J. Metzger, the proprietor of the Oriental Theatre in Beaver City, Nebraska, for example, wrote to the *Motion Picture Herald* about MGM's *The Winning Ticket* (with Leo Carrillo and Louise Fazenda): "Personally I think there was too mucha da spaghetti in this one and our people just don't care for that kind of fruit."[3] But urban audiences were not so sheltered. The caption on a photograph of Novarro released in September 1924, after his success in the Rex Ingram production of *Scaramouche* for Metro, declared: "In Filmdom's directory, where each player stands for something different, it is Ramon Novarro who stands for Romance. Ramon for Romance—because he is handsome, because he typifies the tender lover, because he seems unsophisticated and human—a Prince Charming of the Screen. . . . The faithfulness with which he has portrayed a Bulgarian prince, a Hawaiian and a Frenchman in various Metro pictures makes the prospect of seeing him as an Arab very attractive to his numerous admirers."[4]

Scaramouche (1922) projected Novarro into leading roles, but *Ben-Hur* secured his stardom. He had been playing in Metro features for over a year as one of the lot's possible Valentinos, but with *Ben-Hur* he was able to project the aura of purity that soon became central to his appeal. He portrays the Jewish prince who defends his people against the Romans, sinks to the depths of slavery, then rises to the height of fortune as a charioteer. In all of this, he resists the allure of the beautiful siren Iras (Carmel Myers) and remains faithful to his family and people. Louise's photographs of Novarro for *Ben-Hur* emphasize this earnestness and loyalty, while never playing down his beauty. Several show him in chain mail and a sort of Crusader helmet, praying: the masculine

but sensitive Ben-Hur. Other portraits more directly focus on his physicality as the heroic win-ner of the famous chariot race. In these, his hair is tousled, his eyes blaze (page 10). His look is not directed at a woman; it is not sexual but ecstatic. Novarro, throughout *Ben-Hur,* trod a fine line between the apparent opposites of eroticism and spirituality. This was the key to his appeal, which Louise managed successfully to record.

Louise was limited by social conventions in the depiction of male eroticism. *Ben-Hur,* how-ever, made before the motion picture code went into effect, is surprisingly sensual and may be the only MGM feature of the period that features full male nudity. (In the slave galley scene, a young man is seen chained to the wall, prominently wearing nothing; this is the prelude to the scenes with Novarro in a loincloth.) While in Italy, Novarro even permitted himself to be photographed discreetly in the nude by Bragaglia.[5] It is unclear what circulation this image had in the United States, but MGM owned a negative of the print, so it must have been condoned for markets over-seas; in fact, it was a popular European postcard in the late 1920s. Yet for all this bodily display, Ben-Hur himself is never seen as sexually active. Novarro becomes a beautiful man to look at, not to touch. Louise underscores this aspect of his beauty in a series of photographs of Novarro's head alone, isolated against a white background (opposite). She focuses our attention on the actor's most striking aspect: the sheer elegance of his face.

To counter this problematic emphasis on his beauty, MGM publicity depicted Novarro out-doors, at the beach, in the gym, or playing sports, always playing up his health and virility.[6] More than other male stars, he was at regular intervals throughout his career at MGM made the sub-ject of photo features that stressed his athleticism. Louise, of course, was not invited into the gym with Novarro; those sessions were left to Clarence Bull and later Hurrell. At the same time, No-varro must have been the only romantic lead to be featured in a story in which he welcomed his "greatest fan," Grandma Baker of Oak Park, into his home.[7] Publicity also arranged stories fea-turing Novarro, ever the good bachelor son, in the arms of his family. Despite being the screen's ideal young lover, he was almost never depicted in that role in his offscreen life.[8]

Novarro was a romantic star, to be sure; but unlike Valentino, for whom romance was bound up with dance (and thus his body), Novarro became associated with music. Well before sound ar-rived in Hollywood, music seemed to surround him. In a highly staged photograph by the New York photographer Charles Albin—in which "Ramon strums his lute and sings to his Lillian"—Novarro is seen seated on a Renaissance chair holding a lute and gazing devotedly at a marble bust of Lillian Gish; on the table next to the sculpture are a vase of flowers and a photograph of Gish in a soulful movie clutch. Novarro, the caption states, is the "romantic young soul . . . [who] should have lived in the days of the troubadours."[9] There was nothing hot or jazzy about him. Novarro

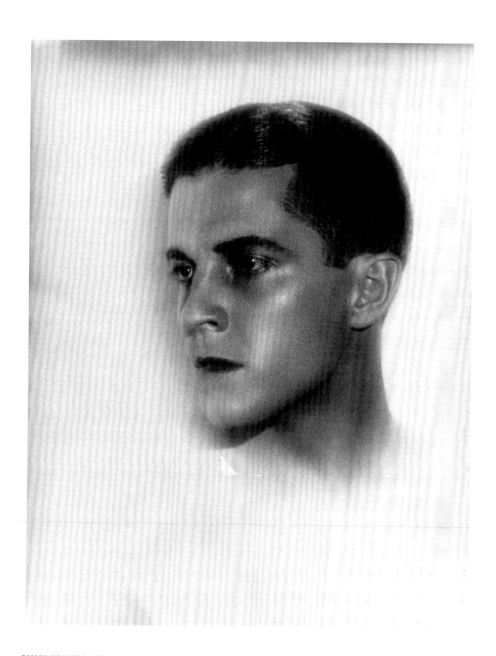

RAMON NOVARRO, 1927

The John Kobal Foundation

Novarro was an exception to the rule that men should not be made
to look beautiful. Louise isolated his head as an aesthetic object, much
as she might do with female stars. The photograph was published in
Picture Play (June 1928, p. 70).

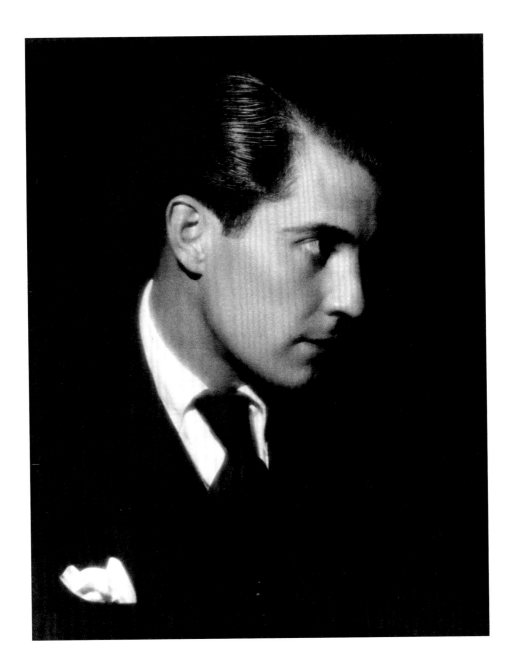

RAMON NOVARRO, 1928

Hulton Archive/Getty Images

The studio used this image on the cover of the sheet music for "Pagan
Love Song," the theme song of Novarro's hit *The Pagan,* in which he was
rarely depicted wearing much of anything at all, much less a tie.

actually played a troubadour a few years later, in *The Student Prince of Old Heidelberg* (1927), and Louise photographed him playing the guitar for a group of admiring children, in an equally staged photograph (page 49).[10] The photograph was published in honor of the first concert Novarro held at the theater he built at his house in 1927, named Teatro Intimo. *Photoplay* announced that he was considered "the coming great tenor" and that when "he has finished his picture contract, he will go troubadouring around the world."[11] Teatro Intimo is itself the subject of many photographs and features, including some by Louise. The professional quality of the theater caught her attention, and she photographed details of the space in close-up, training her lens, for example, on the backstage switchboard (page 51). In this impressively geometric composition Louise seems to be responding to the modernist current in works by such New York–based photographers such as Charles Sheeler. Louise also emphasizes the disjunction between Novarro and his creation: standing on stage, he is dwarfed by the space around him (page 50). Unintentionally, Louise seems to suggest that this theater centers on one man's vanity.

The idea of a professional singing career for Novarro was to be a constant theme for the next few years, one that reached new heights in 1929 when his contract was up for renewal and he seriously contemplated leaving the screen for a musical life on stage. Novarro and the studio reached a compromise worthy of Solomon, in which the actor agreed to spend six months at MGM, with the balance of the year open for him to pursue other creative ventures.[12] Novarro's musical abilities were not lost on MGM producers, however, and he had the distinction to be the first MGM star to actually sing in a movie, when he recorded "Pagan Lover," the theme song of *The Pagan* (1929). Louise's portrait on the cover of the music sheet (opposite) captures him as another kind of singer, the cabaret singer: he is seen in profile, in a dark suit against a dark background—sophisticated but quiet and beautiful. Even as a modern singer, he opts for elegance, not jazz.

John Gilbert (page 193), MGM's biggest male star of the silent era, never sought to imitate Valentino. Although he became the screen's next "great lover," he held the position in a very different fashion. For one thing, Gilbert was distinctly and unambivalently American. He was also the fundamentally decent guy who happens to have the qualities of a romantic hero, the same sort that Harrison Ford represents today.[13] In 1920s terms he was like the displaced midwestern heroes that dominated the fiction of the day (such as Nick Carraway in *The Great Gatsby*, but with more glamour and vitality, less ennui and confusion). In fact, these homegrown characters occupied the center of the American cultural stage. They are physical but not sexual, handsome but never pretty, smart but not intellectual, as they strive to make sense of the changes that marked the postwar period. On the one hand, they are forced to adapt to the new relations between men and women; on the other, they must deal with the new order of the business world. The mythi-

cal world of small-town America, embodied in the Midwest, had been shaken from top to bottom by the war. These heroes are faced with the painful task of adjusting to a new place, one that no longer fits them and into which they no longer fit.

Despite being an all-American type himself, Gilbert seldom played that role, appearing as often as not as a swashbuckler, a prince, or a European. During 1925 and early 1926 he gradually transformed himself. Whereas he had started his career as "the glass of fashion and mould of form," now his sincerity and authenticity begin to be emphasized.[14] His military haircuts and astonishing vigor signal repeatedly his earnestness, subtly undercutting his glamour while strengthening his appeal. Gilbert was always the domestic product, even when he played a foreigner, while Novarro was the import. Indeed, understanding Gilbert as the native son explains the magnetic quality of the Garbo-Gilbert pairing: this was the union of opposites, the foreign exotic and the down-home boy. Garbo could never be an American type because she was fundamentally about sex, and that is never American; sexually centered women always come to no good or get left out of the happy ending. Louise Brooks, the one American actress who embodied something of this quality in the 1920s, made her best films in Europe.[15]

Gilbert could never be anything but a regular guy. This was the crux of King Vidor's *The Big Parade:* Gilbert plays a young midwesterner, living within the protective circle of his family, who goes off to the war in France and returns so changed that he cannot remain constant to his youthful values. Besides, his war experiences have changed him: he has fallen in love with a French girl (Renée Adorée), and finally finds a measure of happiness when he returns to France to regain her. As the MGM program declares, "What a buck private! And what a lover!" Louise, in a critical series of images dating from her first days at MGM, needed to capture these contradictory aspects— Gilbert as everyman *and* Gilbert as romantic hero—but without any of the usual Hollywood props of exotic costumes or settings. This refinement of Gilbert's image, embodied and publicized in her portraits, was noted in the program as well: "There's a danger to every 'society actor' of becoming a 'clothes-horse.' . . . Not so, John Gilbert."[16] The portraits for *The Big Parade* concentrate on Gilbert's ruggedly handsome face, as a soldier both before and after the defining experience of war. Louise depicts him first as the happy, untried doughboy, his hands holding the straps of his backpack as though he had just been marching (this is the image reproduced in the program; see color plate 1). Next we see him experienced and wary, holding a bayonetted rifle, about to go into battle (page 11). Finally his helmet is off, stubble shadows his chin, and his hair has gone all awry.[17] The battle is over and the idealism and illusion have been stripped away, yet Gilbert's vitality survives.

Gilbert was MGM's most valuable male property during its most vulnerable period, from the

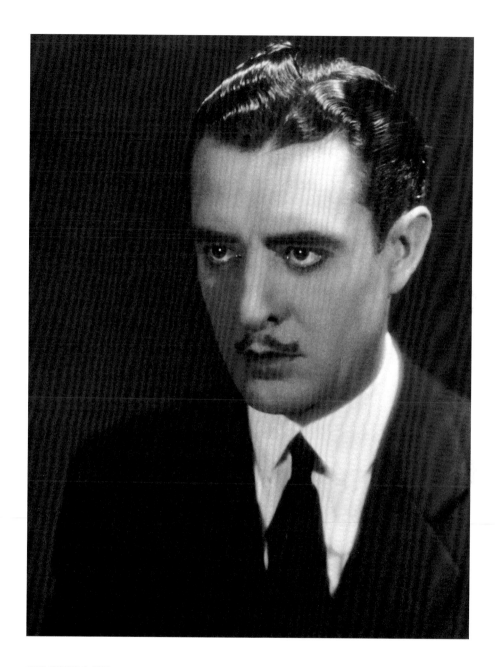

JOHN GILBERT, C. 1928

Private collection

Gilbert hated to have his portrait taken, although he is said to have enjoyed
working with Louise. Men rarely advertised clothing, but this portrait was
used in an advertisement for Lucky Strike in *Liberty,* July 1929.

filming of *Merry Widow* at the end of 1924 to the release of *Flesh and the Devil* at the end of 1926. During these two years, Gilbert starred in virtually all of MGM's more prestigious romance pictures. He was the one male star paired with the all leading actresses on the lot: Mae Murray in *Merry Widow,* Aileen Pringle in *Wife of the Centaur,* Lillian Gish in *La Boheme,* Garbo in *Flesh and the Devil,* Eleanor Boardman in *Bardelys the Magnificent,* and Renée Adorée in his greatest triumph, the astonishingly successful *Big Parade.* For all his screen presence, however, photographs of Gilbert are scarce. Louise identified one reason for this lack: "He hates having his picture taken and sometimes he walks up the steps like a petulant little boy who has something to do like an arithmetic lesson. Then it is my job to kid him out of this mood."[18] When he felt like working, though, Louise compared Gilbert favorably to the always photogenic Novarro: "Novarro's imagination is so keen that he can throw himself into any pose or mood without two seconds' hesitation. John Gilbert is like that, too."[19] New portraits tended to be made only when he appeared in costume dramas such as *Bardelys the Magnificent* and *The Cossacks* (page 47). In other situations, given the conventions of male portraiture, he was reduced to the narrowest range of poses and situations, a bore for a hyperkinetic actor like Gilbert. Gilbert's essential quality as a regular American guy was enhanced, rather than hurt, by the lack of variety in his portraits.

The third of MGM's trio of leading male stars was William Haines. Billy Haines projected youth, and usually played the College Kid. The craze for "collegiates" in the twenties was a new phenomenon, fueled by Fitzgerald's first novels and the dance movies of Crawford and others.[20] At MGM (unlike Paramount, for example), the focus was on youth without sex (which no doubt suited Haines, who was gay), and with his wholesome good looks he was ideal for such roles: he had bounce, energy, and he was known as a wisecracker, "that cheeky specimen of young American manhood."[21] As with Gilbert, photographs of Haines are relatively rare. Most of Louise's images depict him as casually relaxed, the boy next door, or mugging with his co-stars. One rare portrait shows a dashing vision of Haines, the brim of his hat jauntily shading his eyes (page 21); but this image had little do with his onscreen roles. Indeed, it was difficult to convey with a photograph the spirit that made Haines so popular on film: his persona depended on the moving image.

Novarro and Gilbert retained their popularity throughout the twenties, and the studio did not groom younger actors to take over. Perhaps bosses understood that Novarro's brand of "exoticism" was on the wane and wouldn't be replaced in the next generation. Gilbert, it was thought, would mature successfully into older roles (though this dramatically was not to be the case). As for Haines, in contrast, it was becoming difficult for him continually to play a lad of nineteen, and a line of successors formed, ready to assume his brand of youthful dash. These included Johnny

Mack Brown (who had actually played college football), Ralph Forbes, and Robert Montgomery. Women, especially young women, pressured the studio for more youthful romantic leads. As J.H and A.S, from Portland, Oregon, wrote in 1925: We are "trying to express the sentiments of two high school girls concerning the pictures in *Photoplay*. . . . Why can't we have more pictures of the younger actors, such as Bobby Agnew, William Haines, Ben Finney and William Collier, Jr.?"[22] By 1929, Billy Haines was no longer perceived as "younger," and it would not be long before he left movies for good. Of all of his successors, Robert Montgomery was the most successful. He was the rising young male ingenue on the lot in the last year Louise worked there, and succeeded in inheriting Haines's wisecracker sensibility while also playing romantic leads. In sessions with Louise he, like nearly all the other young men on the lot, was carefully subordinated to the women stars he worked with. In two photographs of Montgomery, one with Shearer (page 153) and one with Crawford (page 37), for example, even though his position within the frame is superior to theirs, he remains the junior partner.

MGM, like most studios, employed actors who closely resembled its stars both in appearance and mannerism. These secondary leading men played variations on the main types. For example, Conrad Nagel, perhaps the most successful of this group, was the debonair gentleman, but he always seemed a bit stiff and never managed the roguish charm of John Gilbert. This system of types was both productive and frustrating. A magazine profile of Ricardo Cortez, one of MGM's discarded Valentinos, demonstrates its force: "Ricardo—the First and he doesn't pretend to be a second Valentino."[23] He is described as Austrian, the son of a concert singer and a businessman. At the same time, the article assures the reader, many people compare him to John Gilbert. His identity is constructed primarily in comparison: an actor is hot if he is used as the standard against which others are measured. Such comparisons were not uncontested: "How it does make my blood boil to see John Gilbert named as 'another Valentino successor,'" declares one irritated *Picture Play* reader. "What the fans can see in Gilbert is more than I can comprehend."[24] Conversely, in the same issue, a fan who couldn't stand Valentino, who avoided Novarro because he was compared to Valentino, writes after finally seeing one of his films that she thought he was wonderful.[25]

With the exception of Louise, studio photographers weren't particularly imaginative with their male subjects and tended to photograph them all alike. As a result, perhaps not surprisingly, men were considered much easier to photograph than women. As Russell Ball explained, "A photographer always strives for masculinity in a man's picture. That is why a slight frown, or a severe expression, often brings excellent results. . . . Simplicity is the proper background for men."[26] The need for plainness comes clear in fan comments, as in a letter from a fourteen-year-old boy say-

ing that "Douglas Fairbanks Jr. looks like a girl who has her hair pushed back."[27] The distinction between men and women needed to be preserved, particularly in the case of romantic male leads. Valentino bore the brunt of the abuse heaped on such specimens of male beauty, but the disapprobation was widely spread.[28]

Certain signs of masculinity helped overcome the problem. Most obvious was military dress, and nearly every MGM leading man had at least one opportunity to show off the brass. There was, however, a distinction between combat uniforms, which were extremely rare, and dress uniforms. Hollywood, after all, specialized in fantasy. Novarro was elegantly turned out in *The Midshipman* and in *The Student Prince of Old Heidelberg,* and he wore uniforms in *A Certain Young Man* and *The Flying Fleet.* Even Billy Haines attended West Point (in the eponymous film of 1926), and Gilbert frequently appeared in fancy European dress uniforms. At the same time, these decorative outfits were a little suspect, not quite real. Marion Davies lampooned all of these uniforms in her trouser role in *Beverly of Graustark,* where she dressed up in a multitude of such costumes (wearing a fake mustache to heighten the comic effect).[29]

Even child star Jackie Coogan marched as a cadet, later recreating the scene in Louise's portrait studio. She depicts Coogan with "a slight frown" and grasping his uniform's belt firmly. He was "like a wise old man," recalled Louise.[30] In a series of portraits Louise made of Ralph Forbes in uniform she was forced to grapple with a similar difficulty: Forbes's softly handsome face. In one photograph, made for *The Enemy* (1928), he looks gravely off to the side, his hands on the table in front of him. One hand bears a pinky ring, the other holds a cigarette, so that even his hands play out the conflict between his looks and his putative role. In another photo he tries to fill out his uniform, sitting erectly and stiffly on a stool. It is an unconvincing attempt, his attractiveness at odds with the military demeanor he is asked to display. Only a few years later, when he had put on enough weight to get a little jowly, did he overcome this problem. But by then his MGM career was over.

Two images of Johnny Mack Brown (page 198) and Nils Asther (page 199) illustrate the complexities of a quintessential masculine prop: the cigarette.[31] (Women could smoke in the 1920s, but it was not socially acceptable for "good girls" to do so. Actresses who were photographed smoking were generally doing so in character or else had been permanently typed as vamps. Garbo lights Gilbert's cigarette in the famous scene toward the beginning of *Flesh and the Devil,* but she doesn't smoke herself.)[32] In these two male portraits the smoking, like the tuxedos, is tailored to the players' personas. Brown was a former football player: he was a straight arrow. Indeed, when the talkies came he established himself as a cowboy star. In Louise's photograph, he is seen in profile, seated on the arm of a couch, intently leaning forward to light his cigarette. Brown reads

as a big block of maleness, contrasting strongly with the feminized setting of chinoiserie and embroidery in which he finds himself; so strong is his presence that he effectively erases the setting. Asther, who as a foreigner (he was Swedish) frequently played aristocrats and morally ambiguous lovers, is also seen in profile. But his arm doesn't block the elegant line of his white shirt-front or crease his shoulders. Moreover, he holds his cigarette with utmost elegance in a long holder. But then, within this dangerously sophisticated frame, he frowns slightly as he looks to the side. He may not be as all-American as Brown, but he is equally masculine in a slightly sinister way.[33]

Throughout 1929, the two men were repeatedly paired in fan publicity. In July 1929, for example, *Screen Secrets* characterized Asther as "one of the most romantic figures on the screen today," while Brown was "one of the few noted athletes in the country to make an established name for himself on the screen." But a few months later, the magazine was astounded that fans could not distinguish the two in one of its cut puzzles: "nearly a third mistook Nils Asther for Johnny Mack Brown! Perhaps it was the gym shirt and basketball that started the fans on the wrong foot, for Johnny Brown is a noted athlete."[34] Brown and Asther were similarly positioned for success. Brown seemed on the verge of MGM stardom but lost his place to the next generation of leading men, most noticeably Clark Gable, and went on to make his career in westerns instead. Asther's type did not fare well in the 1930s. His slightly sinister romantic persona played well opposite Garbo but did not work with the other MGM ladies.

Fashion raised another difficult issue for men. Howard Strickling forbade MGM's male stars to appear in fashion ads, for fear of effeminacy.[35] Erté recalled in his autobiography that he had hoped to introduce the idea that men, too, could dress beautifully, but Americans reacted in puritanical horror: "What caused most excitement in the American press . . . was my desire to develop more colorful and imaginative designs in men's clothes." Erté was quoted in the papers: "Men have got to begin by wearing brownish-violet evening suits and continue on the same path until they have formed the habit of consulting the fashion pages as feverishly as women."[36] Instead, evening dress and the occasional white tie were about the limit of the elegance men were permitted.

Rules are made to be broken, however, and in one of Louise's most unusual photographs, she does just that with Brown (page 200), who leans his carefully burnished head on his fist. The image is an imaginative reworking of Man Ray's famous photograph (page 201) of Kiki posed against an African mask, *Noire et blanche,* that had been published in Paris *Vogue* in May 1926; Man Ray's image was, in turn, inspired by Brancusi. Louise has caught the ovoid shape of Brown's cranium, with his hair slicked back and his movie makeup immaculate, and transformed it into a perfect

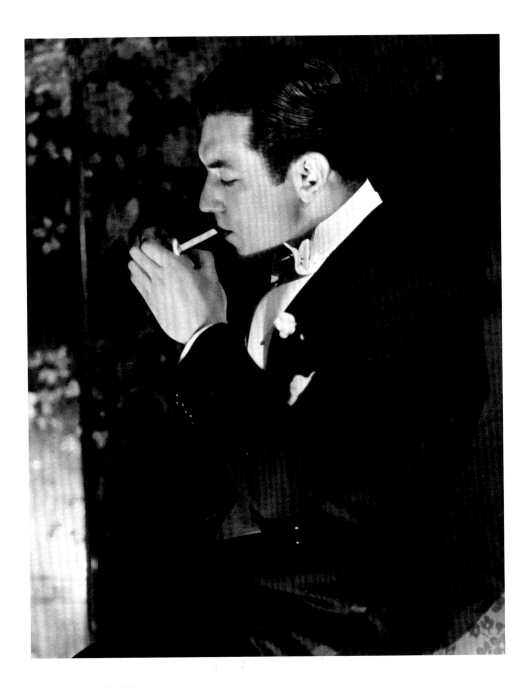

JOHNNY MACK BROWN, 1929

Turner Entertainment Co./MGM Collection;

courtesy of Academy of Motion Picture Arts and Sciences.

Johnny Mack Brown, a former football star, was cast in strongly masculine

roles. Louise captures this aspect of him, despite the elegant setting.

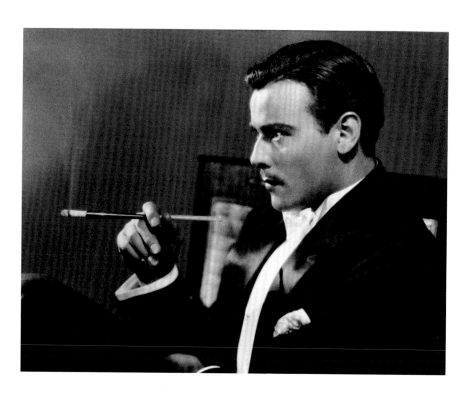

geometric form. Such subtle references to Parisian avant-garde art and the world of fashion are seldom encountered in male portraits. And perhaps it was only possible with a young, untried ac-tor like Brown, who would have had no more control over his looks and his career than his newly arrived female counterparts. Although the studio was building Brown's image on his athleticism, Louise could ignore that persona; indeed, Brown is virtually unrecognizable in this picture. A sim-ilar move toward abstraction may be found in the portrait of Forbes looking out Louise's studio window, in which, backlit, he becomes almost pure profile (page 15). The pensive moment she captures does nothing to advance his screen personality. The photograph is almost antipublicity in its quietness.

Another important genre of portraiture—the star at home—was also carried out differently for men and women.[37] For the men, it was imperative to show them in masculine settings within the domestic milieu. Louise photographed John Gilbert at home squatting in front of a roaring fire, for instance, or seated at his cluttered desk. In one of her best-known photographs (page 202), Gilbert stands at the window of his bedroom. He is not seductive but serious, and without

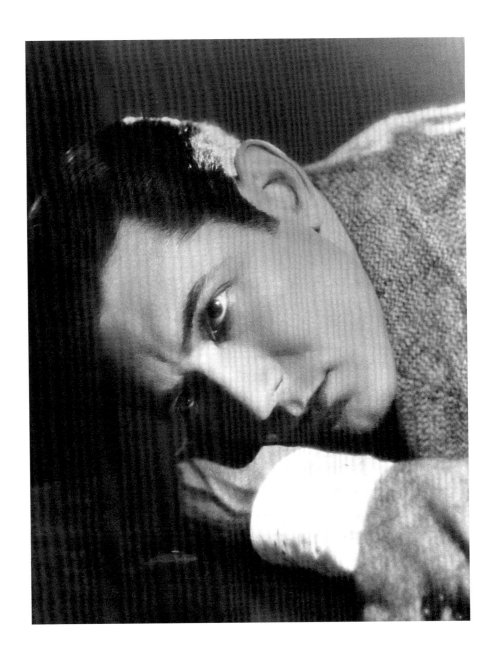

JOHNNY MACK BROWN, 1928

Turner Entertainment Co./MGM Collection;
courtesy of Academy of Motion Picture Arts and Sciences

Louise's compositional inventiveness is well displayed in this image.
Inspired by Man Ray's photograph, she successfully captures Johnny
Mack Brown as a Brancusi head.

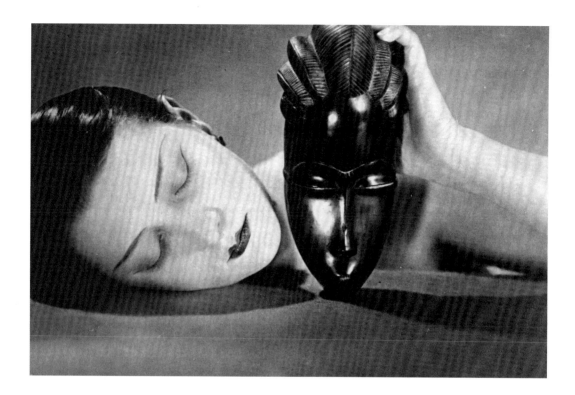

NOIRE ET BLANCHE, 1926, BY MAN RAY

The Museum of Modern Art, New York. Gift of James Thrall Soby.

Man Ray's photograph of the model Kiki and an African mask was
published in Paris *Vogue* in May 1926. Kiki's head is an homage to a
Brancusi sculpture, *Sleeping Muse* (1910).

smiling looks directly into her camera. Here the dominant motif is not elegance, despite the lux-
urious black satin robe, but simple masculinity. In some photographs of male stars at home, Louise
subordinates the subject to the setting, or to the interest of the composition. Gilbert's home it-
self, much like Novarro's theater, gets the star treatment. In these cases Louise used the celebrity
of the performer to justify taking an architectural study. In so doing, she was nonetheless able to
suggest a larger-than-life personality, as in the photograph of Gilbert's bedroom, sans Gilbert him-
self (page 203).

In the end, male stars and romantic leads received far less publicity than the women: they
were never the subject of calendar art, seasonal art, or pinups. Inevitably, complaints arose that

**JOHN GILBERT
AT WINDOW, 1929**
The John Kobal
Foundation
Gilbert had a good
working relationship
with Louise and
allowed her twice to
photograph him at
home.

the studios ignored their men. As one peeved fan, Gladys of Washington, D.C., wrote to *Photo-play:* "We really do want some good pictures of R. Novarro, R. Barthelmes, J. Gilbert and R. Colman. It is very tiresome to see girls, girls, girls, all through a movie magazine, even if we are fond of them. So please won't you give us some pictures of men? I say 'we' because I am writing for a great number of fans."[38] The request, however, had little effect.

203

JOHN GILBERT'S BEDROOM, 1929

Courtesy of the Academy of Motion Picture Arts and Sciences

Louise renders Gilbert's bedroom—the scene of many a fan's
fevered imagination—as an abstract architectural space.

TELLING STORIES

Lillian Gish
Lon Chaney
Buster Keaton
Marie Dressler

chapter 10

FOR THE MOST PART, LOUISE PHOTOGRAPHED PERFORMERS who were stars as opposed to actors. The need to capture the glamorous cinematic personas of these players was more important than the need to portray their acting ability. But the firmament of MGM's heaven had room for another kind of figure: the stars who were actors first—who could transcend looks (and age) yet still hold audiences enthralled. These stars are the hardest to stereotype because they assumed many and often contradictory roles, rather than filling roles tailored to a carefully cultivated public image. Established troupers like Lillian Gish, Lon Chaney, Buster Keaton, and Marie Dressler were neither created nor refined by MGM, and they broke the fundamental rule of stardom as understood by publicity: instead of being recognized for their beauty and glamour, the "actors" were known for their talent. More difficult to sell, these actor-stars relied on their tremendous force of personality, which carried them from film to film. Also in contrast to the romantic stars, these performers rarely, if ever, participated in photo sessions

outside the studio, and their private lives never blurred with their screen work for the entertainment of the fans.

Louise worked with these actors in a very different manner, recalling for them the artistic credo that she had articulated as a teenager in New Jersey: capturing character was the soul of a good portrait. For Louise, painters were superior in some ways to photographers, because in the long process of creating a painting they were able to really study the subject and thus present the sitter's personality in graphic form, by a well-chosen expression or gesture. That should be the goal of the photographer too.[1] Louise always insisted that she was, first and foremost, photographing personality, and this was best seen in her work with veteran actors. As one reporter wrote, "She works like a director getting her best effects for emotional and character pictures by the proper choice of a word."[2]

The most important actor-star at MGM when Louise was hired was Lillian Gish. Gish's remarkable career had begun under the tutelage of D. W. Griffith in 1912, but by 1925 she had been independent for several years. She brought to the studio the credentials of a great actress, but, unusual among her peers, she fought strenuously against being marketed as a star—and almost succeeded. Ultimately, Gish was a star because MGM needed her to be one: luring her in 1925 with a salary of eight thousand dollars a week, the studio needed more than the prestige of her name; they needed fans buying tickets to her films. In her autobiography, she records at length her distaste for the excesses of Hollywood, the hoopla and ballyhoo, the glamour. "In general, I liked making pictures but not the notoriety and publicity surrounding them."[3] In the end Gish walked away from MGM, thus relinquishing her place in Hollywood.

In retrospect the encounter between MGM and Gish is an amusing one—a comedy of misunderstandings and clashing values. At the time, each of the parties must have thought the other blind and stupid. When Gish, on April 14, 1925, arrived in Hollywood under contract for the first time with a major studio, she found that nothing had been done to prepare for her. She suggested for her first undertaking the filming of *La Boheme,* the story of the love between a prostitute and an impoverished artist. The studio gave Gish everything she asked for, including the best director on the lot, King Vidor, and its hottest male star, John Gilbert. Both were Hollywood veterans, ideally suited to working with Gish. Gilbert promptly fell in love with his leading lady and asked to marry her. Gish was not interested. Gish also decided that the key to the sexual tension of the film would be the absence of a kiss between Mimi and Rodolfo. Nothing could have been more contrary to the basic tenets of MGM. The studio won round one, and Gish kissed Gilbert. Her next film, *The Scarlet Letter,* was about an adulteress. If Gish disliked playing romantic roles, Hester Prynne should have proved a soothing antidote. By this time, Gish was also a little wiser

to the studio and demanded a set dominated by Europeans who shared her values, so Victor Seastrom directed and Lars Hanson co-starred as Dimsdale. Gish's next two films, *Annie Laurie* and *The Enemy,* both made in 1927, failed at the box office. She returned to Seastrom in 1928 and they made *The Wind,* which, though now considered a classic, was deemed by contemporary audiences and Mayer to be Gish's third failure in a row. Made just as talkies were becoming the rage, it went virtually unnoticed. Studio and actress agreed to cancel the remaining film in Gish's contract.

In one of the most vivid accounts of the era, the actress Louise Brooks adopts a conspiracy theory to explain this trajectory. She identifies 1925 as the year in which producers declared war on the star system.[4] First, this was the year Wall Street declared its control: stars were too highly paid for the income they generated. Second, there was the question of censorship: stars were too profligate, and such moral deviance disturbed both the studio chiefs and the bankers. In their effort to destroy stars, and so exert control over the industry, they made Lillian Gish the first victim, in a campaign orchestrated by James Quirk, editor of *Photoplay.* And indeed, *Photoplay*'s reviews and gossip items about Gish are astonishingly hostile, particularly given the magazine's close connections with MGM.[5] The truth was that Gish and the studio system were fundamentally incompatible.

Louise's photographs of Gish faithfully reflect both her strengths and weaknesses, as they were perceived by the studio: she is always striking but never even remotely sensual. Louise's initial portrait session with Gish produced her first widely reproduced images, appearing in the September 1925 *Photoplay.* The photographs were taken during the summer, preceding Gish's first MGM production, and were used to announce her signing. But there is nothing glamorous about this great new catch: Gish appears in a stylish but subdued blouse and hat, looking quietly at the camera. Such images of the actress, always dressed plainly and projecting calm, are characteristic. It was during the filming of *The Scarlet Letter* that Garbo met Gish, who enjoyed a considerable European fame. Stiller parked Garbo on the set near Seastrom and Hanson, and the young actress spent hours observing her idol. She commented with a heartfelt sigh: "When I am a beeg—like Miss Gish—I have no publeecity!"[6] It was not just her acting she was studying; Gish's reserve made an impression as well. In the end, Garbo bettered her model as a star with a reluctant relationship to publicity, because she delivered on-screen more successfully than any other actress of the day the pivot of the screen sex drama, the sensuous kiss. What Gish delivered had nothing to do with sex.

Gish initially declared that she would manage her own publicity, bringing outside photographers into the studio. For *La Boheme,* she invited two well-known and prestigious photogra-

phers, Kenneth Alexander and Henry Waxman, to work with her. Alexander was responsible for the portraits of Gish and Gilbert, and Waxman took most of the scene stills. Louise made costume studies with Gish before filming commenced and photographed co-star Gilbert and second lead Renée Adorée.[7] With Gish's next production, *The Scarlet Letter,* Louise was given the opportunity to work with the actress in the portrait studio. In one photograph we see the demure and innocent Gish seated with her hands laid elegantly in her lap; her left hand is cast down, while the right appears to beckon at the ominous shadow Lars Hanson casts on the wall (page 52). Sharply cropped by the frame, his shadow serves to bracket Gish's curving figure on the left.[8] In this way, Louise suggests the different but complementary parts each character, Hester and Dimsdale, plays in their drama of innocence and seduction. A photograph of Gish and Hanson for *The Wind* illustrates the relationship between the two characters in that film equally vividly (page 53). Hanson, in a plaid shirt and neckerchief, lunges forward to clasp Gish's head between his hands to kiss her; she, dressed in white, shrinks from him, her face set to accept what she cannot avoid even as her body rebels. "[Louise's] photographs were magnificent. I took orders from her as I would have from D. W. Griffith," recalled Gish.[9] In another portrait for *The Wind* (opposite), Gish, wearing a farm dress, rides an out-of-control horse, her arm flung backward in pleading desperation. But in fact there is no horse: she sits on a saddle on a barrel in front of a white flat.

Such distinctive photographs, taken in the context of productions and referring to specific narratives, tended not to be used by the studio, however. In the publicity treadmill these were subjected to brutal cropping, as happened with every photographer's work. Although this did not radically disfigure her head shots, it did seriously affect the legibility and disrupt Louise's careful composition and framing of these photographs of stars actually acting. Moreover, her photographs delineating specific moments in a narrative—her "portrait production stills," as we might term them—had to compete with official production stills taken during filming, which not only entered the publicity pipeline well before her work was done but also, in their simple objective of centering the characters in the frame as squarely as possible, proved more useful for most publication purposes. Ironically, her most dramatic photographs were largely irrelevant for publicity purposes.

Gish did occasionally participate in the usual publicity campaigns, but with obvious reluctance. Her one appearance in *Photoplay*'s fashion spread, in her first months at MGM, was an experiment never repeated. Gish's fashion sense simply did not sell. Even when she agreed to publicity photographs, they are decidedly different from those of other leading ladies at MGM. Louise understood Gish as an actress rather than a star. In one photograph taken at the beach, Gish sits on a horse in an immaculately tailored riding outfit, cool and distant, framed by sand and water

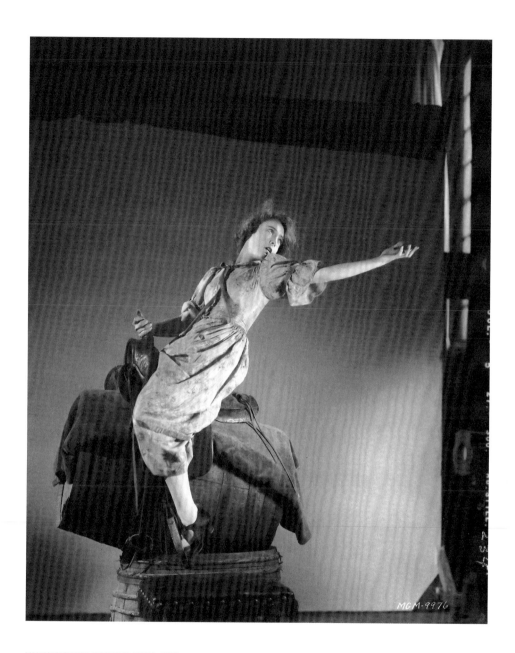

LILLIAN GISH FOR *THE WIND*, JULY 5, 1927

The John Kobal Foundation

Photographs from this sequence would have been tightly cropped by
publicity to focus on Gish's upper body. The information along the side
gives the date, Louise's code (928), and its function: Ad. still 234. In the
image itself is its publicity code number: MGM-9976.

(page 48). How unlike the publicity shots of, say, Joan Crawford or Ramon Novarro at the beach, who kick up their heels for the camera. Instead of presenting the shore as a place for play and relaxation, Louise and Gish emphasize the grandeur of the environment. Indeed, Hollywood photographers rarely made use of the natural beauty surrounding them in southern California, preferring artifice instead.

Among the great male actor-stars, the most versatile was Lon Chaney, "Man of a Thousand Faces." Veteran of more than 130 films, Chaney was one of the initial players in the new Metro-Goldwyn roster. Always popular with audiences, with his 1923 hit, Universal's *Hunchback of Notre Dame,* he became the sort of box office heavyweight Mayer needed. In the realm of verisimilitude, Chaney was Gish's only match at the studio. To play Mimi's death scene in *La Boheme,* she dehydrated herself so severely that the director was seriously concerned for her health. Chaney would punish his body equally hard to shape it for his many roles as a deformed human being: acting with his lower legs bound up against his thighs (*The Penalty,* 1920) or his arms bound against his sides (*The Unknown,* 1928), or with an opaque glass lens inserted in one eye (*Road to Mandalay,* 1926). He distorted his face almost beyond recognition in film after film, delighting audiences with the strenuous demands he placed on himself and the new horrors he would experience.

With Chaney, as with Gish, a collaboration was effected between photographer and subject. As Louise explained, "He absolutely refuses . . . to have a straight portrait made of himself. You will remember that whenever you've seen a picture of Lon Chaney he has been in character."[10] At another point she elaborates: "One of the stars I find most interesting to photograph is Lon Chaney. He is never the same, and yet I know that I have not succeeded, yet, in penetrating to the real Lon Chaney. He is an enigma. . . . He is helpful, because he knows his work so well. He can produce any mood, any expression, in an instant. He acts as vividly for me and my camera as he does on the sets."[11]

The physicality of Chaney's acting is readily demonstrated in Louise's portraits. As on the screen, Chaney, hidden behind heavy makeup, transformed himself in the portrait studio. In *Laugh, Clown, Laugh* (1928), Chaney played a clown (for the second time, having previously appeared as one with Gilbert and Shearer in *He Who Gets Slapped*), and posed—as he did for all his pictures—both for costume studies and for portraits with Louise. In the costume studies, the unknown stills photographer simply records the costume, with Chaney in character. For Louise, however, Chaney pulls out the stops, and the result at times approaches the surreal. In one full-length portrait (opposite), he capers for the camera. Wide-eyed, with an exaggerated smile and hands raised, Chaney is not portraying the stereotypical happy clown. The ambiguous effect is reinforced by strong shadows representing circus elements; in the end it is the clown's psychology, not Chaney per se, that

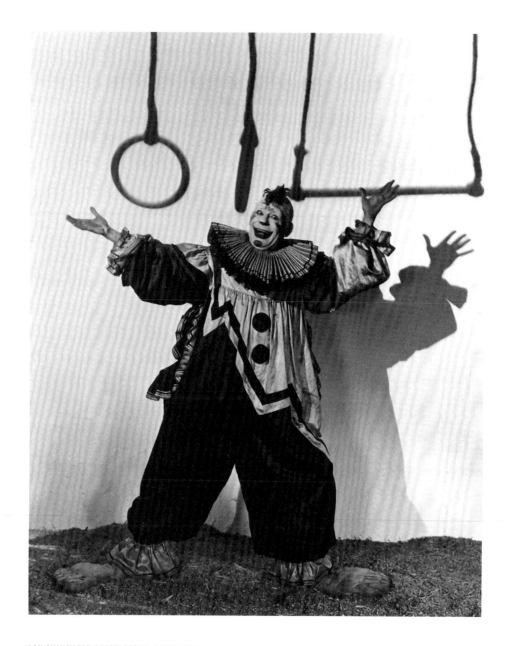

LON CHANEY FOR *LAUGH, CLOWN, LAUGH*, 1928
Courtesy of the Academy of Motion Picture Arts and Sciences
Louise successfully records the manic and surreal qualities of
Lon Chaney's performance as Tito the clown. The photograph
was published in *Photoplay* (May 1928, p. 29).

Lon Chaney ᴛᴍ likeness, courtesy of Chaney Entertainment.

the photograph portrays. In a related pose, this time in close-up, Chaney raises his finger, smiling menacingly (page 56). Close cropping forces our attention on his face, which manages to compete with the oversized ruff that surrounds it. The figure of the clown seems to have had a particular fascination for early-twentieth-century artists and audiences, mirroring as it did the absurdity of the human condition. Louise's images of Chaney with his extreme expressions and grotesquely oversized feet turn him into a freak, summoning up anything but pleasant emotions. The tragedy of *Laugh, Clown, Laugh,* which tells the story of Pagliacci, is flavored with hints of degeneration and despair.

Chaney played a strikingly different character in *The Road to Mandalay.* In that film he is a crook and a thug, his moral deformity visible in his grim visage and leering opaque white eye. Here too Louise is unflinching in her depiction of the actor. In one sequence she adopts a soft pictorialist focus, which might seem inappropriate for this brutal character, but in fact it renders him more threatening. In one close-up, Chaney looms up out of a mist, the eye glowing mysteriously (page 54). Even more ominously, Louise shows Chaney, rendered in profile against a window, playing with the knife that will ultimately kill him (stabbed by his own daughter). The knife glows with menace as he relishes its sharp edge, seeming to use his thumb to sharpen the instrument (page 55). The composition and staging draw our attention away from Chaney's face, in which only the deep lines of his smile register. Here, Louise uses backlighting to underscore the evil and danger of Chaney's character.

Chaney is probably best remembered today for two films he made at Universal, *The Hunchback of Notre Dame* and 1925's *Phantom of the Opera.* But his period of greatest artistic achievement was the five years he spent at MGM, from 1925 until his death in 1930. Louise's portraits of Chaney provide an almost complete survey of the extraordinary roles he created during these remarkable years—as, among many others, an armless knife thrower, a clown, a vampire, Mr. Wu (young and old; see page 91), a marine, and even a woman.

The two leading comic actors at MGM (not including Marion Davies, who was never allowed to think of herself as such) were Buster Keaton and Marie Dressler. Both had formed their talents elsewhere, in vaudeville and, in the case of Keaton, in his own movies. Keaton's quality as an actor lay in the contrast between his still-as-death face and his extraordinarily expressive body. One of Louise's most unusual sequences of photographs is an homage to Chaney, whose face was never the same in any two movies: in this regard, the two are almost antithetical. This sequence of photographs shows him putting on makeup, and propped on the makeup case—the very symbol of Chaney's artistic achievement—is a portrait of Chaney: Keaton is going to compete with

the man of a thousand faces. He begins by making himself up as a thug (page 214), a version of Chaney's low-life characters, like Professor Echo in *Unholy Three.* His nose is squashed; there's a smudge of blood at one side of his mouth and another on his cheek. Chaney, looking on from the photograph, has a frown on his face; he doesn't think much of the imitation. Continuing the parody, Keaton wears a plaid hat that is even more vulgar than the one Chaney wore in the role. In the end, Keaton's silent face subverts the overt emotion one would expect from such a character. In another shot, Keaton is made up as a desperado, with a drooping mustache, hat, and neckerchief. The last photograph from the series (page 215) shows Keaton smashing the makeup case with a chair, abandoning in despair any further thoughts of mimicking Chaney while at the same time revealing for Louise's camera the magnitude of his comic genius.

Veteran stage actress Marie Dressler was a new and relatively undeveloped property during Louise's tenure at MGM. Nearly sixty years old when Mayer brought her to the studio in 1927, she was not new to film, having made several features and shorts a decade before, most notably a series called "Tillie" in which she played the title role (once co-starring with Charlie Chaplin). MGM rescued her from a foundering vaudeville career, and her first film for the studio, *The Callahans and the Murphys,* relied on the broad comedy she had mastered on the stage. Still, nothing in Dressler's career suggested that within a few short years she would be a star shining as bright as Garbo and Shearer. By 1930 she had hit her stride in both serious roles (*Anna Christie*) and comic ones (*Caught Short*), becoming MGM's biggest moneymaker in the early 1930s. One of her greatest attractions, as the timing of her success suggests, was her voice; although she certainly relied on her stalwart physical presence for many of her gags, Dressler was never purely a physical comedian.

Few portraits were apparently made of Dressler during the 1920s, but those that survive are quite interesting. She was often depicted with her frequent co-star, short and skinny Polly Moran, in images that highlighted the actresses' obvious physical differences. Dressler was at her best, however, when she was photographed alone. One such portrait comes from Louise's session for *Caught Short,* in which she captured Dressler full-length and goggling at the camera (page 57).[12] Both photographer and subject use the limits of the format to advantage here. With her slightly awkward, knock-kneed stance, the slightly tentative turn of her body, and the aggressive shock of her eyes, which look directly at us, Dressler is the image of comic confusion. The format—a standing figure in costume against a white wall—is one seen countless times and in a wide variety of circumstances. Nothing could be more basic. But Louise knows that Dressler needs few props. The key lies in the character of the sitter, just as the teenaged Ruth imagined.

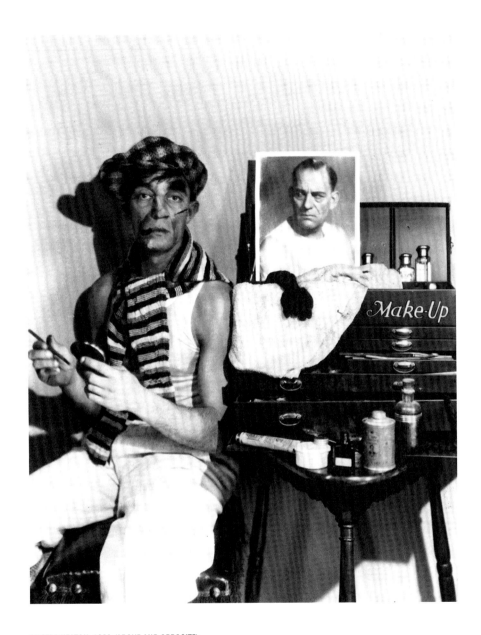

BUSTER KEATON, 1928 (ABOVE AND OPPOSITE)

Hulton Archive/Getty Images

These are two stills from a series of eight in which Keaton pays homage to
Chaney. The caption for number 3 is "How d'you like this one? Underworld
pictures are all the rage nowadays. Think I could play a tough guy like Chaney
does in 'The Big City'?" The last of the series is captioned, "Aw, to thunder
with this stuff! It's too hard work. Besides . . . "

Buster Keaton TM likeness courtesy The Douris Corporation.

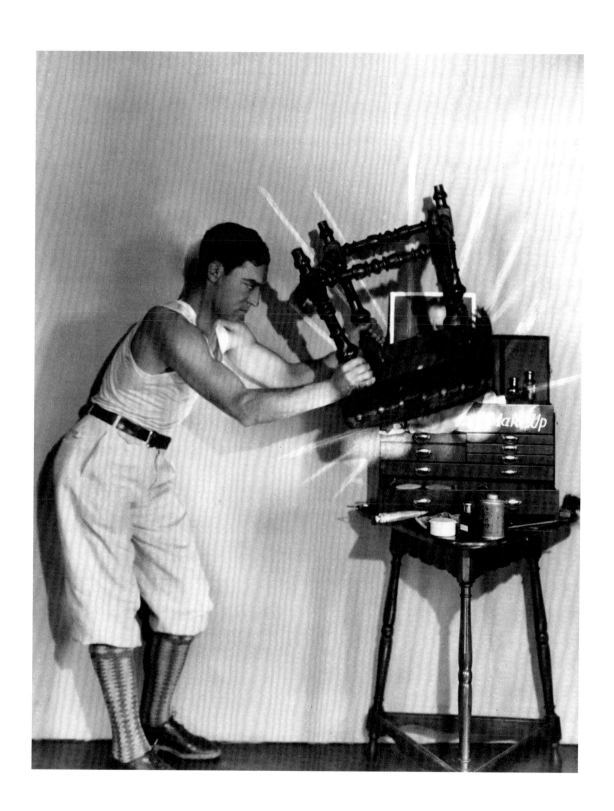

LEAVING MGM

chapter 11

THE YEAR 1929 WAS A TUMULTUOUS ONE FOR MGM, AND
the film industry in general. For Louise it started out like the pre-
vious three. She maintained a hectic schedule, and her work con-
tinued to be published widely, On March 14 Louella Parsons men-
tioned her with great praise in a column: "I have always said—and
I still say it right out in print—that one of the finest photographers
I know is a woman. I speak of Ruth Harriet Louise who has made
Marion Davies, Norma Shearer and other M-G-M beauties even
more beautiful."[1] But by the end of the year she was out of a job,
one of many victims of the most turbulent year in MGM's short
history.

Months before any threat of economic depression loomed,
Mayer was besieged on two fronts simultaneously. In March, com-
petitor William Fox had reached an agreement with the estate of
Marcus Loew to buy a controlling interest in Loew's Corporation—
which meant Mayer was about to be ousted. Ironically, he was saved
by the stock market crash (as well as antitrust concerns), for Fox
lost control of his shares to bankers who decided to let Mayer con-

tinue to run the studio.[2] But the fight over control of MGM was only one battle. Talkies had arrived in 1927, and after delaying for over a year, Mayer and Thalberg were finally forced to convert to sound, at great cost in time and money. The technological changes were enormous enough, but making sure MGM had enough performers capable of talking into microphones was an even bigger task.[3] For a studio built on stars, the critical question was: How was sound going to affect the future? Already throughout Hollywood many great stars had fallen, displaced by theater actors who went on to become the new stars. And it was not only the stars who were affected by the changes. Louise too found herself in a vulnerable position during this uncertain period, her future at the studio depending ultimately on a few key stars and their ability to adapt to sound.

MGM's two greatest stars at the beginning of 1929 were Gilbert and Garbo. Gilbert would be crushed by the new technology, Garbo would thrive and reach ever greater fame. Much has been made of Gilbert's high-pitched voice, which translated poorly to primitive sound recording. The truth of the actor's demise at MGM, however, had more to do with his negotiating a lavish, multimillion-dollar contract with Loew's executives in New York behind Mayer's back. Because of this, Mayer was looking for a way to ruin Gilbert, and talking pictures provided the means. For in truth, Gilbert's voice wasn't so bad (as his first talking picture, *Hollywood Revue of 1929,* shows) that a sympathetic producer and publicity department could not have saved his career. Yet after a series of dismal flops he finally left the studio, the highest-paid actor in town but unable to get work. Garbo, on the other hand, had made it clear that she didn't particularly care what happened with her career or how she would fare in talkies. *The Kiss,* the second film she shot upon her return from her unauthorized four-month stay in Sweden, was MGM's last silent movie. (Although it had a synchronized soundtrack, it contained no dialogue.) October 1929 saw Garbo at work again, now filming her first talkie, *Anna Christie.* Along with Chaney, Garbo was the studio's biggest talkie risk. As with Chaney, MGM need not have worried.

Other stars took a more active role in trying to shape their futures. Ramon Novarro, perhaps nervous about his accent, considered once again an operatic career, and stories were planted in the magazines to stage a graceful exit should one be needed. To prepare, he did what anyone in Hollywood might do when contemplating a career change: he had a new set of photographs taken.[4] Novarro chose not to work at the studio with Louise or Clarence Bull, however. Searching for a new image, in January 1929 he made an appointment with George Hurrell, an independent photographer who had a good reputation with the Los Angeles culturati with whom Novarro socialized. Novarro posed in operatic costumes before Hurrell's camera on several occasions, and together they worked to build a portfolio for the star's musical career.

Norma Shearer, made of considerably sterner stuff than most stars, and in any case unassail-

ably secure in her position as Thalberg's wife, also saw the talkie revolution as an opportunity for change. Shearer was already being built up as the studio's leading dramatic talking actress, and *The Trial of Mary Dugan,* released early in 1929, came with a flood of publicity focusing on Shearer's lovely speaking voice (in which she was aided by her brother Douglas Shearer, who had become the head of sound engineering at the studio). But Shearer was not interested solely in succeeding Lillian Gish as MGM's chief dramatic actress. She wanted to commandeer other adjectives as well—especially "sexy." During Garbo's absence in the winter of 1929 (and with the Swedish star's talking future clouded), Shearer saw an opportunity to intrude on territory that so far had belonged to Garbo alone.

On the advice of Novarro, Shearer, tired of always being depicted as an elegant woman, went to Hurrell for new portraits as well.[5] Already known for his ability in capturing "It"—sex appeal—Hurrell offered Shearer a thrilling new look (page 220). It started with her hair: no longer stylishly set and combed, it springs from her face as though on fire. Shearer had also always been self-conscious about her legs; Hurrell made them appear long and slinky (largely by means of an extraordinary amount of retouching). Stretched out on a chaise in Hurrell's studio, Shearer's body is both languid and tense, her eyes demanding yet inviting. For the first time in her career, Shearer was a seductress. Louise had made Shearer glamorous, but not "hot." Hurrell managed to take the chill off. This was exactly the ammunition Shearer needed to convince her husband to give her the leading role of the bad girl in *The Divorcée.* Thalberg did not want to cast her as an adulterous wife—that was for Garbo—but Shearer prevailed, not only proving her husband wrong at the box office but also winning an Academy Award for her performance.[6]

No wonder Shearer was determined to have Hurrell—rather than Louise—at her side, giving her a leg up, as it were, in her campaign to reign as MGM's uncontested queen. An echo of this struggle survives in a comment ascribed to Thalberg by Hurrell: "Since our temperamental Ruth Harriet Louise has left, I think we can use this man Hurrell in our still gallery."[7] From everything we know about Louise, this description sounds unlikely, and in any case the sequence of events is wrong: Hurrell was already being considered for the job before Louise left.[8] Hurrell was uncharacteristically vague on one crucial point, however, when remembering how he arrived at MGM: "Because of that session with Shearer I got my contract with MGM. I think Ruth Harriet had just left or was leaving. Maybe her going coincided with my getting there. I don't know."[9] Hurrell undoubtedly did know whom he would be replacing at the studio. But as a young, ambitious photographer, he jumped at the opportunity and ignored the consequences.

The differences between Hurrell and Louise were more profound than just temperament, as is immediately apparent from their photographs. The two photographers related to their sitters—

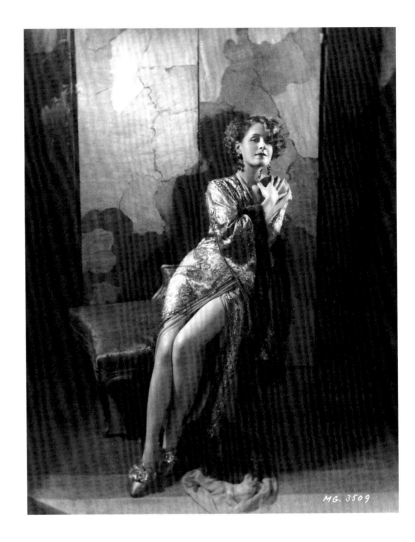

NORMA SHEARER, 1929, BY GEORGE HURRELL (1904–92)

The John Kobal Foundation

Shearer sat for Hurrell at his studio for the first time in 1929. Hurrell thinned Shearer's legs and thighs considerably by enhancing the shadows. So impressed was the actress with the results, she saw that he was hired at MGM.

especially female sitters—in very different ways. Louise made Shearer, for example, elegant, beautiful, glamorous, but never sultry. In a sense this is because she never attempted to objectify her sitters—which was precisely Hurrell's goal. Louise may have been interested in pose or costume, or even setting, but she never turned her subject's face into a mask. Lighting, props, gesture—all served the goal of capturing the humanity of the sitter, the "personality," as Louise asserted at the start of her career. Hurrell, in contrast, used light aggressively to turn his sitters into dramatic sculptures, subduing them to the tools of his trade. In the end, Hurrell looked to the future, offering something new, even a little transgressive. How could MGM resist?

Hurrell was the herald of a great change in the way women were imagined and rendered, as Hollywood responded to larger social developments. In a classic illustration of how sex appeal was now to be achieved by imagemakers, *Motion Picture,* in June 1929, ran a short piece about an unnamed "Hollywood photographer of beautiful women [who] has unique methods of arriving at his results." When the starlet comes to be photographed, he sends her off with her boyfriend into a room to kiss and pet "to get that It look on your face."[10] Hurrell helped bring about that change by offering something the women of MGM wanted: sexy glamour.

Hurrell's photographs of Novarro were ultimately sanctioned by MGM publicity and appeared in the *Los Angeles Times* on October 20, 1929. Louise, it seems, was on the way to losing her place at the studio well before that date. The first significant clue that change was at hand had nothing to do with Novarro or Shearer, but rather Garbo. On August 27, Garbo reported to Bull's, not Louise's, studio, where he spent the day making portraits of her for *The Kiss,* which had just wrapped up production. Perhaps the reason was as simple as a badly timed vacation or illness, but the fact remains that Louise was now considered dispensable as Garbo's photographer. Louise's last documented portrait session at MGM seems to have been with Vilma Banky on December 2, 1929, during filming of the actress's last American (and only MGM) film, *A Lady to Love,* directed by Seastrom. Banky had been Louise's first published Hollywood subject (page 12) and now would be virtually her last.

In the midst of the many changes going on in Hollywood, Louise's very steadiness seems to have worked against her. The stills photographers in Hollywood had unionized in August 1928 (Local 659), but Louise did not join their ranks; she remained unique. Moreover, personal relationships that had supported the studio in its infancy, and brought Louise into its fold, by the end of the decade had been replaced by the impersonal demands of a huge corporation run from the East Coast. MGM could afford only one chief portrait photographer, and sometime during the fall of 1929 Louise was notified that her contract would not be renewed. No records or correspondence survive to suggest how she responded to this news. In the end she was without a strong ally, with even Mayer's attentions elsewhere. The one person who might have been an ally—Clarence Bull, head of stills and her senior colleague—seems instead to have felt competitive toward her.[11] She was younger, more talented, and a woman. On the first business day of January 1930, therefore, the position of chief portrait photographer at MGM Studios belonged to George Hurrell.

A short notice in Louella Parsons's column on December 9 reported, "Metro-Goldwyn-Mayer's famous photographer, Ruth Harriet Louise, is leaving the studio. That is going to be a blow for all the stars on the lot, for Miss Louise knows how to make the plain beautiful and the beautiful

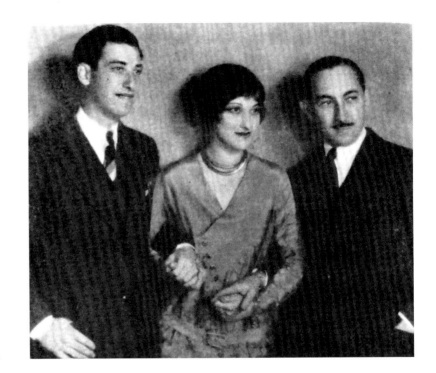

**"ONE OF HOLLYWOOD'S
MOST USEFUL FAMILIES,"**
PHOTOPLAY **(MAY 1928)**

Private collection

Photoplay ran this photo
of Louise with her
husband, writer Leigh
Jason *(right),* and brother,
Mark Sandrich *(left),* in
May 1928, the year after
Louise and Jason married.

more beautiful. She hasn't made any future plans beyond deciding to take a little trip to New York for vacation."[12] MGM, faced with the talkie revolution, had become a business in serious peril of going under. If John Gilbert, with a contract guaranteeing him one million dollars a year, was dispensable, what protection was there for a lowly portrait photographer?

On August 27, 1927, Louise had married writer and director Leigh Jason (Leon Jacobsen, 1904–1979) at Temple B'nai B'rith in Los Angeles, with Rabbi Edgar Magnin officiating and director William Wyler as best man. (Jason had just written the story for Wyler's *Anybody Here Seen Kelly?* at Universal.) It was announced: "Both will continue their careers according to Miss Louise—even though married."[13] A working marriage seems to have suited the couple, at least for a while; in May 1928 in *Photoplay* a photograph of Louise accompanied by her husband and brother (above) is captioned, "One of Hollywood's most useful families."

Although within eighteen months she would be out of a job, Louise did not entirely stop working. Her last recorded professional photography session was an extensive sitting in 1932 with Anna Sten, Samuel Goldwyn's hoped-for answer to Marlene Dietrich's exotic European glamour. In building the publicity for this new star, Goldwyn (who operated outside the studio sys-

tem) commissioned photographs from a large number of independent photographers, including Louise. A set of thirty impressive prints, signed by the photographer, survives, indicating both Louise's continuing technical control and her ability to adapt to the new modes. Sten, looking glamorous and hard, with a cigarette caught between two fingers, is clearly a thirties, post-Hurrell star.[14] In one photograph (page 58), the hard light and harsh highlights, as well as the Vaselined look of her face in close-up, all betray Hurrell's influence.

Even without a studio connection, Louise continued to work as a photographer. As one small piece of evidence, we have a letter to Wyler in which she apologized for breaking a lamp she had borrowed, as she tried to work out of her home.[15] Photographs of her young nephews in a softly pictorialist mode indicate her continuing allegiance to popular art styles of her youth, appropriate for sweet photographs of children. By the same token, a photograph of her sister-in-law in color demonstrates her eagerness to keep current with the latest innovations in color photography, which became popular first in the late 1930s.

Two years after leaving MGM Louise gave birth to her first child, a son named Leigh Jr. A second child, a daughter, was born a few years later, and family duties must have kept her work as a photographer to a minimum. Tragedy came to the family when Leigh Jr. died of leukemia in 1938, at the age of six. Louise became pregnant again two years later, but again fate was unkind: she died on October 12, 1940, at the age of thirty-seven, from complications of childbirth. The baby, a boy, born premature, also died. Louise's obituary in *Variety* mentioned that she had been "formerly a portrait photographer at Metro"; she was identified only as Ruth Jason, not by her professional name.

By that point, almost all the stars Louise had photographed were either at the end of their careers as stars or dead themselves. Chaney, Gilbert, Dressler, and Adorée had all died; Billy Haines, Dorothy Sebastian, and Anita Page were retired. Garbo would make her last movie in 1941, followed by Norma Shearer the next year. Novarro continued to work, but only in character roles. While Crawford remained actively a star, it was in a form created by Hurrell, one wholly divorced from the eager young player photographed by Louise when the young women were both new to MGM and Hollywood.

appendix A

GARBO AND HER
PHOTOGRAPHERS, 1925–1929

Of all the major MGM stars, Garbo was the least photographed. So few were her sittings that it is possible to reconstruct them fairly precisely. Chapter 8 interprets those sessions in relation to Ruth Harriet Louise. In this appendix, we summarize the formal photographs made of Garbo at MGM. Stills photographers who worked on Garbo's productions, where known, will be named, and portrait sessions will be described briefly, with the dates and the names of relevant photographers provided. Selected photo codes will also be listed to give a sense of the manner and chronology in which they were used.

Garbo was photographed professionally several times before arriving in the United States. At least three of those sessions—with Olaf Ekstrand and Henry B. Goodwin in Stockholm in 1924, and with Atelier Binder in Berlin in the spring of 1925—would have been known to MGM publicists, since Garbo certainly arrived with her portfolio; selections from these early photographs appear in the MGM archives.

U.S. PHOTO SESSIONS, JULY 1925–DECEMBER 1929

July 6, 1925: JAMES SILEO, a stringer for Apeda, a photography service used by MGM in New York, photographed Garbo (and Stiller) on ship-

board as they arrived in New York from Sweden. He took at least four photographs (MPGP 6184–87); one appeared in *Photoplay* (Sept. 1925, p. 44), and another appeared in the *New York Graphic,* July 7.

Garbo was also photographed modeling fashions for Weingarten's, a New York department store, for newspaper advertisements, according to Hubert Voight, MGM publicist.

July 1925: RUSSELL BALL, a New York–based freelance photographer hired by MGM, produced the first series of official portraits for Garbo's MGM files: GG-X-I–4 (also listed as MPGP 7403–8). There are three costumes: a leather jacket, a striped dress, and a black fur-trimmed wrap exposing a bare shoulder. The first photograph to be published from this session appeared in *Motion Picture Classic,* Oct. 1925, p. 12.

July 27, 1925: ARNOLD GENTHE, an independent photographer working in New York, photographed Garbo before she left for Hollywood. This session produced at least seventeen images. The first appeared in *Vanity Fair* in November 1925 (p. 80), and others appeared in November 1926 (p. 117) and June 1928 (p. 66). Few were used in fan magazines, but one was accorded a full page in *Picture Play* (June 1927). These photographs were not part of the MGM files until much later, and had little influence on MGM's image of the actress.

September 12, 1925: Garbo and Stiller arrived in Pasadena and were greeted with all the hoopla MGM could muster, including an unidentified stills photographer and a motion-picture cameraman. Garbo's hair has a new permanent wave and she is wearing the same dress she wore when she arrived in New York (MPGP-7483).

September 1925: RUTH HARRIET LOUISE photographed Garbo in her first Hollywood portrait session. The actress's hair is still tightly curled, and she wears a white jacket with a white fur collar. These portraits are numbered GG-X-5–10. Several European publications used these photographs on their covers, including *Mon Ciné* (France, Feb. 26, 1926) and *Vecko Journalen* (Sweden, no. 50).

THE TORRENT, NOVEMBER 27–DECEMBER 20, 1925, PROD. #254

Garbo, new to the studio, was repeatedly photographed both on the set and off for general publicity. As *The Torrent* was a Cosmopolitan Production, no expenses were spared, and the publicity material was equally copious.

 A. Stills photographer: BERT LONGWORTH. (Generally one stills photographer was assigned to each production.) CLARENCE BULL shot the costume studies (MPGP-7415–19).

 B. Portraits: RUTH HARRIET LOUISE. November/December 1925: LOUISE photographed Garbo at least four times, both during and after the conclusion of the filming. Garbo wore a startling array of costumes, many of which are recorded in the portrait sessions.

 1. December 4, 1925: LOUISE was pressed into general publicity purposes and took photographs outdoors, of Garbo, Stiller, and Victor Seastrom along with other members of the Swedish community in Hollywood (MPGP-8590, -8593).

2. The primary portrait session for *The Torrent,* with at least four costumes: a white mantilla and Spanish fan; a contemporary dress with a black straw hat; a plain dress with a wide collar and a hat with upturned brim; and a ruffled flamenco dress. Garbo was also photographed with Ricardo Cortez, her co-star; she wears her simple peasant costume, with a dark blouse, white scarf, and apron (MPGP-9316, -9364).

3. A second (shorter) portrait session in which Garbo wears a white shawl (GG-X-11) and a brocade wrap that is trimmed with white fur (both against a white paisley-print backdrop).

4. December 31, 1925: LOUISE photographed Garbo in a striped fur coat. The actress's hair, which had grown out and was straight throughout the filming of *The Torrent,* is once again tightly curled.

November/December 1925: DON GILLUM, freelance, "action photographer" spent a day shooting Garbo. She wears a leather coat and hat. The well-known photos of Garbo seated next to a lion (MPGP-8384) and with a monkey (MPGP-8812) were taken that day.

THE TEMPTRESS, SPRING/SUMMER 1926, PROD. # 265

Garbo's second MGM movie had the most protracted shooting of any of her American films because Stiller, who began the filming on March 4, was yanked from the set sometime after April 27, to be replaced by Fred Niblo, the MGM master fixer. Shooting did not finish until August 7, whereupon filming for *Flesh and the Devil* began two days later.

A. Stills photographer: BERT LONGWORTH; additionally he made a series of trick photos of Garbo, including one of the actress training a spotlight on herself (MGM-808).

B. Portraits: RUTH HARRIET LOUISE.

1. February 6, 1926: In an experiment not to be repeated, LOUISE photographed Garbo with Antonio Moreno, her co-star, and others (including Lew Cody, who does not appear in the film) acting out various tableaus from the film. The session may have taken place in Louise's studio or on a vacant set. Garbo appears in at least four different costumes. LOUISE exposed something on the order of sixty negatives, few of which were ever used by publicity; most are known only through the surviving original negatives (Kobal Foundation).

2. April 19, 1926: LOUISE photographed Garbo wearing a glamorous "art deco" cap and feathered dress (RHL 2924-58; MGM-586, -589).

3. June 15, 1926: LOUISE photographed Garbo in a light-colored dress with an elaborate collar and a lace cap.

4. June 25, 1926: LOUISE photographed Garbo wearing a light-colored hat and scarf; a gold cape (MPGP-1978); a gold lamé scarf and matching headband (RHL 2239–44); and a black dress with a white collar and orchid (RHL 2931-7; GG-X-12, 13, 15–17).

DON GILLUM photographed Garbo a second time in late winter 1926, before principal photography began, at USC with the men's track team (MPGP-9467, -9784, -9836–8, -9998). The same day he recorded her practicing riding (MGM-333, -354, -965), and took shots of her in Santa Monica modeling clothes (MPGP-9470), on the beach, in the park, and on the steps of her "new house" (MPGP-9496, MGM-59).

FLESH AND THE DEVIL, AUGUST 9–SEPTEMBER 28, 1926, PROD. #282

A. Stills photographer: BERT LONGWORTH. The most striking photographs from the film, and those most often reproduced, are the stills by LONGSWORTH, especially those of Garbo and Gilbert kissing. The best are taken from two scenes: in Garbo's boudoir, after their first night together; and on Gilbert's estate, in the greenhouse. In both instances Garbo maintains a superior position. The first scene (254-49, -50, with both supine; and 254-51, -52, with them sitting up) was shot during the first week of September, and images were reproduced in *Photoplay* in January 1927; the second scene (254-131, -133) was shot September 16.

CLARENCE BULL made the costume studies on September 8 (MGM-3860, -3866).

B. Portraits: RUTH HARRIET LOUISE. The principal portrait session, from October 12, 1926, records Garbo wearing three costumes: a sheer black-lace patterned blouse; a cloche hat and tweed coat; and a sleeveless beaded gown (RHL 4522–30). Garbo was also photographed with Gilbert (MGM-3781, -3814, -3828). (An unattributed still in AMPAS MGM *Flesh and the Devil* production file [282-x-39], a closeup of Garbo's face over the shoulder of a glowering George Fawcett, may be by LOUISE.)

Garbo is suspended in November 1926 and again from February 26 to March 30, 1927.

LOVE, SPRING/SUMMER 1927, PROD. # 310

Garbo began production on *Love,* with Ricardo Cortez as her male lead, on April 7, but filming stopped on May 21 after the actress became ill. Filming resumed on June 22, with all the previous footage scrapped because Cortez had in the meantime been replaced by John Gilbert. This second version completed its principal photography on July 25.

A. Stills photographer: WILLIAM GRIMES. (One Grimes photograph is used on the cover of the sheet music for the film.)

B. Portraits:

1. July 28, 1927: CLARENCE BULL photographed Garbo and Gilbert on the set, first with Garbo posing alone in a riding costume, then seated with Gilbert next to a large tree.

2. July 29, 1927: RUTH HARRIET LOUISE photographed Garbo in white pajamas, in a dress with a tuxedo jacket and large dark hat, in a monogrammed man's black bathrobe (both standing and seated on a sofa reading), and in a man's top coat (RHL 5050–65; MGM-10067, -10070). One of the white pajama photographs is reproduced in *Photoplay* (Oct. 1927, p. 19). (In addition, LOUISE photographed Garbo and Gilbert together for poster art.)

3. August 1927: RUSSELL BALL photographed Garbo in white pajamas (GG-X-18–21) and in a gold lamé cape (GG-X-14) to provide magazine cover art; they were used for *Picture Play* (Nov. 1927) and *Motion Picture* (Dec. 1927), among others. These sessions are easily confused with Louise's session, on whose heels it closely followed. Indeed, a pair of photographs of Garbo in the black bathrobe from Louise's session, but at which she is seated on a small black table, are identified (accurately or not) as by Ball in the Core Biographical files, AMPAS (MG-1328). It should also be pointed out that these are the first additions to Garbo's portrait file since *The Temptress,* and that one (GG-X-14) is mixed into the *Temptress* sequence.

THE DIVINE WOMAN, SEPTEMBER 28–NOVEMBER 7, 1927, PROD. # 332

A. Stills photographer has not been identified.

B. Portraits: RUTH HARRIET LOUISE.

1. Late September/early October: Garbo wears a dark dress with a thin metallic collar (RHL 5594). Two other costumes may belong to this session: a black beret and woollen scarf, and a black cloche hat with a black fur-trimmed coat (repr. in Sembach, *Greta Garbo,* nos. 35, 39, 50).

2. After November 7: Perhaps LOUISE's best session with Garbo. She wears four costumes: a white hat and tweed coat; a pale dress and cardigan; a satin dress with big rolled collar; and a Chinese brocade dressing gown (MGMP-1176, -1467, -1121, -1178). In addition, she is photographed in a black velvet drape, and nude, in profile and in silhouette.

3. November 9, 1927: Poster art of Garbo and Lars Hanson, most certainly by LOUISE (and possibly the same session as above).

THE MYSTERIOUS LADY, MAY 8–JUNE 13, 1928, PROD. # 374

 A. Stills photographer has not been identified.

 B. Portraits: RUTH HARRIET LOUISE.

 1. Prior to shooting in early May, Garbo was photographed with her hair recently waved, in a flowing silk gown, seated on a rococo couch (RHL 6907, MPGP-5023) and in front of a mandala (MGMP-6371) and other oriental props.

 2. At conclusion of filming, Garbo's hair has fully grown out and LOUISE photographed her wearing a dress with a black fur collar. This sessions is one of the first in which Garbo is photographed smiling (RHL 6898–6904, GG-X-24).

A WOMAN OF AFFAIRS, JULY 28–SEPTEMBER 1, 1928, PROD. # 380

 A. Stills photographer: JAMES MANATT.

 B. Portraits: RUTH HARRIET LOUISE.

 1. Garbo was photographed once on the set during the film's production. She wears a jacket with a plaid collar and appears by herself and with Gilbert.

 2. The main portrait session must have been quite long, for it produced many images that were widely circulated. LOUISE photographed Garbo in three costumes: a simple white dress with the collar knotted above her heart; a casual dark jacket (RHL 7727); and a glamorous satin evening dress (GG-X-27, -28; RHL 7724). She also photographed Garbo and Gilbert together, embracing on a couch in her studio (RHL 7638, MGMP-8861).

 3. August 1928: EDWARD STEICHEN made several photographs of Garbo alone and at least two with John Gilbert on the set.

WILD ORCHIDS, OCTOBER 22–NOVEMBER 23, 1928, PROD. # 353

 A. Stills photographer: JAMES MANATT. These photographs made up much of the publicity for *Wild Orchids,* and Manatt was duly credited in fan magazines.

 B. Portraits: RUTH HARRIET LOUISE. The session with LOUISE must have been hurried. There is only one costume , a white dress with an orchid on the left shoulder, and only a few images have been identified. This small group of photographs was used over and over on magazine covers, postcards, and sheet music. Garbo had made clear her intention to leave for Sweden as soon as shooting was done, as Stiller had died there on November 8. She left before retakes had been concluded and proper publicity completed.

Garbo leaves for Sweden December 3, 1928; suspended December 5; returns to New York City March 1929.

THE SINGLE STANDARD, APRIL 15–JUNE 4, 1929, PROD. # 430

A. Stills photographer: JAMES MANATT (negatives from April 16 to June 1). On April 24, 1929, Garbo was photographed wearing matching striped pajamas and robe alone and with costume designer Adrian. These photographs are presumably by Manatt (MGMP-166830).

B. Portraits: RUTH HARRIET LOUISE. On June 1929, LOUISE photographed Garbo in two costumes: a dress with a stylized geometric yoke (in front of a painting by Paul Gauguin) (RHL 104); and a stylized checkerboard-patterned dress (seated on a wooden throne and on a chair, laughing) (RHL 145).

Portrait session: spring/summer 1929. NICKOLAS MURAY photographed Garbo in a short session taking a half-dozen shots.

THE KISS, JULY 16–AUGUST 26, 1929, PROD. # 440

A. Stills photographer: JAMES MANATT.

B. Portraits: CLARENCE BULL, August 27, 1929 (B10825–871, MGMP-20542). This is Garbo's first MGM film for which LOUISE did not take her portraits.

ANNA CHRISTIE, OCTOBER–NOVEMBER 18, 1929, PROD. #456 (ENGLISH VERSION), DECEMBER 1929–JANUARY 1930, PROD. #476 (GERMAN VERSION)

A. Stills photographer: MILTON BROWN.

B. Portraits: CLARENCE BULL, November 19, 1929 (MG-18).

appendix B

MGM PHOTOGRAPHY CODES, 1924–1940

Most of the photographs released by MGM during the 1920s and 1930s bear some sort of identifying mark on the front. This mark (a number or combination of letters and numbers) identifies the image and generally indicates the purpose for which the print was distributed. A publicity sheet for *Ninotchka* (1939), for example, includes three illustrations: they are labeled MG-75802, 1100-74, and GG-X-93. Each number refers to a different classification system, which will be explained in what follows.

Two types of codes are most common. The first identifies production photographs, primarily stills taken on the sets. This code begins with the film's production number, which was assigned by the front office, sequentially, when a property was officially scheduled. Metro-Goldwyn (and later MGM) production numbers, following the merger in early 1924, continued the sequence already established by Goldwyn Pictures. Metro-Goldwyn's first official offering, *He Who Gets Slapped,* starring Lon Chaney, John Gilbert, and Norma Shearer, went into production in the spring of 1924 and was designated number 192. The studio's ambitious schedule is reflected in the quickly escalating production numbers: *The Big Parade,* filming in the spring of 1925, was numbered 229, for exam-

ple, and number 282 was assigned to *Flesh and the Devil,* under way in the fall of 1926. Fifteen years later, *Ninotchka* was production number 1100.

Next, separated from the production number by a dash, comes the number of the individual scene still. The identifying numbers assigned to the scene stills generally follow the film's narrative, not the order in which scenes were shot. Photo 265-244, then, is the 244th still made to promote production number 265, Garbo's *The Temptress* (1926). Important films might generate several hundred stills. For each production, a master stills-book (also called the key set) was created, typically composed of 8 × 10 photographs; the more prestigious films, however, had elaborate books made up of large-format prints. Master still-books might also include costume studies, candid photos taken on the set, and portraits of stars, featured players, and sometimes the director. These latter photos are identified by the letter "x" between the production number and the identifying scene still.

The second common code, a combination of letters and numbers, was established by the publicity department to organize portraits and other general publicity images. Starting with the 1924 merger, publicity photograph codes begin with the letters MPGP (standing for Metro Pictures Goldwyn Pictures). The numerical portion of these publicity codes was assigned, like production numbers, as the images were released, and these move forward sequentially, without regard for star or production. Thus, a portrait of director Rex Ingram on the set of *Mare Nostrum* is labeled MPGP-261; given the low number and the filming schedule of *Mare Nostrum,* it was likely first used by publicity in the spring of 1924. James Sileo's shipboard portrait of Greta Garbo arriving in New York from Sweden in July 1925, more than a year later, is labeled MPGP-6184. Because photographs were numbered according to when they were used by the studio, and not by the date of exposure, older photographs that were rereleased (as when *Ben-Hur* and *The Big Parade* were reissued in the late 1920s), or photographs taken by East Coast or European photographers that took several weeks or months to reach the studio, could be assigned relatively "late" numbers.

During the winter of 1926 the publicity codes (presumably) reached MPGP-9999 (image not located) and a new publicity code prefix was started, MGM (standing for Metro-Goldwyn-Mayer). Like the earlier MPGP designation each image was numbered sequentially as it was released. Whether this change was made because Louis B. Mayer's name was added to the studio late in 1924 or because the numbers had reached ten thousand is not clear; but it is certain that in March 1926 publicity began releasing photographs with MGM designations. While it took almost two years for publicity to release ten thousand images coded MPGP, the ten thousandth MGM photo was coded just fifteen months later, in July 1927. By the end of 1927, with codes approaching MGM-14000, the designation was changed a third time to, MGMP (Metro Goldwyn Mayer Publicity). Two years later the code was changed for the fourth and last time, and MG became the standard through the 1930s and well into the 1940s. A portrait of Louis Armstrong, photographed by Clarence Bull on September 4, 1942, for example, carries the code MG-91750.

As early as 1924, publicity maintained a selective set of star portraits that were approved for general distribution, culled from the hundreds of prints that might be found in a star's photographic archive. These

portraits are identified by the star's initials (sometimes followed by the letter "x") and numbers that in-
crease sequentially as new images were authorized. Garbo's first portraits commissioned by MGM were taken
by Russell Ball in New York during July. Four of these works—GG-X-1, GG-X-2, GG-X-3, GG-X-4—were
included in Garbo's master portrait file. Sometimes multiple codes were applied, reflecting an image's use
for various purposes; thus, one of Ball's early Garbo portraits is identified as both GG-X-2 and MPGP-7403.
Surprisingly few images were included in the portrait file, even for a popular star like Garbo. During her
sixteen years at MGM, for example, just over one hundred images made their way into her master portrait
file. This selectiveness was perhaps to ensure that a specific, approved image was what met the public's eye.
Constant demand for "new" and "exclusive" portraits would seem to render old images quickly out-of-date,
although in fact we find photographs of Garbo reused repeatedly, sometimes as long as a decade after they
were taken.

The photography department also identified individual negatives using codes that rarely appear on
photographs but were used for the original negatives. Clarence Bull developed a method, in use by early
1926, in which the date of exposure as well as other pertinent information was printed on the edge of
each negative. Negatives shot by the stills photographers record the production number along with the
individual still number. The two portrait studios each had a corresponding number that might be printed
on the edge of the negative. Beginning in 1926, Bull's studio may be identified with the number 528,
Louise's studio with number 928. (Bull's number was changed to 530 after Louise left the studio, and 928
was not used again.) Photographs charged to general publicity often had the code "Ad Still 69" printed
on the edge of the negative. Presumably, "69" designated the ledger account to which publicity charged
photographs.

Louise and Bull each had separate numbering systems for the original images they printed and released.
Louise's studio had a simple chronological system, and images printed by her or her assistants often carry
a handwritten identification number (always in pencil) on the back. Louise's system seems to begin with
500; these first images are portraits of John Gilbert in costume for *The Big Parade* taken in July 1925, just
after Louise started at MGM. Numbers 1–499 may correspond to photographs taken by Louise before she
started at MGM, but no such numbered images have been located. In May 1929, after reaching 9999, Louise's
numbers started over (possibly with 1, though the first ones we know of are photographs of Greta Garbo
in *The Single Standard,* numbered 104 and 105). Portraits of Norma Shearer numbered 1347 and 1385, taken
in the fall of 1929, are the last identified images carrying this sort of numbering designation.

Bull's studio had a similar system and may be recognized by the letter B preceding a number. During
the 1930s, Bull's numbers sometimes appear on the face of images released by publicity. The two number-
ing systems, which were totally independent of each other, help to date studio portraits and identify the
film for which the image was taken.

There is an important exception to the use of identifying codes. Virtually none of the vintage large-
format prints (primarily portraits) released by the two portrait studios have any identifying marks on the

front. These prints typically had one of three uses. Reproduction in magazines, ideally full page, particularly in the ubiquitous fan magazines popular during the 1920s and 1930s, was most important. Publicity also maintained a master print collection organized by performer that included an example of every image printed of that performer. Distribution of photos to the stars and featured players was the third principal use; some actors might keep the images (Garbo), while others would distribute them to fans (Crawford). The large-format prints invariably carry the photographer's embossed blindstamp at the bottom (usually lower right) and have an ink stamp on the reverse asking for photographer and studio credit when published. Handwritten notations (names or dates) and sometimes typed and pasted-down studio captions often appear on the reverse as well.

Portraits (and the associated negatives) taken by Louise and Bull, along with photos taken on the set by the stills department, would soon be claimed by publicity, where codes would be added to the face of the negative using the system described above. These publicity codes would be written by hand on the negative (usually at the lower right), and when the negative was printed would identify performer or film. The numbers were written low enough on the image that they could be cropped out when the portrait or still was used in magazines, books, or other printed forms. As the prints went into general distribution (invariably in the 8 × 10 format), publicity routinely made copy negatives and additional prints, especially of popular images. These were often made on thinner stock and with a glossier finish than the portrait studio–generated originals. Relatively few vintage images printed by the photographers themselves or under their supervision survive among the enormous quantity of glossy images circulated, some of which are still being used today.

Additionally, two types of codes used on early MGM photographs were quickly abandoned by publicity but need to be discussed briefly. In 1924, it was not uncommon for stars such as Buster Keaton, Mae Murray, or Marion Davies to have independent production companies. Each of these stars joined MGM initially to take advantage of the studio's enormous distribution network, although this soon changed when the studio began both to produce and distribute. During 1924, however, films made by these powerful stars and released by MGM are not identified by a studio-assigned production number, but by a code indicating the star's production company. The production code for Keaton's film *Sherlock, Jr.,* one of his 1924 MGM comedies, is K22; *The Navigator,* released the same year, is identified as K23. Two 1924 films starring Mae Murray and directed by her husband, Robert Z. Leonard, are similarly coded: *Mademoiselle Midnight* is ML7 (ML standing for Murray and Leonard) and *Circe the Enchantress* is ML8. Marion Davies's films were produced by Cosmopolitan Pictures, and so her first two MGM offerings, *Janice Meredith* and *Zander the Great,* retained the numerical Cosmopolitan codes of 51 and 52, respectively. These codes were discontinued in 1925, after which time all new productions were assigned an MGM number.

Also in use during 1924 and 1925 was a designation for general publicity images not associated with any production and taken by outside photographers. This code begins with the letters "Pub" followed by

a letter and a number. Pub-ᴋ-738, for example, identifies a photo taken at USC of Garbo with a pole vaulter, presumably by independent "action photo" specialist Don Gillum. This code disappears in early 1926, and all later images, regardless of the source, are identified with the publicity codes, ᴍᴘɢᴘ, ᴍɢᴍ, ᴍɢᴍᴘ, or ᴍɢ.

Not surprisingly, given the millions of images released by MGM during the 1920s and 1930s, coding errors occur. Additionally, redundancies occur when a popular image was released a second time and assigned a new code depending on the use. And of course, many prints and negatives have no identifying marks of any sort. Still, the coding systems set up by the MGM publicity and photography departments are generally reliable and help to determine the original (or intended) use of each photograph released as well as the date the photograph was taken and the title of the associated film.

SELECTED METRO-GOLDWYN-MAYER FILM PRODUCTION CODES, 1924–1930

MGM CODE	FILM TITLE	RELEASE DATE	LEADING PLAYER(S)
192	*He Who Gets Slapped*	Nov. 15, 1924	Chaney, Shearer, Gilbert
193	*Tess of the d'Urbervilles*	Aug. 9, 1924	Sweet, Nagel
196	*Sinners in Silk*	Aug. 30, 1924	Boardman, Nagel
198	*His Hour*	Sept. 20, 1924	Gilbert, Pringle
200	*Ben-Hur*	Dec. 30, 1925	Novarro, Myers
207	*The Snob*	Nov. 8, 1924	Gilbert, Shearer
208	*The Merry Widow*	Sept. 12, 1925	Murray, Gilbert
217	*The Unholy Three*	Aug. 16, 1925	Chaney, Busch
229	*The Big Parade*	Dec. 5, 1925	Gilbert, Adorée
230	*The Midshipman*	Oct. 31, 1925	Novarro
238	*Paris*	June 12, 1926	Crawford
239	*Lights of Old Broadway*	Nov. 14, 1925	Davies
240	*La Boheme*	Mar. 13, 1926	Gish, Gilbert, Adorée
243	*The Masked Bride*	Dec. 12, 1925	Murray, Bushman
244	*Dance Madness*	Feb. 6, 1926	Windsor, Nagel
254	*The Torrent*	Feb. 21, 1926	Garbo, Cortez
256	*The Scarlet Letter*	Aug. 21, 1926	Gish, Hanson
259	*Bardleys the Magnificent*	Nov. 13, 1926	Gilbert, Boardman
265	*The Temptress*	Oct. 10, 1926	Garbo, Gilbert
266	*Tell It to the Marines*	Jan. 29, 1927	Chaney, Haines, Myers
275	*The Road to Mandalay*	June 28, 1926	Chaney
279	*Upstage*	Nov. 27, 1926	Shearer

MGM CODE	FILM TITLE	RELEASE DATE	LEADING PLAYER(S)
281	*Annie Laurie*	May 14, 1927	Gish, Kerry
282	*Flesh and the Devil*	Jan. 9, 1927	Garbo, Gilbert
283	*Rose Marie*	Feb. 18, 1928	Crawford, Murray
290	*Valencia*	Jan. 8, 1927	Murray, d'Arcy
293	*The Crowd*	Mar. 10, 1928	Murray, Boardman
298	*The Demi-Bride*	Apr. 2, 1927	Shearer, Myers
301	*Mr. Wu*	May 16, 1927	Chaney, Forbes
302	*The Student Prince in Old Heidelberg*	Sept. 21, 1927	Shearer, Novarro
303	*Callahans and Murphys*	June 16, 1927	Dressler, Moran
305	*The Unknown*	June 18, 1927	Crawford, Chaney
310	*Love*	Nov. 29, 1927	Garbo, Gilbert
313	*Quality Street*	Jan. 7, 1927	Davies, Nagel
320	*Mockery*	Aug. 13, 1927	Chaney, Cortez
323	*The Wind*	Nov. 3, 1928	Gish, Hanson
327	*The Enemy*	Dec. 31, 1927	Gish, Forbes, Brown
332	*The Divine Woman*	Jan. 14, 1928	Garbo, Hanson
343	*The Cossacks*	Apr. 14, 1928	Gilbert, Adorée
345	*The Patsy*	Apr. 7, 1928	Davies, Dressler
352	*Laugh, Clown, Laugh*	Apr. 14, 1928	Chaney, Asther, Young
353	*Wild Orchids*	Mar. 30, 1929	Garbo, Asther
360	*Show People*	Sept. 29, 1928	Davies, Haines
364	*Our Dancing Daughters*	Sept. 1, 1928	Crawford, Page
366	*The Cameraman*	Sept. 15, 1928	Keaton, Day
374	*The Mysterious Lady*	Aug. 4, 1928	Garbo, Nagel
378	*West of Zanzibar*	Dec. 24, 1928	Chaney, Barrymore
380	*A Woman of Affairs*	Jan. 19, 1929	Garbo, Gilbert
390	*Dream of Love*	Dec. 22, 1928	Crawford, Pringle, Asther
392	*Broadway Melody*	Apr. 20, 1929	Page, Love
394	*Hallelujah*	Nov. 30, 1929	McKinney, Haynes
410	*The Trial of Mary Dugan*	June 8, 1929	Shearer, Stone
421	*Hollywood Revue of 1929*	Nov. 9, 1929	Crawford, Shearer, Nagel
423	*Redemption*	Apr. 5, 1930	Gilbert, Boardman, Nagel
430	*The Single Standard*	July 27, 1929	Garbo, Asther, Brown
440	*The Kiss*	Nov. 15, 1929	Garbo, Nagel
456	*Anna Christie*	Mar. 14, 1930	Garbo, Bickford, Dressler

METRO-GOLDWYN-MAYER PUBLICITY CODES, 1924–1942

CODE PREFIX	NO.	SUBJECT (ASTERISK INDICATES ILLUSTRATED IN TEXT)	DATE	FILM OR GENERAL PUBLICITY	MGM PRODUCTION NO.
MPGP	033	Viola Dana	1924	General publicity	
	261	Rex Ingram	1924	*Mare Nostrum*	
	1600	Viola Dana	1924	*Heart Bandit*	
	1924	Novarro and Alice Terry in Rome	1924	*Ben-Hur*	200
	2044	Shearer	1924	*Broken Barriers*	
	2201	Novarro	1924	*Red Lily*	
	2231	Carmel Myers sailing to Rome	1924	*Ben-Hur*	200
	2726	*Great Divide* cast	1924	*Great Divide*	199
	3345	John Gilbert and Aileen Pringle	1924	*Wife of the Centaur*	
	3380	Gish	1924	*Romola*	
	3645	Shearer	1924	*Excuse Me*	209
	4358	Gilbert and Erich von Stroheim	1925	*The Merry Widow*	208
	4558	Novarro (Bragalia photo)*	1925	*Ben-Hur*	200
	5127	Mayer and Davies sign contract	1925	General publicity	
	5906	Renée Adorée	1925	*The Big Parade*	229
	5944	Novarro (Albin photo)	1925	General publicity	
	6084	Erté	1925	General publicity	
	6093	Crawford (Bull photo)	June 15, 1925	General publicity	
	6184	Garbo on ship in NYC (Sileo photo)	July 6, 1925	General publicity	
	6651	Shearer	July 17, 1925	General publicity	
	6736	Novarro	July 18, 1925	*Ben-Hur*	200
	6774	Gish (Alexander photo)	1925	*La Boheme*	240
	7295	Gilbert	1925	*La Boheme*	240
	7405	Garbo (Ball photo)*	July 1925	General publicity	
	7424	Davies (Louise photo)	1925	General publicity	
	7456	Shearer	Aug. 27, 1925	*A Slave of Fashion*	223
	7483	Garbo arrives in Hollywood	Sept. 10, 1925	General publicity	
	7536	Crawford	1925	*Understanding Heart*	
	7538	Chariot race, *Ben-Hur*	Oct. 15, 1925	*Ben-Hur*	200
	7907	Carmel Myers (Louise photo)	1925	*Ben-Hur*	200
	8384	Garbo with lion (Gillum photo)	1925	General publicity	
	8486	Crawford at track (Gillum photo)	1925	General publicity	
	8577	Shearer	1925	*Lady of the Night*	213

CODE PREFIX	NO.	SUBJECT (ASTERISK INDICATES ILLUSTRATED IN TEXT)	DATE	FILM OR GENERAL PUBLICITY	MGM PRODUCTION NO.
MPGP	8590	Garbo, Stiller, and Seastrom (Louise photo)	Dec. 4, 1925	General publicity	
	8785	Stiller at home	1925	General publicity	
	8873	Garbo in car	Dec. 11, 1925	General publicity	
	8874	Garbo	Nov. 19, 1925	*The Torrent*	254
	9171	Garbo with musicians on set	Dec. 23, 1925	*The Torrent*	254
	9191	Garbo (Louise photo)*	Dec. 31, 1925	*The Torrent*	254
	9467	Garbo with pole vaulter (Gillum photo)	1926	General publicity	
	9748	Davies	Feb. 11, 1926	General publicity	
	9773	Crawford	1926	*Paris*	238
	9827	Davies	1926	*Beverly of Graustark*	253
	9836	Garbo with track coach (Gillum photo)*	1926	General publicity	
	9913	Carmel Myers	1926	*Paris*	238
	9998	Garbo with track team (Gillum photo)	1926	General publicity	
MGM	59	Garbo on steps of house	1926	General publicity	
	168	Gilbert at home (Louise photo)	Mar. 22, 1926	General publicity	
	187	Aerial view of MGM*	1926	General publicity	
	586	Garbo on chaise (Louise photo)	Apr. 19, 1926	*The Temptress*	265
	751	Garbo, Moreno, and Stiller	Apr. 17, 1926	*The Temptress*	265
	862	Garbo with visitors on set	Apr. 27, 1926	*The Temptress*	265
	1430	Carmel Myers (Louise photo)*	May 20, 1926	General publicity	
	1444	Garbo with tiger cub (Gillum photo)	1926	General publicity	
	2059	Garbo	July 14, 1926	*The Temptress*	265
	2073	Mae Murray (Louise photo)	July 10, 1926	*Altars of Desire*	278
	2682	Shearer	July 27, 1926	*Upstage*	279
	2801	Shearer (Louise photo)*	1926	*Upstage*	279
	3162	Novarro and Alice Terry (Louise photo)	Aug. 5, 1926	*Lovers*	287
	3276	Vidor wedding	Sept. 8, 1926	General publicity	
	3317	Garbo	Sept. 2, 1926	*Flesh and the Devil*	282
	3576	Garbo and Gilbert at piano	Sept. 13, 1926	*Flesh and the Devil*	282
	3828	Garbo and Gilbert (Louise photo)	Oct. 12, 1926	*Flesh and the Devil*	282
	3868	Garbo, Hanson, and Clarence Brown	Sept. 21, 1926	*Flesh and the Devil*	282
	4124	Crawford in Santa outfit (Louise photo)	Oct. 4, 1926	General publicity	
	4341	Gish (Bull photo)	Oct. 21, 1926	*Annie Laurie*	281

	4686	Gilbert and Renée Adorée	Nov. 11, 1926	*The Show*	294
	4973	Pauline Starke and Edmund Goulding	Nov. 22, 1926	*Women Love Diamonds*	296
	5907	Shearer	Dec. 1, 1926	*The Demi-Bride*	298
	5912	Renée Adorée	Jan. 10, 1927	*Mr. Wu*	301
	6430	Renée Adorée	Feb. 3, 1927	*Mr. Wu*	301
	7249	Crawford	Mar. 26, 1927	*The Unknown*	305
	7273	Chaney	Mar. 2, 1927	*The Unknown*	305
	7492	Gish on beach with horse (Louise photo)*	1927	General publicity	
	7897	Conrad Nagel	Mar. 21, 1927	*Quality Street*	313
	8554	Garbo and Gish on set	Apr. 21, 1927	*The Wind*	300
	9976	Gish (Louise photo)*	July 5, 1927	*The Wind*	300
	10127	Chaney	June 27, 1927	*Mockery*	320
	10198	Garbo and Gilbert on set	July 7, 1927	*Love*	310
	11971	Shearer and Thalberg wedding	Sept. 29, 1927	General publicity	
	13677	Garbo and Hanson	Oct. 9, 1927	*The Divine Woman*	332
	13969	John Gilbert	Dec. 1927	*The Cossacks*	343
	14265	Novarro	Feb. 12, 1927	*The Student Prince in Old Heidelberg*	302
MGMP	146	Gilbert and Renée Adorée (Louise photo)	Dec. 29, 1927	*The Cossacks*	343
	773	Chaney (Louise photo)	Feb. 6, 1928	*Laugh, Clown, Laugh*	352
	801	Loretta Young (Louise photo)	Feb. 8, 1928	*Laugh, Clown, Laugh*	352
	890	Novarro (Louise photo)	Feb. 10, 1928	*Across to Singapore*	354
	2018	Crawford as Venus de Milo (Louise photo)*	1928	General publicity	
	2720	*Show People* set	Apr. 9, 1928	*Show People*	360
	2932	Crawford tap dancing (Louise photo)	Apr. 12, 1928	General publicity	
	2945	Crawford and Johnny Mack Brown (Louise photo)	Apr. 12, 1928	*Our Dancing Daughters*	364
	2991	Novarro's Teatro Intimo (Bull photo)	Mar. 31, 1928	General publicity	
	3384	Gilbert at home (Louise photo)	Mar. 17, 1928	General publicity	
	4215	Crawford and Ruth Harriet Louise (Bull photo)*	May 14, 1928	General publicity	
	5893	Crawford and Johnny Mack Brown	July 23, 1928	*Our Dancing Daughters*	364
	7249	Crawford	Mar. 26, 1928	*The Unknown*	305
	7369	Shearer at beach	July 23, 1928	General publicity	
	8423	Crawford and Nils Asther	Oct. 5, 1928	*Dream of Love*	390

CODE PREFIX	NO.	SUBJECT (ASTERISK INDICATES ILLUSTRATED IN TEXT)	DATE	FILM OR GENERAL PUBLICITY	MGM PRODUCTION NO.
MGMP	9333	*Woman of Affairs* set	Aug. 24, 1928	*A Woman of Affairs*	380
	9953	Garbo and Nils Asther (Manatt photo)	Dec. 5, 1928	*Wild Orchids*	353
	10735	Novarro and Dorothy Janis (Bull photo)	Dec. 27, 1928	*The Pagan*	393
	10849	Keaton on set	Nov. 1928	*Spite Marriage*	407
	11347	Crawford as Hamlet (Louise photo)*	1929	General publicity	
	12008	Anita Page and Bessie Love	Feb. 13, 1929	*Broadway Melody*	392
	13283	Keaton and Dorothy Sebastian	Nov. 28, 1928	*Spite Marriage*	407
	18328	Shearer	July 16, 1929	General publicity	
	18931	Crawford with knife (Louise photo)	1929	General publicity	
	19852	Shearer and Robert Montgomery (Louise photo)	Sept. 21, 1929	*Their Own Desire*	447
	20441	Novarro fencing (Louise photo)	Sept. 14, 1929	*Devil May Care*	443
	20515	Garbo (Bull photo)	Aug. 27, 1929	*The Kiss*	440
	20791	Davies and King Vidor	Oct. 1, 1929	*Not So Dumb*	449
	21715	Garbo and Clarence Brown	1929	*Anna Christie*	456
	21721	Novarro in gym (Bull photo)	Oct. 19, 1929	General publicity	
	21871	Shearer and Robert Montgomery (Louise photo)	1929	*Their Own Desire*	447
	22245	Bessie Love wearing ballet shoes	Nov. 1, 1929	General publicity	
	22427	Vilma Banky (Louise photo)	Nov. 18, 1929	*A Lady to Love*	459
	22943	Edward G. Robinson (Louise photo)	Nov. 23, 1929	*A Lady to Love*	459
	22985	Bessie Love (Louise photo)	1929	General publicity	
MG	18	Garbo (Bull photo)	Nov. 19, 1929	*Anna Christie*	456
	416	Shearer (Louise photo)*	1929	*Their Own Desire*	447
	552	Shearer (Louise photo)*	1929	*Their Own Desire*	447
	609	Novarro	Dec. 19, 1929	*In Gay Madrid*	458
	1337	Garbo (Louise photo)	1929	*The Single Standard*	430
	2348	Vilma Banky (Louise photo)	Dec. 2, 1929	*A Lady to Love*	459
	2849	Novarro	Mar. 15, 1930	*Call of the Flesh*	470
	3405	Renée Adorée (Bull photo)	Feb. 19, 1930	General publicity	
	5087	Garbo (Hurrell photo)	1930	*Romance*	489
	11418	Garbo (Bull photo)	Dec. 12, 1930	*Inspiration*	521
	12763	Garbo as Sphinx (Bull photo)	Dec. 12, 1930	General publicity	

	13543	Garbo (Bull photo)		Dec. 12, 1930	*Inspiration*	521
	16549	Garbo (Bull photo)		July 18, 1931	*Susan Lenox*	561
	19387	Garbo (Bull photo)		Nov. 19, 1931	*Mata Hari*	579
	21164	Garbo and Barrymore (Archer photo)		Jan. 28, 1932	*Grand Hotel*	603
	22724	Garbo (Bull photo)		Apr. 13, 1932	*As You Desire Me*	615
	52159	Garbo on board *Gripsholm*		May 3, 1936	General publicity	
	56799	Jean Harlow (Bull photo)		May 27, 1936	*Saratoga*	987
	57476	Garbo (Bull photo)		Nov. 23, 1936	*Camille*	938
	63980	Garbo (Bull photo)		Sept. 2, 1937	*Conquest*	983
	75825	Garbo (Bull photo)		Aug. 9, 1939	*Ninotchka*	1100
	86385	Garbo (Bull photo)		Oct. 3, 1941	*Two-Faced Woman*	1190
	91750	Louis Armstrong (Bull photo)		Sept. 4, 1942	*Cabin in the Sky*	1267

RUTH HARRIET LOUISE CHRONOLOGICAL NUMBERING SYSTEM

RHL NO.	SUBJECT	FILM OR GENERAL PUBLICITY	MGM PRODUCTION NO.	ILLUSTRATION (PAGE)	DATE
500	Gilbert	*The Big Parade*	229	11	July? 1925
503	Gilbert	*The Big Parade* (MPGP-5906)	229	Color 1	July? 1925
1189	Novarro	*The Midshipman*	230	**	Aug.? 1925
1198	Novarro	*Ben-Hur*	200	10	Aug.? 1925
1410	Garbo	General publicity		39	Sept. 1925
1507	Carmel Myers	*Ben-Hur* (MPGP-7907)	200	84	Sept. 1925
1509	Carmel Myers	*Ben-Hur*	200	9	Oct. 1925
1814	Garbo	*The Torrent*	254	**	Dec. 1925
2242	Garbo	*The Temptress*	265	41	Mar./Apr. 1926
2517	Chaney	*The Road to Mandalay*	275	55	Apr. 1926
2533	Chaney	*The Road to Mandalay*	275	54	Apr. 1926
2652	Mae Murray	*Altars of Desire*	278	20	Sept. 1926
3044	Patricia Avery	General publicity		130	1926
3855	Patricia Avery	General publicity		25	1926
4326	Gish	General publicity (MGM-7492)		48	1927
4820	Gish and Hanson	*The Scarlet Letter*	323	***	1927
5054	Garbo	*Love*	310	42	June/July 1927
5234	Novarro	General publicity (MGM-10813)		189	1928
5319	Dorothy Sebastian	*The Demi-Bride*	298	115	Oct. 1927
5326	Dorothy Sebastian	*The Demi-Bride* (MGM-12357)	298	24	Oct. 1927

RHL NO.	SUBJECT	FILM OR GENERAL PUBLICITY	MGM PRODUCTION NO.	ILLUSTRATION (PAGE)	DATE
5594	Garbo	*The Divine Woman*	332	43	Oct. 1927
5720	Gilbert and Adorée	*The Cossacks*	343	14	1927
5774	Crawford	*Rose Marie*	283	32	1927
5830	Renée Adorée	General publicity (mask photo)		132	1928
6073	Chaney	*Laugh, Clown, Laugh* (MGMP-8036)	352	211	1928
6084	Chaney	*Laugh, Clown, Laugh*	352	56	Feb. 1928
6114	Garbo	*The Divine Woman*	332	viii	Nov. 1927
6126	Garbo	*The Divine Woman*	332	44	Nov. 1927
6128	Garbo	*The Divine Woman*	332	45	Nov. 1927
6311	Johnny Mack Brown	General publicity		200	1928
6535	Crawford	General publicity		148	1928
6592	Novarro	General publicity		190	1928
6931	Anita Page	General publicity		26	1928
7391	Nils Asther	General publicity		199	1928
7480	Crawford	General publicity		35	1928
7609	Shearer	General publicity (MGMP-8005)		34	1928
7724	Garbo	*A Woman of Affairs*	380	46	Sept. 1928
7842	Shearer	General publicity		141	1928
8039	Mary Doran	General publicity		18	1928
8081	Garbo	*Wild Orchids*	353	38	Nov. 1928
8325	Nina Mae McKinney	*Hallelujah*	394	23	1929
8792	Gilbert	General publicity		202	1929
8931	Crawford and Fairbanks	*Our Modern Maidens*	413	***	1929
9387	Crawford	General publicity		30	1929
9448	Josephine Dunn	General publicity		27	1929
9861	Gilbert	*The Cossacks*	343	47	1928
9908	Johnny Mack Brown	General publicity		198	1929
9980	Nils Asther	General publicity		***	1929
104	Garbo	*The Single Standard*	430	***	May 1929
408	Crawford	*Untamed*	438	***	1929
702	Novarro (Teatro Intimo)	General publicity		***	1929
1230	Vilma Banky	*A Lady to Love*	459	13	Dec. 1929
1385	Shearer	General publicity		****	1929

ACKNOWLEDGMENTS

Our many questions were answered by colleagues Cari Beauchamp, Michael Blake, Kevin Brownlow, Arlene Croce, Robert Edwards, Matthew Kennedy, Kevin Lewis, William J. Mann, Lawrence Quirk, Jan Seidler Ramirez, and Anthony Slide.

Collectors of Louise material Eric Bernhoff, Louis F. D'Elia, Robert Flynn Johnson, Michael King, Paul Morrissey, Bill Safka and Arbe Bareis, Lou Valentino, and Douglas Whitney generously shared their knowledge and photographs. Harriet Culver opened her rich archive at Culver Pictures and gave us free rein to examine her treasure trove of original prints. We are especially grateful to Ned Comstock, at the Cinema/Television Library at the University of Southern California; David Allison, Sarah McDonald, and Mark Lynch at Hulton Archive; Sid Avery, Archive Director, Motion Picture and Television Photo Archive; Ruth Patt and Chris Becker, Jewish Historical Society of Central Jersey; Eugenia Spalding, New Brunswick Public Library; Gary Morrison, Assistant Registrar, Columbia University; Margaret Barrett, Butterfield and Butterfield; Marty Jacobs, Theatre Collection, Museum of the City of New York; Mary Corliss, Film Stills Archive, Museum of Modern Art; Anne Shumard, National Portrait Gallery; the staffs of the Photograph Collection, the Getty Museum,

and the Film and Theater Division, New York Public Library; Roy Windham at Baby Jane of Hollywood; Larry Edmunds Bookshop; the world of eBay; and the staff at AMPAS, especially Robert Cushman, who made the Academy's extraordinary resources available to us.

Friends, as always, are owed special thanks: David Butler, Betsy Hamilton Cuthbertson, Linda Dunn, David Kahn, Trudy Prescott Nuding, Carol Pardo, Christina Polischuk, Jill Quasha, Phoebe Simpson, Barbara Tannenbaum, and for special help and encouragement, Thomas Kren and Robert Loper.

The staff at the Santa Barbara Museum of Art encouraged and supported this book from the beginning, and special thanks go to Karen Sinsheimer, Curator of Photography; Cathy Pollock, Editor; Marshall Price, Assistant Curator, and Bob Frankel, Director; and the staff of the Registrar's Office. We would also like to thank our accommodating editors Eric Smoodin, Sue Heinemann, and most especially Anne Canright at the University of California Press. Special thanks go as well to Nicole Hayward, our book designer.

We had the privilege and good fortune to speak with five of Louise's subjects, Frederica Sagor Maas, Anita Page, Maurice Rapf, the late Douglas Fairbanks Jr., and most importantly, Freda Sandrich, Louise's sister-in-law and the widow of her brother, Mark Sandrich. This book would not have been possible without the important insights each contributed to a time gone by.

Sometimes the cliché that without one person a project would not have been possible is accurate, and in our case it is especially true. We owe our thanks to Simon Crocker who generously made his time, contacts, resources, and literally thousands of Ruth Harriet Louise's negatives at the John Kobal Foundation available to us for study.

NOTES

INTRODUCTION

1. John Kobal, *The Art of the Great Hollywood Portrait Photographers* (New York: Knopf, 1980), p. 122.

2. John Kobal has focused attention on the importance of Hollywood still photography, especially portrait photography, in such books as *Hollywood Glamor Portraits* (New York: Dover, 1976) and *The Art of the Great Hollywood Portrait Photographers* (New York: Knopf, 1980). Other relevant surveys and exhibitions include David Fahey and Linda Rich, *Masters of Starlight: Photographers in Hollywood* (Los Angeles: Los Angeles County Museum of Art; New York: Ballantine, 1987); AnneMarie Hürlimann and Alois Martin Müller, *Film Stills: Emotions Made in Hollywood* (Zurich: Museum für Gestaltung Zürich, 1993); and Joel W. Finler, *Hollywood Movie Stills: The Golden Age* (London: B. T. Batsford, 1995).

3. Quoted in Diana Altman, *Hollywood East: Louis B. Mayer and the Origins of the Studio System* (New York: Birch Lane Press, 1992), p. 96.

4. Letter to *Ohio State Lantern,* Jan. 9, 1922, p. 1, quoted in Paula S. Fass, *The Damned and the Beautiful: American Youth in the 1920s* (New York: Oxford University Press, 1977), p. 307.

5. Dorothy Spensky, "Languishing Romances," *Photoplay,* Sept. 1925, p. 28.

6. Laura Mulvey, in a classic essay entitled "Visual Pleasure and Narrative Cinema" (*Screen* 16, no. 3 [1975]: 6–18; repr. in *Visual and Other Pleasures* [Bloomington: Indiana University Press, 1989], pp. 14–27), argues forcefully that movies address male spectators and are conditioned by the "male gaze." Her work has remained a touchstone in thinking about the relationship between women audiences and Hollywood.

7. Christine Gledhill, ed., *Stardom: Industry of Desire* (London: Routledge, 1991); Judith Mayne, *Cinema and Spectatorship* (New York: Routledge, 1993); Jackie Stacey, *Star Gazing: Hollywood Cinema and Female Spectatorship* (New York: Routledge, 1994); and Maggie Humm, *Feminism and Film* (Edinburgh: Edinburgh University Press, 1997), are useful surveys.

8. The role of women, as well as the imagery of women, in Hollywood in the early years has been the subject of much interest lately. See early essays by Anthony Slide, "The Role of Women," in *Early American Cinema* (Metuchen, N.J.: Scarecrow Press, 1994), pp. 151–66; and Martin F. Norden, "Women in the Early Film Industry," in *The Studio System,* ed. Janet Staiger (New Brunswick, N.J.: Rutgers University Press, 1995); also Janet Staiger, *Bad Women: Regulating Sexuality in Early American Cinema* (Minneapolis: University of Minnesota Press, 1995). The Center for the Study of Women in Early Cinema, Duke University, Chapel Hill, N.C., is devoted to these issues.

9. From *A Preface to Morals,* quoted by Sumiko Higashi, *Cecil B. DeMille and American Culture: The Silent Era* (Berkeley: University of California Press, 1994), p. 174.

10. Quoted in ibid., p. 145.

CHAPTER 1. RUTH GOLDSTEIN BECOMES RUTH HARRIET LOUISE

1. Katherine Albert, "She Bosses the Stars: The Story of Ruth Harriet Louise," *Screenland,* Sept. 1928, pp. 32, 94–95.

2. Ruth M. Tildesley, "Directing Directors: Ruth Harriet Louise, Only Woman Photographer in Motion Pictures, Doesn't Mind 'Bossing' Megaphone Men Now!" *Hollywood Life,* Aug. 1926, pp. 58–59, 93. In quoting these words as Louise's own, we realize that the journalism in fan magazines must be treated cautiously. Such caveats aside, the information in the various articles on Louise is consistent enough to be used with some confidence.

3. The source of much of this family history is Freda Sandrich, the widow of Mark Sandrich. We are very grateful for her wonderful memories and conversation, in interviews conducted on June 13, 15, and 25, 1998.

4. Louise was born at the family home at 301 West 150th Street in Manhattan. At some point the family moved to Brooklyn, where Mark graduated from New Utrecht High School, Bensonhurst, in 1918. Louise finished her schooling in Trenton.

5. Conversation with 1920s MGM screenwriter Freddie Sagor Maas, Sept. 9, 1997.

6. *Banner* 3, no. 4 (Aug. 1922): 11. The editor concludes, "We understand he has taken up residence at Hollywood. Our best wishes."

7. Conversation with Freda Sandrich, June 15, 1998.

8. *Banner* 5, no. 2 (March 1924): 5.

9. Tildesley, "Directing Directors," p. 58. The same story appears in Albert, "She Bosses the Stars," p. 95. Albert was a publicist at MGM.

10. *Banner* 3, no. 6 (Nov. 1922): 13.

11. "Capturing Stars: The Story of Ruth Harriet Louise, the Girl Who Is Considered America's Most Brilliant Photographer," *Royal Magazine* 57, no. 339 (1927): 224.

12. The following quotations are all taken from Ruth Goldstein, "The Better Photography," *Banner* 3, no. 6 (Nov. 1922): 6–7.

13. In a 1927 interview she did say that "soon she began to get calls for portraits all over New York" ("Capturing Stars," p. 224), but beyond that virtually nothing is known of her New Brunswick career.

14. Louise was joined by her mother and father. Rabbi Goldstein retired from Temple Ashe Emeth in 1925, and was replaced by Joseph Sarachek. Letters of thanks for the farewell gift from the congregation to Rabbi Goldstein are recorded in the Sisterhood minutes, March 3 and June 2, 1925, Central New Jersey Jewish Historical Society, New Brunswick, N.J.

15. Margaret Chute, "Girl Photographer," *Modern Weekly,* Aug. 4, 1928, p. 804.

16. Flynn's photograph is reproduced in *The Film Daily Yearbook,* ed. Jack Alicoate (New York: Film Daily, 1926), p. 30.

17. "Capturing Stars," p. 225.

18. A second possibility, most certainly apocryphal, still arises in discussions of Louise's early Hollywood history. Both Anita Page, an MGM star whom Louise frequently photographed, and Bud Graybill, an MGM portrait photographer, remember clearly that it was William Randolph Hearst and his mistress, Marion Davies, who wanted Louise and were responsible for her Hollywood career. Graybill asserts that Clarence Sinclair Bull (head of the stills department) "said Hearst brought her to the studio. He should know" (Bud Graybill, letter to John Kobal, Jan. 29, 1978, John Kobal Foundation Archives). If this unlikely story were true, it would be ironically apt, since her beginning—riding into the studio on the recommendation of a star—would then resemble the situation that caused her termination, four and a half years later. Freda Sandrich, however, suggests that Hearst would have wanted Louise only to photograph them at their beach house, and well after Louise started work at MGM (Davies did not move into the house until late summer 1927). Photographs by Louise of Davies at the beach house support this version. Al St. Hilaire, moreover, confirms that it was Carmel Myers who got Louise the job (taped interview with John Kobal, John Kobal Foundation Archives, n.d.). Both the first MGM publicity chief, Joe Jackson, and the second, Pete Smith, who took over before the end of 1924, were said to have had crushes on Carmel Myers—which may well have influenced Louise's being hired; see Gary Carey, *All*

the Stars in Heaven: Louis B. Mayer's MGM (New York: Dutton, 1981), p. 107; and Roland Flamini, *Thalberg: The Last Tycoon and the World of MGM* (New York: Crown, 1994).

19. Frances Marion, *Off with Their Heads* (New York: Macmillan, 1972), p. 146. MGM was jokingly called "Mayers-Ganza-Mishpoka" (Mayer's whole family); see Samuel Marx, *Mayer and Thalberg: The Make-Believe Saints* (New York: Random House, 1975), p. 67.

20. One photograph from the session is reproduced in *Motion Picture Classic,* Oct. 1925, p. 34. See also Marx, *Mayer and Thalberg,* p. 51, for another version of the story.

21. Albert, "She Bosses the Stars," p. 95.

22. Tildesley, "Directing Directors," p. 58. A photograph of Duval from this first session is reproduced in "Capturing Stars," p. 226.

23. Harrison Rhodes, "High Kingdom of the Movies," in *American Towns and People* (New York: Robert M. McBride, 1920), p. 211.

24. Terry Ramsaye, *A Million and One Nights: A History of the Motion Picture* (New York: Simon & Schuster, 1927), 2:681, 835. Frederick James Smith, "The Business of Making Motion Pictures," *Motion Picture,* Oct. 1925, p. 16, gives slightly different figures: total investment, $1.5 billion; people employed, 300,000; average weekly attendance, 50 million; theaters in United States, 16,000; studio salaries, $75 million; annual total costs, $200 million; annual admissions income, $520 million; total productions scheduled, 950.

25. Harry Reichenbach (as told to David Freedman), *Phantom Fame: The Anatomy of Ballyhoo* (New York: Simon & Schuster, 1931), p. 153. Reichenbach worked for Mayer in 1914; see Charles Higham, *Merchant of Dreams: Louis B. Mayer, MGM, and the Secret Hollywood* (New York: Donald I. Fine, 1993), p. 26.

26. See Bosley Crowther, *The Lion's Share: The Story of an Entertainment Empire* (New York: Dutton, 1957), pp. 69–71, 79–81; and Higham, *Merchant of Dreams,* pp. 66–70.

27. "The motion picture public itself is young," argues Mr. Thalberg. "Its age range is between eighteen and twenty-four. A player who waits seven years to reach them will be too old. At Metro we are giving Ralph Forbes, Marcelline Day, Dorothy Sebastian, Joan Crawford, and such beginners, education, leads and publicity simultaneously" (quoted in Ruth Waterbury, "Youth," *Photoplay,* Nov. 1927, p. 46, reprinted in *Photoplay Treasury,* ed. Barbara Gelman [New York: Crown, 1972], p. 114).

28. Rhodes, "High Kingdom of the Movies," p. 210. "The fans are young and the new stars are young," declared Waterbury, "Youth," in *Photoplay Treasury,* p. 114. See also Cynthia Felando, "Hollywood in the 1920s: Youth Must Be Served," in *Hollywood Goes Shopping,* ed. David Desser and Garth S. Jowett (Minneapolis: University of Minnesota Press, 2000), pp. 82–107.

29. Reichenbach, discussing his invention of the press book to publicize a show, declared: "Louis B. Mayer, now head of Metro-Goldwyn-Mayer, then but a local exhibitor, was one of the first to recognize the value of the press book which has since become the universal method of trade promotion in the picture business" (*Phantom Fame,* p. 149).

30. See *The Film Daily Yearbook* (1925), p. 796.

31. *Photoplay,* March 1925, p. 56, and May 1925, p. 42.

CHAPTER 2. LOUISE'S STUDIO PRACTICE

1. "The 1925 MGM Studios Tour," MGM Film Archive, Turner Entertainment/Time Warner–AOL.

2. See Mark A. Vieira, *Hurrell's Hollywood Portraits* (New York: Abrams, 1997), p. 26.

3. Margaret Chute, "Girl of Twenty-two Who Photographs Film Stars," *Everybody's Weekly,* Sept. 8, 1928, n.p.

4. Anita Page letter to Robert Dance, n.d. (postmarked June 20, 1998). Kobal (*Art of the Great Hollywood Portrait Photographers,* pp. 102–9) has an extended and sensitive discussion of the trust necessary between photographer and subject.

5. Chute, "Hollywood's Girl Photographer," p. 807.

6. Anita Page letter, 1998.

7. Budd Schulberg, *Moving Pictures: Memoirs of a Hollywood Prince* (New York: Stein & Day, 1981), p. 212.

8. The "MGM Studio Tour" short shows thirteen still men at work, but a photograph of Bull and his stills photographers in 1926 includes only nine men; see Terence Pepper and John Kobal, *The Man Who Shot Garbo: The Hollywood Photographs of Clarence Sinclair Bull* (London: National Portrait Gallery; New York: Simon & Schuster, 1989), p. 19.

9. Ibid., p. 21.

10. See the MGM photographer Bud Graybill's comments on planning stills campaigns, in Kobal, *Art of the Great Hollywood Portrait Photographers,* p. 56.

11. Al St. Hilaire taped interview with John Kobal, n.d., John Kobal Foundation Archives. St. Hilaire worked for Louise for four months before she left MGM.

12. Douglas Fairbanks Jr., conversation with Robert Dance, March 12, 1996. On the slow tempo of an 8 × 10 camera, see the comments of the photographer John Engstead in John Kobal, *People Will Talk* (New York: Knopf, 1986), p. 531. Kobal describes the typical equipment and film at some length in *Art of the Great Hollywood Portrait Photographers,* pp. 66–67.

13. Anita Page letter, 1998.

14. Albert, "She Bosses the Stars," p. 32. Some actors rebelled at sitting for portraits, since at some studios they were paid only for the work on the movie set and were expected to do the portrait and publicity work on their own time; see the comments of Colleen Moore in Kobal, *People Will Talk,* p. 33.

15. Hurrell's description of his working technique (see Kobal, *People Will Talk,* pp. 259, 263) sounds very much like Louise's: his warm and cozy studio, his use of music, and his constant activity chime with descriptions of Louise at work. Whitney Stine (*The Hurrell Style* [New York: John Day, 1976], p. 8) contrast's Hurrell's little place with the "cold, damp, sterile surroundings of the still gallery"—referring to Bull's studio on the ground floor. The emotional importance of music in the silent movies was univer-

sally recognized. In a humorous discussion of how difficult it was for actresses to emote in front of the cold eye of the camera, Rhodes attributes the whole success of the project to the violinist who "almost under the lovely creature's nose draws forth from his instrument the low, thrilling strains which immediately inspire her to have her will of her victim. Never before have the charms of music . . . been so thoroughly recognized" (Rhodes, "High Kingdom of the Movies," p. 218).

16. Chute, "Hollywood's Girl Photographer," p. 805.

17. In another photograph of Louise at work, she wears a boldly patterned sack dress that again barely restricts her movements. See ibid., p. 804.

18. But Hurrell insisted on using his old Verito lens. The camera equipment he inherited from Louise is detailed in Vieira, *Hurrell's Hollywood Portraits,* p. 27. Hurrell also remembered being the first studio photographer to use a diffusion lens (Kobal, *People Will Talk,* pp. 260, 262). Freda Sandrich (interview, June 6, 1998) remembers that Louise used cold cream on her lens for the soft-focus shots. Her assistant, however, has suggested that the soft focus was produced in the lab (St. Hilaire interview with Kobal).

19. Nickolas Muray, "The Amateur Movie Producer," *Photoplay,* Apr. 1927, pp. 51–52.

20. At camera tests, one might find an assistant director, one or two cameramen, four electricians, a makeup man, and a couple of property men present, so important was the lighting to the success of the test. See "Could You Face the Camera?" *Motion Picture,* July 1926, pp. 37–38.

21. Russell Ball, "How to Have Your Photograph Made," *New Movie Magazine,* Sept. 1930, p. 129.

22. A. L. Wooldridge, "Through Different Lenses," *Picture Play* 31, no. 4 (Dec. 1929): 55.

23. See *Eve,* Sept. 12, 1925, p. 9, in Ruth Harriet Louise Scrapbooks, Margaret Herrick Library, Academy of Motion Picture Arts and Sciences (AMPAS).

24. St. Hilaire interview with Kobal.

25. Kobal asserts that Louise always worked from a full-length pose; see *Art of the Great Hollywood Portrait Photographers,* p. 94.

26. Kobal, *People Will Talk,* pp. 374, 380.

27. The prints themselves often indicate on the verso how many copies of each size were to be made. George Hurrell confirms the point:: "I used to make 11 × 14 prints. These 8 × 10 stills you see today, they were just for handing out to the editors, for newspapers mostly, because the magazines would get 11 × 14 prints" (in Kobal, *People Will Talk,* p. 258). Elsewhere (ibid., 261) he states that he only made one print; the rest were made by the studio. The prints marked on the back with quantities thus become all the more telling: they are the primary original—the artist's proof, as it were.

28. Louise seems to have supervised printing and cropping on a regular basis. The MGM files for *The Trial of Mary Dugan* contain several revealing prints. Photo 8555 in file MGMP 14, for example, has outlined on the verso the enlargement and cropping that were to be done to focus on the figure of Shearer; in other words, Louise worked through the large prints to move in on the essential image.

29. At AMPAS, the Core Biographical Collection contains signed exhibition prints of Norma Shearer, Lili

Damita, Anna May Wong, and others (all undated) and a signed set of Anna Sten prints (dating from 1932).

CHAPTER 3. THE PORTRAIT PHOTOGRAPH

1. *Photoplay* 27, no. 2 (Jan. 1925). The Pach brothers are credited with photographs of Metro stars. And Apeda, in New York, continued to photograph Metro stars such as Eleanor Boardman and John Gilbert in 1925 (reproduced in *Photoplay,* July 1925).

2. See as well the comments of Marianne Margolis on the "affectionate front" that Muray provides the stars; *Muray's Celebrity Portraits of the Twenties and Thirties* (New York: Dover, 1978), intro.

3. "A camera man can do even more for a star than a director can do in some ways. A director can make a girl act, but he can't turn her into a radiant beauty. A camera man can do this, through marvelous devices of lighting; and he often does" (Alice M. Williamson, *Alice in Movieland* [New York: D. Appleton, 1928], p. 275).

4. King Vidor, *A Tree Is a Tree* (New York: Harcourt, Brace, 1952), p. 95.

5. From Mike Steen, *Hollywood Speaks: An Oral History* (New York: Putnam, 1974), pp. 208–24 (interview with James Wong Howe).

6. Reproduced in John Kobal, *Hollywood: The Years of Innocence* (New York: Abbeville Press, 1985), p. 133. In one of the more amazing demonstrations of stupidity, *Biograph,* in contrast, refused to send out star photographs. Kevin Brownlow (*Hollywood: The Pioneers* [New York: Knopf, 1979], p. 158) reproduces a letter from *Biograph,* published in the issue of May 21, 1910, returning $2.50 from a fan who wanted a photograph of a star: "We are not issuing photographs of the artists comprising our stock company."

7. Quoting *Variety,* April 6, 1927, L'Estrange Fawcett (*Film Facts and Forecasts* [London: G. Bles, 1927]) notes that Colleen Moore received fifteen thousand letters every month and sent out twelve thousand photographs; Clara Bow received eleven thousand letters a month and sent out eight thousand photographs.

8. Hurrell in Kobal, *People Will Talk,* p. 258. This was true for Garbo, for example.

9. All quotations from Archer's article are from *Cinematographic Annual,* ed. Hal Hall, vol. 1 (Hollywood: American Society of Cinematographers, 1930), pp. 245–251.

10. These categories overlap somewhat with those of Paul Trent, as outlined in *The Image Makers: Sixty Years of Hollywood Glamour* (New York: McGraw-Hill, 1972), p. 34. Trent, in perhaps the first modern survey of Hollywood portrait photographs, sets out seven categories of star portraits, redressing Archer's omission. John Kobal gives a fuller and more historically accurate set of categories in *Art of the Great Hollywood Portrait Photographers,* p. 58.

11. The most famous such example is the scene in *Broadway Melody of 1938* when Judy Garland sings "Mr. Gable" to a scrapbook filled with photographs of him.

12. Walter Ramsey, "The Hollywood Circus," *Motion Picture,* Aug. 1919, p. 16. And Jan Gordon and Cora

Gordon (*Star-dust in Hollywood* [London: George Harrap, 1930], p. 165) reproduce a Christmas card from director Jim Cruze and his wife, Betty, which shows a party at their home, including a young starlet racing around crying, "I want you all to look at my stills."

13. *Motion Picture,* Jan. 1929, pp. 46–47.

14. Reproduced in *Vanity Fair,* Jan. 1928, p. 53.

15. Herbert Howe, "On the Road with Ramon," *Motion Picture,* July 1927, p. 93.

16. Ronald L. Davis, *The Glamour Factory: Inside Hollywood's Big Studio System* (Dallas: Southern Methodist University Press, 1993), p. 147.

17. Michael G. Ankerich, *Broken Silence: Conversations with 23 Silent Film Stars* (Jefferson, N.C.: McFarland, 1993), p. 15.

18. Ibid., p. 250.

19. *Photoplay,* March 1925, p. 86.

20. Robert C. Cannom, *Van Dyke and the Mythical City Hollywood* (Culver City, Calif.: Murray & Gee, 1948), p. 140.

21. *Picturegoer,* Feb. 1929, pp. 27–29.

22. Ankerich, *Broken Silence,* p. 214.

23. Williamson, *Alice in Movieland,* p. 93.

24. *Motion Picture,* June 1929, p. 101.

CHAPTER 4. THE PUBLICITY DEPARTMENT AND THE FAN

1. Alexander Walker, *Stardom: The Hollywood Phenomenon* (New York: Stein & Day, 1970), p. 246. Anthony Slide provides a useful description of the fan magazines and their origins in *The Idols of Silence* (South Brunswick, N.J.: A. S. Barnes, 1976).

2. Reichenbach, *Phantom Fame,* p. 162. For a recent study of such early advertising campaigns, see the discussion of *Flaming Youth* (First National, 1924) in Sara Ross, "The Hollywood Flapper and the Culture of Media Consumption," in Desser and Jowett, *Hollywood Goes Shopping,* pp. 74–76.

3. Kathryn Fuller, in *At the Picture Show: Small-Town Audiences and the Creation of Movie Fan Culture* (Washington, D.C.: Smithsonian Institution Press, 1996), pp. 156–57, describes the importance of stars in advertising campaigns from as early as the mid-1910s. She also discusses at length the degree to which James Quirk, editor of *Photoplay,* aimed his magazine at women and the youth market.

4. Reichenbach, *Phantom Fame,* p. 151.

5. Gary Carey, *All the Stars in Heaven: Louis B. Mayer's MGM* (New York: Dutton, 1981), pp. 107–8; and Kobal, *Art of the Great Hollywood Portrait Photographers,* pp. 55–56.

6. *Film Daily Yearbook* (1929), p. 780.

7. *Photoplay,* more than any other fan magazine, took the lead in defining the movie fan as a woman. See Fuller, *At the Picture Show,* p. 147.

8. Fawcett, *Film Facts and Forecasts,* pp. 238–39.

9. Letter from M. G. T., Philadelphia, Pa., to *Photoplay,* Oct. 1929, p. 10.

10. Walker, *Stardom,* p. 250.

11. *Screen Secrets,* July 1929, p. 82.

12. Ankerich, *Broken Silence,* p. 242.

13. *Picturegoer,* Feb. 1929, p. 53.

14. *Motion Picture,* Oct. 1929, p. 15. See also in the *Photoplay* of July 1928 (p. 101) an advertisement for Blatz chewing gum, where one could get twenty autographed photos of stars and an album for twenty wrappers from single sticks plus twenty cents. The photos are the standard postcard size, 3½ × 5½: "There's a real thrill in showing your friends a wonderful collection of your favorite screen star photos." See also Kobal, *Art of the Great Hollywood Portrait Photographers,* p. 41.

15. Fuller, *At the Picture Show,* p.146.

16. Prices were as follows: 16 × 20: b&w-$2; sepia $2.50; hand c.$4; 11 × 14: b&w-$1; sepia 1.25; h-c $2.

17. Letter from M. G. T. to *Photoplay,* Oct. 1929, p. 10.

18. Rhodes, "High Kingdom of the Movies," pp. 203–4.

19. *Photoplay,* Aug. 1928, pp. 38ff.

20. Davies received 5,500; Shearer, 5,000; Novarro, 4,800; Garbo, 4,500; Crawford and Haines, 4,000 each. Ibid., p. 131.

21. Letter from Mary Bulfrey, Syracuse, N.Y., to *Screenland,* June 1929, p. 16. Every now and then, the studios and fan magazines would promote a story of a movie star's bond with a fan. In a series of photographs by Russell Ball, Ramon Novarro is shown welcoming as a guest in his home one Grandma Baker from Oak Park, Illinois. In one, he signs copies of a portrait taken by Louise in which he is costumed for *Ben-Hur,* his most famous role (in the MGM Novarro file, AMPAS).

22. Fuller, *At the Picture Show,* p. 146.

23. *Photoplay,* Jan. 1924, p. 33; Jan. 1926, p. 36.

24. *Screenland,* Oct. 1925, pp. 32–34.

25. *Screenland,* June 1929, p. 16.

26. These photographs are in the MGM Stills Collection, Greta Garbo Biographical File, vol. 1, at AMPAS (nos. 137 [MGMP-1202]–141).

27. The scrapbook is housed in the University of Southern California Library, Special Collections.

CHAPTER 5. SELLING FASHION AND GLAMOUR

1. *Royal Magazine* comments, for example, on "her queer, original clothes" ("Capturing Stars," pp. 224–25).

2. A 1929 *New York Times* editorial, for example, cites at some length specific kinds of product placement, from automobiles to food. See Charles Eckert, "The Carole Lombard in Macy's Window," in *Movies and Mass Culture,* ed. John Belton (New Brunswick, N.J.: Rutgers University Press, 1996), p. 109.

3. Letter from Kathryn Beam, Canton, Pa., to *Photoplay,* May 1928, p. 10.

4. Reichenbach, *Phantom Fame,* p. 169. And in 1919: "More women see deMille's pictures than read fashion magazines"; quoted in Higashi, *Cecil B. DeMille and American Culture,* p. 144.

5. *Photoplay* announced in November 1923 (p. 35) that William J. Moll would write a series to guide readers "in their efforts to apply in a practical and inexpensive manner" the interiors created for the screen.

6. Marguerite Henry, "Adapt the Dining Room of the Screen to Your Home Use," *Photoplay,* July 1925, pp. 72ff.

7. *Photoplay,* July 1925, pp. 74–75. *Photoplay*'s Shopping Service ("Will be glad to purchase for you articles shown on these pages") was at 221 W. 57th St., New York, but it shipped out of Chicago (Interior Decorating Department, *Photoplay,* 750 N. Michigan Ave., Chicago).

8. See Sara Ross, "The Hollywood Flapper and the Culture of Media Consumption," in Desser and Jowett, *Hollywood Goes Shopping,* p. 60.

9. Swanson was under contract to appear in high fashion in public. She reputedly spent $25,000 a year on fur coats alone. See Walker, *Stardom,* p. 130.

10. Gloria Swanson, *Swanson on Swanson* (New York: Random House, 1980), p. 166.

11. Marion, *Off with Their Heads!* p. 74.

12. Margaret Farrand Thorp, *America at the Movies* (New Haven, Conn.: Yale University Press, 1939), pp. 90–91.

13. See Stella Bruzzi's discussion of "clothing's distancing, disruptive potential" in *Undressing Cinema: Clothing and Identity in the Movies* (London: Routledge, 1997), p. 34. For specific examples, consider *Altars of Desire* (1926), *Dance Madness* (1926, with clothes by Erté), or most films starring Aileen Pringle.

14. See Higham, *Merchant of Dreams;* and Erté, *Things I Remember: An Autobiography* (New York: Quadrangle/New York Times Book Co., 1975), pp. 81–83.

15. The claim that Hollywood was more important than Paris was made as early as 1919; see Higashi, *Cecil B. DeMille and American Culture,* p. 144. But actions speak louder than words. Caroline Rennolds Milbank (in *New York Fashion: The Evolution of American Style* [New York: Abrams, 1989]) discusses at some length the repeated attempt in the 1920s by Paris designers to introduce longer hemlines and the American resistance. She does not, however, recognize the power of Hollywood, with its numerous depictions of active, sporting women, as playing a large role in this resistance.

16. For a suggestive discussion of the period before 1925, see Maureen Turim, "Seduction and Elegance: The New Woman of Fashion in Silent Cinema," in *On Fashion,* ed. Shari Benstock and Suzanne Ferriss (New Brunswick, N.J.: Rutgers University Press, 1994), pp. 173–89.

17. Lois Shirley, "Your Clothes Come from Hollywood," *Photoplay,* Feb. 1929, pp. 70–71, 130. The claim was reiterated contantly: "Hollywood, as usual, is the birthplace of all that is new and delectable in fashion suggestions for American women" ("Hollywood—Home of Fashion," *Screen Secrets,* July 1929, p. 41). An article in the June 1928 issue of *Motion Picture,* illustrated by caricatures, satirized this trend

(D. G. Shore, "If Hollywood Had Its Way Paris Fashion Would Be Out," pp. 56–57). Contemporary audiences were aware of the political ramifications of this connection as well: "We must remember to trim our 'Votes for Women' with a little lace and ribbon—if we would keep our Man a 'Lover' as well as a 'Husband,'" declares the introductory intertitle to DeMille's *Old Wives for New* (1918), quoted in Higashi, *Cecil B. DeMille and American Culture,* p. 147.

18. "How the Little Ingenue Can Be Smart, Too!" *Screenland,* June 1929, p. 54.

19. *Photoplay,* July 1925, pp. 56–57; Nov. 1925, pp. 52–53.

20. *Photoplay,* March 1929, p. 80.

21. Thorp's comments in 1939 underline this development: "However thick the luxury in which a star is lapped, she takes care today to make it known that she is really a person of simple wholesome tastes, submitting to elegance as part of her job but escaping from it as often as possible" (*America at the Movies,* p. 74).

22. Features of this sort nearly always heralded the return of a star from her most recent European trip; see, for example, the story about Mae Murray in the September 1925 issue of *Photoplay,* p. 64.

23. *Photoplay,* Jan. 1924, p. 51.

24. Whether the decision to use a major star to introduce this innovation was that of the studio or the magazine, it exemplifies the close connections between *Photoplay* under the editorship of James Quirk and MGM.

25. *Vanity Fair,* Oct. 1925, p. 11.

26. See the "The Lillian Gish Frock," at $49.75 (at least it was expensive!), in *Photoplay,* July 1925, pp. 69ff.

27. *Photoplay,* Aug. 1929, p. 48.

28. In the February 1926 issue of *Photoplay* (p. 58) Shearer is shown wearing a Fair Isle knit cap sent by a fan; the next month (p. 51), her headgear is a Japanese scarf. In May 1926 (p. 55) she goes shopping wearing an elegant dress—the same one she wore in a photo taken by Muray in the April issue.

29. Eckert, "The Carole Lombard in Macy's Window," pp. 101–2. Although the financial arrangements between the studio and the stores are unclear, the relationship was likely rather informal at first.

30. Conversation with Freda Sandrich, June 6, 1998.

31. Donald Albrecht, analyzing the popular dissemination of modern architecture via the movies, discusses a similar phenomenon. He argues, however, that the set designs of French films were responsible for this positive reception, before cubist and art deco designs were adopted by Hollywood in the late 1920s. See his *Designing Dreams: Modern Architecture in the Movies* (New York: Harper & Row, 1986). We would point out, however, that the two cinemas are not so far apart in date, and that costume and accessories matter as much as sets. For the relationship between the cinema and the "new modes of technology, representation, spectacle, distraction, consumerism, ephemerality, mobility, and entertainment" that constituted modernism, see Leo Charney and Vanessa R. Schwartz, eds., *Cinema and the Invention of Modern Life* (Berkeley: University of California Press, 1995).

32. Quoted in Anne Tucker, *Works on Paper: Edward Steichen—The Condé Nast Years* (Houston: Museum of Fine Arts, 1984), n.p.

33. In a photo for Bradley Knitwear of Dorothy MacKail in a cubist print bathing suit against a futurist background, the pattern is described as "futuristic" (*Photoplay,* July 1929, p. 7).

34. *Vanity Fair,* July 1925, p. 35. Colette made a similar assessment when she declared in *Vogue* in 1925: "Short, flat, geometrical and quadrangular. Feminine wear is fixed along the line of the parallelogram. And 1925 shall not see the comeback of soft curves, arrogant breasts and enticing hips" (quoted in Sara Bowman and Michel Molinare, *A Fashion for Extravagance: Art Deco Fabrics and Fashions* [New York: E. P. Dutton, 1985], p. 114). Hollywood would successfully resist her conclusions, however.

35. Ball, "How to Have Your Photograph Made," p. 71.

36. Elizabeth Wilson, *Adorned in Dreams: Fashion and Modernity* (Berkeley: University of California Press, 1987), pp. 12, 15.

37. Cecil Beaton, *The Glass of Fashion* (London: Weidenfeld & Nicolson, 1954), p. 89. As Fass (*The Damned and the Beautiful,* p. 280) writes, such boyishness "must be understood in terms of two distinct but related consequences of this new access between the sexes. They express not conflict but a well-poised tension between the informal boyish companion and the purposeful erotic vamp." In other words, this new model of female physicality was an expression of a new understanding of sexual and social relations between men and women.

38. On Steichen's fashion photographs, see Dorothy Johnstone, *Real Fantasies: Edward Steichen's Advertising Photography* (Berkeley: University of California Press, 1997). For photographs published in *Harper's Bazaar* in these years, see Baron Adolphe de Meyer, *A Singular Elegance: The Photographs of Baron Adolph de Meyer,* with text by Anne Ehrenkranz (San Francisco: Chronicle Books in association with the International Center of Photography, 1994), pp. 126–31.

39. For an interesting discussion of exoticism in Hollywood from a slightly later period, see Sara Berry, "Hollywood Exoticism: Cosmetics and Color in the 1930s," in Desser and Jowett, *Hollywood Goes Shopping,* pp. 108–38.

40. On Louise's exhibition prints, see chapter 2, note 29.

41. Herbert Howe, "A Jungle Lorelei," *Photoplay,* July 1929, p. 36.

42. Turim, "Seduction and Elegance," p. 157.

43. David Bordwell has emphasized the specific connection to lighting; see "Glamour, Glimmer, and Uniqueness in Hollywood Portraiture," in *Hollywood Glamour, 1924–1942: Selected Portraits from the Wisconsin Center for Film and Theater Research* (Madison, Wis.: Elvehjem Museum of Art, 1987).

44. Thorp, *America at the Movies,* p. 65. George Hurrell would have put the emphasis almost entirely on the first element: sex appeal. Moreover, he felt that stills (the term he used for all his photographs) were better for projecting this sexualized glamour than the movie itself. "The cleavage wasn't a problem. You could do it with stills easier than in films, with stills you could plan and organize it. . . . By the way you

pose them, and you can't do that in motion pictures because they gotta move." Hurrell was talking about the 1930s, however, and the relationship between fashion, glamour, and sexuality was very much in formation in the previous decade. For more on what Hurrell had to say on the subject, see Kobal, *People Will Talk,* pp. 255–72.

45. Thorp, *America at the Movies,* pp. 69–70.

CHAPTER 6. WHAT IS A STAR?

1. Eugene Brewster, "What Is a Star?" *Motion Picture,* Sept. 1925, pp. 57 ff.

2. Walker, *Stardom,* pp. 121, 125. He also details the increasing resentment of studios and producers as production costs soared and star salaries seemed to squeeze profits, through 1924.

3. See, for example, Richard Dyer, *Stars,* rev. ed. (London: British Film Institute, 1998); and Richard deCordova, *Picture Personalities: The Emergence of the Star System in America* (Urbana: University of Illinois Press, 1990). For a discussion of how contracts and other specific elements of stardom were administered in this period, see Myrtle Gebhart, "How a Star Is Made," *Picture Play,* March 1929, pp. 84–87, 106.

4. Brewster, "What Is a Star?" p. 105.

5. Leo Rosten, *Hollywood: The Movie Colony, the Movie Makers* (New York: Harcourt Brace, 1941), p. 243.

6. Quoted in Scott Eyman, *The Speed of Sound: Hollywood and the Talkie Revolution, 1926–1930* (New York: Simon & Schuster, 1997), p. 244.

7. Mary Eunice McCarthy, *Hands of Hollywood* (Hollywood: Photoplay Research Bureau, [1929]), pp. 73–78.

8. Ball, "How to Have Your Photograph Made," pp. 68 ff.

9. *Photoplay,* Oct. 1923, p.35. Indeed, looking too much like a star could kill a career. In a cautionary tale, *Motion Picture* (May 1929, p. 40) described the fate of Jeraldine DeVorak (photographed by Louise to look like a sullen Garbo) and Paul Vincente (who "looked so like Valentino"): "The screen holds out a hand to them, then pushes them away. It shows a flicker of interest, then turns its back on them. They are not failures. They have penetrated within the sacrosanct portals. Producers are aware of them. They don't feel the fear of salvation. But their eyes have a more haunted look than the hungriest extra."

10. Selma Robinson, "What Is the Quality That Makes a Star?" *Motion Picture,* July 26, pp. 51, 88. As Fuller (*At the Picture Show,* pp. 178, 181) points out, there is ample data on audience response from the period to know that "both men and women alike obsessively concentrated on actresses' bodies, movements and mannerisms."

11. Heather Addison documents the obsessive focus on the female body, as a site where the interests of Hollywood glamour and consumer buying converge, in this early period in "Hollywood, Consumer Culture, and the Rise of 'Body Shaping,'" in Desser and Jowett, *Hollywood Goes Shopping,* pp. 3–33.

12. Jameson Sewell, "What Is Camera Beauty?" *Photoplay,* July 1925, p. 38.

13. In a scrapbook of Joan Crawford clippings (Jesse Turner Collection, Library of Congress Film and Theater Collection). The dimensions given for "Early Greek and Modern Hollywood" are: Height 5'4", 5'3½"; Weight 135 lbs., 112 lbs.; Chest 34¾", 32¾"; Hip 37½", 35¾"; Calf 13½", 12½"; Ankle 8", 7½".

14. Height 5'4" Pola Negri; Eyes Mary Pickford; Neck 12½" Norma Talmadge; Chest 33" Greta Garbo; Arm 18" Clara Bow; Waist 26" Bebe Daniels; Wrist 6" Gloria Swanson; Hips 36" Gilda Gray; Thigh 18" Aileen Pringle; Calf 13½" Norma Shearer; Ankle 8" Marion Davies; Feet 3AA Ann Pennington; Weight 118 lbs. Billie Dove.

15. Kobal, *People Will Talk*, p. 260.

16. Joan Crawford (with Jane Ardmore), *A Portrait of Joan* (New York: Doubleday, 1962), pp. 12–13.

17. Avery was a secretary who got a small part in Novarro's *That Certain Party,* according to *Picture Play,* Aug. 1926, p. 73; her departure, after a small role in *Annie Laurie,* is discussed in *Picture Play,* June 1927, p. 47.

18. *Eve,* Sept. 12, 1928, pp. 510–11; in Ruth Harriet Louise Scrapbook, AMPAS.

19. *Picture Play,* Sept. 1925, p. 9.

20. Gish remembered that it was Schenck and the East Coast office who signed her, and that he signed her without Mayer's knowledge. See Lillian Gish, *The Movies, Mr. Griffith, and Me* (Englewood Cliffs, N.J.: Prentice-Hall, 1969), p. 277.

21. Alexander Walker (*Stardom,* chaps. 8 and 14) connects these changes to the nature of the financing of the studios, as does Louise Brooks; see her *Lulu in Hollywood* (New York: Knopf, 1982), pp. 93–94.

22. For more on Murray's story, see Jane Ardmore, *The Self-Enchanted: Mae Murray—Image of an Era* (New York: McGraw-Hill, 1959)*;* Norman Zierold, *Sex Goddesses of the Silent Screen* (Chicago: Henry Regnery, 1973), esp. pp. 133–58; and Higham, *Merchant of Dreams.*

CHAPTER 7. QUEENS OF THE LOT

1. Rosten, *Hollywood,* p. 243.

2. For more on Shearer, see Gavin Lambert, *Norma Shearer: A Life* (New York: Knopf, 1990); and Lawrence Quirk, *Norma* (New York: St. Martin's Press, 1988).

3. For example, Fred Fox, "Symbol of New Blood . . . the Ascent of Shearer," *Hollywood Vagabond,* Sept. 22, 1927, p. 7.

4. Surprisingly, she doesn't seem to have been photographed extensively by the in-house photographer Clarence Bull during 1924 and 1925; her publicity therefore depended largely on these earlier portraits. The studio's intensive use of portraits generated by its own stills photographers begins with Louise.

5. *Screenland,* June 1929, p. 16.

6. Albert, "She Bosses the Stars," p. 95.

7. Tellingly, in an article on fashion, Shearer is described as "very sensible and charming to dress" (Shirley, "Your Clothes Come from Hollywood," p. 130).

8. *Motion Picture,* Feb. 1929, pp. 46–47.

9. And even while Louise was photographing her, Shearer took full advantage of other photographers, especially in New York, to explore new looks.

10. See Lambert, *Norma Shearer,* p. 61 and passim.

11. For more on Davies, see her *The Times We Had: Life with William Randolph Hearst* (Indianapolis: Bobbs-Merrill, 1975); and Fred Guiles, *Marion Davies* (New York: McGraw-Hill, 1972).

12. Albert, "She Bosses the Stars," p. 94.

13. For more on Crawford, see her *Portrait of Joan;* Bob Thomas, *Joan Crawford* (New York: Simon & Schuster, 1978); and Lawrence Quirk, *The Films of Joan Crawford* (New York: Citadel, 1968).

14. See Crawford, *Portrait of Joan,* p. 14.

15. Frederica Sagor Maas, *The Shocking Miss Pilgrim: A Writer in Early Hollywood* (Lexington: University of Kentucky Press, 1999), p. 71.

16. Crawford, *Portrait of Joan,* p. 12.

17. Ibid., p. 13.

18. Among the male actors, only Lew Cody gets a short scene of his own.

19. *Photoplay,* Dec. 1928, p. 23.

20. *Motion Picture,* Jan. 1926, p. 42.

21. Dorothy Manners, "Joan Does the Charleston," *Picture Play,* Aug. 1926, p. 48.

22. Fred Fox, "Little Girl in a Big City," *Hollywood Vagabond,* May 12, 1927, p. 5. For Fitzgerald, see Bob Thomas, *Thalberg: Life and Legend* (Garden City, N.Y.: Doubleday, 1969), p. 105.

23. Jazz dancing lay at the very heart of what it meant to be a young, modern person. See Fass, *The Damned and the Beautiful,* pp. 300–306.

24. Crawford apears in June, pp. 46–47.

25. See, for example, *Screenland,* June 1929, inside back cover.

26. *Photoplay,* Aug. 1929, pp. 64ff.

27. Quoted in Thomas, *Joan Crawford,* p. 271.

28. Conversation with Freda Sandrich, June 6, 1998.

CHAPTER 8. PHOTOGRAPHING GARBO

1. Chute, "Girl of Twenty-two," n.p.

2. See, for example, Anne Hollander's review of Barry Paris's *Garbo* in the *New Republic* (Apr. 3, 1995, p. 32): "It is significant that Garbo's appeal endures as much in her photographs as in her movies. Above everything, it was and is the Face. . . . It was the close-ups in the movies and the portrait photographs that drew forth her real gift and made her immortal."

3. Rudolf Arnheim, *Film Essays and Criticism,* trans. Brenda Benthien (Madison: University of Wisconsin Press, 1997), pp. 216–17.

4. Roland Barthes, *Mythologies,* trans. Annette Lavers (New York: Hill & Wang, 1972), pp. 56–57. Kobal (*Art of the Great Hollywood Portrait Photographers,* p. 26) comments: "From this period came the definitive image of beauty for the twentieth century—the face of Garbo [in] her portraits by Ruth Harriet Louise . . . and Clarence Sinclair Bull."

5. Quoted in Brooks, *Lulu in Hollywood,* p. 98.

6. See Barry Paris, *Garbo* (New York: Knopf, 1995), pp. 80 ff. It should also be noted that Mayer offered contracts to two other actors from *Gösta Berling's Saga,* Lars Hanson, who accepted the offer, and Mona Martenson, who did not.

7. The caption on a photograph from Ball's session reads: "This is the latest portrait of Greta Garbo taken in New York before her departure for the West Coast. She will appear in Maurtiz Stiller's production of Ibanez' novel, 'The Temptress'" (private collection, New York).

8. The session was arranged by Voight, and the photographs were taken in her hotel room. Voight also claims that she went to "Weingarten's, the inexpensive clothier in New York to pose for some publicity pictures" (Hubert Voight [as told to Gurdi Haworth], "I Loved Garbo," *New Movie Magazine,* Feb. 1934, p. 87). A photograph from this session was published by James M. Fidler, "Is Garbo Bluffing?" *Screenland,* Aug. 1933, p. 25.

9. Genthe's subsequent account of the sitting is much elaborated and romanticized. Even he, however, knew that Garbo had sat for MGM's stills photographers while in New York. He claims that she did not show his photographs to the studio because "they have so many of me already." See Genthe, *As I Remember* (New York: Reynal and Hitchcock, [1936]), pp. 166–67.

10. The portfolio also included photos taken in Stockholm two years before by Olaf Ekstrand and Henry Goodwin.

11. Ball's photographs are used as late as February 1926 (in *Photoplay*), in part because they were already in circulation. Louise's photographs taken in conjunction with *The Torrent* were not released until the winter of 1926.

12. See Genthe's photograph of Jane Cowl, a Shakespearean ingenue, published in *Vanity Fair,* Sept. 1925, p. 38.

13. Genthe claims that, some time before the photographs appeared in *Vanity Fair,* he urged Garbo to show them to senior producers who were just then visiting from the West Coast and that they realized immediately how striking she was; see Genthe, *As I Remember,* pp. 167–68.

14. Richard Watts Jr., writing for the *New York Herald Tribune,* quoted in Michael Conway, Dion McGregor, and Mark Ricci, *The Films of Greta Garbo* (New York: Cadillac, 1963), p. 47.

15. Paris, *Garbo,* p. 89. Such a delay, however, was nothing compared to the wait that occurred earlier in the year as Lillian Gish and Thalberg fretted over a suitable vehicle for her MGM debut.

16. Genthe, *As I Remember,* pp. 167–68.

17. Captions on MGM-4436 (fur coat), MPGP-8812 (monkey), and MGM-1444 (tiger) (40A, 20, and 22, respectively, in MGM Biography file, AMPAS).

18. Carl Teet, "The Young Swedish Girl Was Scared," *Hollywood Studio* 6, no. 7 (Nov. 1971): 10–11.

19. Carey, in *All the Stars in Heaven,* p. 106, suggests that in this awkward encounter between future star and the newly consolidated MGM, "the studio department learned a valuable lesson. All contract players required a custom-tailored campaign, one based on careful examination of their capability to deal with stardom and with their screen image." But this credits MGM's publicity department with more intelligence than it deserves. Much more realistic is Paris's description of hostile MGM publicity personnel, in *Garbo,* pp. 177–78.

20. Pepper and Kobal, *Man Who Shot Garbo,* p. 22.

21. The 8 × 10 originals have a slit cut in them, and a cutout of Garbo's head (plus part of her torso in a long wedge) is slipped through it and taped down on the back of the photograph. These were circulated in 11 × 14 format, as well as 8 × 10, which suggests how important Garbo became as a piece of merchandise.

22. It is worthwhile citing the contemporary example of Gwyneth Paltrow and Brad Pitt, she, a young actress with only two starring roles under her belt, and he, the leading young male star of the day (in the action/sexy looks category). During their relationship she became a star, in good measure through association with him. The difference is that at the end of Garbo and Gilbert's relationship, she was the leading star; at the end of Paltrow and Pitt's, he still made millions more than she.

23. Brooks, *Lulu in Hollywood,* p. 95.

24. Gordon and Gordon, *Star-dust in Hollywood,* p. 154.

25. She was not unique is this: Mae Murray assumes the superior position to John Gilbert in some stills of *The Merry Widow.*

26. See Fuller, *At the Picture Show,* chap. 9, esp. pp. 186–91.

27. Swanson, *Swanson on Swanson,* pp. 173–74.

28. Karen Swenson, *Greta Garbo: A Life Apart* (New York: Scribner, 1997), pp. 134–40.

29. In the course of these months Garbo also sat for two other photographers: Clarence Sinclair Bull and Russell Ball. In the work of all three, we find clear indications of mutual influence.

30. Ball during this period spent some time every year working on the West Coast for MGM.

31. It is published, for example, in *Vida da Greta Garbo* (Madrid, 1929), opposite p. 96.

32. This and subsequent quotes are from Edward Steichen, *A Life in Photography* (New York: Doubleday, 1963), n.p. (facing plate 112). Steichen suggests that he connected to Garbo so directly because he "had let her do whatever she wanted, instead of ordering her or asking her to do this or that." This statement comes eight lines after he writes that "I suggested we try something else and asked her to stand."

33. *Photoplay,* Nov. 1928, p. 10: "Here is a preview of her new hairdress, as she wears it in *Woman of Affairs,* with three inches trimmed off."

34. One is reproduced in *Vanity Fair,* Dec. 1928, p. 89.

35. Paul Gallico is even clearer in his comments: "Two eyes, a nose and a mouth and their arrangement formed the magical personality of the most splendid creature of not only the Golden Decade but, so far, of the century as well. . . . For she was incarnate that unattainable woman who haunts the dreams of every man and boy . . . the distillation of Eros that is the despair of man." See Nickolas Muray, *The Revealing Eye: Personalities of the 1920s in Photograph,* with text by Gallico (New York: Atheneum, 1967), p. 112.

36. Ibid., pp. xix–xx.

37. "Doubles or Quits," in *The Vanity Fair Book* (New York: John Day, 1931), pp. 116–17; the two are reproduced side by side. See also Leonard Hall, "Garbo vs. Dietrich" (Feb. 1931), reprinted in *Photoplay Treasury,* pp. 166–68.

38. *Vanity Fair Book* (1931), pp. 20–23.

39. *Photoplay,* Nov. 1929, p. 29.

CHAPTER 9. LOOKING AT MEN

1. See Miriam Hansen, *Babel and Babylon: Spectatorship in American Silent Film* (Cambridge, Mass.: Harvard University Press, 1991), pp. 254–68.

2. This and subsequent quotations are from Dorothy Calhoun, "Meet the New Sheiks Who Are Storming the Screen," *Motion Picture,* Sept. 1925, pp. 32ff.

3. Martin J. Quigley Papers, testimonials, folder 28, Special Collections, Georgetown University Library.

4. See Quigley Papers, folder 28. Novarro was appreciated in Europe as well; see Max Montague, *Les grands artistes de l'écran: Ramon Novarro* (Paris: Publications Jean Pascal, n.d. [1927?]).

5. More than likely he wore a thong that was airbrushed out.

6. See, for example, *Picture Play,* Nov. 1926, p. 84: "He is, too, a splendid natural athlete . . . one of the best all-round athletes in the [film] colony." The article is illustrated with photographs of Novarro fencing, boxing, and playing volleyball on the beach.

7. See the sequence of photographs in the AMPAS Core Collection files, c. 1930.

8. The MGM publicity department capitalized on Novarro's romantic charms whenever possible, using scene stills such as a series of photographs taken by Clarence Bull of the actor with Dorothy Janis, for *The Pagan* (1929). These show Novarro clad only in a loincloth, with Janis in his arms.

9. Published in *Motion Picture,* Sept. 1925, p. 71.

10. Published in *Photoplay,* Oct. 1927, p. 81.

11. *Photoplay,* Dec. 1928, p. 6: "[Novarro] will make pictures six months each year and devote the other half of the year to pursuits that suit his fancy . . . to continue his vocal studies."

12. It was also in his roles as an opera and folk singer that Hurrell photographed him at the beginning of 1929: Ramon as Parsifal, as a gypsy, and as a chorister singing "Ave Maria."

13. For an extended discussion of Gilbert's qualities as an actor, see Jeanine Basinger, *Silent Stars* (Middletown, Conn.: Wesleyan University Press, 1999), pp. 371ff.

14. "John Gilbert as Buck Private," *The Big Parade,* MGM souvenir program [1925], n.p., private collection.

15. Clara Bow, the all-American "It" girl, offered a persona centered on "good times," which included sex but was not dominated by it. Garbo, in contrast, is never made happy by love.

16. "John Gilbert as Buck Private."

17. The last photo was published in *Photoplay,* Feb. 1926, p. 22; its caption read: "Simple, tired, dirty, bewildered, John Gilbert in 'The Big Parade' has visualized the very spirit of the American doughboy."

18. Albert, "She Bosses the Stars," pp. 32, 92.

19. Chute, "Girl of Twenty-two," n.p.

20. See Fass, *The Damned and the Beautiful;* and Mary P. Ryan. "The Projection of a New Womanhood: The Movie Moderns in the 1920s," in *Our American Sisters: Women in American Life and Thought,* ed. Jean E. Friedman and William G. Shade (Lexington, Mass.: D. C. Heath, 1973), pp. 366–84.

21. Chute, "Hollywood's Girl Photographer," p. 805. The degree to which his homosexuality was hinted at is astonishing, however. Although headlines like "A Gay Young Man" are surely innocent (*Picture Play,* Aug. 1926, p. 82), a squib revealing that he and his "best friend . . . Jimmy Shields, an extra boy," live together seems less so (*Photoplay,* Nov. 1928, p. 108).

22. *Photoplay,* July 1925, p. 12. Another correspondent wrote, "I have been looking for months for a good-sized photo of Dix and have been unable to find one in *Photoplay*" (*Photoplay,* Nov. 1923, p. 10). This is part of a constant theme in letters and articles about images of pretty boys and handsome men. The photographer Bud Graybill discusses the lengths to which MGM went to tone down Robert Taylor's beauty and make him look "less like a girl" in Kobal, *Art of the Great Hollywood Portrait Photographers,* p. 84.

23. Dorothy Spensley, "Ricardo the First . . . ," *Photoplay,* Sept. 1925, p. 63.

24. Letter from R. P. Leavitt, Wollaston, Mass., to *Picture Play,* Feb. 1926, p. 11.

25. Letter from Rosalind Rubelle, Los Angeles, to *Picture Play,* Feb. 1926, p. 10.

26. Russell Ball stated that "men are always much easier to photograph than women" ("How to Have Your Photograph Made," p. 69).

27. Letter from John Francis Clemmons, "Brickbats and Bouquets," *Photoplay,* Oct. 1929, p. 10.

28. Gaylyn Studlar, "The Perils of Pleasure? Fan Magazine Discourse as Women's Commodified Culture in the 1920s," in *Silent Film,* ed. Richard Abel (New Brunswick, N.J.: Rutgers University Press, 1996), pp. 263–97.

29. And then there were the countless majorette outfits worn by starlets for general publicity purposes, where the alluring display of gorgeous legs undercut any military significance to the braids and epaulets. Combat uniforms were never treated so cavalierly, and women were never photographed in them.

30. Chute, "Girl of Twenty-two," n.p.

31. The most common action in a screen test for a man was "usually . . . to light a cigarette, seat himself jauntily, or walk about" (Selma Robinson, "Could You Face the Camera?" *Motion Picture,* July 1926, p. 37). Bordwell, *Hollywood Glamour,* makes a similar point.

32. On "good girls" and smoking, see Fass, *The Damned and the Beautiful,* pp. 292–300.

33. As late as 1929, after he had appeared in a score of MGM movies, publicity was still uncertain how to type him. Cedric Belfrage, in an article entitled "Home, Swede, Home" (*Motion Picture,* March 1929, pp. 33, 106), suggests that he was "too learned, too intelligent and too frank," another melancholic, so-phisticated Swede.

34. *Screen Secrets,* July 1929, p. 12; Oct. 1929, p. 61.

35. Flamini, *Thalberg,* p. 74. Conrad Nagel was one exception, appearing in an ad for a tailor in Los An-geles; see *Hollywood Vagabond,* Sept. 15, 1928, p. 3.

36. Erté, *Things I Remember,* pp. 76–77.

37. See Jeffrey Charles and Jill Watts, "(Un)Real Estate: Marketing Hollywood in the 1910s and 1920s," in Desser and Jowett, *Hollywood Goes Shopping,* pp. 260ff.

38. *Photoplay,* Jan. 1926, p. 12.

CHAPTER 10. TELLING STORIES

1. See the comments in "Capturing Stars," p. 224; and Wooldridge, "Through a Different Lens," p. 108.

2. Albert, "She Bosses the Stars," p. 95.

3. Gish, *Movies, Mr. Griffith, and Me,* p. 264,

4. Brooks, *Lulu in Hollywood,* pp. 96–97.

5. Margaret Reid, in an article written during the filming of *La Boheme,* for example, underlines the con-trast between the "genuinely old-fashioned," sweet, and lovely Gish and her eight-thousand-dollar-a-week salary: "I find it impossible to call up a mental picture of eight thousand dollars a week at all, but I understand it is a pretty sum" (Reid, "Looking On with an Extra Girl," *Photoplay,* Feb. 1926, p. 52). Madeline Glass, in an article entitled "Do They Criticize Me?" for *Picture Play* (Nov. 1926, p. 20), also comments on her "excessive refinement," her "nineteenth-century quality," and wonders if she mightn't play something a little more vigorous. She is never able to answer her initial question, however: "Is Lillian Gish a great actress or merely a mechanical technician?"

6. Jim Tully, "Greta Garbo," *Vanity Fair,* June 1928, p. 67. This is a version of a statement that appears in numerous publications, beginning as early as *Motion Picture,* July 1926, p. 74: "Greta Garbo says that when she reaches the astral heights of a Lillian Gish, 'I will no longer have publicity . . . shake hands with prize-fighters and egg-and-milkmen so they have pictures to put in papers.'"

7. A rather uninteresting photograph of Gish spinning, taken for *The Scarlet Letter,* represents one of the very few times Ruth's work was published in *Vanity Fair* (Aug. 1926, p. 39).

8. Cf. James Manatt's still of Garbo in *Wild Orchids,* where Garbo stands with a similar shadow cast ominously on the wall beside her. In contrast to Gish, however, Garbo is positioned so that nothing detracts from her costume.

9. Kobal, *Art of the Great Hollywood Portrait Photographers,* p. 127.

10. Albert, "She Bosses the Stars," p. 95.

11. Chute, "Hollywood's Girl Photographer," p. 806.

12. Images from this session were used in the publicity for *Caught Short,* although production did not begin until late winter 1930 after Louise had left MGM. This photo was taken in 1929 and may have been intended for another film.

CHAPTER 11. LEAVING MGM

1. Louella Parsons, *Los Angeles Examiner,* March 14, 1929.

2. Mayer used his close connections with President Hoover to arouse the government against Fox. See Higham, *Merchant of Dreams,* pp. 143–52.

3. According to the *Hollywood Vagabond,* Oct. 6, 1928, p. 1, for example, in fall 1928 some two hundred voices were being tested every week.

4. In fact, Novarro had already scheduled a European singing tour and planned to open in Berlin in March 1929. Illness, however, forced him to cancel. See Allan R. Ellenberger, *Ramon Novarro* (Jefferson, N.C.: McFarland, 1999), p. 96.

5. Her visit may have taken place in mid-October 1929; see Vieira, *Hurrell's Hollywood Portraits,* p. 18.

6. Costume designer Adrian also won his first Academy Award for the picture—another confluence of photographer, designer, and star like that which helped create Ruth Harriet Louise at the beginning of her MGM career.

7. Stine, *Hurrell Style,* p. 9.

8. Hurrell's specific memories of the sequence of the acceptance of his photographs by MGM suggests that he knew he was being considered by MGM for a job that fall; see Kobal, *People Will Talk,* p. 258.

9. Ibid.

10. *Motion Picture,* June 1929, p. 119.

11. Hurrell remembered: "[Bull] thought that when Ruth Harriet Louise left that at last he was going to have his chance. And he hated my guts all the time thereafter" (Vieira, *Hurrell's Hollywood Portraits,* p. 28). Bull does not mention Louise once in his own memoirs (written with Raymond Lee), *The Faces of Hollywood* (New York: A. S. Barnes, 1968).

12. Louella Parsons, *Los Angeles Examiner,* Dec. 9, 1929.

13. The primary survey we have of Louise's career is a pair of personal scrapbooks she made, and there is a startling difference between the two. The first one, covering the years 1925 and 1926, chronicles the care-

ful efforts of someone deeply excited about the movies: reproductions of her photographs are culled from magazines and newspapers and pasted decoratively onto the pages, with all the love of a fan. The second consists solely of press clippings from a publicity service.

14. Another image from this session was published in *Picture Play,* Dec. 1932, p. 28; it was Louise's last professional appearance.

15. Undated letter to William Wyler, AMPAS.

BIBLIOGRAPHY

ARCHIVES AND PHOTO SERVICES

Margaret Herrick Library, Academy of Motion Pictures Arts and Sciences, Los Angeles (AMPAS)

Cinema/Television Library, University of Southern California, Los Angeles

Special Collections, Arts Library, University of California, Los Angeles

Film Stills Archive, Museum of Modern Art, New York

John Kobal Foundation, London

Santa Barbara Museum of Art, Santa Barbara

Martin Quigley Papers, Special Collections, Georgetown University, Washington, D.C.

Hulton Archive Photograph Collection, London

Culver Picture Service, New York

Film Division, Library of Congress, Washington, D.C.

BOOKS

Abel, Richard, ed. *Silent Film.* New Brunswick, N.J.: Rutgers University Press, 1996.

Albrecht, Donald. *Designing Dreams: Modern Architecture in the Movies.* New York: Harper & Row, 1986.

Altman, Diana. *Hollywood East: Louis B. Mayer and the Origins of the Studio System.* New York: Birch Lane Press, 1992.

The American Stage of Today: Biographies and Photographs of One Hundred Leading Actors and Actresses. Introduction by William Winter. New York: P. F. Collier, 1910.

Ankerich, Michael G. *Broken Silence: Conversations with 23 Silent Film Stars.* Jefferson, N.C.: McFarland, 1993.

Archer, Fred. *Fred Archer on Portraiture.* San Francisco: Camera Craft, 1954.

———. "The Still Picture's Part in Motion Pictures." In *Cinematographic Annual.* Vol. 1. Edited by Hal Hall. Hollywood: American Society of Cinematographers, 1930, pp. 245–52.

Ardmore, Jane. *The Self-Enchanted: Mae Murray—Image of an Era.* New York: McGraw-Hill, 1959.

Arnheim, Rudolf. *Film Essays and Criticism.* Translated by Brenda Benthien. Madison: University of Wisconsin Press, 1997.

Balshofer, Fred J., and Arthur C. Miller. *One Reel a Week.* Berkeley: University of California Press, 1967.

Barthes, Roland. *Mythologies.* Translated by Annette Lavers. New York: Hill & Wang, 1972.

Basinger, Jeanine. *Silent Stars.* Middletown, Conn.: Wesleyan University Press, 1999.

Beaton, Cecil. *The Glass of Fashion.* London: Weidenfeld & Nicolson, 1954.

Beauchamp, Cari. *Without Lying Down.* New York: Scribner, 1997.

Belton, John, ed. *Movies and Mass Culture.* New Brunswick, N.J.: Rutgers University Press, 1996.

Berg, A. Scott. *Goldwyn.* New York: Knopf, 1989.

Blake, Michael F. *Lon Chaney: The Man behind the Thousand Faces.* Vestal, N.Y.: Vestal Press, 1993.

Blei, Franz. *Die göttliche Garbo.* Giessen: Kindt & Bucher Verlag, [1930].

Blum, Daniel. *A Pictorial History of the Silent Screen.* New York: G. P. Putnam's, 1953.

Blumer, Herbert. *Movies and Conduct.* New York: Macmillan, 1933.

Bordwell, David. *Hollywood Glamour, 1924–1942: Selected Portraits from the Wisconsin Center for Film and Theater Research.* Madison: WCFTR, 1987.

Bowman, Sara, and Michel Molinare. *A Fashion for Extravagance: Art Deco Fabrics and Fashions.* New York: E. P. Dutton, 1985.

Broman, Sven. *Conversations with Greta Garbo.* New York: Viking, 1992.

Brooks, Louise. *Lulu in Hollywood.* New York: Knopf, 1982.

Brownlow, Kevin. *Hollywood: The Pioneers.* New York: Knopf, 1979.

———. *The Parade's Gone By.* New York: Knopf, 1960.

Bruzzi, Stella. *Undressing Cinema: Clothing and Identity in the Movies.* London: Routledge, 1997.

Bull, Clarence, and Raymond Lee. *The Faces of Hollywood.* New York: A. S. Barnes, 1968.

Butler, Ivan. *Silent Magic: Rediscovering the Silent Film Era.* New York: Ungar, 1988.

Carey, Gary. *All the Stars in Heaven: Louis B. Mayer's MGM.* New York: Dutton, 1981.

Carr, Larry. *Four Fabulous Faces: Swanson, Garbo, Crawford, Dietrich.* New York: Gallahad Books, 1970.

Charney, Leo, and Vanessa R. Schwartz. *Cinema and the Invention of Modern Life.* Berkeley: University of California Press, 1995.

Conway, Michael, Dion McGregor, and Mark Ricci. *The Films of Greta Garbo.* New York: Cadillac, 1963.

Crawford, Joan (with Jane Ardmore). *A Portrait of Joan.* New York: Doubleday, 1962.

Crowther, Bosley. *Hollywood Rajah: The Life and Times of Louis B. Mayer.* New York: Holt, Rinehart & Winston, 1960.

———. *The Lion's Share: The Story of an Entertainment Empire.* New York: Dutton, 1957.

Dardin, Tom. *Keaton.* New York: Limelight Editions, 1996.

Davies, Marion. *The Times We Had: Life with William Randolph Hearst.* Indianapolis: Bobbs-Merrill, 1975.

Davis, Ronald L. *The Glamour Factory: Inside Hollywood's Big Studio System.* Dallas: Southern Methodist University Press, 1993

Day, Beth. *This Was Hollywood: An Affectionate History of Filmland's Golden Years.* New York: Doubleday, 1960.

deCordova, Richard. *Picture Personalities: The Emergence of the Star System in America.* Urbana: University of Illinois Press, 1990.

de Meyer, Adolph, Baron. *A Singular Elegance: The Photographs of Baron Adolph de Meyer.* Text by Anne Ehrenkranz. San Francisco: Chronicle Books in association with the International Center of Photography, 1994.

Desser, David, and Garth S. Jowett, eds. *Hollywood Goes Shopping.* Minneapolis: University of Minnesota Press, 2000.

Doane, Mary Ann. *The Desire to Desire: The Woman's Film of the 1940s.* Bloomington: Indiana University Press, 1987.

Dressler, Marie. *My Own Story.* Boston: Little, Brown, 1934.

Durgnat, Raymond, and John Kobal. *Greta Garbo.* London: Studio Vista, 1967.

Dyer, Richard. *Stars.* Rev. ed. London: British Film Institute, 1998.

Eames, John Douglas. *The MGM Story.* Rev. ed. New York: Crown, 1979.

Eckert, Charles. "The Carole Lombard in Macy's Window." In *Movies and Mass Culture,* edited by John Belton, pp. 95–118. New Brunswick, N.J.: Rutgers University Press, 1996.

Ellenberger, Allan R. *Ramon Novarro.* Jefferson, N.C.: McFarland, 1999.

Erté [Romain de Tirtoff-Erté]. *Things I Remember: An Autobiography.* New York: Quadrangle/New York Times Book Co., 1975.

Eyman, Scott. *The Speed of Sound: Hollywood and the Talkie Revolution, 1926–1930.* New York: Simon & Schuster, 1997.

Fahey, David, and Linda Rich. *Masters of Starlight: Photographers in Hollywood.* Los Angeles: Los Angeles County Museum of Art; New York: Ballantine, 1987.

Fass, Paula S. *The Damned and the Beautiful: American Youth in the 1920s.* New York: Oxford University Press, 1977.

Fawcett, L'Estrange. *Film Facts and Forecasts.* London: G. Bles, 1927.

The Film Daily Yearbook. Edited by Jack Alicote. New York: Film Daily, 1924–30. (An annual publication.)

Finler, Joel W. *Hollywood Movie Stills.* London: B. T. Batsford, 1995.

Flamini, Roland. *Thalberg: The Last Tycoon and the World of MGM.* New York: Crown, 1994.

Fountain, Leatrice Gilbert. *Dark Star.* New York: St. Martin's Press, 1985.

Fowles, Jib. *Starstruck: Celebrity Performers and the American Public.* Washington, D.C.: Smithsonian Institution Press, 1992.

Fuller, Kathryn H. *At the Picture Show: Small-Town Audiences and the Creation of Movie Fan Culture.* Washington, D.C.: Smithsonian Institution Press, 1996.

Gabler, Neal. *An Empire of Their Own: How the Jews Invented Hollywood.* New York: Crown, 1988.

Gaines, Jane, and Charlotte Herzog, eds. *Fabrications: Costume and the Female Body.* London: Routledge, 1990.

Gelman, Barbara, ed. *Photoplay Treasury.* New York: Crown, 1972.

Genthe, Arnold. *As I Remember.* New York: Reynal & Hitchcock, [1936].

Gish, Lillian. *Dorothy and Lillian Gish.* New York: Scribner's, 1973.

———. *The Movies, Mr. Griffith, and Me.* Englewood Cliffs, N.J.: Prentice-Hall, 1969.

Gledhill, Christine, ed. *Stardom: Industry of Desire.* London: Routledge, 1991.

Gomery, Douglas. *The Hollywood Studio System.* New York: St. Martin's Press, 1986.

Gordon, Jan, and Cora Gordon. *Star-dust in Hollywood.* London: George Harrap, 1930.

Guiles, Fred. *Marion Davies.* New York: McGraw-Hill, 1972.

Hansen, Miriam. *Babel and Babylon: Spectatorship in American Silent Film.* Cambridge, Mass.: Harvard University Press, 1991.

Haskell, Molly. *From Reverence to Rape: The Treatment of Women in the Movies.* Harmondsworth, Eng.: Penguin, 1974.

Hay, Peter. *MGM: When the Lion Roars.* Atlanta: Turner, 1991.

Hays, Will H. *See and Hear: A Brief History of Motion Pictures and the Development of Sound.* [New York], 1929.

Hicks, Roger, and Christopher Nisperos. *Hollywood Portraits: Classic Shots and How to Take Them.* New York: Amphoto Books, 2000.

Higashi, Sumiko. *Cecil B. DeMille and American Culture: The Silent Era.* Berkeley: University of California Press, 1994.

Higham, Charles. *Merchant of Dreams: Louis B. Mayer, MGM, and the Secret Hollywood.* New York: Donald I. Fine, 1993.

Humm, Maggie. *Feminism and Film.* Edinburgh: Edinburgh University Press, 1997.

Hürlimann, AnneMarie, and Alois Martin Müller. *Film Stills: Emotions Made in Hollywood.* Zurich: Museum für Gestaltung Zürich, 1993.

Izod, John. *Hollywood and the Box Office, 1895–1986.* New York: Columbia University Press, 1988.

Jacobs, Jack, and Myron Braum. *The Films of Norma Shearer.* Secaucus, N.J.: Citadel, 1977.

Jowett, Garth, Ian C. Jarvie, and Kathryn H. Fuller. *Children and the Movies: Media Influence and the Payne Fund Controversy.* Cambridge: Cambridge University Press, 1996.

Karren, Howard. "The Star Who Fell to Earth." *Premiere,* winter 1991, pp. 54–56.

Kennedy, Matthew. *Marie Dressler.* Jefferson, N.C.: McFarland, 1999.

Kindem, Gorham, ed. *The American Movie Industry: The Business of Motion Pictures.* Carbondale: Southern Illinois University Press, 1982.

Kobal, John. *The Art of the Great Hollywood Portrait Photographers.* New York: Knopf, 1980.

———. *Hollywood: The Years of Innocence.* New York: Abbeville Press, 1985.

———. *Hollywood Glamour Portraits.* New York: Dover, 1976.

———. *People Will Talk.* New York: Knopf, 1986.

Koszarski, Richard. *An Evening's Entertainment: The Age of the Silent Feature Picture, 1925–1928.* New York: Scribner's, 1990.

Lambert, Gavin. *Norma Shearer: A Life.* New York: Knopf, 1990.

Lawton, Richard, and Hugo Leckey. *Grand Illusions.* New York: McGraw-Hill, 1973.

Longworth, Bertram. *Hold Still . . . Hollywood.* Los Angeles: Ivan Deach Jr., 1937.

Maas, Frederica Sagor. *The Shocking Miss Pilgrim: A Writer in Early Hollywood.* Lexington: University of Kentucky Press, 1999.

MacCann, Richard Dyer. *The Silent Screen.* Lanham, Md.: Scarecrow Press, 1997.

Mann, William J. *Wisecracker.* New York: Viking, 1998.

Margolis, Marianne Fulton. *Muray's Celebrity Portraits of the Twenties and Thirties.* New York: Dover, 1978.

Marion, Frances. *Off with Their Heads!* New York: Macmillan, 1972.

Marx, Samuel. *Mayer and Thalberg: The Make-Believe Saints.* New York: Random House, 1975.

Mayne, Judith. *Cinema and Spectatorship.* London: Routledge, 1993.

McCarthy, Mary Eunice. *Hands of Hollywood.* Hollywood: Photoplay Research Bureau, [1929].

Mitchell, Alice Miller. *Children and the Movies.* Chicago: University of Chicago Press, 1929.

Modleski, Tania. *Feminism without Women: Culture and Criticism in a "Postfeminist" Age.* New York: Routledge, 1991.

Moore, Colleen. *Silent Star.* New York: Doubleday, 1968.

Motion Picture Almanac. Chicago: Quigley, 1929 and 1930. (An annual publication.)

Muray, Nickolas. *The Revealing Eye: Personalities of the 1920s in Photographs.* With text by Paul Gallico. New York: Atheneum, 1967.

Palmborg, Rilla Page. *The Private Life of Greta Garbo.* Garden City, N.Y.: Doubleday, Doran, 1931.

Paris, Barry. *Garbo.* New York: Knopf, 1995.

Payne, Robert. *The Great Garbo.* New York: Praeger, 1976.

Pepper, Terence, and John Kobal. *The Man Who Shot Garbo: The Hollywood Photographs of Clarence Sinclair Bull.* London: National Portrait Gallery; New York: Simon & Schuster, 1989.

The Picturegoer's Annual for 1930. London: Amalgamated Press, [1930].

The Picturegoer's Who's Who and Encyclopedia of the Screen Today. London: Odhams Press, 1933.

Quirk, Lawrence. *The Films of Joan Crawford.* New York: Citadel, 1968.

————. *Norma.* New York: St. Martin's Press, 1988.

Raeburn, Anna, and John Kobal. *Crawford.* London: Pavillion, 1986.

Ramsaye, Terry. *A Million and One Nights: A History of the Motion Picture.* 2 vols. New York: Simon & Schuster, 1927.

Rapf, Maurice. *Backlot: Growing Up with the Movies.* Lanham, Md.: Scarecrow Press, 1999.

Reichenbach, Harry (as told to David Freedman). *Phantom Fame: The Anatomy of Ballyhoo.* New York: Simon & Schuster, 1931.

Rhodes, Harrison. "High Kingdom of the Movies." In *American Towns and People,* pp. 199–226. New York: Robert M. McBride, 1920.

Rosenblum, Naomi. *A History of Women Photographers.* New York: Abbeville Press, 1994.

Rosten, Leo. *Hollywood: The Movie Colony, the Movie Makers.* New York: Harcourt Brace, 1941.

Ryan, Mary P. "The Projection of a New Womanhood: The Movie Moderns in the 1920s." In *Our American Sisters: Women in American Life and Thought,* edited by Jean E. Friedman and William G. Shade, pp. 366–84. Lexington, Mass.: D. C. Heath, 1973.

Schatz, Thomas B. *The Genius of the System: Hollywood Filmmaking in the Studio Era.* New York: Henry Holt, 1996.

Schulberg, Budd. *Moving Pictures: The Memoirs of a Hollywood Prince.* New York: Stein & Day, 1981.

Seldes, Gilbert. *Movies for Millions.* London: Batsford, 1937.

Selznick, Irene Mayer. *A Private View.* New York: Knopf, 1983.

Sembach, Klaus-Juergen. *Greta Garbo: Portraits, 1920–1951.* New York: Rizzoli, 1986.

Sjolander, Ture. *Garbo.* New York: Harper & Row, 1971.

Slide, Anthony. *Early American Cinema.* Metuchen, N.J.: Scarecrow Press, 1994.

————. *The Idols of Silence.* South Brunswick, N.J.: A. S. Barnes, 1976.

————. *The Silent Feminists: America's First Women Directors.* Lanham, Md.: Scarecrow Press, 1996.

————. *Silent Portraits: Stars of the Silent Screen in Historic Photographs.* Vestal, N.Y.: Vestal Press, 1989.

Spencer, Charles. *Erté.* New York: Clarkson N. Potter, 1970.

Stacey, Jackie. *Star Gazing: Hollywood Cinema and Female Spectatorship.* London: Routledge, 1994.

Staiger, Janet. *Bad Women: Regulating Sexuality in Early American Cinema.* Minneapolis: University of Minnesota Press, 1995.

———, ed. *The Studio System.* New Brunswick, N.J.: Rutgers University Press, 1995.

Stamp, Shelley. *Movie-Struck Girls: Women and Motion Picture Culture after the Nickelodeon.* Princeton, N.J.: Princeton University Press, 2000.

Stars of the Movies. Hollywood: Hollywood Publicity Company, 1927.

Stars of the Photoplay. Chicago: Photoplay Magazine, 1924 and 1930. (An annual publication.)

Steele, Valerie. *Paris Fashion: A Cultural History.* New York: Oxford University Press, 1988.

Steen, Mike. *Hollywood Speaks: An Oral History.* New York: Putnam, [1974].

Stine, Whitney. *The Hurrell Style.* New York: John Day, 1976.

Studlar, Gaylyn. *In the Realm of Pleasure: Von Sternberg, Dietrich, and the Masochistic Audience.* Urbana: University of Illinois Press, 1988.

Swanson, Gloria. *Swanson on Swanson.* New York: Random House, 1980.

Swenson, Karen. *Greta Garbo: A Life Apart.* New York: Scribner's, 1997.

Teet, Carl. "The Young Swedish Girl Was Scared." *Hollywood Studio* 6, no. 7 (Nov. 1971): 10–11.

Thomas, Bob. *Joan Crawford.* New York: Simon & Schuster, 1978.

———. *Thalberg: Life and Legend.* New York: Doubleday, 1969.

Thorp, Margaret Farrand. *America at the Movies.* New Haven, Conn.: Yale University Press, 1939.

Trent, Paul. *The Image Makers: Sixty Years of Hollywood Glamour.* New York: McGraw-Hill, 1972.

Turim, Maureen. "Seduction and Elegance: The New Woman of Fashion in Silent Cinema." In *On Fashion,* edited by Shari Benstock and Suzanne Ferris. New Brunswick, N.J.: Rutgers University Press, 1994.

Vidor, King. *A Tree Is a Tree.* New York: Harcourt, Brace, 1952.

Vieira, Mark A. *Hurrell's Hollywood Portraits.* New York: Abrams, 1997.

Wagenknecht, Edward. *The Movies in the Age of Innocence.* Norman: University of Oklahoma Press, 1962.

Walker, Alexander. *Garbo: A Portrait.* New York: Macmillan, 1980.

———. *Joan Crawford: The Ultimate Star.* New York: Harper & Row, 1983.

———. *Sex in the Movies.* Harmondsworth, Eng.: Penguin, 1968.

———. *Shattered Silents.* New York: William Morrow, 1979.

———. *Stardom: The Hollywood Phenomenon.* New York: Stein & Day, 1970.

Williams, Linda, ed. *Viewing Positions: Ways of Seeing Film.* New Brunswick, N.J.: Rutgers University Press, 1994.

Williamson, Alice M. *Alice in Movieland.* New York: D. Appleton, 1928.

Wilson, Elizabeth. *Adorned in Dreams: Fashion and Modernity.* Berkeley: University of California Press, 1987.

Woody, Jack. *Lost Hollywood.* Altadena, Calif.: Twin Palms, 1987.

Zierold, Norman. *Sex Goddesses of the Silent Screen.* Chicago: Henry Regnery, 1973.

CONTEMPORARY ARTICLES

Note: Titles in bold about Ruth Harriet Louise.

Albert, Katherine. "**She Bosses the Stars.**" *Screenland,* Sept. 1928, pp. 32, 94–95.

Ball, Russell. "How to Have Your Photograph Made." *New Movie Magazine,* Sept. 1930, pp. 68–71, 129.

Brewster, Eugene. "What Is a Star?" *Motion Picture,* Sept. 1925, pp. 57, 103–4.

Brokaw, Clare Boothe. "The Great Garbo." *Vanity Fair,* Feb. 1932; repr. *Reader's Digest,* July 1932, pp. 30–33.

"**Capturing Stars.**" *Royal Magazine* 57, no. 339 (1927): 219–26.

Chute, Margaret. "**Girl of Twenty-two Who Photographs Film Stars.**" *Everybody's Weekly,* Sept. 8, 1928.

———. "**Hollywood's Girl Photographer.**" *Modern Weekly,* Aug. 4, 1928, pp. 804–7.

Gebhart, Myrtle. "How a Star Is Made." *Picture Play,* March 1929, pp. 84–87, 106.

Goldstein, Ruth. "**The Better Photography.**" *Banner* (Young Men's Hebrew Association, New Brunswick, N.J.) 3, no. 6 (Nov. 1922): 6–7.

Larkin, Mark. "What Happens to Fan Mail." *Photoplay,* Aug. 1928, pp. 38–40, 130–33.

"Metro-Goldwyn-Mayer." *Fortune,* Dec. 1932, pp. 50–64, 114–16, 118, 120, 122.

Muray, Nickolas. "Amateur Movie Producer." *Photoplay,* Apr. 1927, pp. 51, 130.

Robinson, Selma. "Could You Face the Camera?" *Motion Picture,* July 1926, pp. 37–38, 107.

———. "What Is the Quality That Makes a Star?" *Motion Picture,* July 1926, pp. 51, 88, 89.

Shirley, Lois. "Your Clothes Come from Hollywood." *Photoplay,* Feb. 1929, pp. 70–71, 130.

Stillman, Joseph. "The Stills Move the Movies." *American Cinematographer,* Nov. 1927, p. 7.

Tildesley, Ruth. "**Directing Directors.**" *Hollywood Life,* Aug. 1926, pp. 58–59, 93. [Louise photographing MGM directors.]

Voight, Hubert [as told to Gurdi Haworth]. "I Loved Garbo." *New Movie Magazine,* Feb. 1934, pp. 31–32, 87–90.

Waterbury, Ruth. "Youth" (1927). In *Photoplay Treasury,* edited by Barbara Gelman. New York: Crown, 1972.

Wooldridge, A. L. "Metro-Goldwyn-Mayer." *Fortune,* Dec. 1930, pp. 51–64, 114, 116, 118, 120, 122.

———. "**Through a Different Lens.**" *Picture Play,* Dec. 1929, pp. 54–55, 108. [Louise photographing President Hoover.]

INDEX

Page numbers in italics refer to illustrations

285

TEXT	10.75/16 Adobe Garamond
DISPLAY	Akzidenz Grotesk and Regency Script
DESIGNER	Nicole Hayward
COMPOSITOR	Integrated Composition Systems
PRINTER & BINDER	Friesens